ON RECORD | 1983 | G. BROWN

CONTENTS

ON RECORD ENTRIES ARE NOT ORDERED ALPHABETICALLY, BUT ORGANIZED INTUITIVELY—A MIXTURE OF SEGUES BY MUSICAL GENRE OR STYLE.

007 INTRODUCTION

008 JOURNEY
010 ZZ TOP
012 GENESIS
014 U2
016 THE POLICE
018 STEWART COPELAND
020 STEVIE NICKS
022 DONNA SUMMER
024 POINTER SISTERS
026 BILLY JOEL
028 BRYAN ADAMS
030 JOHN COUGAR MELLENCAMP
032 MITCH RYDER
034 ROBERT PLANT
036 DEF LEPPARD
038 QUIET RIOT
040 MÖTLEY CRÜE
042 NIGHT RANGER
044 STYX
046 KISS
048 BLUE ÖYSTER CULT
050 BLACK SABBATH
052 DIO
054 RAINBOW
056 IRON MAIDEN
058 STEVIE RAY VAUGHAN
060 KENNY ROGERS
062 LIONEL RICHIE
064 PHILIP BAILEY
066 LINDA RONSTADT
068 BARBRA STREISAND
070 RITA COOLIDGE
072 CARPENTERS
074 AMERICA
076 BIG COUNTRY
078 MEN AT WORK
080 LITTLE RIVER BAND
082 DIVINYLS
084 HEAVEN

086 TIM FINN
088 PETER SCHILLING
090 PAUL YOUNG
092 EURYTHMICS
094 MODERN ENGLISH
096 ABC
098 BOW WOW WOW
100 UB40
102 R.E.M.
104 THE B-52'S
106 GREG KIHN BAND
108 JONATHAN RICHMAN
110 THE BONGOS
112 VIOLENT FEMMES
114 MEAT LOAF
116 CHEAP TRICK
118 THE TUBES
120 RAMONES
122 X
124 JOAN JETT & THE BLACKHEARTS
126 LOVERBOY
128 PAYOLAS
130 RED RIDER
132 TRIUMPH
134 DAVE EDMUNDS
136 MICK FLEETWOOD
138 JIM CAPALDI
140 TOM WAITS
142 FRANK ZAPPA
144 JOE "KING" CARRASCO
146 HERBIE HANCOCK
148 WYNTON MARSALIS
150 GEORGE BENSON
152 WEATHER REPORT
154 RARE SILK
156 CLARENCE CLEMONS
158 PATRICK SIMMONS
160 JOHN HAMMOND
162 JOAN ARMATRADING
164 MARIANNE FAITHFULL
166 THE CALL

168 WIRE TRAIN	**236** BONNIE TYLER	**288** AL JARREAU	**344** EDDIE MURPHY
170 THE ROMANTICS	**236** LAURA BRANIGAN	**292** OXO	**344** RODNEY DANGERFIELD
172 THE PLIMSOULS	**236** OLIVIA NEWTON-JOHN	**292** BURNING SENSATIONS	**348** ROXY MUSIC
174 ZEBRA	**240** ELVIS COSTELLO & THE ATTRACTIONS	**292** RED ROCKERS	**348** BRIAN ENO
176 FASTWAY	**240** GRAHAM PARKER	**296** THE SYSTEM	**348** WAS (NOT WAS)
178 DOKKEN	**240** T-BONE BURNETT	**296** EBN-OZN	**349** PINK FLOYD
180 JON BUTCHER AXIS	**244** JACKSON BROWNE	**296** MINISTRY	**349** ELECTRIC LIGHT ORCHESTRA
182 DIANA ROSS	**244** COREY HART	**300** NONA HENDRYX	**349** PLANET P
184 NATALIE COLE	**244** RICK SPRINGFIELD	**300** CHERYL LYNN	**350** BOB DYLAN
186 ANGELA BOFILL	**248** ADAM ANT	**300** SHALAMAR	**350** PAUL SIMON
188 WOMACK & WOMACK	**248** JOBOXERS	**304** EARTH, WIND & FIRE	**350** VAN MORRISON
190 CHAMPAIGN	**248** ROMAN HOLLIDAY	**304** KOOL & THE GANG	**351** JOE JACKSON
192 THE ISLEY BROTHERS	**252** REAL LIFE	**304** THE S.O.S. BAND	**351** DONNIE IRIS
194 B.J. THOMAS	**252** NAKED EYES	**308** THE MANHATTANS	**351** MARTY BALIN
196 GARY MORRIS	**252** KAJAGOOGOO	**308** MIDNIGHT STAR	**352** YAZ
198 MAC McANALLY	**256** THE KINKS	**308** RAY PARKER JR.	**352** WANG CHUNG
200 THE STATLER BROTHERS	**256** ROD STEWART	**312** THE DEELE	**352** HEAVEN 17
202 ANNE MURRAY	**256** ERIC CLAPTON	**312** GAP BAND	**353** METALLICA
204 DEBORAH ALLEN	**260** CHRISTOPHER CROSS	**312** DAZZ BAND	**353** MINOR THREAT
206 MANNHEIM STEAMROLLER	**260** JIMMY BUFFETT	**316** JOHN DENVER	**353** THIN LIZZY
208 DAVID BOWIE	**260** GUY CLARK	**316** WILLIE NELSON & MERLE HAGGARD	**354** LOS LOBOS
208 PAUL McCARTNEY	**264** AC/DC	**316** DON WILLIAMS	**354** 38 SPECIAL
208 ELTON JOHN	**264** BLACKFOOT	**320** GEORGE STRAIT	**354** MARSHALL CRENSHAW
212 MADONNA	**264** KROKUS	**320** ALABAMA	**355** BOB MARLEY & THE WAILERS
212 PAT BENATAR	**268** CARLOS SANTANA	**320** THE OAK RIDGE BOYS	**355** ARETHA FRANKLIN
212 HEART	**268** QUARTERFLASH	**324** BARBARA MANDRELL	**355** JAMES INGRAM
216 DURAN DURAN	**268** MARILLION	**324** CRYSTAL GAYLE	**356** THE ROBERT CRAY BAND
216 SPANDAU BALLET	**272** THE MOTELS	**324** SHELLY WEST	**356** B.B. KING
216 TEARS FOR FEARS	**272** BANANARAMA	**328** RICKY SKAGGS	**356** NEW EDITION
220 THE HUMAN LEAGUE	**272** NINA HAGEN	**328** JOHN CONLEE	**357** NITTY GRITTY DIRT BAND
220 THOMPSON TWINS	**276** ROLLING STONES	**328** LEE GREENWOOD	**357** CHARLY McCLAIN
220 WHAM! U.K.	**276** THE MOODY BLUES	**332** JEFFREY OSBORNE	**357** CHARLIE HADEN
224 CULTURE CLUB	**276** ASIA	**332** LUTHER VANDROSS	
224 STRAY CATS	**280** WALTER EGAN	**332** DIONNE WARWICK	**358** ACKNOWLEDGMENTS
224 NEIL YOUNG	**280** MARTIN BRILEY	**336** MTUME	
228 THE FIXX	**280** IAN HUNTER	**336** JAMES BLOOD ULMER	
228 A FLOCK OF SEAGULLS	**284** BEE GEES	**336** PIECES OF A DREAM	
228 ECHO & THE BUNNYMEN	**284** IRENE CARA	**340** THE MANHATTAN TRANSFER	
232 TALKING HEADS	**284** MICHAEL SEMBELLO	**340** PETER ALLEN	
232 KING SUNNY ADÉ	**288** SPARKS	**340** SERGIO MENDES	
232 RE-FLEX	**288** RICK JAMES	**344** MECO	

PHOTOGRAPH BY STEPHEN COLLECTOR

ON RECORD VOL. 10 1983

STILL AN up-and-coming young band in 1983, U2 was one of those rare outfits capable of turning adversity in its favor. And there was plenty of adversity at Red Rocks Amphitheatre on June 5. The Irish rockers had soaked every nickel they had into readying their performance at the 9,000-capacity outdoor venue to shoot for a future worldwide broadcast. Yet temperatures dropped to 40 degrees at showtime, and day's worth of drizzle evolved into a deluge, turning the video production into a logistical and technical nightmare. If not for the group's substantial financial investment, the show would have been cancelled or moved elsewhere without hesitation.

But U2 and crew got on the phone to radio stations. They promised to play an indoor concert the following night for ticketholders, but they also implored folks to come up to Red Rocks so the band wouldn't film to an empty house. Roughly 4,000 fans showed up.

And then U2 pulled off a star-making feat. The event ceased being a concert after the second song. From that point on, it became more of a church service. To say that the kids were "going nuts" understated the vibe—kids went nuts at Judas Priest concerts. This was something substantially more, a tangible communion between a band and its audience in the most nightmarish surroundings imaginable.

And to think I almost didn't go to the show. I figured I'd stay warm and dry and make the next night's makeup gig. But something spurred me to make the drive to the foothills in the storm, and I've never regretted it. Having contracted with *The Denver Post*, I dashed off a soggy overnight review, fumbling to come up with a suitable lede on deadline: "A lot of things had to go wrong for U2's Red Rocks show to come off so right."

It turned out I was the only reporter there, and I made my bones with that review. When the drama of the 19-song concert made its way to *Under a Blood Red Sky*, a lionized live album and groundbreaking video, it propelled U2 (and Red Rocks) to global superstardom. My "wrong/right" line became part of the show's lore.

The voluble Bono offered a great quote in the aftermath: "I'd like to thank the man who invented the wide-angle lens—he made the 4,000 people there look like millions!" He graciously credited me and other Denver-based supporters from the stage for many years. Funnily, when INXS played Red Rocks three years later, the members asked the venue manager where the bonfires and fog were—they thought it came with the place!

Other events of significance transpired in 1983. Michael Jackson's *Thriller* was on its way to becoming the biggest-selling album of all time. Compact discs went on sale in the US. MTV music videos drove album and singles sales and heavily influenced radio play. Metallica, Megadeth, Anthrax and Slayer pioneered the thrash-metal genre. And I got to access something most fans didn't—the opportunity to go to all the concerts, receive all the new releases for review and wade through their press kits. I was and am a very lucky boy. Please allow me to share. — **G. Brown**

ON RECORD 1983 [JOURNEY]

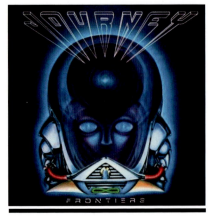

Billboard 200: *Frontiers* (#2)
Billboardd Hot 100: "Separate Ways (Worlds Apart)" (#8); "Faithfully" (#12); "After the Fall" (#23); "Send Her My Love" (#23)

Frontiers by Journey exploded, selling more than 4 million copies and kicking off a record-breaking tour.

WHEN SINGER Steve Perry joined Journey in 1977, it became apparent that his soaring vocal style would become the band's signature, destined to rule the airwaves. But Journey continued to evolve, adding Steve Smith's technically precise drum work for another dimension to the band's sound. Drafting keyboardist Jonathan Cain from the Babys meant the hitmaking machinery was complete. Journey unveiled the results on 1981's *Escape*, a classic rock album that spawned no fewer than five radio staples.

"If you handpick a band, it's usually a disaster," Cain explained. "But with this version of Journey, the personalities clicked. You can dream of all the success you want, but there's no master plan. We had no idea *Escape* would become as popular as it did. Steve and Neal (Schon, guitarist) just locked in—'Hey, we can do this!'"

The camaraderie that existed between Journey members was nothing calculated, as Cain's recruiting attested. "The Babys were disenchanted because of financial problems and other hassles. But I still performed the best I could every night, and it paid off. I got close to the Journey members being on the road, and when (original keyboardist) Gregg Rolie retired, they called. I was in shock, but from day one, I was a member of the band, not a sideman—they demanded my equal participation."

Cain's keyboard work added the sonic textures that made *Escape* such a monster—but with the success came a ration of critical backlash. Portions of the rock press accused Journey of being a soulless outfit of hit-mongers who cranked out commercial music for the undiscerning masses.

But the group had made strides to answer the critics with *Frontiers*. Although familiar Journey characteristics appeared throughout the album, several tracks reflected a more progressive nature. Perry sang in a lower register than before, and the added grit and raw edge in his voice on the power ballad "Faithfully" made it one of Journey's most effective new songs. The track "Separate Ways (Worlds Apart)" gave the band a No. 1 hit on rock radio.

Cain pointed to *Frontiers* as a catharsis for the band. "We want to progress, be happy as musicians," he insisted. "When you make music for arenas, there has to be a certain common denominator, and finding that is a skill in itself. We found out that we're pretty damned good at it. There was a lot going on in our lives and in the group that we needed to get out. We used the music as a vehicle to escape those feelings."

Cain felt the band was just then tapping into a new phase of creativity. "In the last few years, I've gone from playing organ to piano to synthesizers, and that progression has been incredibly exciting. I'm having to read books to keep up on microprocessors and stuff. That's a big challenge, and everyone else in the band is finding their own challenges. Anyone who thinks Journey is a bunch of corporate fat cats—well, we're ready to put it in their faces." ∎

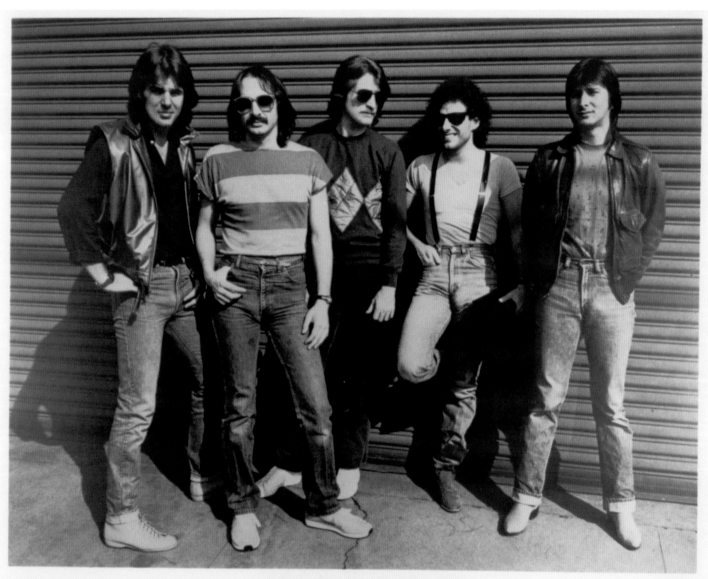

JOURNEY MANAGEMENT:
HERBIE HERBERT
NIGHTMARE, INC.
SAN FRANCISCO, CAL.

8302

ON RECORD 1983 [ZZ TOP]

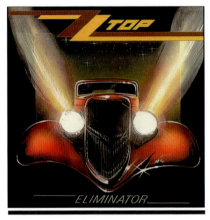

Billboard 200: *Eliminator* (#9)
Billboard Hot 100: "Gimme All Your Lovin'" (#37); "Sharp Dressed Man" (#56); "Legs" (#8)

The fledgling cable-television outlet MTV aired audacious music videos that propelled ZZ Top into pop culture.

AFFECTIONATELY DUBBED as "that little ol' band from Texas," ZZ Top's lineup had remained unchanged since its formation in 1969. Guitarist Billy Gibbons, bassist Dusty Hill and drummer Frank Beard attained a long-lived status among rock acts, known for the hits "La Grange" and "Tush." "We've always written and played within the original rock 'n' roll mode," Gibbons said. "You know the recipe. Fast cars, fast women, fast food—fast music."

The trio was known for live performances, dragging one of the most spectacular productions ever mounted on the Worldwide Texas Tour (1976-'77)—a buffalo, a steer, a rattlesnake and assorted cacti were all onstage. But by the album *Eliminator*, Gibbons had pushed the band into a more modern direction, beginning to experiment with synthesizers, sequencers and drum machines and integrating influences from new wave, punk and synth-pop. Over seamless mechanical rhythms, he added his masterful repertoire of bluesy chops and some patented stop-start arrangements.

Commensurately, the album's three clever music videos—for "Gimme All Your Lovin'," "Sharp Dressed Man" and "Legs"—formed a loose trilogy, with Gibbons and Hill wearing sunglasses, hats and long beards, backed by the red hot rod that graced the cover of *Eliminator* ("our '33 Ford Coupe, our pride and joy," Beard clarified). Their popularity on the MTV television channel made the veteran band members international heroes.

The good-natured Hill appreciated "Gimme All Your Lovin'"—"As much loving as we're getting, it should be a single," he agreed. Regarding "Sharp Dressed Man," "I always look cool in basic black, not to mention my cheap Beatle boots that are a half-size too small in case I have to sing—not better, just higher," he allowed. "It worked for Smokey Robinson, didn't it?"

The guys had been into women's lower extremities for years, going back to "A Fool for Your Stockings," and they got to the heart of the matter on "Legs"—the colorful clip brought out Gibbons and Hill's fur-covered spinning Dean guitars. "You know, we're moving down—from 'Tush' to 'Legs,'" Hill said. "Actually, we're building up to our next album when we write a song about feet." "One day," Gibbons added, "we'll do a song called 'The Dr. Scholl's Shuffle.'" ■

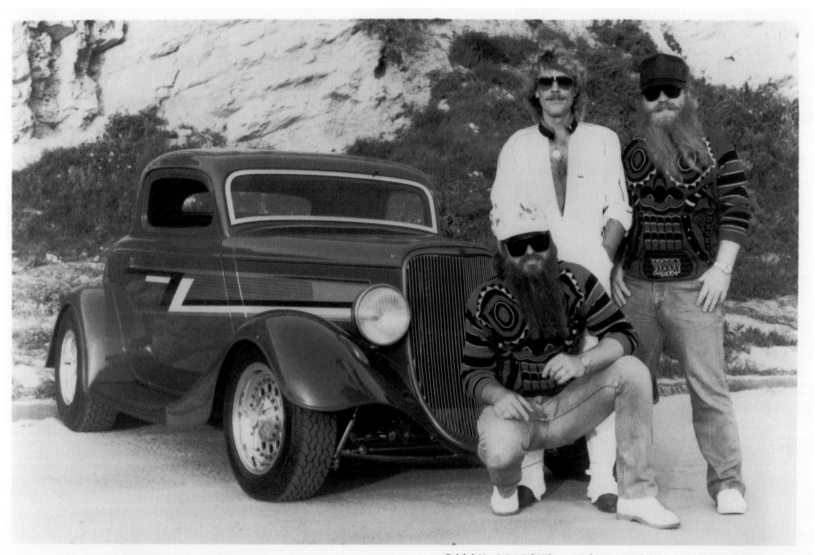

BILLY GIBBONS, FRANK BEARD, DUSTY HILL

ON RECORD 1983 [GENESIS]

Billboard 200: *Genesis* (#9)
Billboard Hot 100: "Mama" (#73); "That's All" (#6); "Illegal Alien" (#44); "Taking It All Too Hard" (#50)

From Genesis' first studio release in two years, "That's All" became the band's maiden Top 10 hit in the US.

GIVEN THEIR healthy egos, most rock stars could no longer play nice in a band setting once they had pursued solo projects. The three members of Genesis might have fallen into that category. In 1980, drummer and singer Phil Collins embarked on a fruitful solo career that he had termed more important than his work with Genesis. Meanwhile, guitarist Mike Rutherford and keyboardist Tony Banks had released their second solo albums, *Acting Very Strange* and *The Fugitive*, respectively, featuring their first work as lead vocalists.

But in the trio's case, the outside projects hadn't undermined Genesis' collective success. The *Genesis* album spawned four hit singles and continued a trend set in 1975 wherein each new record by the band outsold its predecessor. Recorded and mixed at the Farm in Surrey, England, all nine songs were jointly written by Banks, Collins and Rutherford.

"We're the first band to have gone off for individual projects and yet stayed together," Rutherford speculated. "But it's actually better for us now. For many years, all we did was Genesis, to the point where we didn't even think about it. Now when we get together, we rather look forward to it because we've been doing so much away from each other. If all you know is being with the same guys for 14 years, you need a wider experience."

Rutherford admitted he already was budgeting his output. "I started out in this business as a songwriter—everyone in Genesis did," he explained. "Now that Genesis has less need for material, I want to get back to writing for other people."

Genesis was newly notorious for its stellar rock videos. "It's the first chance we've had to spend time on them," Rutherford noted. "In the past, we finished an album, rushed off on tour and squeezed in a quick video shoot. This time we figured we should spend more energy on videos, since they're being seen so much these days. I think 'Mama' shows how much better they can look if we put our finger in the pie. Our best one of all is 'Illegal Alien'—it's quite funny."

So Genesis' free-form approach to stardom continued unabated. "We re-evaluate things when we're together," Rutherford reasoned. "As long as we find it worthwhile, we'll have no reason to stop. We now see ourselves as three people playing with Genesis because we want to, rather than just because we're in a successful band." ∎

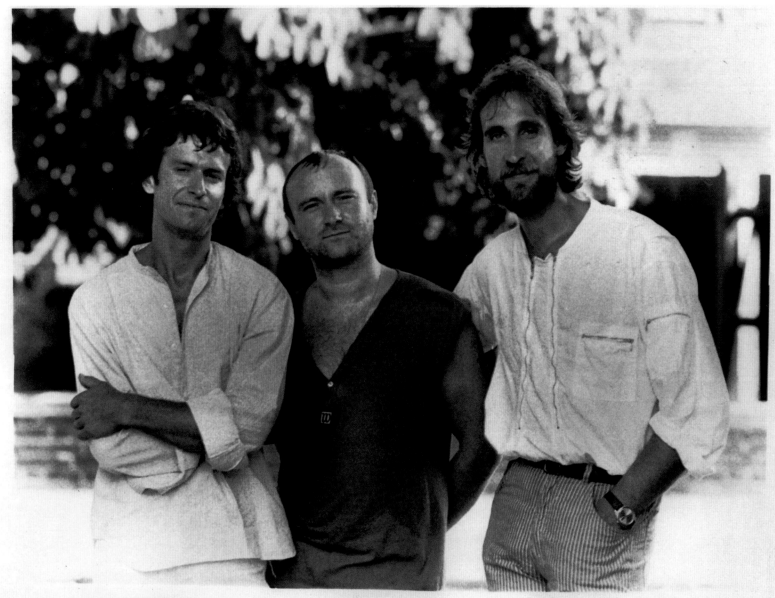

GENESIS

Pic. Joe Bangay.

ON RECORD | 1983 | [U2]

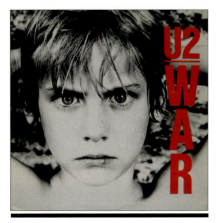

Billboard 200: *War* (#12)
Billboard Hot 100: "New Year's Day" (#53)

No longer an unknown quantity, U2 called for repentance, repulsion and reaction with a bristling album, *War*.

AVOIDING TENUOUS fads, U2 willingly took chances with its craft and its career. "I Will Follow" and "Out of Control," two songs from the debut album *Boy*, exemplified the band's fresh, urgent sound, with an emphasis on The Edge's guitar and Bono's jagged and commanding vocals. Many people expected *October*, the second release, to make concessions to the music industry's prevailing commercial trend, but U2 delivered another album of deeply emotive tunes, moving away from the youthful outlook of *Boy* towards a more spiritual musing.

That vision was borne out by the success of *War*, U2's third album, which bridged the appeal of new wave and hard rock. The band's first No. 1 album in the UK, it knocked Michael Jackson's *Thriller* from the top of the charts. The group's scope had evolved to include a more dynamic sense of purpose than ever before.

"When we're recording, it becomes quite an intense and exhausting experience," The Edge explained. "But it produces something deep—each record is a personal statement. We never go in trying to corporately decide on a stance. If we hit on topics that are a little 'dodgy'—well, it's straight from the heart."

"New Year's Day" and "Sunday Bloody Sunday" helped signal U2's reputation as a politically and socially conscious group. The former was inspired by the Polish Solidarity movement. In the latter protest song, Bono's lyrics attempted to match up the events of the 1972 Bloody Sunday shooting in Northern Ireland with Easter Sunday.

On the supporting tour, Bono immortalized his holy gladiator profile, unfurling and waving a huge white flag in the growing crowds during "Sunday Bloody Sunday." Part of the band's appeal—a subtle message of peace and brotherhood—could be attributed to the Christian beliefs that three members (Bono, The Edge and drummer Larry Mullen) shared. They chose to communicate through their music rather than foisting their faith on the public.

"We're not just sentimental Irish lads—I think there's more depth to us than that," Bono insisted. "But I just detest the way religion is turned into an industry in America. I want to kick in the television in disgust when I see people begging for funds. We'll never do that. We just want to share a message." ∎

U 2

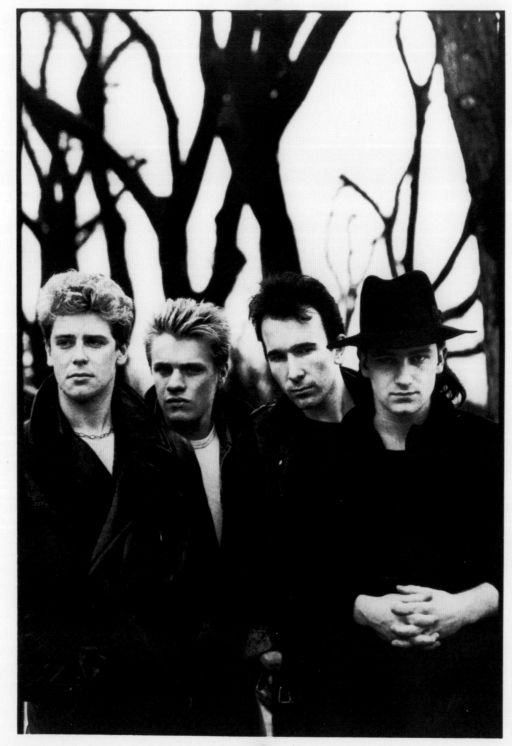

Photo Credit: Anton Corbijn

ON RECORD 1983 [THE POLICE]

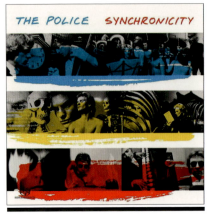

Billboard 200: *Synchronicity* (No. 1)
Billboard Hot 100: "Every Breath You Take" (No. 1); "Wrapped Around Your Finger" (#7); "Synchronicity II" (#17); "King of Pain" (#17)

The Police, at the pinnacle of their commercial ascendancy, produced another blockbuster album, *Synchronicity*.

SIX YEARS into their career, the Police had little left to prove as a commercial entity. *Synchronicity*, the band's fifth album, would sell more than 8 million copies in the US alone, and "Every Breath You Take" quickly took its place as a classic and won a Grammy for Song of the Year. "King of Pain" and "Wrapped Around Your Finger" also became hits.

Rarely had a band been such a hit with critics and consumers at the same time. Everyone knew all along that the Police lineup—bassist/vocalist Sting, guitarist Andy Summers and drummer Stewart Copeland—was smart, articulate and ambitious, but in the music business, you couldn't be both rich and respectable without also being talented, charismatic and, above all, canny. That same savvy had the British rock trio facing the challenge of maintaining their lofty status.

"There's only one thing to do logically, and that's get off," Summers admitted. "Not that that's what we're doing. It's a very difficult situation. Our success has crystalized with *Synchronicity*. The media likes to make tensions in the band more dramatic than they really are because it reads better in the papers, but it's not that far from the truth—it is a very convulsive group of people, and that's the kind of chemistry that makes it work.

"I don't think you can have great rock 'n' roll without that personal chemistry, the ability to play. We're going through a historical process right now that happens to anybody that becomes very successful, and you have to take a philosophical view of that—otherwise you go mad. We're happy at the moment—we'll finish this tour, next year we'll probably release a live album, and then we'll see what happens."

Sting had become the most visible member of the band, both onstage and off. He'd been acting in movies and otherwise drawing attention to himself, eclipsing Summers and Copeland, the band's founder. His film résumé already included an appearance in *Quadrophenia* and his perverse sexual exorcism in *Brimstone & Treacle*. Fans would see him sporting bright crimson hair and a loincloth as he plotted to murder the hero in David Lynch's rendition of Frank Herbert's science-fiction novel, *Dune*.

With all three members busying their individual calendars for the future, it didn't seem to leave much time for the Police as a unit. "If we're really progressing with the music and still coming up with the goods, it's worth staying together," Summers said. "But the minute we start staying together for money, if we start making the last album over again, then it's time to quit."

After their record-breaking concert tour in support of *Synchronicity* filled stadiums and arenas around the world, the Police disbanded. ■

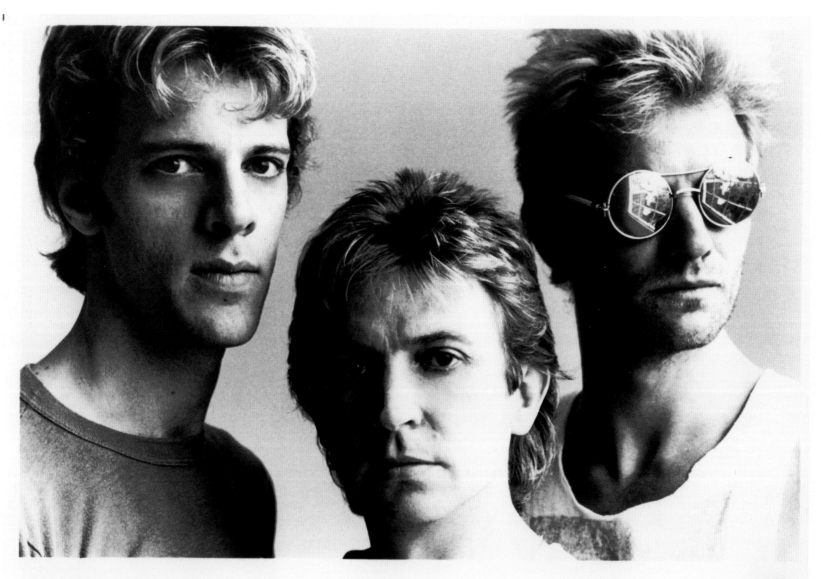

THE POLICE

ON RECORD — 1983 — [STEWART COPELAND]

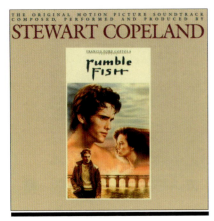

Billboard 200: *Rumble Fish* (#157)

Drummer of the Police, Stewart Copeland found a new forum for his music with the film score for *Rumble Fish*.

SATISFIED WITH the income and perquisites of his worldwide stardom with the Police, Stewart Copeland tackled a challenging major project for himself outside of the band—he wrote and recorded the score for Francis Coppola's film *Rumble Fish*. Critics were divided about the film, but most hailed Copeland's inventive use of nonmusical sounds and the effective way he evoked and manipulated the film's sense of time running out—a central element in Coppola's heavily symbolic telling of S.E. Hinton's story.

"Francis and I discussed how to link music, the style of photography and the structure of dramatic action to capture the idea of time passing and running out," Copeland noted. "I suppose the reason he called me was that I'm a rhythm expert, a 'rhythmatist'—it almost makes me sound like some kind of scientist. The music essentially represents the elapsing time of Rusty-James (the film's protagonist, played by Matt Dillon). He has got to wake up and see the truth or be lost."

Copeland recorded the city noises—traffic, sirens—of Tulsa, Oklahoma, the site of *Rumble Fish*. Mechanical sounds were also a part of his score. "There's a lot of rhythm coming from different places—broken air conditioners, faulty machinery, a printing press, an engine and so on. You can click off the moments with the sound of a refrigerator. That led me to think of the science of finding patterns. All those different rhythms helped to convey the passing of time."

He put those sounds on a tape loop and then worked on integrating them into the score, using a computer called a "musync," which printed out film frame by frame—images were on top, with dialogue underneath and musical staves below that. According to Copeland, the musync made it possible to precisely plot the music and work out the tempos in between. The peripheral, supporting role of music gave him a fresh perspective on composition and performance.

"As a player in a band, I've always thought in terms of songs, where you have a hook and a lyric and everything blazing away for three minutes. In a film, the main focal points are the action and the dialogue—there is no song. The picture is the top line, and music points out the emotional content of the scene—whether you're supposed to be laughing or feeling serious. You can achieve great dramatic effect with just a few little elements, because the picture does so much of the work."

Copeland's score earned him a Golden Globe nomination. It also featured one vocal number—the album opener, "Don't Box Me In," sung and co-written by Stan Ridgway, formerly the leader of Wall of Voodoo. Released as a single, the song charted in the UK, and the music video received airplay on MTV. ∎

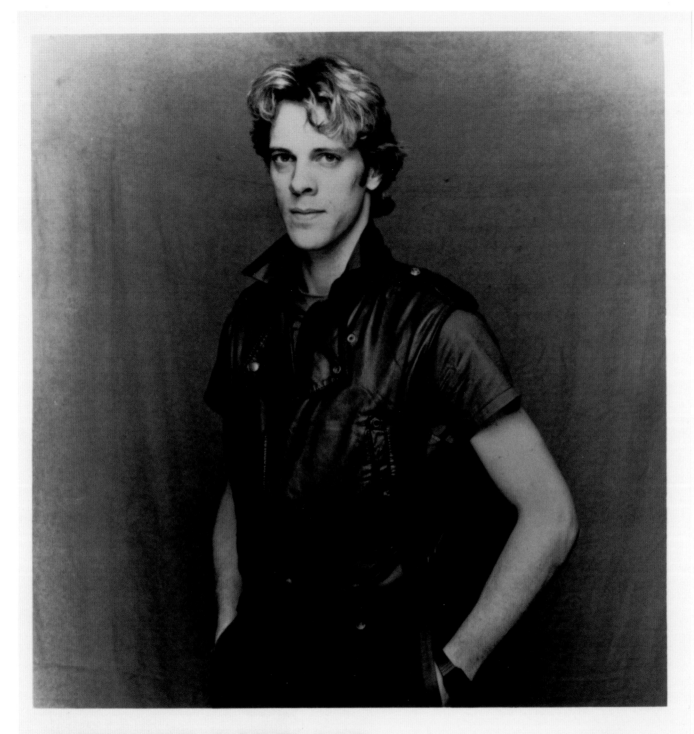

STEWART COPELAND

"Rumble Fish"

ON RECORD | **1983** | **[STEVIE NICKS]**

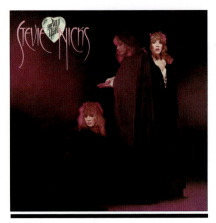

Billboard 200: *The Wild Heart* (#5)
Billboard Hot 100: "Stand Back" (#5);
"If Anyone Falls" (#14); "Nightbird" (#33)

"Stand Back," the big hit from Stevie Nicks' *The Wild Heart*, featured an uncredited contribution from Prince.

WHILE REMAINING a member of Fleetwood Mac, Stevie Nicks began her solo career in 1981 with the release of *Bella Donna,* which reached No. 1 on the album charts. Following Fleetwood Mac's *Mirage,* which topped the charts in 1982 and spawned her hit "Gypsy," Nicks was a star attraction seemingly enjoying her glory days. But her best friend, Robin Anderson, died of leukemia, and a devastated Nicks, driven to take care of her kindred soul's baby son, Matthew, married Kim Anderson, the widower.

The Wild Heart, Nicks' second solo album, sold more than a million copies. A duet, "Nightbird," introduced Sandy Stewart as her co-writer and vocalist. Tom Petty wrote "I Will Run to You," and he and the Heartbreakers performed on the track. But *The Wild Heart* was highlighted by the Top 5 smash "Stand Back."

"Right after I got married, I heard this wonderful song Prince had done called 'Little Red Corvette,'" Nicks revealed. "As soon as I heard it, I went 'Boy, I love that' and started humming to myself, and in a matter of minutes I had hummed along a different melody than what Prince had done. Me being honest, I immediately called Prince and told him what I had written and how.

"And he came down and played on the song. He told me he was doing the video of 'Little Red Corvette' that day, and since I know how videos always take a lot longer than anybody thinks, I didn't think he'd show up. We did it in one take, one time, and that's what you hear—me singing live, Sandy on her synthesizer, Prince playing that dah-dah-dah-dah-dah, very kind of 'Edge of Seventeen' thing, and a drum machine." Toto's Steve Lukather contributed guitar work.

"'Stand Back' became an anthem, an 'I'm tired of listening to all your great advice because it's gotten me nowhere so I'm listening to myself now' kind of anthem," Nicks said. "It came slightly out of strength, slightly out of being in love, slightly out of being married and ever so slightly out of hearing the first three chords of 'Little Red Corvette.'"

Nicks and Anderson got a divorce after only three months—when the effects of their grievous loss abated, they realized they were not a match. ∎

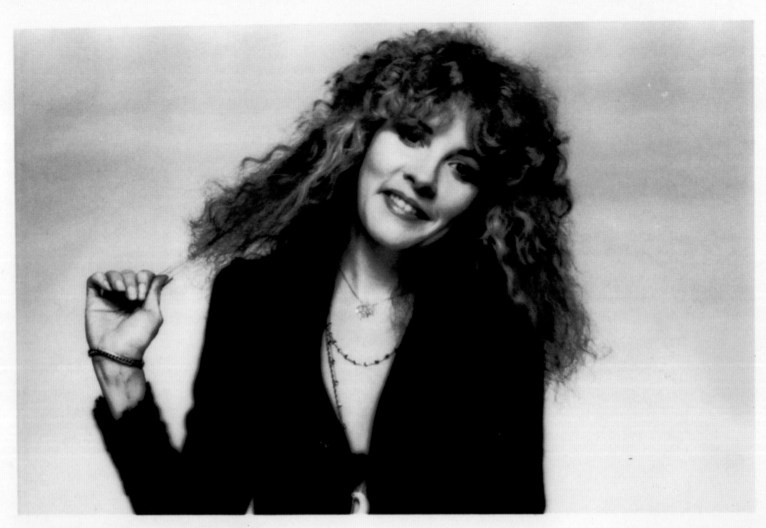

STEVIE NICKS

Modern Records EST 1980

ON RECORD | 1983 | [DONNA SUMMER]

Billboard 200: *She Works Hard for the Money* (#9)
Billboard Hot 100: "She Works Hard for the Money" (#3); "Unconditional Love" (#43); "Love Has a Mind of Its Own" (#70)

"She Works Hard for the Money," became Donna Summer's signature song, a refutation of her disco identity.

GAINING A global following in the Seventies as the undisputed queen of the disco era, singer Donna Summer ruled the charts with hits like "Bad Girls," in which she postured as a proud prostitute. In 1979, her struggle to cope with fame and her salacious identity led her to intensify her Christianity. *She Works Hard for the Money* reflected Summer's reinforced values.

Working with Michael Omartian, who had produced Christopher Cross' Grammy-sweeping debut album, Summer was credited with writing or co-writing every track on the record. "Our meeting was divinely inspired, and the Lord has watched over us throughout the recording," she said. "Each song is a message, an inspiration, an expression. They're all honest feelings coming from deep within."

The title track told of the hardships of the working woman based on a true story. While attending a gala celebrity party at Chasen's, a famous Beverly Hills restaurant, Summer encountered an exhausted restroom attendant named Onetta Johnson asleep at her post with a television blasting. Summer's immediate comment was, "She works hard for the money."

"I knew there was a song from the very moment I saw her," Summer recalled. "She epitomizes the working woman, all of her difficulties and challenges."

A celebration of a humble, principled life, "She Works Hard for the Money" emerged as a massive hit. On "Unconditional Love," England's Musical Youth joined Summer in expressing her devotion to Jesus, and "Love Has a Mind of Its Own" was a haunting duet with gospel singer Matthew Ward of the 2nd Chapter of Acts. "He's a Rebel" won Summer her third Grammy Award, for Best Inspirational Performance, and she sang about God's guidance in "People, People."

"This album is a statement that I'm so proud and honored to make—it tells of my beliefs and my way of life, who I am and my devotion," Summer explained. "And these feelings, through the lyrics, are me, always and forever." ∎

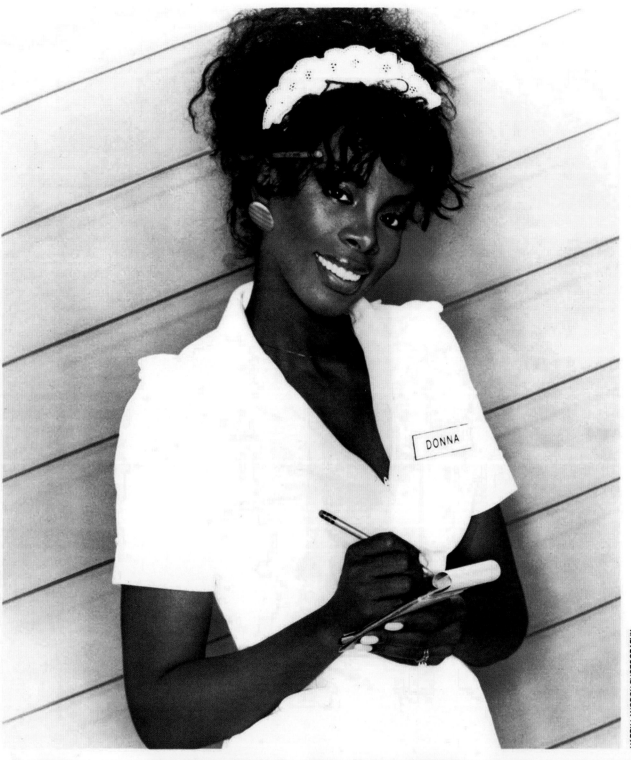

DONNA SUMMER

ON RECORD | 1983 | [POINTER SISTERS]

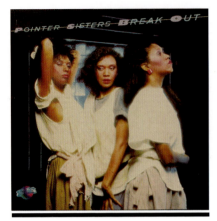

A spate of sensuous and spirited hits from the protean **Pointer Sisters** enlivened both the pop and R&B charts.

Billboard 200: *Break Out* (#8)
Billboard Hot 100: "I Need You" (#48); "Automatic" (#5); "Jump (For My Love)" (#3); "I'm So Excited" (#9); "Neutron Dance" (#6); "Baby Come and Get It" (#44)

BORN AND raised in Oakland, California, the Pointer Sisters made a habit of taking appreciable chances with their material. Beginning with "Yes We Can Can" in 1973, they demonstrated their ease with putting across scat-jazz and soul material—and even country, winning a Grammy for Best Country Vocal Performance by a Duo or Group (the hit "Fairytale").

In 1978, the Pointer Sisters took a break from the craziness of touring and recording and found Richard Perry, one of the decade's most successful record producers. "We have a 50-50 agreement with him," sister June Pointer noted. "It's like a marriage. We had a meeting and totally agreed with our change of direction. It was a good time to make that move, because there were a lot of single artists on the charts but no groups."

The ladies dropped their Forties-ish vocal style and jumped into rock 'n' roll, curbing the trademark harmonies and up-tempo sound. The debut of the new partnership, a brilliant cover of Bruce Springsteen's "Fire," laid claim to the easy-listening market, giving them a huge dose of commercial and critical credibility. The hits kept on coming, as demonstrated on "He's So Shy" and "Slow Hand."

"The other sound just wasn't paying off as well financially as contemporary music," June explained. "We just wanted commercial material that pleased all of us. There were more lead vocals than harmonies, but that was something new and different for us. We like to try things all the time."

With *Break Out*, the Pointer Sisters and Perry again staked out a new direction, and their career exploded with four Top 10 dance-pop smashes in a row—"Automatic," "Jump (For My Love)," a remixed version of "I'm So Excited" and the driving "Neutron Dance." "Automatic" and "Neutron Dance" featured Ruth Pointer on lead.

"I'm singing a lot more lead parts that I've ever done," she said. "You can't stick with the same routine. I've always had a low and strange voice, and, in the past, it's been hard for me to do a lot of leads, but this just evolved naturally."

"We used a lot of new synthesizers and drum machines—it's like we were in a laboratory," June revealed. "But in terms of the material, with songs like 'Automatic,' 'I Need You' and 'Jump,' it's the most personal record we've ever done."

"I'm So Excited" was the one single to feature a lead vocal by Anita Pointer. "*Break Out* shows how much we've grown up as artists," she said. "We don't want to sound like anybody else, and we never have. Ruth sings a lot of the leads I used to sing, and it sounds great. We really got it together on this record." "It's high-energy—we're still dripping when we come offstage," Ruth insisted. "We'd never go doo-wop," added June. "No way, baby." ∎

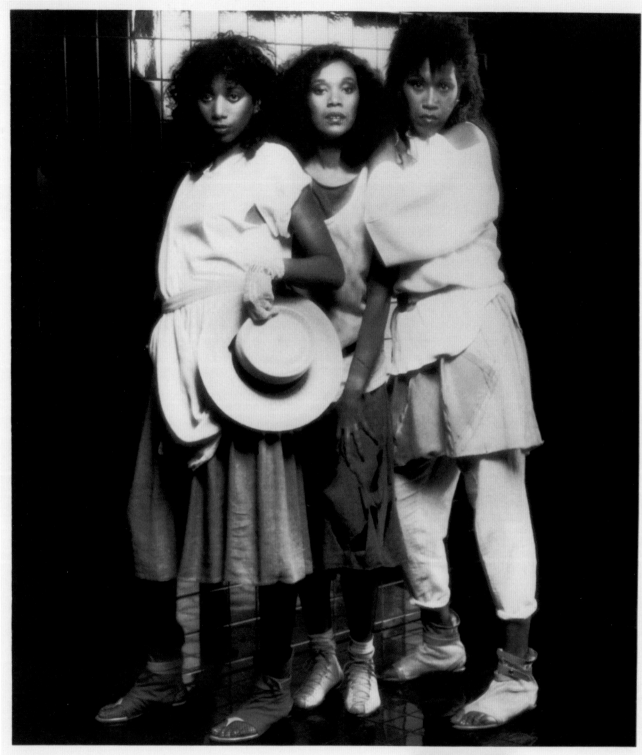

POINTER SISTERS

Manufactured and Distributed by RCA Records and Cassettes

ON RECORD 1983 [BILLY JOEL]

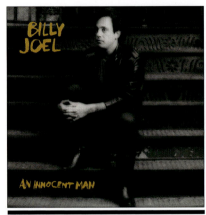

Billboard 200: *An Innocent Man* (#4)
Billboard Hot 100: "Tell Her About It" (No. 1); "Uptown Girl" (#3);
"An Innocent Man" (#10); "The Longest Time" (#14);
"Leave a Tender Moment Alone" (#27); "Keeping the Faith" (#18)

The exuberance of *An Innocent Man* and six radio smashes restored Billy Joel to his multiplatinum standing.

NO ONE could say Billy Joel was predictable. Just when folks had him pegged as a late Seventies balladeer on the strength of *The Stranger* and *52nd Street*, the spunky piano man responded with the rock sound of *Glass Houses*. Hot on its heels came *Songs from the Attic*, a not-so-standard live reprisal of some early overlooked material. And just when it seemed that Joel didn't know what to record next, he released *The Nylon Curtain*, his most lushly produced, thematically ambitious work.

So Joel's decision to pay homage to his rock 'n' roll roots on *An Innocent Man* wasn't that surprising. "I wanted it to *sound* like I was having fun," he explained. "I'd just gotten off the road when suddenly, there were a lot of women around. I felt like I'd just come out of a cocoon—I was in love with 15 of them at once. I wrote 10 songs in seven weeks—something I've never done before. It's the gamut of passions that come with romance. All the songs are based on the old records I loved as a kid. Also, this is a singer's album—I hit all the high notes I've always wanted to sing."

"Tell Her About It" became Joel's second No. 1 smash. "I was picturing the Supremes or Martha & the Vandellas—those girl groups always sang, 'Listen, girl, you gotta do this.' I turned it around and sang, 'Listen, boy…' It's an older guy giving a younger guy advice, to avoid his mistakes."

The music video of "Uptown Girl"—"a typical 'I'm from the wrong side of the tracks' song"—featured supermodel Christie Brinkley, Joel's future wife. "I remembered how many Four Seasons hits were a big part of our lives in junior high school—'Rag Doll,' 'Walk Like a Man,' 'Candy Girl.' In those days, it always sounded as if the singer was going to get married by the end of the song—Frankie Valli saw a vision of a picket fence as soon as he saw the girl. Maybe that's why they were so great to hear on the car radio when you were out on a heavy date."

"An Innocent Man" was about "a guy telling a woman, 'I know that when you treat me badly it's not because I've done something wrong, it's because somebody else has hurt you.' I'm saying here that it's time to take chances again—to go out into the world and start all over from scratch. The music has the feel of Ben E. King's 'Spanish Harlem.'"

"The Longest Time" peaked at No. 1 on the adult contemporary charts. "There's a song by the Tymes, 'So Much in Love,' that has stayed with me all my life, so I wrote a new melody with that kind of feeling. We had a cappella groups try it, and they stayed in key with each other, but they naturally flattened out as their breath ran out. Finally, Phil (Ramone, Joel's producer) said, 'You do it.' I didn't want to. The problem with doing your own background voices—the bass part, the high part, the harmonies—is you sound too much like yourself, you don't get enough personality. He said, 'So why not take on a different character with every part?' So I sang one voice as if I were Black, another as if I were an Italian from Newark. The hard part wasn't staying in key. It was staying in key as an Italian from Newark." ■

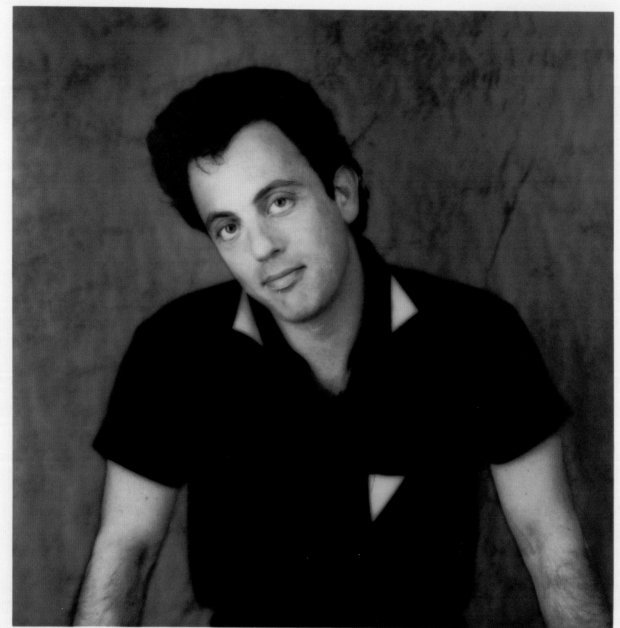

BILLY JOEL

ON RECORD 1983 [BRYAN ADAMS]

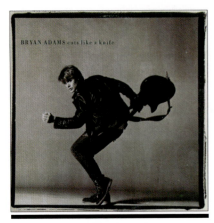

With *Cuts Like a Knife*, his breakout album, Canadian **Bryan Adams** rose to fame in both his native country and the US.

Billboard 200: *Cuts Like a Knife* (#8)
Billboard Hot 100: "Straight from the Heart" (#10); "Cuts Like a Knife" (#15); "This Time" (#24)

HE HAD always been a self-assured songwriter, but Bryan Adams hadn't always been patient. "Yeah, I wanted to call my second album *Bryan Adams Hasn't Heard of You, Either*," the guitarist admitted. "But that would have been a mistake. Things got a lot better with that second album."

"A lot better" meant a No. 1 album-rock track with "Lonely Nights," plus similar charting status for a song he co-wrote for Prism, "Don't Let Him Know." Adams emerged as the latest Canadian export to be in the right place at the right time, a leading craftsman when it came to churning out accessible "heavy-metal pop," as he called it. His songs (co-written with collaborator Jim Vallance) had been in demand since he was 17, when artists such as Prism and Bachman-Turner Overdrive covered them.

"I'd always been a big music fan, and I met all those other artists while living in Vancouver," he explained. "It was a hard process getting them to record my stuff, because I wasn't experienced in the industry. But once I had a few songs under my belt, it made it easier to get a record deal of my own."

Adams was hungry for recognition, to put a face and name alongside his tunes. His self-titled first album went unnoticed, but it furthered his notoriety as a songwriter—tracks from the record were re-recorded by acts such as Bob Welch and Scandal. His following record, *You Want It – You Got It* (the erstwhile *...Hasn't Heard of You...*) put his raspy voice on the radio via "Lonely Nights."

With *Cuts Like a Knife*, Adams chewed up the airwaves, with three tracks—the ballad "Straight from the Heart" (a Top 10 US hit), "This Time" and the title track—receiving major airplay. "This record kicks ass—it's better than any girlfriend I've ever had," he said. A tour with Journey served to bolster his already considerable confidence and proved to be the final step toward his own headlining status. Adams was ready to step back from other artists' demands on his songwriting.

"Vallance and I are an 'idea team,'" he summed up. "We're writing anywhere from 15 to 18 songs a year that we're happy with—the rest is just tripe. But I've finally gotten it to the point where I'm gonna save them all for myself and only give away the ones that I don't end up using. If I can pull off my songs believably, I'll consider myself a true artist. Hopefully, what I'm doing instinctively is right." ∎

BRYAN ADAMS

ON RECORD 1983 [JOHN COUGAR MELLENCAMP]

Uh-Huh was the first record accredited to **John Cougar Mellencamp**, appending the rocker's actual surname.

Billboard 200: *Uh-Huh* (#9)
Billboard Hot 100: "Crumblin' Down" (#9); "Pink Houses" (#8); "Authority Song" (#15)

A MIDWEST rebel, John Mellencamp grew up in Seymour, Indiana, a small community reeking of the desperation born of limited options. By 14, he was fooling around with rock bands, playing guitar and singing. He moved into an apartment at 18, pouring concrete and installing telephones. When he wrote his first song at 23, his friends were impressed. So, with a year's worth of unemployment benefits in hand after being laid off by the phone company, he set out for New York to make a record.

His first experience with the music business left him embittered. A management firm offered to record him, but also gave him a new last name—Johnny Cougar's first record, a catchall of cover songs, was a flop, and he severed the relationship. He was then introduced to the president of Riva Records, and Pat Benatar's cover of "I Need a Lover"—a Johnny Cougar track that had success in Australia—hit the airwaves in 1979, months before the *John Cougar* version of the song became his first US charting single. He followed it with *Nothin' Matters and What If It Did*, an album spawning the hits "This Time" and "Ain't Even Done with the Night."

Then came his astonishing breakthrough—*American Fool* was the biggest-selling album of 1982, reaching No. 1 simultaneously with two Top 10 singles, "Hurts So Good" and "Jack and Diane." "I decided to stop trying to be 'artistic' like John Cale, because nobody was taking me seriously anyway," he said. "So I decided to go back to my roots and write songs that you could sing along with."

Success didn't change his lifestyle or smooth away his rough edges, but he had enough clout to reclaim his actual last name, recording *Uh-Huh* as John Cougar Mellencamp. The Top 10 album spawned the hits "Pink Houses," "Crumblin' Down" and "Authority Song"—uncompromising heartland rock that paid his homage to the Rolling Stones.

"I played each song on an acoustic guitar, picked up an electric guitar and we played it—one song was rehearsed at one o'clock, and by three, it was recorded," Mellencamp said. "This is the kind of music we've played ever since we were kids, but we've finally let it out of the bag. It's the kind of music I wrote when I did 'Hurts So Good.' I finished that song and everyone said I shouldn't put it out. Then it went Top 5. So we figured, hell, now we're free to do a whole album of our kind of music."

The key to *Uh-Huh* was "Pink Houses," a song he called the best he had ever written. "I was driving back from the Indianapolis airport with a friend on a highway elevated 40 feet over the ground, looked down and saw an old guy sitting in his backyard in front of a pink house with a dog in his arms staring up at me with this real contented smile on his face. It was obvious that he thought he'd really made it in life. But there he was with a damned six-lane highway running through his backyard." ■

JOHN COUGAR MELLENCAMP **PolyGram Records**

ON RECORD | 1983 | [MITCH RYDER]

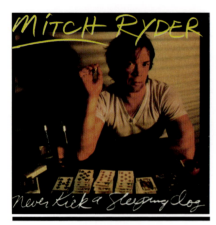

Mitch Ryder returned to a major label with *Never Kick a Sleeping Dog*, produced by a fervent and famous fan.

Billboard 200: *Never Kick a Sleeping Dog* (#120)
Billboard Hot 100: "When You Were Mine" (#87)

IN A near 20-year career, first gaining fame fronting the Detroit Wheels with high-energy hit records such as a "Devil with a Blue Dress On/ Good Golly Miss Molly" medley, "Jenny Take a Ride!" and "Sock It to Me - Baby!," Mitch Ryder reckoned as an impassioned soul shouter, tough and sexy. In 1970, he cut the *Detroit* album, helping create a powerful guitar-driven style that epitomized the hard-rock music of the Motor City along with bands like the Stooges and MC5.

Unfortunately, that type of roots-of-punk sound went ignored through most of the Seventies, and Ryder spent the first half of that decade touring without a record contract. He started his own label with independent distribution, then his next few albums came out in Europe only. He stopped performing and headed to Denver, working a day job for five years and writing songs at night.

John Cougar Mellencamp took it upon himself to open the door for Ryder, one of his idols, to commercial prominence once again. In the wake of the success of his *American Fool*, Mellencamp remained content to stay in Indiana, offering to produce a new album for Ryder, titled *Never Kick a Sleeping Dog*. The two musicians first met through a radio show.

"I called John to thank him for saying nice things about me on the air, and he asked me what I was doing in my career," Ryder explained. He and Mellencamp found they had a lot in common. "I had seen John on *Saturday Night Live* a couple of years back, and I remember remarking to my wife that he reminded me an awful lot of myself when I was younger, the way he took care of himself on stage."

Using a converted farmhouse for a recording studio, Mellencamp's pet project reflected Ryder's blue-eyed soul and hard-rock roots. "John helped give it a modern sound," Ryder said, "but it also had the basic, raw style I've always played." *Never Kick a Sleeping Dog* featured some new songs written by Ryder, one by Mellencamp, plus some surprise covers, including Prince's "When You Were Mine," which grazed the pop charts.

Ryder was excited about the album, but he didn't see it as a comeback. "I've never been away," he smiled. "I just see it as an opportunity to get back into the mainstream." Mellencamp found the experience especially rewarding. "Mitch was one of the people who taught my generation how to rock," he explained. "Producing that album was, to me, an example of what can make this business really mean something." ■

MITCH RYDER **PolyGram Records**

ON RECORD 1983 [ROBERT PLANT]

Billboard 200: *The Principle of Moments* (#8)
Billboard Hot 100: "Big Log" (#20); "In the Mood" (#39)

Touring behind *The Principle of Moments*, Robert Plant appealed to a wider audience than Led Zeppelin had.

FOR MORE than a dozen years, Robert Plant had brought forth a singular image of a rock performer, celebrated for an unmistakable voice and charismatic presence as the lead singer and lyricist for Led Zeppelin. Following the death of drummer John Bonham, Led Zeppelin disbanded in 1980. Plant embarked on a solo career two years later, releasing *Pictures at Eleven*, a triumphant return to active duty.

Plant followed up with *The Principle of Moments,* capturing a range of mesmerizing ballads (the popular tracks "Big Log" and "In the Mood") as well as blistering rock ("Other Arms"). As on *Pictures at Eleven*, Phil Collins (of Genesis and solo fame) sat in on drums. In support of the album, Plant embarked on his first tour. Audiences accepted the fact that he and his band, led by guitarist Robbie Blunt, weren't performing Led Zeppelin material.

"I can tell that the audience is different from the Zeppelin days," he said. "Back then, there was a manic, high-tension feeling in the air—a sense of confusion. Now there's not that intimidation. There are more females showing up—the crowds are more evenly proportioned. For which I'm glad—who wants to sing for 15,000 guys?"

A very insular unit, Led Zeppelin never had an opening act, nor used any outside musical assistance. Plant perceived a difference between having total responsibility versus working within a group.

"I'm thrilled to have the ability to expand," the singer said. "I was cautious at first—it was like stepping into a pool that you can't see the bottom of. I didn't know if I had the respect of other musicians. But I'm very flattered by the amount of attention my work is receiving. I plan to use a lot of different musicians in the next few years to keep me on my toes, to keep changing. I like the drama that you get when you employ the help of other people." ∎

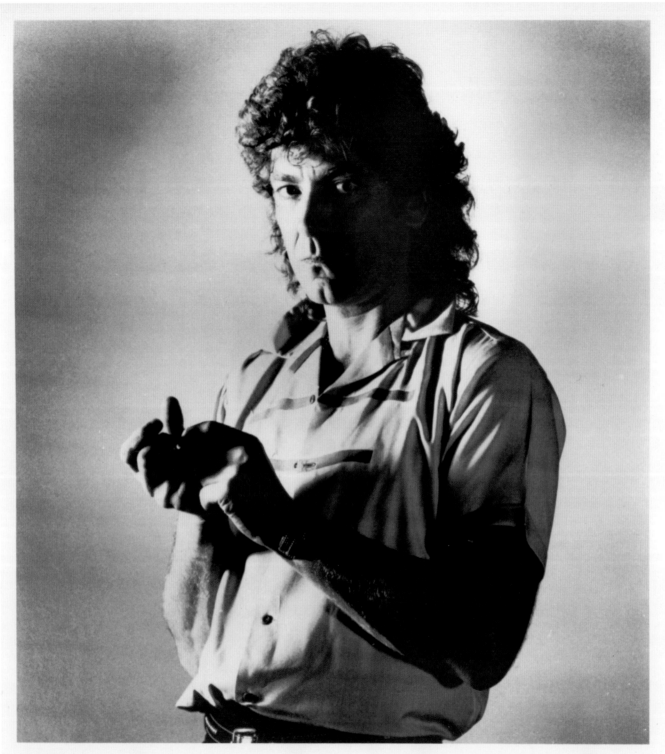

ON RECORD | 1983 | [DEF LEPPARD]

Def Leppard transitioned to massive mainstream prosperity with the sophisticated production of *Pyromania*.

Billboard 200: *Pyromania* (#2)
Billboard Hot 100: "Photograph" (#12); "Rock of Ages" (#16); "Foolin'" (#28)

ON THE strength of the album *Pyromania* and the smash singles "Photograph," "Rock of Ages" and "Foolin'," the members of Def Leppard were the hottest challengers vying for the hard-rock throne. Their breakthrough belied their youth—all in their early twenties, they had gained exposure in a minimum amount of time.

"We've been lucky in terms of timing and making good-sounding albums," singer Joe Elliott noted. "But our songs are the strongest thing about us. We've always fancied that. That's why other talented people have been anxious to work with us in the first place."

Robert John "Mutt" Lange, whose AC/DC and Foreigner achievements had been multiplatinum sellers, brought his touch to the studio. A fastidious attention to detail defined Lange's recording techniques—burnished guitar and drum sounds, multitracked layers of vocal harmonies. His production shifted *Pyromania* away from the heavy-metal riffs of the band's first two albums toward a more radio-friendly style.

"Mutt has a lot to do with it—he's like what George Martin was to the Beatles," Elliott admitted. "He's a songwriter, a multi-instrumentalist, an arranger—we bounce ideas off each other, and it works. He was able to give us his undivided attention."

The polished, satisfying crunch of "Photograph" and "Rock of Ages" turned Def Leppard into a household name—the hits ranked as the most requested videos on MTV and became staples of rock radio. Only Michael Jackson's *Thriller* kept *Pyromania* out of the No. 1 spot.

"We were pretty excitable in the early days, being 16, 17, 18 years old," Elliott assessed. "The main influences were the melodic side of rock, like UFO, Thin Lizzy and Bad Company. Now we've been able to incorporate a lot of melody into each song—a little melody isn't going to hurt anybody!" ■

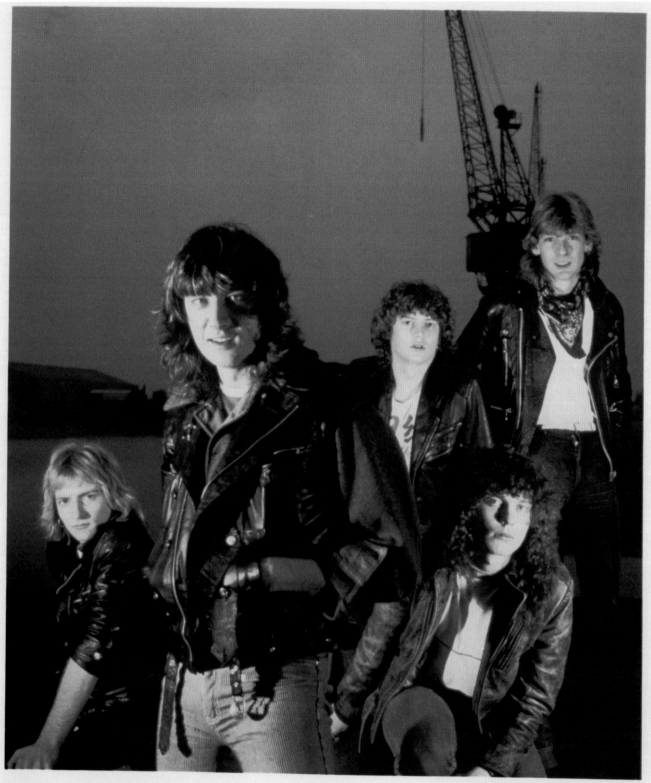

DEF LEPPARD

PolyGram Records

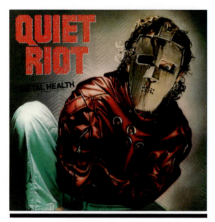

Billboard 200: *Metal Health* (No. 1)
Billboard Hot 100: "Bang Your Head (Metal Health)" (#31); "Cum on Feel the Noize" (#5)

One of the year's big success stories, Quiet Riot attained major metal glory with the multiplatinum *Metal Health*.

STEERING CLEAR of synthesizers and electronic gimmickry, Quiet Riot preferred the throbbing pulse of head-banging heavy metal. The Los Angeles quartet's *Metal Health* album spotlighted two anthems about breaking out and busting loose, the raucous title track and a version of "Cum on Feel the Noise," Slade's early Seventies classic.

"'Metal Health' is our anthem," lead vocalist Kevin DuBrow stated. "Heavy metal is in the vibe of the music, the insanity going on among the four of us, but people think it's all leather and studs. The old Quiet Riot sometimes had to work at being that outrageous with wild clothes and stuff."

DuBrow formed the "old Quiet Riot" in 1975 with the late Randy Rhoades, who went on to become the lead guitar whiz with Ozzy Osbourne before his death in a horrific plane crash in March 1982. DuBrow had an immediate sense of Rhoads' greatness as a player.

"He had this long, huge thumbnail—that was weird," he recalled. "But it was like finding buried treasure. Seventeen years old, and he had it all, image and presentation as well. He was determined to be successful—he was in a band of high-school friends, and then he joined a band of foreigners to step up."

In the late Seventies, the original Quiet Riot members found themselves at the top of the L.A. hard rock heap, selling out club dates, but they were unable to land an American record deal (with Rhoads, they scored two moderately successful albums in Japan). Quiet Riot called it quits in 1980, and DuBrow went on to form his own outfit. Remaining true to his hard-rock roots in the face of shifting trends, DuBrow refused to don a white shirt and skinny black tie to become, in his words, "another Knack clone."

In early 1982, he decided to revive the Quiet Riot moniker as bassist Rudy Sarzo rejoined, and the band scored a recording contract. The new lineup also consisted of guitarist Carlos Cavazo and drummer Frankie Banali. "I hate the fastest and loudest guitar players, the Milton Million-Notes," DuBrow said. "Carlos learned from Jeff Beck that sometimes it's not what you play, but what you leave out to make those notes count."

Metal Health made history as the first heavy-metal debut album to hit No. 1, and Quiet Riot basked in the ambience of success—endless concert appearances, heavy MTV exposure and sales of more than five million copies worldwide. But DuBrow lacked diplomacy—he did interviews lambasting the group's label, the rock press and many fellow L.A. acts. His bandmates couldn't get him to shut up.

"There've been so many disappointments, so many ups and downs," Banali said. "Now all we want to do is go out on the road and keep playing our hearts out." ■

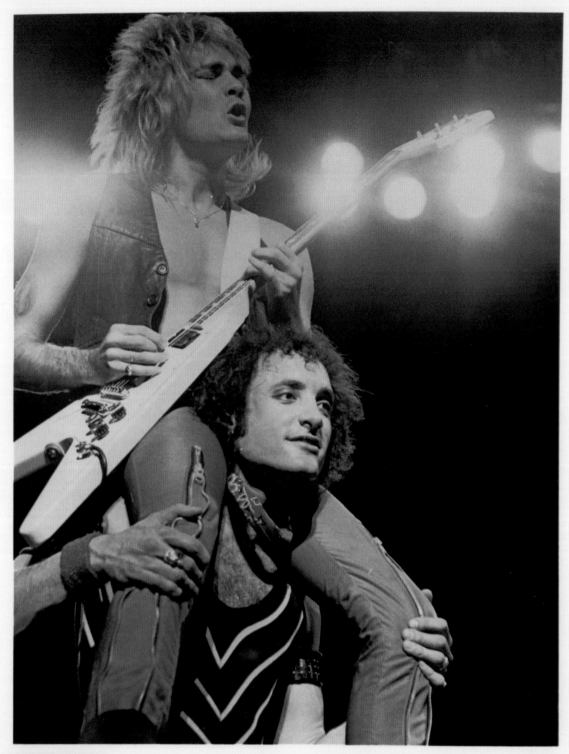

 QUIET RIOT

WARREN ENTNER MGT.
(213) 655-3942

Photo: Anastasia Pantsios

ON RECORD | 1983 | [MÖTLEY CRÜE]

Billboard 200: *Shout at the Devil* (#17)
Billboard Hot 100: "Looks That Kill" (#54);
"Too Young to Fall in Love" (#90)

Called mindless, perverse and dangerous, the members of Mötley Crüe must have been doing something right.

THE FOUR guys in Mötley Crüe were upfront about their flamboyant leather-and-makeup image—they felt that a lot of kids missed out on the heydays of Seventies shock-rockers such as Alice Cooper and Kiss, and they were all too willing to take up the slack. Where Cooper and Kiss occasionally flashed a sense of humor, however, the Los Angeles-based group came off a lot more sinister. The breakthrough album, *Shout at the Devil*, replete with a black pentagram on the cover, came under the are-they-Satanists scrutiny with which most heavy-metal bands had to deal.

"We're intellectuals on a crotch level, obsessed with sex, fast cars and faster women," bassist Nikki Sixx stated. "A lot of people are intimidated by us—the first time they see us, they realize that there hasn't been a band like us in a while. But the second time, they'll have a good time with us backstage and realize that there's nothing bad about us."

Still, the four associates weren't exactly choirboys—they were extremely into behind-the-scenes antics and a barrage of substance use. Who could blame them for choosing the right line of work?

"To be honest, I didn't know there was this much work," Sixx laughed. "It's not like when we were still in California, sitting around and screwing up. Now there are record store appearances, interviews, visits to radio stations, sound checks, gigs, parties—we're channeling our energy into the road instead of getting in trouble. Of course, we still set the occasional hotel phone on fire, but we're thriving on touring—we're hustling, doing something for ourselves."

Mötley Crüe gained attention as the opening act on Ozzy Osbourne's tour, and the heavy-metal legend endorsed the band's "take-no-shit-and-grab-some-tit" attitude. "We're just a good team," Sixx mused. "Take any band that is real extreme—if a parent or anybody with authority says no, kids will turn around and listen to them immediately. And that's us—the more people say no, the bigger we'll get. We're not for the we're-a-happy-family crowd—I don't care if they like us or not. We're the real American youth." ■

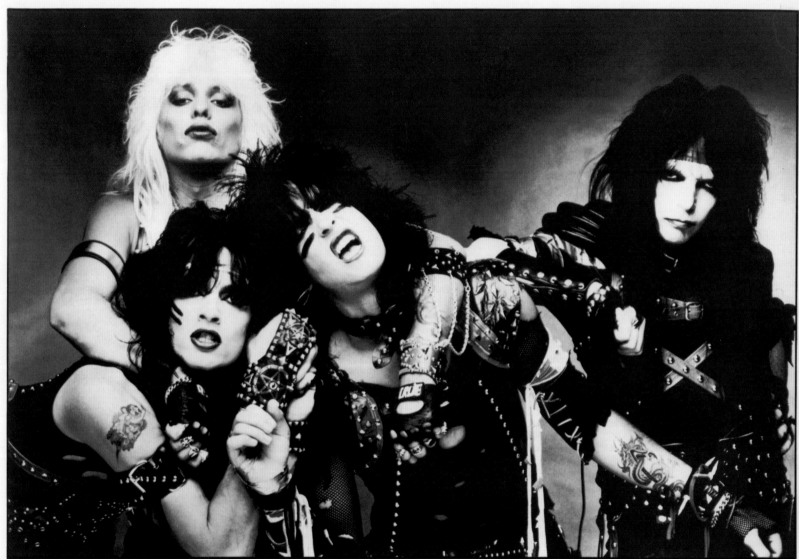

VINCE NEIL
TOMMY LEE NIKKI SIXX MICK MARS

MÖTLEY CRÜE

ON RECORD 1983 [NIGHT RANGER]

A retreat from the band's style of hard rock, "Sister Christian" proved to be **Night Ranger**'s milestone moment.

Billboard 200: *Midnight Madness* (#15)
Billboard Hot 100: "(You Can Still) Rock in America" (#51); "Sister Christian" (#5); "When You Close Your Eyes" (#14)

DESPITE ROCK radio's romance with new-wave music, there was still plenty of room for guitar-based groups that stuck to tried-and-true production formulas. One of the newer bands to challenge in that ultra-commercial genre of power, melody and enthusiasm was Night Ranger.

Night Ranger evolved from Rubicon a California funk-rock group co-founded by lead singer and bassist Jack Blades. Guitarist Brad Gillis, a veteran of Ozzy Osborne's band, and drummer Kelly Keagy joined the regionally successful band before it broke up in 1979. They formed a short-lived act called Stereo, which laid the foundation for Night Ranger. The band first gained attention with 1982's "Don't Tell Me You Love Me," a single that sported a furious dueling guitar break from Gillis and Jeff Watson.

Night Ranger's *Midnight Madness* featured two hits. "(You Can Still) Rock in America" was a frenzied bit of musical jingoism. "When we were out touring, a lot of people wanted to get up and declare their love for rock 'n' roll—some magazines were saying it was being replaced by synth-pop," Blades noted. "'Rock in America' could have been titled 'Rock in Japan,' maybe. They went nuts over there, and the album was gold a week after its release. Maybe they have something for blond-haired guitar players, I dunno. We just wanted to go shopping for electronics gear!"

However, the surprise hit was "Sister Christian," a stately power ballad written by Keagy. "People think of us as rockers, but we figured that song was a chance to expand—it chased the 'elusive female audience' or something like that," Blades said with a laugh. "Brad, Kelly and I used to play that tune four years ago in our band Stereo. But we always knew it would surface."

Blades thought both songs laid the foundation for something bigger. "Now people can't group us with Mötley Crüe anymore. We're not 'heavy metal.' We like to think we're 'stainless steel'—we're not gonna rust. We're gonna be around for a while."

Blades' sense of humor and level-headed approach to the band's good fortune was typical of Night Ranger. The group had worked with producer Pat Glasser since its inception—"He mortgaged his house and brought us to Los Angeles to cut the master tapes to get us our record deal, so he's the sixth member of the band." Manager Bruce Cohn, who previously steered the Doobie Brothers through the music biz, helped make *Midnight Madness* a smash.

All that camaraderie was almost off-putting, and Blades knew it. "There's nothing that makes us good copy right now, other than we're burnt to a crisp." He finally admitted that Night Ranger had one problem. "It happens in the Midwest all the time. Kids come up to us and say, 'Hey, are you guys *Knight Rider* (a television show featuring K.I.T., a talking car)?' They know the name of our band. They're just confused." ∎

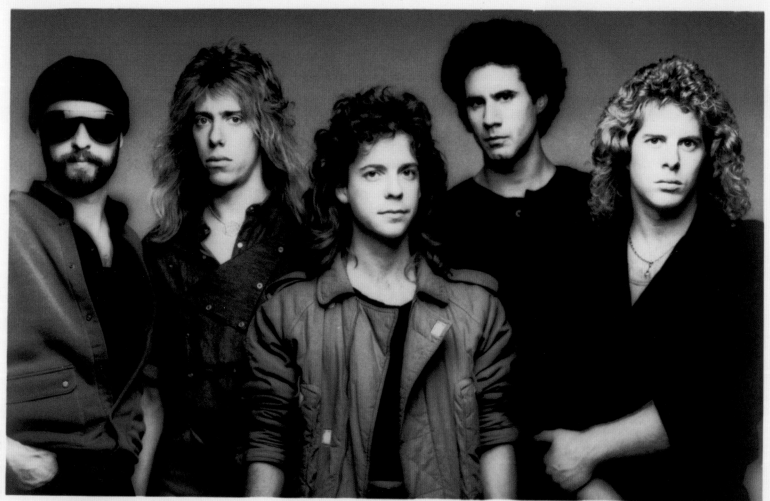

Photo: GARY WEXLER

12/83

.MCA RECORDS

ON RECORD — 1983 — [STYX]

Billboard 200: *Kilroy Was Here* (#3)
Billboard Hot 100: "Mr. Roboto" (#3); "Don't Let It End" (#6); "High Time" (#48)

The extravagant conceptualization of Styx's *Kilroy Was Here* had to be sorted out among members of the band.

VOTED THE most popular band in America in a 1980 Gallup poll, Styx sold millions of albums and its songs were ubiquitous on the radio. Facing the challenge to top themselves, the members of the Chicago-based band conjured up a unified narrative for their next recording.

Kilroy Was Here spawned its quota of hits—"Mr. Roboto," "Don't Let It End"—but it wasn't the typical collection of let's-party teen anthems. The musical fantasy was set in the future when a group called "The Majority for Musical Morality," led by a crusading creep named Dr. Everett Righteous, had banned rock music from a robot-oriented society. Kilroy, a rocker imprisoned some years earlier, rekindled his fervor for the music, and *Kilroy Was Here* concerned his struggle to bring back rock 'n' roll.

"Dennis (DeYoung, lead singer and keyboardist) came up with the concept early on," guitarist James "J.Y." Young explained. "Even while we were working on our last album, he was promoting the idea in our minds. Everyone was very skeptical, because the idea of group members portraying characters was foreign to us at the time. We all definitely resisted it a great deal."

But DeYoung rammed the concept through, and the five players in Styx set about writing and recording *Kilroy* and shooting a slick 10-minute film that opened concerts on the band's tour.

"We finally decided to go with it because we didn't have a better idea," Young laughed. "But I like going with thematic things—it gives me a focus as to what to write my lyrics about so I don't have to bare my soul personally, and I find that more comfortable. The film is a positive creative achievement on our part—we hired the best professional people in Los Angeles. I think we did well—people use the verb 'acting,' but we didn't have any formal training. I don't think any one of us had even acted in a school play."

It was all very ambitious, but Styx faced a nagging question—did the kids who comprised the group's audience understand any of that stuff? "We really didn't know if fans were gonna go for it," Young admitted. "Some have gotten into the storyline, and others have come just to see what (guitarist) Tommy Shaw's rear end looks like when he wiggles it. As a concert experience, *Kilroy* has been appreciated. If someone says it's the best show he's ever seen, though, he probably means it's the most expensive."

At the conclusion of the tour, the members of Styx parted ways. ∎

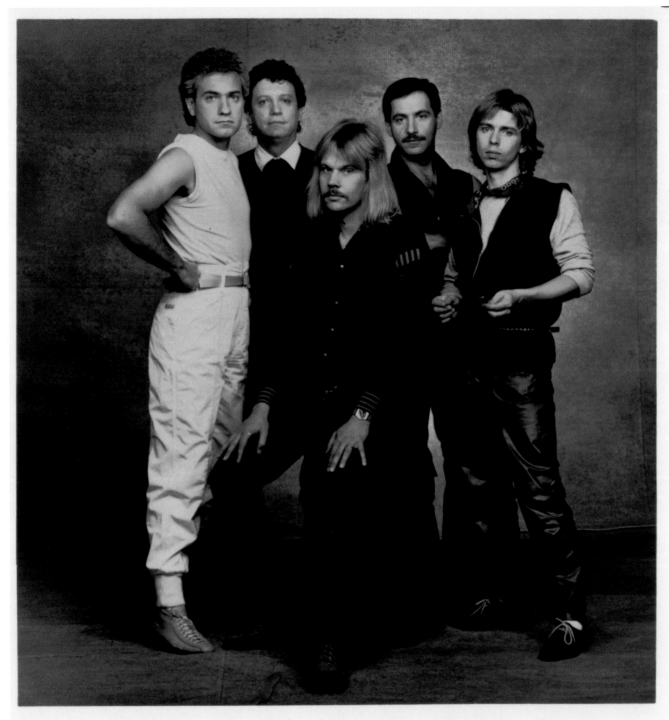

DENNIS DE YOUNG JOHN PANOZZO JAMES (J.Y.) YOUNG CHUCK PANOZZO TOMMY SHAW

FRONT LINE
MANAGEMENT COMPANY, INC.
9044 MELROSE AVENUE, THIRD FLOOR, LOS ANGELES, CALIFORNIA 90069 · (213) 859-1900

ON RECORD | 1983 | [KISS]

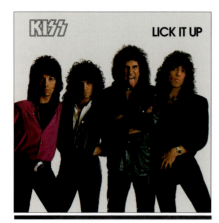

Billboard 200: *Lick It Up* (#24)
Billboard Hot 100: "Lick It Up" (#66)

Removing the trademark makeup for the first time, **Kiss** initiated a new generation of devotees with *Lick It Up*.

IN THE mid to late Seventies, Kiss showed flair in cranking out some catchy rockers—"Strutter" from the 1974 debut album, the breakthrough "Rock and Roll All Night" from the live album, and even "Calling Dr. Love" after the band turned its machine-shop sound into a more radio-wise commodity.

A bigger factor was the bombast of Kiss' incredibly energetic live performances. Concerts were more explosive than a Sunday afternoon in Beirut, and it took a lot of moxie for bassist Gene Simmons to do his fire-spitting trick night after night. And Kiss always exhibited a moronic charm as media parasites—they would do anything to get their makeup-wearing mugs in the papers.

But Kiss hadn't mattered much in recent years. The band had concentrated on foreign markets such as Europe and South America—meeting with the same success it previously had attained in the US—and in that absence, radio programmers had all but ignored the group's albums.

So Kiss modified its act. The members were back on the airwaves with the title track from *Lick It Up,* with singer Paul Stanley wailing on the chorus. The group still had an overblown stage production featuring a 60-foot-wide tank that belched fumes and smoke and ostensibly blew up part of the sound system. The change came in the image department. Kiss finally took off its makeup and iconic costumes, a move that would have ranked as earth-shattering in past years.

According to Simmons, however, going cold turkey with the cold cream wasn't meant to be anything special. "We went to Europe first without makeup because we didn't want media-crazy America to make too much of it," he explained. "We didn't do interviews saying, 'We're gonna take it off tomorrow!' The point is that *Lick It Up* is our 18th record, we're proud of it, and we're going on tour. Period."

The strategy seemed strangely smug, but it worked—*Lick It Up* was Kiss' first record to achieve platinum status in three years. Along with the makeup about-face came a personnel change. A drunk Ace Frehley crashed his DeLorean one night in late 1982, and the resulting internal injuries meant that the guitarist couldn't tour anymore. "We decided that the best thing was for him to stay home and for us to continue," Simmons noted matter-of-factly. "He'll continue his lifestyle, which is with a wife and baby."

Vinnie Vincent, Frehley's successor, infused a variety of chops into the heavy Kiss sound, and the band barnstormed America with its just-folks look. Simmons was thankful that the years of putting on and taking off the greasepaint didn't leave him and his mates with complexions resembling rhino hide. "Ironically enough, it was probably good because it had an oil base to it—it left us smooth and soft. As you can tell," he laughed, "we're still stunning." ■

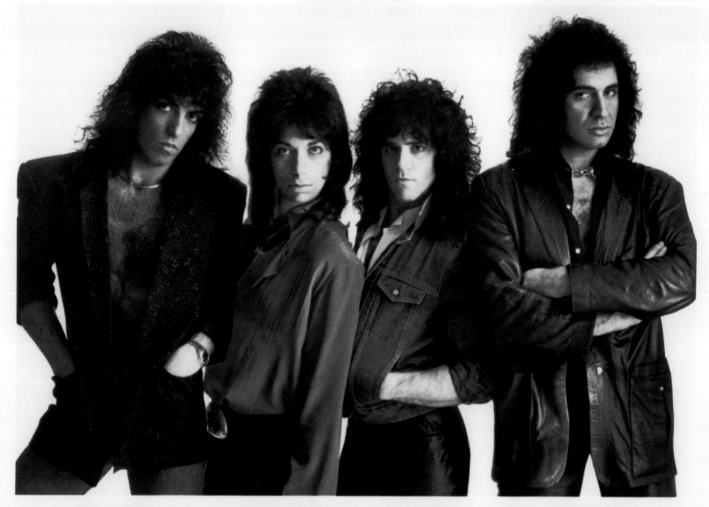

PAUL STANLEY VINNIE VINCENT ERIC CARR GENE SIMMONS

RECORDS
810 SEVENTH AVENUE NYC 10019 BOOKING AGENCY: AMERICAN TALENT INTERNATIONAL GENERAL CONTACT: GLICKMAN/MARKS MANAGEMENT
888 SEVENTH AVENUE NYC 10019 655 MADISON AVENUE NYC 10021 (212) 752-7455

ON RECORD | 1983 | [BLUE ÖYSTER CULT]

Billboard 200: *The Revölution by Night* (#93)
Billboard Hot 100: "Shooting Shark" (#83)

Blue Öyster Cult's stylish "Shooting Shark" came to be the trailblazing heavy-metal band's last charting single.

WELL-VERSED IN surviving the roller-coaster ride of popularity since the Seventies, Blue Öyster Cult shaped a sound to come back in vogue on *The Revölution by Night*. The album featured "Shooting Shark," the premier hard-rock band's finest commercial effort since "(Don't Fear) The Reaper." The track had its share of Cult-ish elements, but its stately tempo and creamy sax solo were surprising production flourishes. Randy Jackson, an in-demand session musician, played bass guitar.

"We've worn the heavy-metal tag proudly through the years, but I don't think we have to be so linear about our music," singer Eric Bloom noted. "'Shooting Shark' is about as far away from heavy metal as we've gotten, and it's one of our best songs." If the imagery of "Shooting Shark" was a little vague, there was a reason—the words were inspired by a poem written by Patti Smith, the waif-like punk singer who had disappeared from the music scene for a few years.

"Donald (Roeser, aka Buck Dharma, BÖC's guitarist) had carried that lyric around with him for years, and he finally wrote the tune for it," Bloom explained. "No one knows where Patti is—she's presumably in Detroit, living as a housewife with no desire for contact with the music world. So none of us know what the hell a 'shooting shark' is supposed to be!"

The opening "Take Me Away," which also received significant airplay on mainstream-rock radio, featured the Cult's meatiest guitar riff in years, thanks to Canadian rock musician Aldo Nova, who co-wrote the tune with Bloom. Credit also went to Bruce Fairbairn (who had produced Loverboy)—his radio-ready values balanced BÖC's well-rehearsed work. ∎

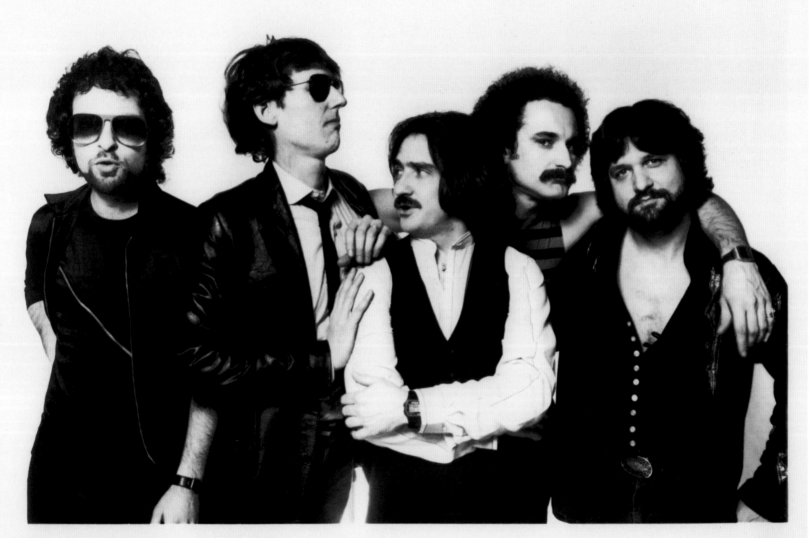

BLUE OYSTER CULT

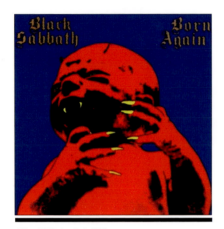

Billboard 200: *Born Again* (#39)

Born Again was **Black Sabbath**'s only album and tour with Ian Gillan and drummer Bev Bevan as participants.

WHEN PLANS were unveiled to tour in support of the *Born Again* album, Black Sabbath also announced the most ambitious stage design in its 15-year history—a replica of Stonehenge, the 5,000-year-old British monument. The heavy-metal masters figured that the set would have an obvious connection with their music, given the air of mystery and the pagan rituals that supposedly took place at the site.

The hype went out—the 60-by-40-foot stage included two trilithons (the most recognizable of the Stonehenge formations), backdrops including Stonehenge's sarsen-stone horseshoe ring, plus 1,158 lights, four remote-controlled on-stage spotlights and a plethora of other special effects. And then they tried to take it out on the road.

"The set turned out to be bigger than the real Stonehenge itself," guitarist Tony Iommi explained. "It was an enormous bloody thing, and the people sitting behind the stage couldn't see—there were too many 'stones.' So we had to do away with the full set, send some of it back to England. I imagine we'll give it away to some charity—or maybe I'll use it as a garden fence."

That turmoil paled next to personnel changes Black Sabbath had weathered. The first change occurred when vocalist Ronnie James Dio left and the band recruited Ian Gillan, the famed ex-lead singer of Deep Purple. "We all come from the same background, and we've been involved with rock 'n' roll for a long time and seen a bit of success, so we met on equal footing," Gillan explained. "That first meeting lasted for 12 hours! It was really magic—when we started to talk over a few drinks, the chemistry was there."

Unfortunately, that acquisition solved only half of the act's problems—it still needed a reliable drummer. Bill Ward's alcoholism had affected the band since 1980, when his inability to perform forced the cancellation of Sabbath's half of a double bill with Blue Öyster Cult in Denver. Ward had been on his treatment program twice when he finally showed up to record *Born Again*, and his playing in the studio was sharp enough to give hope for his permanent return.

But problems with his second wife caused him to return to drink. "He couldn't find any help in England," Iommi noted ruefully. "There are no Alcoholics Anonymous numbers or anything like that there. So we had to get him back in for a cure." Enter Bev Bevan, the "Birmingham basher" who had secured his place in rock history by drumming with the legendary Move and later with Electric Light Orchestra. After the demise of ELO, Bevan was doing nothing at all when the call from Black Sabbath came.

Gillan felt confident that the new version of Black Sabbath was going to stick around awhile. "We're prepared for the long haul," he said with a chuckle. "We're professionals, and we're prepared to spend the next decade together."

Gillan and Bevan departed the band following the completion of the *Born Again* tour. ■

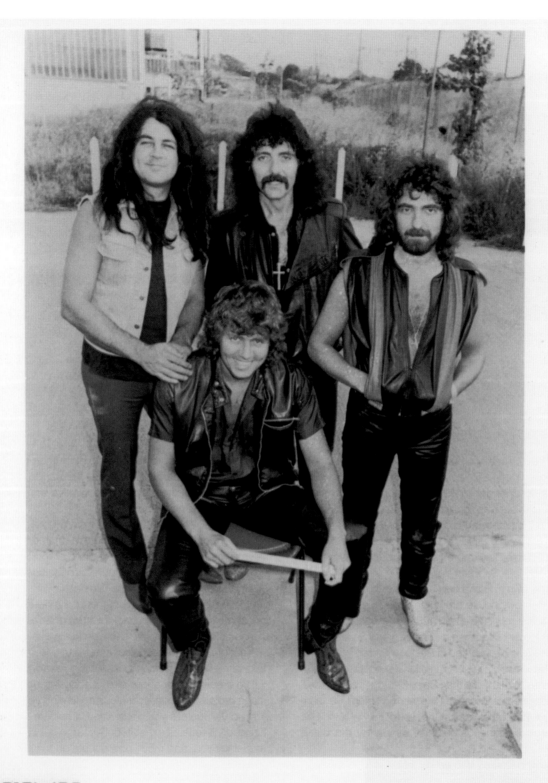

Black Sabbath

JET MANAGEMENT
Don Arden
213-553-6801

ICM
Steve Jensen
213-550-4000

EXPOSURE
Heidi Ellen Robinson
213-841-8140

ON RECORD 1983 [DIO]

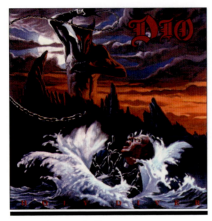

Billboard 200: *Holy Diver* (#56)

After years of fronting other groups, Ronnie James Dio, the erstwhile vocalist of Black Sabbath, founded Dio.

HAVING RISEN as one of heavy metal's pre-eminent vocalists with Rainbow and Elf, Ronnie James Dio replaced the fired Ozzy Osbourne as Black Sabbath's lead singer in 1979. He appeared on three successful studio albums but was finally ready to leave. Relationships had been tested, and the pint-sized Dio was hurt and angry at those who held him to be volatile and difficult. "Let's call a spade a spade," he said bluntly. "It's Ritchie Blackmore (who founded Rainbow with Dio) and the people in Black Sabbath."

He headed out on his own to form a new band. First to join the group, simply called Dio, was powerhouse drummer Vinny Appice, who left Black Sabbath with the singer at the end of 1982. They went to England in search of a bass player and a guitar player, recruiting veteran bassist Jimmy Bain, with whom Dio had worked in Rainbow for two years, and Vivian Campbell, a phenomenal 21-year-old guitarist suggested by Bain.

"It makes more sense to call it Dio than Bain, Campbell or Appice," Dio said. "I chose these people because I like them. If I didn't like them and they were the greatest musicians in the world, they wouldn't be in this band. They have to be friends because we tour too much and see each other too frequently."

A Bach aficionado who studied trumpet as a child, Dio still listened to classical music "because it takes me away from what I do most of the time—I can appreciate that form of imagination," he explained. "I have always been a lyricist in all the bands I've worked with, and I have written all the melody lines. So I've written a great part of the material on this new album."

Holy Diver combined an emphasis on melodic phrases with the crushing confidence of metal. Lyrical themes conjured up fantasy tales of medieval times—dungeons and dragons, swords and sorcery, damsels in distress. The debut record included two metal classics, "Rainbow in the Dark" and the title track.

"I love that history of the Knights of the Round Table—it's time we got some of those values back," Dio said. "I've always felt that there's a market for music that leans toward the fantastic. The idea that heavy metal equates with hedonism annoys me. Rock 'n' roll is wonderfully free-form, but I don't look at it as a tool for a party."

Dio embarked on a tour and pushed the boundaries of elaborate stage production, with a set featuring flowing volcanos and caves. "It's just not Dio unless you get a little Camelot in there somewhere," he insisted. "It reflects my attitude—you go out and play for the people that enjoy you, and they'll turn people on to what you're doing if you give them good value for their money. This band has a lot of style, and everything we do proves that point." ∎

RONNIE JAMES DIO

WARNER BROS.

ON RECORD 1983 [RAINBOW]

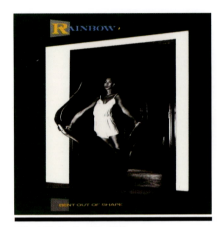

Billboard 200: *Bent Out of Shape* (#34)
Billboard Hot 100: "Street of Dreams" (#60)

Never just another heavy-metal band, Rainbow disbanded in the wake of the businesslike "Street of Dreams."

THE HISTORY of Rainbow dated back to 1975, when guitarist Ritchie Blackmore parted ways with Deep Purple to pursue a solo career. Numerous personnel changes marked Rainbow's time together, but the group managed to keep the spirit of Deep Purple alive through the efforts of Blackmore and fellow alumnus Roger Glover.

But the hard-rock band was still searching for that elusive pop crossover smash. Rainbow had had near-hits with such radio-ready tracks as "Since You've Been Gone" and "I Surrender," but those cuts were written by Russ Ballard, a hitmaker-for-hire. "It was hard to get Ritchie to do that type of song in the beginning," bassist and producer Glover noted. "But now he wants that sort of material to come out of the band instead of someone outside the band."

Rainbow hoped that "Street of Dreams," a slowed-down, slickly produced track from the album *Bent Out of Shape* would do the trick. Singers had come and gone, but Joe Lynn Turner had sent the group to a new level of US success fronting the band, and he wrote "Street of Dreams" with Blackmore. Glover credited an excitement surrounding Rainbow with the addition of David Rosenthal (keyboards) and Chuck Burgi (drums).

"There's a whole new vitality now, plus the little girls seem to like Joe Lynn better than any other singer we've worked with," he said. "My extra role as producer is minimal, because it's really Ritchie's band—everything has to be to his liking. He's very much the same as when I first met him—very demanding, but no more on anyone else than he is on himself. Which is why he'll always get more respect."

Rainbow had been stable enough to weather constant rumors of a Deep Purple reunion. "There's a lot of pressure to reform by people who stand to make money," Glover noted. "Ian (Gillan, the original singer) got Jon Lord (keyboards) and Ian Paice (drums) to agree, and they came to us asking if we'd consider a tour of South America. But the promoters told us they'd rather have Rainbow than Deep Purple, so we decided not to mess with what we've got. The legend of Deep Purple has grown far bigger than the band could ever be."

But by April 1984, after a tour, Blackmore relented. The members of Rainbow went their separate ways when the attempt to reform Deep Purple succeeded. ■

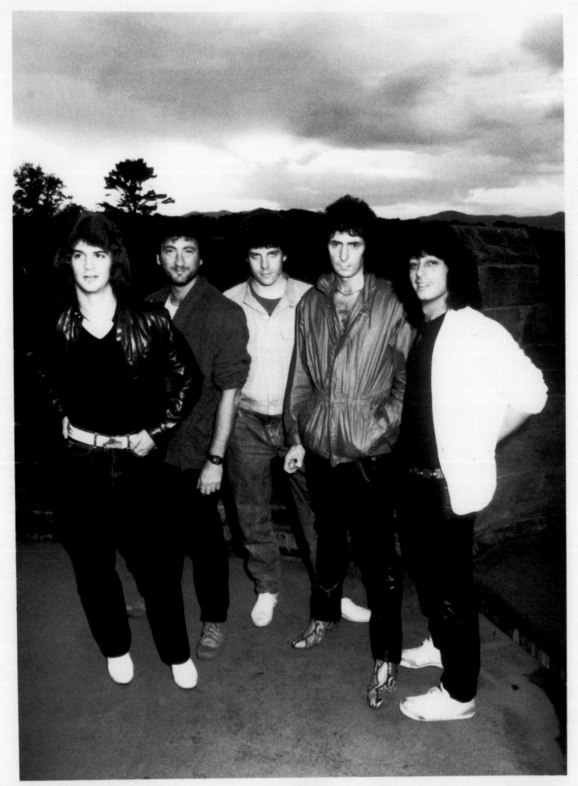

RAINBOW **P**oly**G**ram Records

ON RECORD 1983 [IRON MAIDEN]

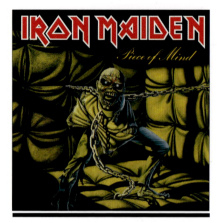

Billboard 200: *Piece of Mind* (#14)

With *Piece of Mind*, British metal band **Iron Maiden** debuted in the US charts and delivered a splashy stage show.

THROUGH THREE albums and the ferocity of live performances on two world tours, Iron Maiden had built an international following rarely equaled in rock music. Working with producer Martin Birch and new drummer Nicko McBrain for *Piece of Mind*, the band recorded powerful songs inspired by literature ("The Trooper," based on Alfred, Lord Tennyson's poem "The Charge of the Light Brigade") or mythology ("Flight of Icarus").

But a large number of the "moral police" misinterpreted Eddie, the band's mascot, who assumed the guise of a lobotomized mental patient for the cover of *Piece of Mind*. "Ah, the devil worship bit," singer Bruce Dickinson said. "On the last album, *The Number of the Beast*, the album sleeve (which depicted Eddie controlling Satan like a marionette) was actually drawn about a year before by Derek Riggs for a UK single. We thought we'd keep it for the next album, so there we were with artwork without any songs.

"It just so happened that Steve (Harris, bass) wrote a track entitled 'The Number of the Beast,' inspired by *The Omen II*. That song is a warning, a dream or nightmare—certainly not 'get your black candles out and invert your altar and let's go worship the devil.' That's bullshit. I don't think people in America listen to the lyrics. We're not angels—we don't go to church every Sunday. On the other hand, we don't spend time messing around worshipping the devil. The fans know that. They think it's a real laugh."

Radio was disinclined towards Iron Maiden's music, although "Flight of Icarus" and "The Trooper" brought a meaningful level of exposure. "We know we've got a big following," Harris said. "There are more and more people all the time who want to hear Iron Maiden. We're just a bit bemused, because there are bands getting a lot of airplay and not selling any records, and we're a band getting very limited airplay and selling lots of records." ∎

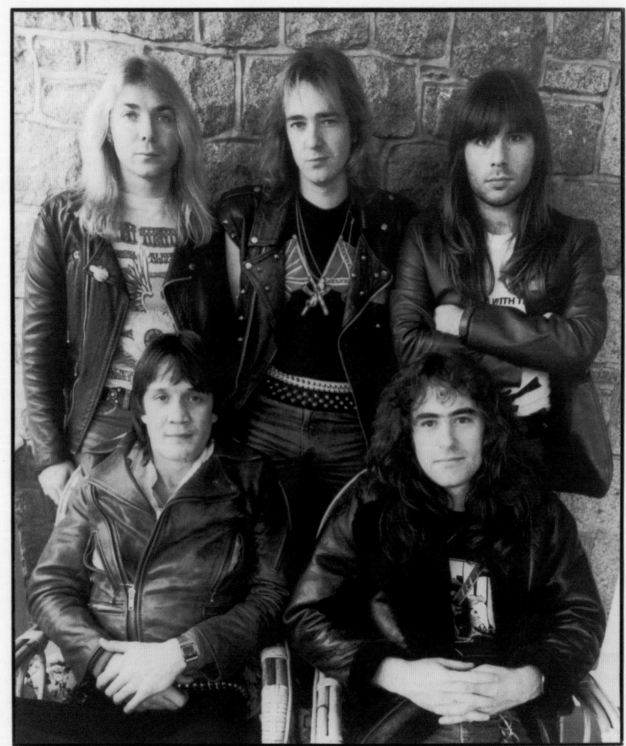

Photo: Ross Halfin / 1983

IRON MAIDEN

ON RECORD — 1983 — [STEVIE RAY VAUGHAN]

Billboard 200: *Texas Flood* (#38)

Guitarist Stevie Ray Vaughan played and sang the blues, but seemed to be having a much better time than that.

EXPLODING ONTO the popular music scene with *Texas Flood*, a debut album filled with his singularly fluid blues-rock chops, Stevie Ray Vaughan received both critical acclaim and commercial success. The Austin-based guitarist's concert dates with his band Double Trouble sold out, and he garnered a slew of awards and celebrity fans—David Bowie even had him execute most of the sizzling lead guitar work heard on the *Let's Dance* album.

With the sudden prominence, Vaughan re-evaluated his craft. His musical expertise was unquestioned, but he knew the real challenge was putting aside the glib comparisons with Johnny Winter and George Thorogood and dealing head-on with the pressures that came with being an overnight media darling.

"I've always been hopeful and confident about people liking what we're putting out," Vaughan reflected. "But I didn't expect things to be moving so fast—it's quite shocking, actually. There's a whole bunch to enjoy, because we're being heard like we want to. But in other ways, it's hard to deal with, because what some people expect of us is a little bit much. In Canada, they had an advertisement billing me as the 'World's Greatest Guitarist.' I felt idiotic showing up there, and I don't understand. I just do what I do."

With his accomplished playing, Vaughan bridged the gap between blues and rock genres. "I figure I was 'discovered' by my mom and dad when I came out," he laughed. "But really, if anybody did any discovering, hopefully it was me when I first tried to play the guitar some 21 years ago and figured out I could play as well as most people—and I don't mean that to sound egotistical."

The singlemindedness of Vaughan's Texan cohorts honed his own approach to music. Without any prompting, he listed the blues musicians he had listened to, both as a youngster and as a star. "There are people who will hock their guitars until they get paid from a gig and it's still worth it. Nobody cares if it's about money or not. Everyone goes around trading musicians and bands, trying to do different gigs with different people to stay real."

The raucous sound and straightforward production on *Texas Flood* became clear on two self-penned songs, "Love Struck Baby" and "Pride and Joy." "We could only get the studio for two days," Vaughan shared. "So there are only two overdubs on the record—I broke a string a couple of times, and I corrected a couple of notes on one song.

"It's wild to hear of people like Fleetwood Mac taking months in the studio. Think of how much of that time is spent getting back the freshness you had in the first place. Those records sound technically perfect, and I respect that, but if a song isn't happening in the first take, you should just move on and come back to it when you have the feeling. I always want my records to have that live sound." ∎

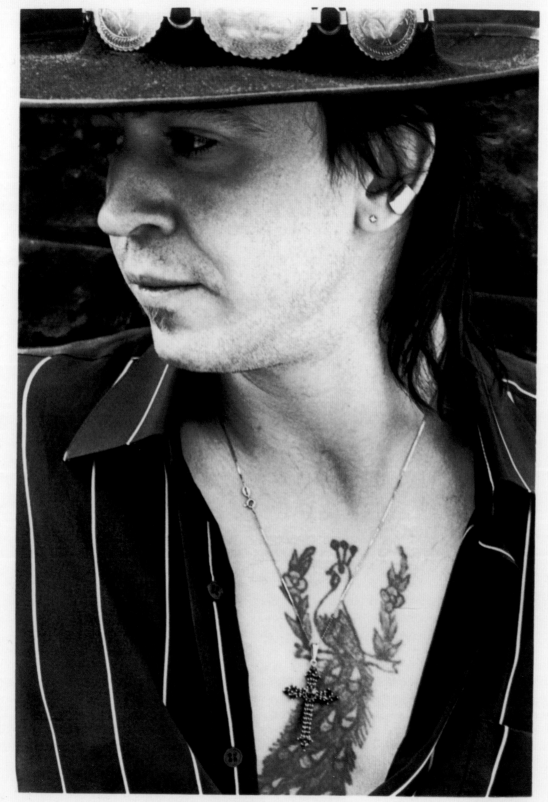

STEVIE RAY VAUGHAN

Billboard 200: *Eyes That See in the Dark* (#6)
Billboard Hot 100: "Islands in the Stream" (No. 1);
"This Woman" (#23); "Eyes That See in the Dark" (#79)

Written by the Bee Gees, "Islands in the Stream," **Kenny Rogers**' duet with Dolly Parton, became a monster hit.

AS A duet partner with Dottie West, Kim Carnes and recently Sheena Easton ("We've Got Tonight," a Bob Seger tune), Kenny Rogers had found considerable fortune. Thus, the enthusiastic response to "Islands in the Stream," recorded as a duet with Dolly Parton, came as no surprise—produced by Barry Gibb of the Bee Gees, it hit No. 1 hit on the pop, country and adult contemporary charts and sold more than 2 million copies.

"It's always been my theory that you need to do a duet every so often just to break up the monotony, because you can only disguise your voice so many ways," Rogers noted. "It allows you to have continued product out without the oversaturation of your sound. Plus, people feel like they're getting something extra when there's two artists they like on a record. The moment someone gets in the studio and sings a little better than you do, you realize there's a little more in the well that you can reach for."

Many industry insiders had wondered why Rogers had worked so hard on his previous album, *We Got Tonight*, the final album for Liberty Records, before entering into a new recording contract with RCA Records (reportedly the largest advance in the history of country music) with *Eyes that See in the Dark*. Artists often finished their obligations to a label with a live album or a greatest-hits compilation.

"As corny as it sounds, integrity is very important to me," he said.

"I think if I sloughed off on that album, it might have helped my first album on RCA come out sooner, but a few albums down the road RCA would start wondering what *their* last album would sound like. You can't start a relationship until you end one. I figured I owed Liberty the best album I could give them. It helps everybody, including my fans, if I do quality work."

Indeed, Rogers' commitment to the commercial sensibilities his detractors cited were the same ones that his notoriously faithful fandom depended upon. "I was talking to a critic who has always slammed me, because he's a country music purist. I understood his frame of reference, but I believe I am the ultimate purist—a pure commercial artist. If I don't think something will sell, I won't do it. I chose to do music instead of real estate or plumbing, and I'm a fool not to try and do as well as I can in my chosen field."

For *Eyes That See in the Dark*, Rogers essentially put himself in the hands of Gibb. "It was an experiment for me," Rogers said. "I'm not a singer, I'm a stylist—when I'm deprived of my ability to personalize a song, I lose what I have to sell. Barry was locked into his conception of the songs, but that wasn't wrong—he was doing what he was supposed to do, make the best record he could. We've ended up selling 5 million of them around the world, so you can't say he wasn't successful." ∎

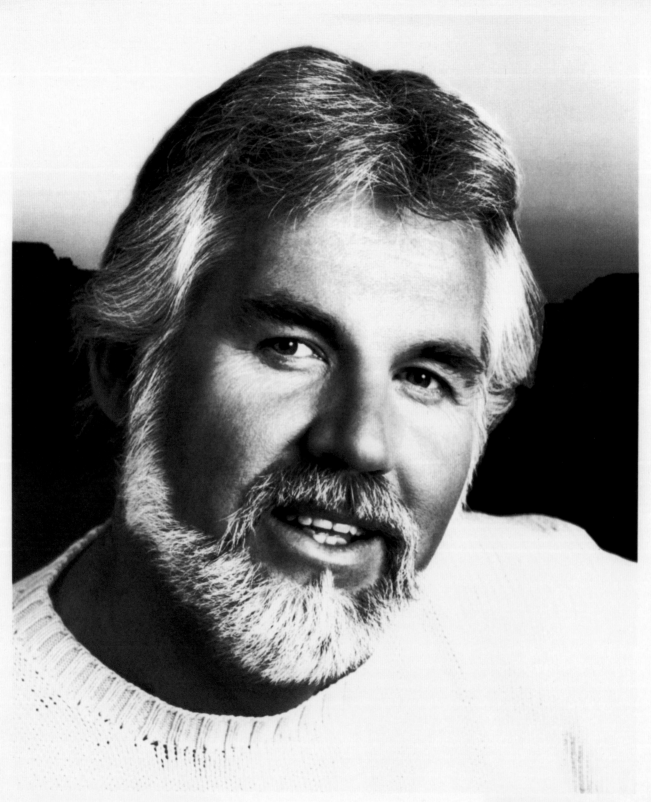

ON RECORD 1983 [LIONEL RICHIE]

Lionel Richie's *Can't Slow Down* earned a couple of Grammy Awards, including the coveted Album of the Year.

Billboard 200: *Can't Slow Down* (No. 1)
Billboard Hot 100: "All Night Long (All Night)" (No. 1);
"Running with the Night" (#7); "Hello" (No. 1);
"Stuck on You" (#3); "Penny Lover" (#8)

THE HOTTEST commodity in pop music as a singer, songwriter and producer, Lionel Richie's string of hit records extended back to the Commodores and the group's first release in 1974, "Machine Gun."

"I'd love to say that I went to Juilliard and someone discovered me writing music, but that's not the way it happened," He recalled. "Early on, I found I was too small to play football, too short to play basketball and too slow to run track. My grandma, whose house I grew up in, was a piano instructor who played Bach and Beethoven. Later, in college, all you heard at campus parties were the Supremes and the Temptations. And because it was the South, it was hard not to hear country music."

Motown songwriters taught Richie the craft of structure and lyrics that grabbed a listener's interest, and he credited Motown founder Berry Gordy with teaching him the complexities of the music business. The Commodores, formed by students attending Tuskegee Institute, found their greatest success when Richie began to write songs geared toward broad pop acceptance, and the country-tinged "Easy" helped give the group its first platinum album.

Richie followed it with the timeless ballad "Three Times a Lady," and then "Still" and "Sail On." His first work outside the Commodores was writing "Lady," giving Kenny Rogers the biggest single of his career. He wrote, produced and sang (with Diana Ross) "Endless Love," which held down the No. 1 spot for nine weeks. In 1982, he released his first solo album and watched its first single, "Truly," top the charts and win him his first Grammy for Best Pop Male Vocalist.

Can't Slow Down, Richie's second solo album, propelled him into the first rank of international superstars, with five singles hitting the Top 10 of the pop charts. "All Night Long" burst with calypso party energy, and "Penny Lover," co-written with wife Brenda, patterned classic love songs. "Stuck on You" drew upon the country spice Richie had used successfully in the past, "Running with the Night" featured a burning guitar solo by Toto's Steve Lukather, and "Hello" closed the album with a genuine and direct lyric.

"Success gives freedom to try new things, to go in new directions, and it's all just melted together for me," Richie enthused. "But I never want to go too fast and leave any of my fans behind. The whole point is to take people with me." ■

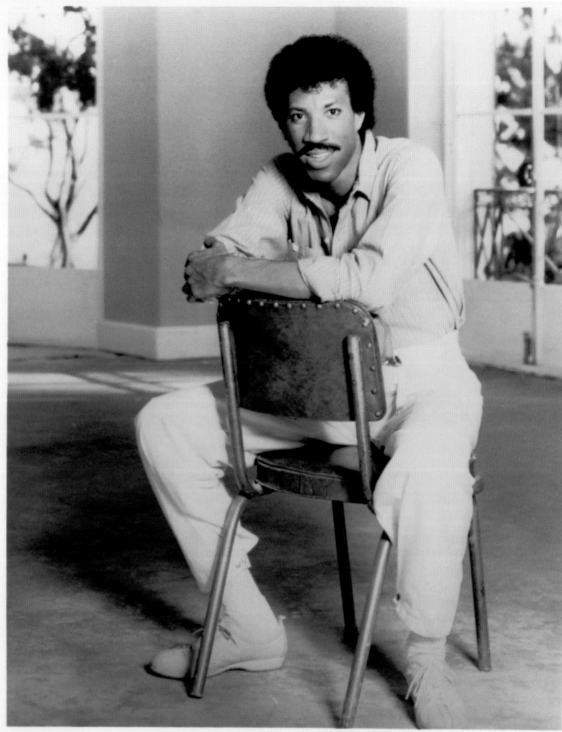

Photo by: GREG GORMAN

LIONEL RICHIE

MANAGEMENT/PUBLIC RELATIONS
(213) 854-4400

ON RECORD 1983 [PHILIP BAILEY]

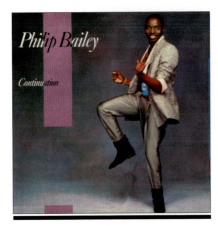

Billboard 200: Continuation (#71)

A multifaceted lead singer for Earth, Wind & Fire, **Philip Bailey** made his solo debut with "I Know," an R&B hit.

BORN IN raised in Denver, Colorado, Philip Bailey stated that music had been his first love for as far back as he could remember. After singing in local groups throughout his teens, he moved to Los Angeles in pursuit of a musical career and became a featured member in Maurice and Verdine White's fledging band. A co-writer of many songs, Bailey was an integral part of Earth, Wind & Fire's meteoric rise to the top of the music world, shattering concert attendance and album sales records.

Bailey was featured on smash after smash—"Devotion," "Shining Star" and "After the Love Is Gone"—with his glistening falsetto often at the center of those songs. He stepped out of the group setting and demonstrated his talents as a vocalist, songwriter and arranger on *Continuation*. Featuring a wealth of top-notch studio session help, the album was produced by legendary jazz-pop musician George Duke.

"When I started looking for a producer, I wanted someone who wouldn't just give me finished tracks and ask me to sing," Bailey said. "Working with George was great because we did just that—work together. There was a lot of music brewing inside me that I wanted to share on record. This project was naturally the next step for me."

Bailey also led a gospel group, and he was interested in recording in that genre as well. "I want to develop to my fullest potential as an 'artist's artist,'" he said. "I always want the music to stay fresh and new, to be as excited about it as the first day I picked up an instrument or ever sang a song. When you keep that type of excitement, that's when the magic begins. That's the magic that you're able to share with others, a blessing."

Enterprise from an essential part of a successful group usually indicated an impending solo career, but Bailey conveyed that he was still active in Earth, Wind & Fire. "I've been working with Maurice White for 13 years now. We've built something special, and I have no intention of walking away from that." However, with the November release of Earth, Wind & Fire's 13th album, *Electric Universe*, White put the band on hiatus, believing it needed a break. ■

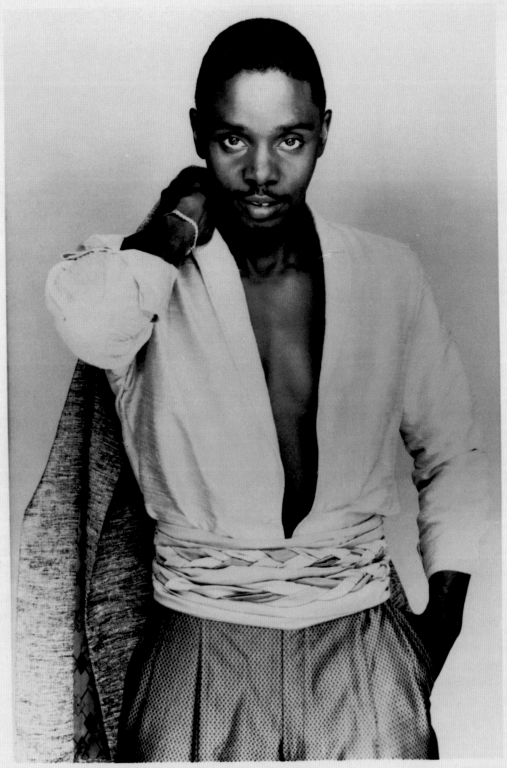

PHILIP BAILEY

Linda Ronstadt collaborated with veteran arranger Nelson Riddle on the classic torch songs of *What's New*.

Billboard 200: *What's New* (#3)
Billboard Hot 100: "What's New" (#53)

DURING HER nearly two decades as a recording artist, singer Linda Ronstadt had covered most all the stylistic bases, from country, folk and rock to R&B, Gilbert & Sullivan and new wave. *What's New* was her most ambitious project to date—an album of traditional pop standards composed by such songwriting legends as Irving Berlin, George & Ira Gershwin and Gordon Jenkins. It stood as something of a return to Ronstadt's roots, to the music she heard during her childhood in Arizona.

"When I first tried to sing songs like these, I couldn't make those sounds very smoothly, so I thought I couldn't do it," she laughed. "Then I got very distracted by rock 'n' roll for a number of years! The fact that most of the songs on *What's New* were recorded by Frank Sinatra and Billie Holiday doesn't mean that I wanted to do songs associated with them. It's just that they were the two best singers during the time I was growing up, and they recorded most of the great pop material."

Ronstadt brought famed arranger and conductor Nelson Riddle out of retirement to record the classic ballads. Riddle, 62, had been one of the most active and celebrated figures in American popular music for more than four decades. In live performance and on film, record, radio and television, his work had brought him into contact with most vocal greats. But perhaps his most memorable collaborations had been with Sinatra, which resulted in a series of best-selling albums during the Fifties and early Sixties.

In terms of his work on *What's New*, the most important of those albums was *Frank Sinatra Sings for Only the Lonely*, which reached No. 1 in 1958 and had a chart run of 120 weeks. Three songs from that album—"What's New," "Guess I'll Hang My Tears Out to Dry" and "Goodbye"—made it onto *What's New*. Riddle also wrote a classy big-band arrangement of "I've Got a Crush on You," a song she had previously performed on *The Muppet Show* TV series.

The album's sentimental nature and Ronstadt's heartfelt interpretations of the songs turned *What's New* into a surprise triple-platinum hit. "Romance is better than almost anything, except music," she mused. "I seem to have plenty of romance in my life, but marriage has never been in the cards for me. I'm not saying that it never will, but there isn't anything pushing me in that direction right now."

Putting *What's New* in perspective with her career was simpler. "I'd like to think I'm flexible enough as a singer to continue expressing myself in a way that's appropriate and honest as I get older, as my taste, my attitudes and the things that I want to communicate change," she explained. "I hope that my music will reflect the whole generation that's growing with me." ∎

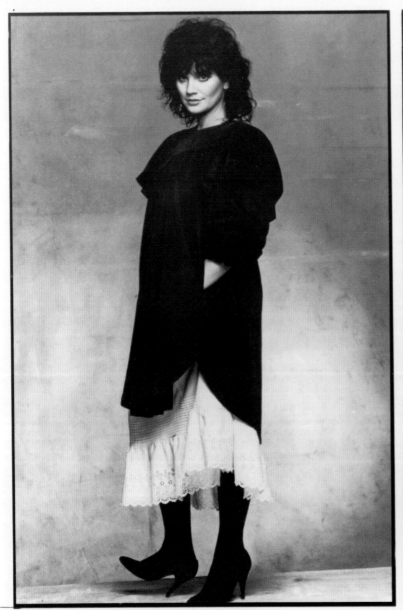 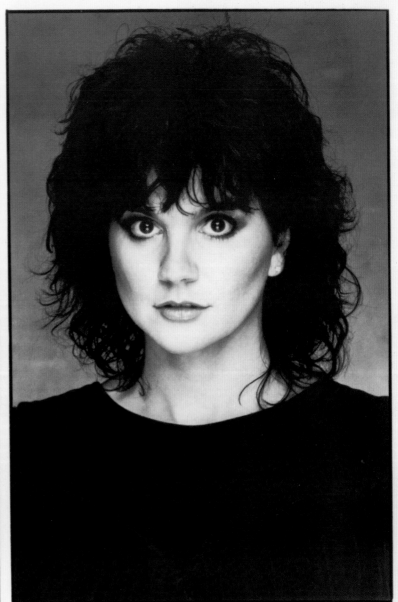

LINDA RONSTADT

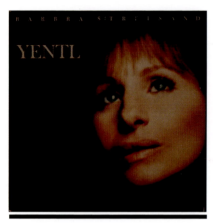

Billboard 200: *Yentl* (#9)
Billboard 200: "The Way He Makes Me Feel" (#40)

Yentl, **Barbra Streisand**'s directorial debut, had an Oscar-nominated hit single, "The Way He Makes Me Feel."

BARBRA STREISAND'S distinguished career had included feature films, Broadway plays, record albums, television specials and countless awards and honors—she was the only performer to have earned Grammy, Tony, Emmy and Academy awards. With the motion picture *Yentl*, she became the first woman to produce, direct, write and perform the title role for a major studio film. It marked the culmination of Streisand's effort to bring "Yentl, the Yeshiva Boy," Isaac Bashevis Singer's short story, to the screen.

"In 1968, I had just finished work on *Funny Girl* when I read it," Streisand recalled. "I was absolutely captivated and enchanted—I called my agent and told him I just found my next film." She acquired the filming rights, but she faced discouragement from agents and movie studios over the project's viability and worked on 11 films in the interim. "No one wanted to make *Yentl*," Streisand admitted. "By the time we started shooting, I had been involved with the project for 14 years."

Yentl was the story of a young, turn-of-the-century Eastern European girl who disguised herself as a boy to study the Talmud, an education usually denied to women. The deception succeeded until she fell in love with a male student and the girl he was engaged to fell in love with her. Trapped by her disguise and unable to reveal her identity, Yentl retreated to an inner world, singing to reveal her thoughts as internal monologues in the film.

Streisand drew upon long-standing relationships for the songs—the score featured music by Michel Legrand, with lyrics by the Oscar-winning team of Marilyn & Alan Bergman. "Originally I had no intention of using music, but I'm happy it turned out that way," Streisand explained. "Once Yentl leaves her village, she lives a secret life that can't be shared with anyone, and we all believed that the best way to capture that voice was in musical narrative. There was really no better way to reveal Yentl's perspective."

The soundtrack album to *Yentl* contained songs with the same orchestral arrangements used in the film, plus a "studio version" of "The Way He Makes Me Feel" produced by Phil Ramone and Dave Grusin that hit No. 1 on the adult contemporary charts. *Yentl* won an Oscar for Best Score and a Golden Globe Award for Best Motion Picture Musical, and Streisand received the Golden Globe for Best Director. ∎

BARBRA STREISAND stars as Yentl, a young woman at the turn of the century who must disguise herself as a man in order to pursue an education, in United Artists' "YENTL," a romantic drama with music from MGM/UA Entertainment Co.

©MCMLXXXIII by Ladbroke Entertainments Limited. All rights reserved. Permission granted for reproduction in newspapers and periodicals only. Use of this photography in any other manner, including but not limited to publication in books, retrospectives, biographies, or in connection with the sale or advertising of posters or of any other product or service, permitted only with the written permission of the copyright proprietor.

YTL-19

Rita Coolidge's "All Time High," the theme to *Octopussy*, a James Bond film, became an adult-contemporary hit.

CLAIMING A couple of million-selling singles in 1977 with "Higher and Higher" and "We're All Alone," Rita Coolidge had enough success to be included in the annals of pop history. She got her first notoriety in the early Seventies as a background vocalist on Joe Cocker's infamous "Mad Dogs and Englishmen" and then as Kris Kristofferson's wife. She parlayed her experience into her own recording contract, and her label had stuck with her for over a decade.

The execs had high hopes for *Never Let You Go*, which was hailed as a big change of pace for Coolidge—it contained five tunes by some of England's finest new-wave songwriters, notably a cover of Yaz's "Only You." Coolidge admitted little familiarity with the artists—the songs were brought to her by a longtime mentor, producer David Anderle. "We decided that we would make a splash with a modern kind of record, but it's not a new-wave record," Coolidge warned. "The energy is just a little brighter."

The album also contained material by some renowned talents. Coolidge deserved a little sympathy for her tardy version of Bob Seger's "We've Got Tonight." "I recorded it as a duet with Jermaine Jackson," she explained. "I knew it was the best thing I had done in years—and then Kenny Rogers and Sheena Easton rush-released their version and it went to No. 1. It was *my* idea to do that song."

Coolidge's victory turned out to be a movie soundtrack—she sang "All Time High," the theme song for the James Bond film *Octopussy*. "And you know, Sheena Easton was supposed to do it," she smiled, noting the irony. "But she blew it. After she did 'For Your Eyes Only' (a 1981 Bond theme), they put her on TV to promote it and all she did was talk about her own album."

"All Time High" became a Top 10 hit in nine countries and topped the adult-contemporary charts in America. After the success of the song, it was added to later pressings of *Never Let You Go*. ∎

RITA COOLIDGE

Billboard 200: *Voice of the Heart* (#46)

Arriving after Karen Carpenter's death, *Voice of the Heart* contained songs from her last **Carpenters** sessions.

AFTER THE song "(They Long to Be) Close to You" went to No. 1 in 1970, the world embraced the appeal of Carpenters music—Karen's velvety contralto voice and Richard's meticulous, grand arrangements. The brother-sister duo's brand of soft, melodic pop produced countless hits—"We've Only Just Begun," "For All We Know, "Rainy Days and Mondays," "Superstar," "Hurting Each Other," "Yesterday Once More," "Top of the World," "Please Mr. Postman."

But in time, there was an unexpected cost to the nonstop pace of the siblings' career. Karen Carpenter was gone at 32, the victim of anorexia nervosa.

"Karen never thought she was in serious trouble—that's part of the disorder," Richard said. "She was always concerned because as a child she was definitely on the plump side. In 1967, she decided with our family doctor to go on a sensible diet. She lost 20 pounds and was fine. But as time went on, more and more attention was being paid to this 'thin is in' thing, and she became concerned that she should lose more.

"Anorexia began to manifest itself in late '74 or early '75. She tried a couple of diets that didn't work, and then she just started starving herself. By the summer of '75, we were on a breakneck tour after a breakneck recording schedule. When you're starving yourself and working your ass off, of course it's going to catch up with you."

Karen spent the last year of her life in New York, working with a therapist. Ultimately, she volunteered to be hospitalized with "hyper-alimentation" treatments that helped her gain 30 pounds, and she returned to L.A. to complete a new album. But she died in her parents' home in Downey, California, from what the L.A. coroner determined was "heartbeat irregularities brought on by chemical imbalances associated with anorexia nervosa."

Richard produced the posthumous *Voice of the Heart* less than a year after Karen's death, including some previously unreleased material from earlier albums. He described "Make Believe It's Your First Time" as "pop laced with country," and "Your Baby Doesn't Love You Anymore," a lavishly orchestrated, big production number, showcased the grandeur and exquisiteness of his sister's voice.

"When you take someone of Karen's magnitude—and, in a sense, a celebrity really belongs to the world—this means a lot to so many people whose lives have been touched by that artist," Richard said. "We had all this material—I couldn't see leaving it on the shelf. If our positions had been reversed, I know she would have done the same thing." ∎

RICHARD CARPENTER

KAREN CARPENTER

ON RECORD | **1983** | **[AMERICA]**

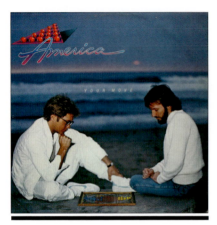

Billboard 200: *Your Move* (#81)
Billboard Hot 100: "The Border" (#33)

Continuing a collaboration with producer Russ Ballard, "The Border" translated into America's final Top 40 hit.

SONS OF American military personnel, America—Gerry Beckley and Dewey Bunnell (with co-founder Dan Peek, who left in 1977)—met at London's Central High School in the mid-Sixties. They played in dance bands before becoming America in 1970. Barely out of school, they were blessed with immediate success as they released "Horse with No Name," followed by America's debut album, which both hit the No. 1 position.

One soft-rock hit single after another dominated the charts—"I Need You," "Sister Golden Hair," "Tin Man," "Lonely People" and "Ventura Highway." The group's audience began to decline in the late Seventies, but in 1982, "You Can Do Magic," from the *View from the Ground* album, catapulted Beckley and Bunnell back into the musical spotlight. Russ Ballard, the former Argent guitarist, wrote and produced the single.

For *Your Move*, Bunnell and Beckley brought in Ballard once again, and the duo faced the challenge of working with an album's worth of outside material. "Somehow, when you're writing for yourself, you keep everything as comfortable as possible," Bunnell said. "But when you're recording other people's songs, you have to push your voice to meet the song's demands."

"We were able to just concentrate on the performing and leave the producing and most of the writing reins to Russ," Beckley added. "I think this is one of our most commercial albums to date. And, after the success of 'You Can Do Magic,' I certainly don't want to knock commerciality." Ballard co-wrote "The Border" with Bunnell, who reworked Ballard's lyrics. The song, with strings by the Royal Philharmonic Orchestra and a spirited saxophone solo by Raphael Ravenscroft, ranked with America's best material. ■

Personal Management:
KATZ-GALLIN-MOREY

Photo: Henry Diltz / 1983

America

Billboard 200: *The Crossing* (#18)
Billboard Hot 100: "Fields of Fire (400 Miles)" (#52); "In a Big Country" (#17)

A distinctive guitar sound stimulated **Big Country**'s *The Crossing* and the rousing, anthemic "In a Big Country."

THE ROCK music scene caught on to Big Country's charms right off the bat. The Scottish band heralded a return to guitar-based rock in an age of synthesizer pop—Stuart Adamson had arrived at a ringing guitar setting that sounded like Jeff Beck playing the bagpipes. And Big Country didn't espouse standard I-luv-girls inanities in its lyrics. Instead, like the band U2, Big Country sang about purposeful things, the potential for greatness.

Big Country formed out of the ashes of the Skids, the group that fostered Adamson's guitar chops. "Even before the Skids, when I was playing dancehalls in Scotland in 1976, I always said I wanted to do things with guitars nobody has ever done before," Adamson said in a thick brogue. "I wanted to use them as integral, even orchestrated elements within a song, not just rhythm and lead guitars. I almost got it right with the Skids, only the enjoyment went out of it after our second album."

At the same time, bassist Tony Butler and drummer Mark Brzezicki departed On the Air, a band that supported the Skids on their last British tour. "Rather than joining another group, we decided to start our own little business as a freelance rhythm section," Butler recalled. The duo dubbed themselves Rhythm for Hire and played on various sessions, including work on some of Pete Townshend's solo efforts.

When Butler and Brzezicki banded with Adamson and guitarist Bruce Watson to form Big Country, Steve Lillywhite ended up producing their debut album. "We wanted Steve in the first place, but he was busy with U2's *War* album," Butler explained. "We ended up waiting until he was available. He came to see us play at Wembley (Stadium in England) with the Jam—we sat down and talked and decided to go from there."

Refined by Lillywhite, *The Crossing* combined emotional, idealistic lyrics and Adamson's soaring guitar work for a panoramic texture. "Stuart's style is completely unique, something he's created himself, and it's what first attracted me to him," Butler noted. "It's just part of his sound, not something he could lose by the formation of Big Country. It was bound to linger on in some form."

"In a Big Country," the group's first American single, climbed into the Top 20. "Some people think 'In a Big Country' is a concept," Butler explained. "But it's just a statement—'In a big country, dreams stay with you.'" "Big Country are not punk, new wave, heavy metal, progressive or pop," Adamson added. "If you really want me to tell you what we're about, then I'd say Big Country plays stirring, spirited stuff—music to move mountains by." ∎

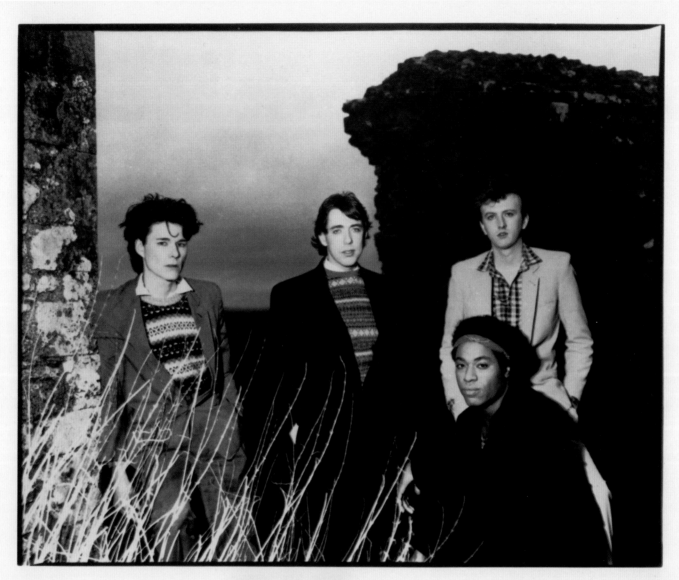

 PolyGram Records

ON RECORD 1983 [MEN AT WORK]

Billboard 200: *Cargo* (#3)
Billboard Hot 100: "Dr. Heckyll & Mr. Jive" (#28);
"Overkill" (#3); "It's a Mistake" (#6)

Their American acceptance backed by a Grammy for Best New Artist, Australia's Men at Work released *Cargo*.

FEW SUCCESS stories were as heartening as Men at Work's. Within a year, the act had gone from playing bars in its native Australia to a No. 1 album, *Business as Usual*, which had topped the American charts for months and spawned two smash singles, "Who Can It Be Now" and "Down Under."

With *Cargo*, their second album, Men at Work faced the challenge of following up their sudden fame. One factor in their favor was that they had recorded *Cargo* nearly nine months prior to the peak success of *Business as Usual*. Hence, *Cargo* featured little self-consciousness or calculation—tracks such as "Overkill" and "It's a Mistake" showed singer Colin Hay maintaining and refining his writing style.

The band's first American performance in support of *Cargo* was co-headlining at US Festival '83, and Men at Work—Hay, saxophonist/keyboardist Greg Ham, guitarist Ron Strykert, bassist John Rees and drummer Jerry Speiser—turned in one of the massive event's most captivating performances. Hay addressed the huge crowd in a wry, provocative manner—a role he developed, he said, when Men at Work were banging away on the club circuit in Australia.

"We still play the pubs at home—they're an Australian band's meat and potatoes," he noted. "You can play larger theaters, but if you leave the pub scene, you can never get back in. The whole thing is set up differently there—a band starts out of a desire to work together, and then after working live for a long time, they get a record deal. Over here, often bands form around a principal person who fills a specific need, like a hot guitar player—then they look for a record deal before they even attempt to play in concert."

The supportive Aussie pubs and hotels allowed groups to disregard cover versions of popular songs, so the competition to survive on original material was stiff. The best bands, brought up in that intense milieu, had survived a critical public to hone their acts.

"It gets strange when you have 2,000 people crammed into a small club, sweating and pulsating just two feet away from you," Hay recalled. "People can't get to a bar or toilet, so they load up with these huge jugs of beer and drink straight from them." Ham noted several incidents when his saxophone was used as an ashtray, a spittoon and other emergency devices. "You certainly find out what they like and what they don't like," Hay laughed.

With that experience, Men at Work had no qualms about surviving in the American market. "For whatever reasons, there's a situation in Australia right now that's conducive to good music," Hay said. "We're one of the first groups to do well over here and still sound Australian—I think most people figure Air Supply is American. But there's some heart now, a spirit that is missing in a lot of groups over here. Maybe we've stepped into that void." ∎

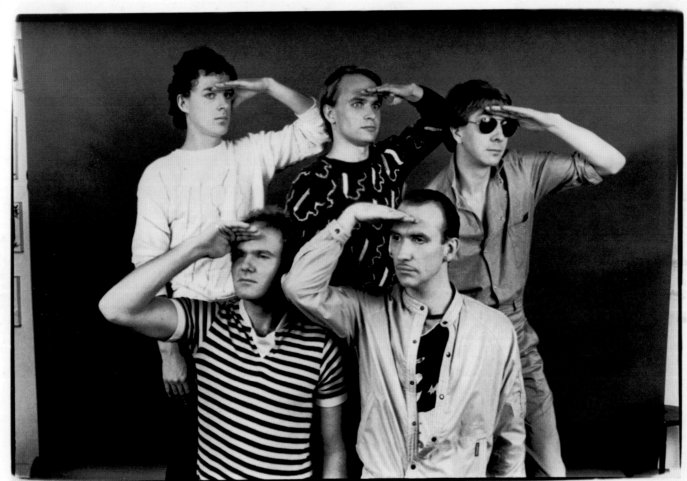

PHOTOGRAPH: LAURA LEVINE

ON RECORD | 1983 | [LITTLE RIVER BAND]

Billboard 200: *The Net* (#61)
Billboard Hot 100: "We Two" (#22);
"You're Driving Me Out of My Mind" (#35)

The Net was **Little River Band**'s first album to feature John Farnham, one of Australia's most popular singers.

SCORNING ELABORATE images, the singers and songwriters of Little River Band went about their craft with determination and professionalism. The Australian act's hallmarks of honeyed harmonies, masterly musicianship and infectious pop sounds had resulted in 11 singles in the US Top 40, with six Top 10 hits—"Reminiscing," "Lady," "Lonesome Loser," "Cool Change," "The Night Owls" and "Take It Easy on Me."

The exit of Glenn Shorrock, the group's original lead singer, resulted in the integration of John Farnham. Replacing a frontman was a risky move for any established act, but for LRB, the results were reassuring. "There really wasn't any doubt about recruiting John," bassist Wayne Nelson explained. "He's been the biggest solo act in Australia for many years, and we had all played on his albums in one capacity or another. Quite literally, he joined the band one day at 11 in the morning and we were in the studio by noon."

The Net showcased a harder-edged sound than on previous Little River Band releases, punctuated by the use of brass and percussion. The album spawned a hit single, "We Two," and Farnham was eager to revitalize the group's in-concert presentation. But his first time facing an American audience led to a comical scenario.

"It was at a hockey stadium in Colorado," Nelson, the band's lone American, recalled. "The group had come over from Australia to do a mini-tour, to prove that things were working with a new singer and guitarist (Steve Housden) and that we were alive and well. For those shows, we were using some fog machines to create a visual atmosphere for our opening number.

"Well, it was so cold in that place that the fog condensed and formed a cloud so thick that the crowd couldn't see us—and we couldn't see each other! We launched into 'A Long Way Home' and John blanked out on the lyrics, even though he'd been singing it with us in Australia for ten months. He looked around frantically for another band member to help mouth the words, but it was like a freighter in a harbor looking for a lighthouse. Finally, the stagehands had to open a back door for the fog to escape."

Audiences were then treated to an onstage demeanor unlike that of previous years. "There is a striking difference now," Nelson enthused. "Musical conflicts between Glenn and the rest of us dated back to the formation of the band eight years ago. They boiled over to the point where we were doing our jobs in tunnels—there was communication from individuals to the crowd, but there was no communication across the stage. There is that mutual respect now, and we have John to thank for it." ∎

Graham Goble Steve Housden Derek Pellicci Wayne Nelson Beeb Birtles John Farnham

· LITTLE · RIVER · BAND ·

Photo: Greg Noakes / 1983

The excellence of **Divinyls'** *Desperate* announced that Australia had spawned yet another international act.

THE FOCAL point of Divinyls was singer Christina Amphlett, whose explosive and unpredictable performances earned comparisons to AC/DC's Angus Young—she ranted, she slobbered, she danced in a spasmodic fit. Her intense posturing found a place in memorable, pulsating songs co-written with guitarist Mark McEntee.

"I've been singing since I was seven and been in bands since I was 14," Amphlett allowed. "Life goes on, and you do different things, but I'm still committed to music. Divinyls is the first band that I've written songs for."

The Australian band first started performing in the bars of Kings Cross, the "sin capital" of Sydney's nightlife. Film director Ken Cameron caught their act and thought Divinyls were perfect for his movie, *Monkey Grip*. Amphlett got a supporting role playing a temperamental rock singer based on herself, and Divinyls provided the soundtrack for the film.

The group recorded *Desperate*, its first American album, in New York with Mark Opitz, one of Australia's leading producers. An exceptional single, the feisty, slashing "Boys in Town," gave fresh treatment to the standard rejection-in-relationships theme, and the dynamic sound belied the group's youth (all members were in their early twenties).

Divinyls commenced an extensive Australian tour before setting their sights on the US. Nearly everyone who saw the band in concert was won over, a little bemused by Amphlett's schoolgirl-uniform-with-fishnet-stockings getup and possessed demeanor.

"It's incredible when you get here," she admitted. "Australia is about the same size, but you just play in certain cities down there. America is so vast—but we'll tour as much as we need to until people notice us." ∎

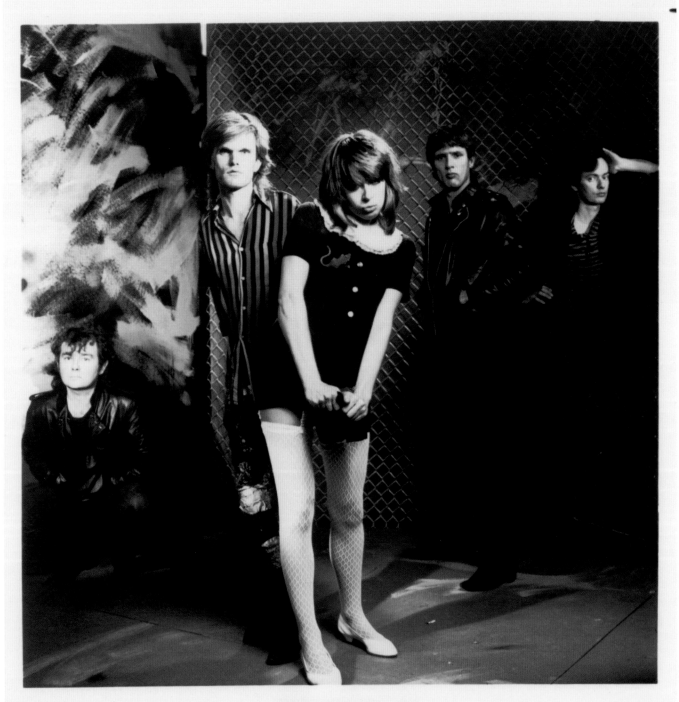

DIVINYLS

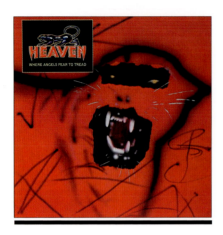

Australia's latest sensations, Heaven received a favorable response among the heavy-metal cognoscenti.

SINCE HE left Scotland at age 14 to take up music in Australia, Heaven singer Allan "Eddie" Fryer had worked hard at his reputation as a flashy, disdainful showman. "It was either sing or end up in jail, y'know?" he recalled. "I served my apprenticeship, sticking to my guns, biting off more than I could chew. There was nothing to lose. I was getting sick and tired of seeing these punk bands around that couldn't play to save their lives. I thought, 'I'm not a bad singer—all I need is the recognition.'"

Much of that recognition came when Fryer was considered for the lead singing slot in AC/DC, a position vacated when Bon Scott died in 1980 of alcohol poisoning. "AC/DC's producers knew my band Fat Lip, and that's when I figured I was doing something right," Fryer said. But at the same time Fryer was being approached in Australia, band members in Europe had solicited Brian Johnson and gave him the job.

Fryer used his newly gained confidence to start Heaven, and the band crossed the US in support of its second album, *Where Angels Fear to Tread*. "Australia needs a kick up the ass," the irrepressible singer noted. "When you're there, they take advantage of you. When you're away, they realize what they've lost."

A big factor in promoting the band's rough-and-tumble image was its humorous free-for-all video of the track "Rock School." Shot on location at Great Neck South High School on Long Island, the clip got its share of MTV airplay.

"It's been banned in Britain because of the sex and violence," Fryer said of the anthem. "But the video's just to show what we're like—we're not a disco-type band. That's a real fight you see (between the group and a swarm of football players). It was the fourth take, and real punches started getting thrown. We couldn't even take our jeans off the next day, we were so bruised and cut up."

An over-the-top version of a Motown classic, "Love Child," the Supremes' No. 1 hit of 1968, was another highlight, and Fryer had Heaven willing to take things to the limit. "We've got a sound of our own. A lot of American bands have the same guitar and drum sound, but we want to keep Heaven a real raw band, and we're staying in the US until we make it. America will eventually find out about us," he sniggered, "because, as you know, Heaven can wait."

Internal differences caused the lineup to disband the following year. ■

Top and bottom, both from the promotional video "Rock School," directed by Martin Kahan, filmed on location at Great Neck South High School, New York.

PHOTOGRAPHS: LAURA LEVINE

8312

Billboard 200: *Escapade* (#161)

While still a member of his longtime band Split Enz, frontman **Tim Finn** found fun with a solo album, *Escapade*.

AS A founding member, vocalist, songwriter and keyboardist for New Zealand's Split Enz, Tim Finn had painted imaginative musical portraits for nearly a decade. When the band took an extended vacation, Finn was afforded the time to record *Escapade* on his own. With Ricky Fataar, a one-time Beach Boys drummer who had amassed session and production credits, and musical partner Mark Moffatt co-producing, Finn explored the different sides of human relationships.

"I was living a fairly quiet life in Melbourne, and a lot of thoughts came through my head," he explained. "I started to write a lot of male-female songs again. I could feel the mood changing around me—people are clinging to one another with more intensity than over the past 10 years. Men and women are becoming good friends again. I ended up writing songs from three sides—the anticipation of a relationship, the relationship itself, and then through to the end of it."

Finn won Australasian success with *Escapade* and the single "Fraction Too Much Friction." "That was one of the songs written in the past," he noted. "I think I'd had a row with somebody, and the phrase 'fraction too much friction' popped into my head, along with the tune. It's got that nice reggae feel, but it's also got a strange folky quality to it."

Finn felt an obligation to Split Enz and went back to the studio with the band. "I'd like to do another solo album and another one after that, and just follow it as a separate progression from the band. Split Enz is a result of work and cohesive effort—it's almost an organic thing now, with a life of its own. My solo career is just starting. It's given me a fresh slant on things, made me feel like a new artist."

After that year's Split Enz album titled *Conflicting Emotions*, Finn left the group permanently to focus on a solo career. ■

TIM FINN

Billboard 200: *Error in the System* (#61)
Billboard Hot 100: "Major Tom (Coming Home)" (#14)

"Major Tom (Coming Home)" cemented the entry of Teutonic artist Peter Schilling into American pop culture.

A SYNTH-POP song about an astronaut abandoned in space, Peter Schilling's "Major Tom (Coming Home)"—a retelling of David Bowie's classic 1969 hit "Space Oddity"—was all over the radio. The German musician originally recorded the tune in his native language but sang the international hit version in English. He showed up in America for the first time to promote the unofficial sequel from his *Error in the System* album.

"I've been playing for ten years, unsuccessfully for nine, but the last year has been very exciting," he explained. "I had written the backing track and needed some words. One night I saw an old movie from 1969 starring Gregory Peck (*Marooned*) about astronauts stranded in space, so I wrote the lyrics around that theme. I called the character Major Tom (the same protagonist Bowie conceived in 'Space Oddity') because it sounded good. I could just as easily have called him Captain Kirk or Mr. Spock."

Schilling joined a band as a teenager, and at the age of 20, he began performing on the German folk club circuit while laboring in the merchandising division of WEA Records of West Germany. "It was like working on the auto-assembly line—basically a job I took just to earn money and get by. But in the course of eight months, I learned quite a bit about the music business."

After a mandatory year of military service, Schilling's musical career was set in motion when he signed with Peer Southern, an international song publisher. Some of his numbers were covered by other bands, but in late 1981 he found the match for his creativity in guitarist Armin Sabol.

"That was a big turning point for me," Schilling admitted. "You see, I'm a writer—I can write melodies and lyrics. I can arrange, I have a feeling for music. But I can't play an instrument, and Armin is a great guitarist—I can give him the framework on a song, and he can put it all together. I am 27 and I live in Stuttgart, Germany, where I have lived all my life. I was raised without parents—maybe that's why I hang onto the music, *ja*?"

Schilling's publishers asked David Lodge and Matthew Garey to turn the German lyrics to "Major Tom (Völlig Losgelöst)" into English. Schilling observed that the US success of "Major Tom (Coming Home)" was rare for records originally sung in his mother tongue.

"A year ago, German musicians began to make high-quality pop and rock music sung in German. This was something new in my country—for the first time, radio stations began playing both English and German-language records. Unfortunately, these stations are once again playing 90 percent English and American artists—I'm the only German in the West German Top 10. I'm rather proud of that, but also saddened by the lack of acceptance for German-language songs. It's some kind of a national complex, I think." ■

PETER SCHILLING

ON RECORD 1983 [PAUL YOUNG]

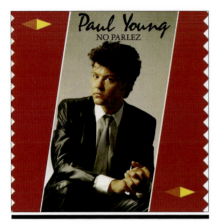

Billboard 200: *No Parlez* (#79)
Billboard Hot 100: "Wherever I Lay My Hat (That's My Home)" (#70); "Come Back and Stay" (#22); "Love of the Common People" (#45)

The debut album *No Parlez* introduced England's soulful **Paul Young**, a vocalist who selected choice material.

HE DIDN'T have a funny haircut or wear outrageous clothes or makeup. He didn't even play a synthesizer. But Paul Young did have a warm, soul-accented voice and an ear for interpreting other people's songs. "I think most of us English musicians are bit overshadowed by Boy George (of Culture Club)," Young chuckled. "But you can see why—he's gotten himself across a lot quicker than the rest of us could have."

Young's reedy voice was shaped by such early influences as Otis Redding, Sam Cooke and Bobby Womack. "But Paul Rodgers (of Free and later Bad Company) was my starting point," he said. "A lot of people that he influenced are heavy-metal singers. I've gone on to do soul music, but his voice is what got me started."

Young's novel song selection had developed over the years as well, and the assured *No Parlez* won him his own acclaim. His first major UK smash was a fervent rendering of "Wherever I Lay My Hat (That's My Home)," an obscure Marvin Gaye B-side. That single had peripheral success on the US charts, but with the hit "Come Back and Stay," Young succeeded in cracking the American market, and his interpretation of Waylon Jennings' "Love of the Common People," further established him on radio.

"The English press has gotten on me for doing other people's songs," he admitted. "It's not that I can't be bothered to write songs, because I have written quite a few, But when you think of it, there are a million songs. And chances are that 10 percent of them are going to be better than the stuff you're going to write. So why not listen to them and make great albums? You can take someone's song and twist it around to your way of thinking." ■

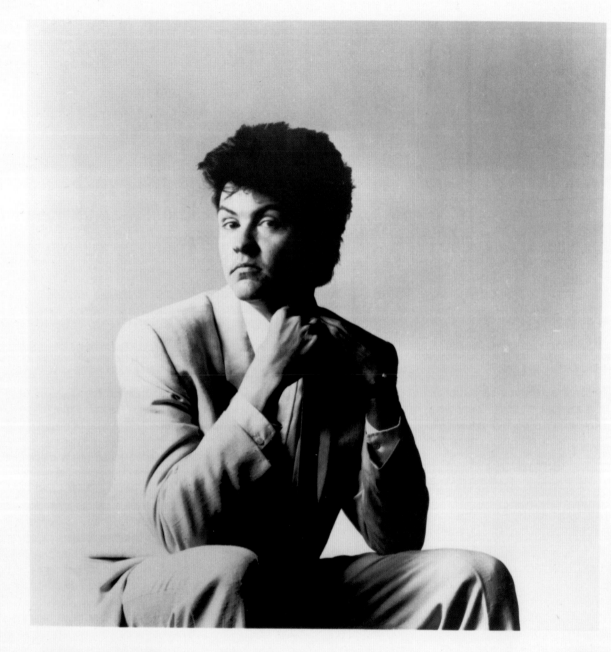

Paul Young

ON RECORD | 1983 | [EURYTHMICS]

Eurythmics' "Sweet Dreams (Are Made of This)" proved synth music didn't have to be cold, sterile or trendy.

Billboard 200: *Sweet Dreams (Are Made of This)* (#15)
Billboard Hot 100: "Sweet Dreams (Are Made of This)" (No. 1); "Love Is a Stranger" (#23)

THE NUMBER of electronic synthesizer-based bands in popular music was rapidly reaching a saturation point. Every group had access to the same technology—with the push of a few buttons, out came a slick-sounding song. But who really had a musical vision behind the high-tech veneer?

Eurythmics carried the potential of an important act. The British group's principals, singer Annie Lennox and guitarist/keyboardist Dave Stewart, fashioned a sleek, well-crafted sound on *Sweet Dreams (Are Made of This)*, a worldwide Top 10 seller. The magnificent title track shaped up as the duo's first hit in America, a No. 1 single.

"We've tried to take some of the energy that came out of the punk movement, the sweetness from soul music, and the alienation of European synthetic mechanical rhythms, and blend it together," Lennox said.

Stewart and Lennox formed Eurythmics upon disbanding the Tourists, a unit whose two outstanding albums never received proper consideration in the States. The Tourists also suffered from being labeled a Sixties revivalist band, due to their hit remake of Dusty Springfield's classic "I Only Want to Be with You." The end result was the formation of Eurythmics, with third Tourist Peet Coombes retiring from music to concentrate on writing novels.

Unfortunately, a "best of" compilation of Tourists music released by their old record label got no endorsement from Lennox. "As far as I'm concerned, it's a joke," she fumed. "We heard that they hadn't even taken it from the master tapes—it's the type of disgusting thing that record companies do. I'm surprised they didn't release it in a brown paper bag. The only reason it was released was to make money, and I guarantee Dave and I won't see a penny of it. I hate it."

With the global success of Eurythmics, Stewart and Lennox were hard-pressed to spend time in every demanding market. Stewart had collaborated with Tom Petty on several songs for Petty's next album, as well as producing a track for the Ramones. Lennox became a pop icon in the wake of the "Sweet Dreams (Are Made of This)" music video, memorable for her theatrical gender-bending imagery; she allowed that she'd "been thinking of getting into a bit of acting, but it's in a formative stage."

On tour, Eurythmics aimed to prove they were more than just a product of the studio. "Yes, I play synthesizer on stage, but I also switch off on guitar and sax," Stewart explained. "We also have live drums, a bassist and another keyboard player, as well as three girl backup singers. I don't think anyone who sees us live can pigeonhole us as another synthesizer band. We have the influence of a soul show—emotion." ∎

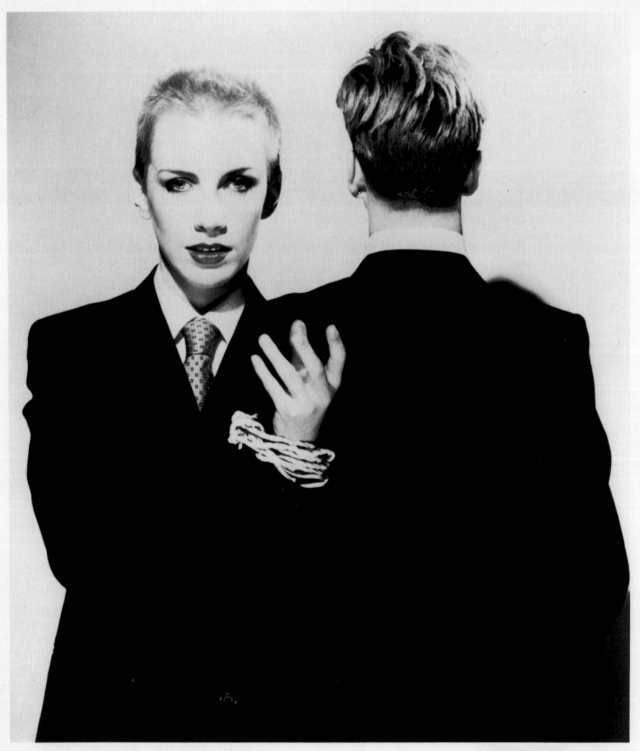

Billboard 200: *After the Snow* (#70)
Billboard Hot 100: "I Melt with You" (#78)

"I Melt with You" by **Modern English**, a British new-wave ensemble, finally reached radio ubiquity in America.

THE NEW music revolution had benefited so many groups that it got hard to tell the players apart. But one signature tune and a memorable image was all that it took for a band to make a mark. With "I Melt with You," a slow-breaking single that was an import-bin favorite and a dance-club hit before cracking the US airwaves, Modern English became the latest British export to storm the American shores.

"Our biggest success has been here," lead singer Robbie Grey noted. "We're not necessarily forsaking our English following by spending so much time here, but in the States you can play to so many more people—and sell more records."

Like so many other bands, Modern English had its origins in the British punk scene circa 1978, the members admittedly inept on their instruments but brimming with ideas. "We couldn't play a note when we started out," Grey admitted, "and we're quite proud of the fact. We got our energy from groups like the Sex Pistols. Music had gotten so boring, it was just another industry. It's supposed to be about ideas."

The band (called the Lepers in their punk days) solidified their lineup in 1981 to become Modern English—Grey, guitarist Gary McDowell, bassist Michael Conroy, keyboardist Stephen Walker and drummer Richard Brown. They released their first album, *Mesh and Lace*, in England only. "It was raw, self-produced music—more sounds than songs," Grey explained.

For *After the Snow*, the quintet's US debut featuring "I Melt with You," Modern English enlisted the assistance of producer Hugh Jones (of Echo & the Bunnymen fame). "People who have heard both albums claim that there's a drastic change in styles," Grey noted, "but the only difference was using a producer, nothing more than that. Hugh becomes another member of the band in the studio. He helps in writing, in coming up with melodies, and the actual recorded sound."

"I Melt with You" crept onto American playlists and became an MTV staple, and the song was featured prominently in the teen comedy *Valley Girl*. Most of the tunes on *After the Snow* were atmospheric, moody pieces—the forceful "Life in the Gladhouse" explored totally dissimilar territory from the melodic groove of "I Melt with You."

"We've matured and gotten better on our instruments," Grey mused. "We're learning about the business side of things. And the live show is harder, more aggressive than the record." In concert, the band's look baffled audiences. Grey had a charismatic puppet-like set of movements onstage, but guitarist McDowell was the real eye-catcher—with his gravity-defying hairstyle, pencil-thin mustache and tattooed knuckles, his synthesized guitar work was almost secondary to his appearance.

"We want to be different," Grey chuckled. "We want to keep people a little confused." ■

MODERN ENGLISH

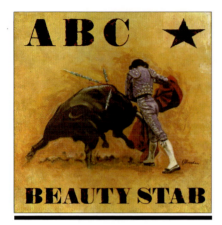

Billboard 200: *Beauty Stab* (#69)
Billboard Hot 100: "That Was Then but This Is Now" (#89)

ABC received a tepid reaction to *Beauty Stab*, the follow-up album to the English pop band's landmark debut.

A NEW-WAVE masterpiece, 1982's *The Lexicon of Love* established ABC as a major group to watch. The songs "Tears Are Not Enough," "The Look of Love," "Poison Arrow" and "All of My Heart" took modern pop music through sophisticated twists and turns—lead singer Martin Fry's romantic scenarios were studded with detailed, lustrous orchestral arrangements and producer Trevor Horn's inventive use of the latest technology.

The band's ascendancy culminated in *Mantrap,* a long-form video pastiche of a tour documentary and an espionage thriller directed by the in-demand Julian Temple. "It's no *Ghandi* and was never intended to be," Fry said. "It was more a chance to showcase a live show in an imaginative way. I'm glad we did it. Around the world in 80 days—in fact, around the world in a gold lamé suit."

The world tour culminated with Fry purportedly flushing his attire down a toilet in Tokyo's Keio Plaza Hotel. He, guitarist and keyboardist Mark White and saxophonist Stephen Singleton then commenced work on their next album, employing drummer Andy Newmark, who had recently recorded and toured with Roxy Music.

Beauty Stab departed from the glossy, stylized production of *The Lexicon of Love*. The band jettisoned the gorgeous pop slickness of synthesizers and drum machines for a harder guitar-oriented sound "that isn't limited to anyone's notion of disco soundtracks or pseudo-sophistication, but geared to potent songs, pure and simple," Fry said.

Lyrically, the songs cited the new-age conservatism that was running unchecked in the UK—"less premeditated, more intuitive and direct, less fiction and more fact." The lead single "That Was Then but This Is Now" served as a self-explanatory manifesto. And the members of ABC produced the album themselves. "All we needed was a good idea of our own strengths and weaknesses," Fry said. "More people should try it. The age of the big-wig Svengali producer is over. *Beauty Stab* is exactly what we wanted and more."

The public struggled to match his enthusiasm. *Beauty Stab* ranked as a disappointing sequel, not as critically or commercially successful as the band's first album. ∎

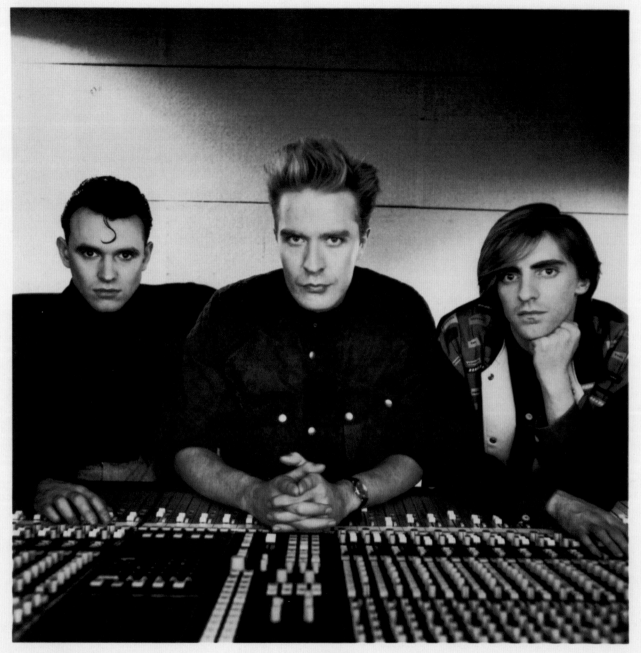

ABC PolyGram Records

ON RECORD 1983 [BOW WOW WOW]

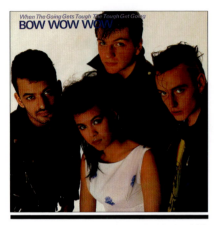

Billboard 200: *When the Going Gets Tough, the Tough Get Going* (#82)
Billboard Hot 100: "Do You Wanna Hold Me?" (#77)

Bow Wow Wow splashed onto US shores with a readiness for tribal rhythms and a mythos of mischief-making.

THE WORD "faddish" could have been applied to Bow Wow Wow when entrepreneur Malcolm McLaren formed the English band in 1980. Fresh off of foisting the Sex Pistols on the world, the enfant terrible of the rock music scene had recruited 13-year-old Annabella Lwin, a Burmese refugee, and teamed her with musicians appropriated from Adam Ant's band.

Then it was easy to have Lwin pose semi-nude and have her sing "C·30 C·60 C·90 Go!" as the first cassette-only single, which advocated home taping at a time when music piracy was a hot-button issue, thus infuriating the British music industry.

It seemed more hype and hustle than the foundation of a long-lasting career, but Bow Wow Wow survived long enough to be considered part of the "new music" vanguard. Lwin severed her relationship with McLaren when she had her fill of exploitation. She linked up with Matthew Ashman (guitar), Leigh Gorman (bass) and Dave Barbarossa (drums), and they found themselves on the American charts and MTV with the single "I Want Candy," a remake of the 1965 hit by the Strangeloves.

Following that newfound success, Bow Wow Wow released its second album, *When the Going Gets Tough, the Tough Get Going*, produced by Mike Chapman, who had created breakthrough albums for Blondie. The band scored its second US charting single, "Do You Wanna Hold Me?"

"Malcolm was manipulative, but it was our own doing to go along with him at the time," Lwin noted, sounding wiser than her 16 years. "I personally am looking ahead now, because we're learning more all the time. We're still young enough to come up with something different than people expect."

Plans to embark on a world tour were aborted when the band fired Lwin and broke up. ■

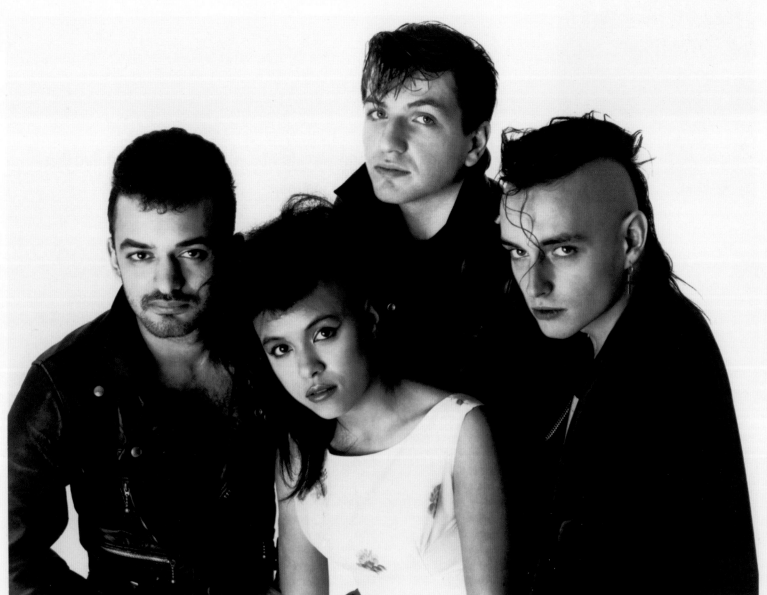

Billboard 200: *Labour of Love* (#15)
Billboard Hot 100: "Red Red Wine" (#34)

An intoxicating reggae-pop version of Neil Diamond's "Red Red Wine" became **UB40**'s calling card in America.

COMING FROM the working-class communities in Birmingham, England, UB40 formed in the summer of 1978. Most of the members of the eight-piece, multiracial group were unemployed—their name, in fact, referred to the number on a British government unemployment benefits form. Only a few of them could play an instrument.

But UB40 had an overriding love of reggae and a desire to establish the band as legitimate British exponents of that Jamaican style. The first American release, *1980-1983*, was a compilation of ten English singles and album tracks. Less than six months later, the group was back with *Labour of Love*, a collection of ten reggae classics first recorded between 1969 and 1972 by pioneering artists.

"We thought *Labour of Love* would be a successful album, just because the songs were so great and hadn't been heard by most people in their original versions," drummer James Brown observed. "From the very beginning, we wanted to reinvent these covers in a way. But when we first got together in the punk days, you didn't do that kind of thing. It was almost like trickery. Most of the songs hadn't had the exposure—they were hits in our local area, but not around the world. It was an untapped goldmine for us."

Choices sprawled from the obscure (Boy Friday, Lesley Kong) to the familiar (Jimmy Cliff's "Many Rivers to Cross")—even Neil Diamond's "Red Red Wine," in an arrangement similar to that of Jamaican-born singer Tony Tribe's 1969 version.

"We had no idea the song had anything to do with Neil Diamond—we had never heard of him until much later," Brown claimed. "We thought it was a reggae hit that we remembered listening to when we were younger. You have to respect him—obviously it's a good, well-written song."

"Red Red Wine" gave UB40 its first hit in the US. "We're a pop band in England, and we're in the business of establishing reggae as pop music," Brown said. "We want the normal, everyday record-buying public to buy our records, and we don't care if they're Democrats or Republicans. Some people overestimate the spiritual and political content of reggae. You can pontificate all you want, but reggae can be as popular as rock 'n' roll or soul music or jazz. It just needs to be given the chance." ∎

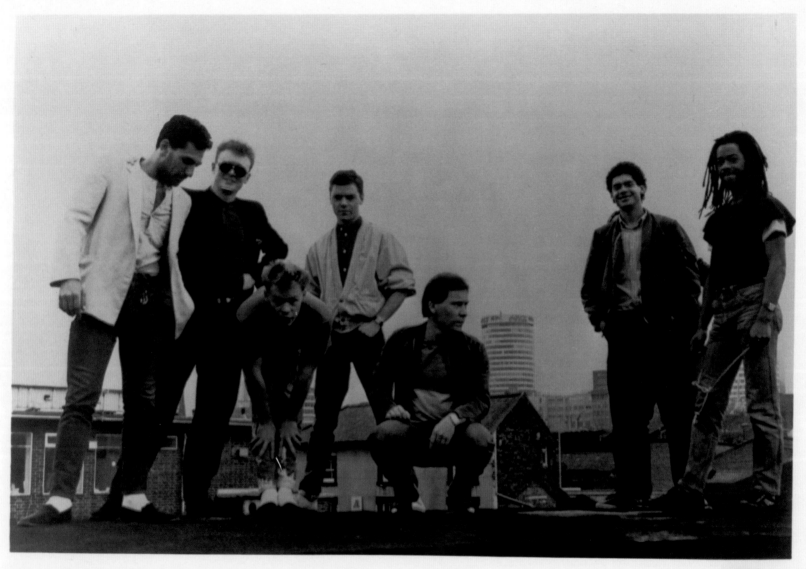

UB 40

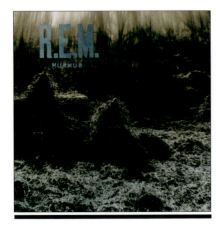

Billboard 200: *Murmur* (#36)
Billboard Hot 100: "Radio Free Europe" (#78)

Defying all the corporate-rock rules, R.E.M. brought a DIY freshness to the scene with "Radio Free Europe."

INDICATIVE OF R.E.M.'s charms, with a unique small-combo sound and tight, subtle melodies, "Radio Free Europe" had been an underground hit since its independent release in 1981—a small yet satisfying accomplishment that generally exceeded the members' expectations.

The band formed in April 1980 with the express intention of combatting the boredom of life in Athens, Georgia, the bucolic home of the University of Georgia. Guitarist Peter Buck and singer Michael Stipe, who were living in a dilapidated, abandoned church that conveniently had a stage, recruited fellow students Mike Berry (bass) and Mike Mills (drums) to perform in one large bacchanal for friends.

The foursome immediately developed a following, and before long, R.E.M. was opening for acts in Atlanta's largest clubs. Converts found the chime and surge of the music compelling and unusual, and several labels scouted the band. I.R.S. Records signed R.E.M., and the acclaimed EP *Chronic Town* led to a full-length album, *Murmur*, produced by Mitch Easter and Don Dixon.

A new version of "Radio Free Europe" was its lead single, the band's first to reach the *Billboard* charts, and *Murmur* racked up extravagant accolades in most critics' polls. The quirky pop strains couldn't be traced to any one geographical area. "We never try to make records that sound like what's on the radio," Stipe explained. "We're into non-cool records—things that sound fresh." "People can't say, 'They sound like this group or that one'—we were trying to avoid all influences," Buck added.

The resolutely independent quartet hadn't pursued the standard path to pop success, declining offers to tour with established acts such as the Clash and the B-52's. A stint with the English Beat marked R.E.M.'s first collective effort to break into the national concert market. "Opening for other bands is rather masochistic," Stipe remarked, "but the Beat are good guys. There seems to be more acceptance of different music now, more people seem anxious to hear it. That's a flattering enough reason to move on it." ∎

R.E.M. PETE BUCK MIKE MILLS BILL BERRY MICHAEL STIPE

photo: Sandra Lee-Phipps

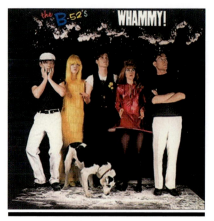

Billboard 200: *Whammy!* (#29)
Billboard Hot 100: "Legal Tender" (#81)

The B-52's grabbed the opportunity to amend their singular, splashy sound on their third album, *Whammy!*

ROCK MUSIC overflowed with overachievers, but the B-52's were more than comfortable with the status they had attained. "We started out as a party band with humor," singer Fred Schneider admitted. "And that's still all that we try to be."

The *Whammy!* album perpetuated the wacky tradition the New York-cum-Athens, Georgia outfit established in the late Seventies with "Rock Lobster" and "Private Idaho." The music continued to wed omnipresent dance rhythms—a blend of Sixties pop/soul/surf music and B-grade sci-fi movie soundtracks—to nonsensical lyrics. "I think it'll be great to roller skate to," drummer Keith Strickland opined.

What changed was the members' distinctive approach to recording, relying heavily on synthesizers and drum machines. Ricky Wilson and Strickland played all the instruments on the backing tracks; the rest of the band—Schneider, Kate Pierson and Cindy Wilson—provided vocals only. According to Schneider, the biggest breakthrough for the B-52's had been a more prolific songwriting output.

"We've had different rates of working in the past," he said, alluding to the group's sporadic releases. "But now we're finding our own tempo to write songs. The biggest factor has been just finding time together to write, because we've found that we can't write on the road."

"Legal Tender." "Whammy Kiss" and "Song for a Future Generation" all got dance-club play. On tour, the band added two horn players to supplement the sound. "We're not very didactic," Schneider laughed. "We'd rather let people get what they want out of our concerts. All we do is generate a lot of energy and try to get the audience going along with us. I think we're succeeding, even though people aren't dressing as wigged out for our shows as they used to. Now it's just us looking silly." ∎

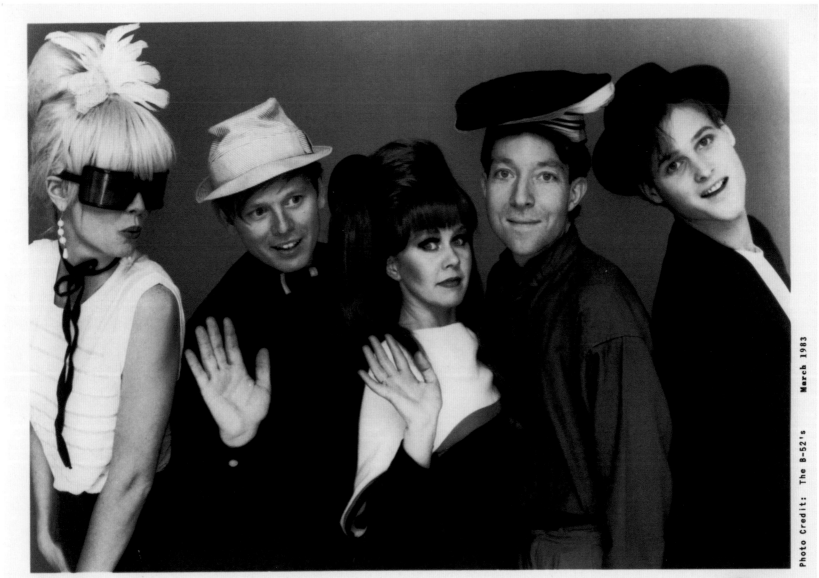

ON RECORD | 1983 | [GREG KIHN BAND]

Billboard 200: *Kihnspiracy* (#15)
Billboard Hot 100: "Jeopardy" (#2); "Love Never Fails" (#59)

Greg Kihn Band made its biggest showing on the pop singles charts with the funky fascination of "Jeopardy."

THE MAJORITY of rock musicians approached their work with a combination of awe and trepidation, fretting over each new release as if it were a newborn child. Would it sell more than the last one? Was there a hit single? Every move was plotted out and marketed in a make-or-break manner.

Which was what made the success of the Greg Kihn Band refreshing. Using "the classic rock guitar lineup," Kihn and his cohorts cranked out an album every eight months like clockwork, and the culminating effect had been to ingrain the Bay Area group into the public consciousness with singles such as "The Breakup Song" and "Happy Man." "It's really no problem getting me into the studio—it's keeping me out," Kihn explained. "I'm just trying to get better and perfect my craft."

That included his songwriting. "I think it's awfully pretentious to think in terms of albums," Kihn said. "It's easier for me to let each song be what it wants to be—a ballad, reggae or a hard rocker. I feel confident the band can play in any style a song demands. I've been trying to get an 'economy of expression,' saying things in fewer words—that's why I like Buddy Holly. And I made a conscious effort to write songs for my own vocal range."

Kihn's straightforward approach yielded another hit with "Jeopardy," his most successful track—it rose to #2 (behind Michael Jackson's "Beat It") and created smiles on the dance floor. And as he did with "Beat It," "Weird Al" Yankovic parodied "Jeopardy" as "I Lost on Jeopardy"—Kihn made a cameo appearance in the music video. Kihn, who grew up in Baltimore, claimed he aspired to be the rock equivalent of Brooks Robinson, the legendary Baltimore Orioles third baseman.

"His style and grace really impressed me," Kihn said. "Certain guys are so casual—they just breeze through their jobs. And it made you feel good that, when you talked to them, they were just normal people. Only a few people in my life have done that. Brooks Robinson—chewing gum, smiling, being a Hall of Famer—inspired me. That's what I wanted to be as a musician." ■

GREG KIHN

Distributed by Elektra/Asylum Records
A Warner Communications Co.

PHOTO CREDIT: JACKI SALLOW/1983

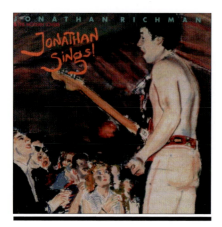

The most eccentric performer on the music scene, Jonathan Richman maintained his minimalist, oddball style.

FOR MORE than a decade, Jonathan Richman had steadfastly promoted his personal musical vision without commercial success. One listen revealed the reason for his cult status—his simple songs resembled nursery rhymes, and his demeanor reflected a childlike sense of humor and naivete.

And it wasn't as if Richman—who sang tunes such as "I'm a Little Dinosaur" on his hands and knees—salvaged his performing techniques with overpowering musical gifts. His unpolished vocals and informal recording techniques—such as shouting out cues to band members as if they hadn't rehearsed—ostensibly left little to recommend him.

Yet you couldn't easily dismiss his influence. Several acts had covered "Roadrunner," his ode to the highway (with Greg Kihn getting the hit). The various incarnations of his band, the Modern Lovers, had spawned such musicians as Jerry Harrison of Talking Heads and David Robinson of the Cars. And even though Richman came across as flaky in concert, his vulnerability and lack of inhibition was certainly admirable.

"I grew up in the suburbs of Massachusetts," RIchman noted in his endearing croak of a voice. "I heard live bands in junior high but didn't start singing or playing until I heard the Velvet Underground, out of New York City. They made an atmosphere, and I knew then that I could make one, too!"

Jonathan Sings! was his first album release in several years, recorded with a new Modern Lovers lineup. Richman knew he would never be considered part of the musical mainstream, even if the recent directness in rock could be traced to his style.

"I get a lot of evil things written about me," he admitted. "But it's the audiences that I care about. If people come to the shows, they… well, I was about to say that they can see for themselves, but there are times when they believe more in what they've read than what they're witnessing with their own eyes. That gets to me once in a while."

Surely the sight of Richman strumming on a battered acoustic guitar while singing the ditty "Hello There Little Insect" would give anyone pause. "I don't know what I'm going to do before I do it onstage," he insisted. "I don't use a set list. I don't know if I'll smile—I might be sad that night. Lots of times I think I'm hilarious. But I don't do 'parody' or 'satire' or 'tongue-in-cheek' stuff. I read those words about myself occasionally."

Richman wasn't sure what the immediate future held. "I don't think the record company is gonna want to stick me on another record until they see how this one does," he allowed. "The main thing I want to do is shows—that's my favorite thing. I like telling people about my life. I am in my music like I am as a person." ■

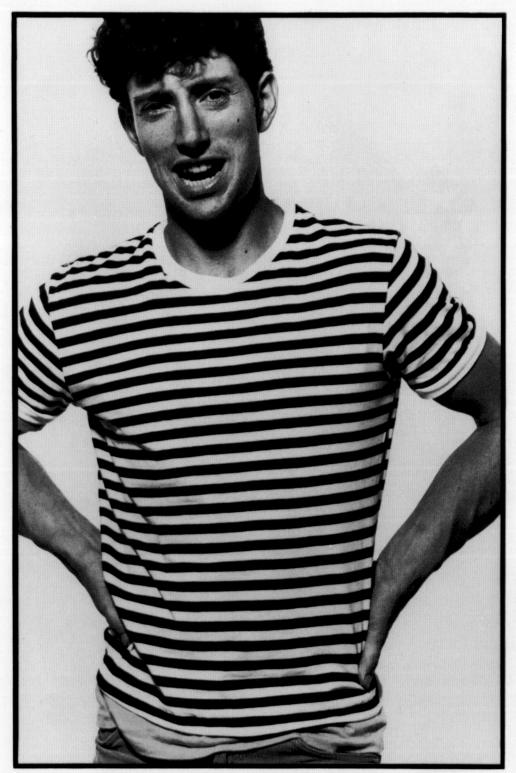

JONATHAN RICHMAN

Photo Credit: HOWARD ROSENBERG

The Bongos, a maverick, self-reliant recording act, got a taste of fame with the album *Numbers with Wings.*

MAKING HIS way to New York from Tampa, Florida, Richard Barone helped form the Bongos in 1978. They made their home in Hoboken, New Jersey, a tiny port town directly across the Hudson River from Manhattan, where the rent was affordable and the creative climate favorable. Rehearsing in the back room at Maxwell's, the band soon launched the bar and restaurant as a rock club, creating approachable pop-rock in a guitar/bass/drums format.

Barone, the lead vocalist and guitarist, said he drew inspiration from the Beatles, the Velvet Underground, David Bowie and Motown's lineup. "We try to use our influences as a vocabulary, to express our own ideas," he said. "Hopefully, the Bongos will never stand to represent one style, image or musical formula. Our only goal is to express ourselves instinctively."

The Bongos took on the New York scene, muscling their way onto radio playlists and touring the East Coast club and college circuit. Then they leapt across the ocean, recording self-produced British singles in England for Fetish Records, a tiny independent label.

"It was a matter of mutual fascination," Barone said. "We met Rod (Pearce, director of Fetish) in a club in Hoboken and we were intrigued with the idea of working with an independent record company, helping it develop and learning the ropes. Rod was interested in the idea of signing an American pop band and trying to break us in England."

The Bongos moved up to a major label and released the mini-LP *Numbers with Wings*. It marked the first time guitarist James Mastro appeared on a Bongos record, although he had already accompanied the band on several tours. The quartet also used an outside producer, Richard Gottehrer, who had helped bring Blondie and the Go-Go's to the charts.

"I also admire Tony Visconti, Trevor Horn and Phil Spector, of course," Barone said. "It is, naturally, impossible to be objective producing yourself when you're in the middle of recording—are you overdoing or undoing it?"

Numbers with Wings soared to No. 1 on college radio charts, and the Bongos made their bones when the video of the title track was nominated for Best Direction at the first MTV Video Music Awards. ∎

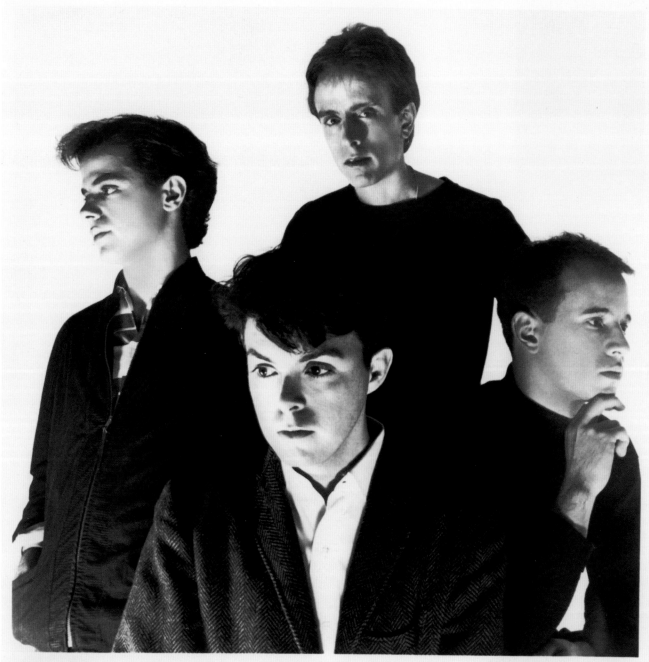

ON RECORD | **1983** | **[VIOLENT FEMMES]**

Billboard 200: *Violent Femmes* (#171)

Violent Femmes produced a distinctive cult classic, a self-titled debut of folk-punk led by "Blister in the Sun."

WITHOUT HAVING heard or seen the Violent Femmes, you might have assumed that it was an all-girl motorcycle gang or female mud-wrestling troupe. But a listen to the combo revealed a mild-mannered approach that belied its strange moniker. "We come into towns where the papers are saying, 'This band is redefining sex roles in society' and stuff like that," leader Gordon Gano said. "It's just our name, although I guess it is a little wacky sounding. But we're simply three guys from Milwaukee."

The Violent Femmes resulted from chance and circumstance. In 1981, Gano was playing solo in the Milwaukee area with no particular plan. "Milwaukee's an okay place to get something going artistically since there aren't any distractions," he said. "But there aren't any places to play or enough people to support it."

But that summer, Gano met Victor De Lorenzo and Brian Ritchie, a duo best described as "a free-lancing rhythm section. They had plans to go to Minneapolis to form a band with friends, so we played as Gordon Gano & the Violent Femmes for a few weeks. It was real loosely formed, definitely temporary."

When the Minneapolis plans fell through, the trio decided to set more permanent goals. In a stripped-down mode, Violent Femmes would busk in front of drug stores and delis, or play for free for lines of people waiting outside movie theaters and rock concerts. One such impromptu performance impressed the Pretenders, who asked them to open their Milwaukee show that night.

When a demo tape fell on deaf ears, they recorded their own album. Then two fortuitous things happened—Slash Records, a small independent label, picked up the record; and Slash was in turn picked up by Warner Bros. Records for distribution, an agreement that put *Violent Femmes* in stores across the country. The album garnered Gano and company a burgeoning underground following with its raw rehearsal-hall sound.

The instrumentation for the group's wry ditties was off the beaten track—in addition to the acoustic setting provided by Gano's guitar, the Femmes' sound was predicated on the tranceaphone, a percussion instrument of De Lorenzo's invention (a one-headed floor tom covered with a metal wash basin played with steel brushes). No one could put a finger on how the diverse influences—from Fifties doo-wop to garage band simplicity to elements of Eighties new-wave music—added up on "Blister in the Sun" and "Gone Daddy Gone."

"With the tranceaphone and us being acoustic and our name, people think there's a heavy concept at work," Gano said. "And there's not. At our first rehearsals, the same songs we're playing now were done on the typical electric guitar-bass-drums setup that you'd expect. And there's nothing to say that we won't return to that. Right now, we're still kinda waiting to see where all of this takes us." ■

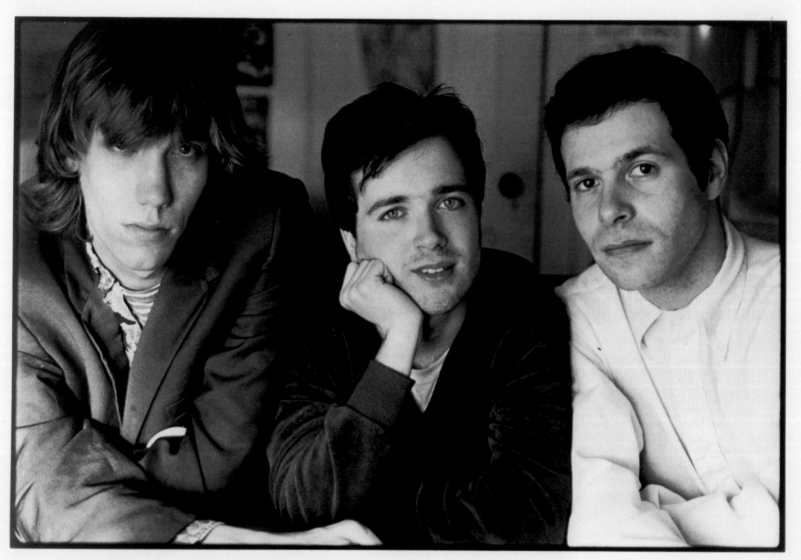

violent femmes

BRIAN RITCHIE GORDON GANO VICTOR DELORENZO

PHOTO: GEORGE LANGE

The age-old axiom "The bigger they are, the harder they fall" seemed particularly apt in the case of Meat Loaf.

BREAKING ONTO the rock scene in 1977 with *Bat Out of Hell*, a debut album that eventually sold 9 million copies, Meat Loaf presented an unforgettable image to the public. At a time when rock musicians took pains to appear as traditionally wraithlike as possible, the hefty singer looked like a grocer who was eating up all the profits. And from inside his man-mountain stature came a voice of near-operatic proportions. But that voice failed Meat Loaf as suddenly as it had catapulted him to stardom. At the height of *Bat Out of Hell*'s popularity, the pressures of that success stripped him of his singing powers and left him in a career limbo. He was just finding his way back in supporting his third album, *Midnight at the Lost and Found*.

Meat Loaf—real name Marvin Lee Aday, "but nobody ever calls me that"—had no qualms about dissecting the ups-and-downs of the past several years. "The problems with my voice were all stress-related," he admitted. "I just let myself go wacko from and during the success—it was psychosomatic. I spent over two years doing nothing but wondering where my voice had gone. I finally decided to work, so I starred in the movie *Roadie*. My psychiatrist told me to do it just to be doing anything."

He attempted recording a follow-up to *Bat Out of Hell*, but Jim Steinman, who had written the songs for *Bat*, got tired of waiting for Meat Loaf's voice rehabilitation to finish and used the material intended for the second album as his own first solo record, *Bad for Good*. Other Steinman tunes were gathered for Loaf's eventual release, 1981's *Dead Ringer*. The title track was a smash in Europe, Australia and Canada—nearly everywhere but America, a fact that still irked Meat Loaf.

"Radio had closed minds just because it was a duet with Cher," he fumed. "It was a hit song, as was proven elsewhere. In other countries, it didn't make a difference that Cher had played Las Vegas and Atlantic City, but over here the radio people said, 'Oh, I'm sorry, but we don't play *her kind of music*.'"

Meat Loaf was contractually obliged to release a new album, and legendary producer Tom Dowd helmed *Midnight at the Lost and Found*. "He was the one who helped me get my confidence back. He just said, 'Ah, there ain't nothing wrong with you, kid. They're just songs—get in there and sing 'em!'" The album didn't feature the songwriting prowess of Steinman, who had given the hits "Total Eclipse of the Heart" and "Making Love Out of Nothing at All" to Bonnie Tyler and Air Supply, respectively.

Loaf was forced into finding songs. "I don't like songwriting, but I'm getting better at it. I learned a few tricks from the best guy in the biz. I'll be working with him again, as soon as he gets away from his shithead manager who's suing me for all my money. I'm serious—I'm poor! I mean, I'm being forced to eat Twinkies and tuna fish sandwiches, and to walk from gig to gig…" ■

MEAT LOAF

ON RECORD | 1983 | [CHEAP TRICK]

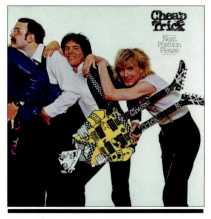

Billboard 200: *Next Position Please* (#61)

Cheap Trick recruited Todd Rundgren to produce *Next Position Please*, a polished album that failed to catch fire.

SURGING TO the forefront of American power-pop bands in the late Seventies with a loony but sharp image and several anthemic singles to its credit ("Surrender," "Dream Police"), Cheap Trick was poised for a lengthy ride at the top. But the veteran Midwest quartet had laid low of late. *One on One*, the group's 1982 album, contained a couple of should-have-been hits (the power ballad "If You Want My Love" and the rocker "She's Tight"), but the band had already suffered a crucial loss of momentum. Singer Robin Zander explained the happenings.

"The biggest factor was a nine-month period where we were in limbo because of legal hassles (with the band's record label)," he noted. "It was a major lawsuit that was just an excuse for a bunch of lawyers to have cocktails together, but it came down when we were in the middle of recording *One on One*. Everything is back to normal now, thankfully."

Todd Rundgren stepped into the producer's chair for *Next Position Please*. He was the latest in a succession of Cheap Trick studio mentors (following George Martin and Roy Thomas Baker). "Todd was good to work with because he's a rock musician, too," Zander enthused. "He understands sound that nonguitarists or nonsongwriters can't possibly grasp. He knows the ins-and-outs of a band because he's in one himself (Utopia)."

True to form, *Next Position Please* featured a new array of different instrumental textures, courtesy of bonkers guitarist Rick Nielsen. "Rick's come up with a greater variety of songs this time that hasn't been on our last few albums," Zander said. But two singles, a cover of the Motors' "Dancing the Night Away" (a decision made by the label) and the stellar "I Can't Take It" (written by Zander), failed to chart. Hardcore fans called attention to an overlooked gem—"Heaven's Falling," a Rundgren composition. ∎

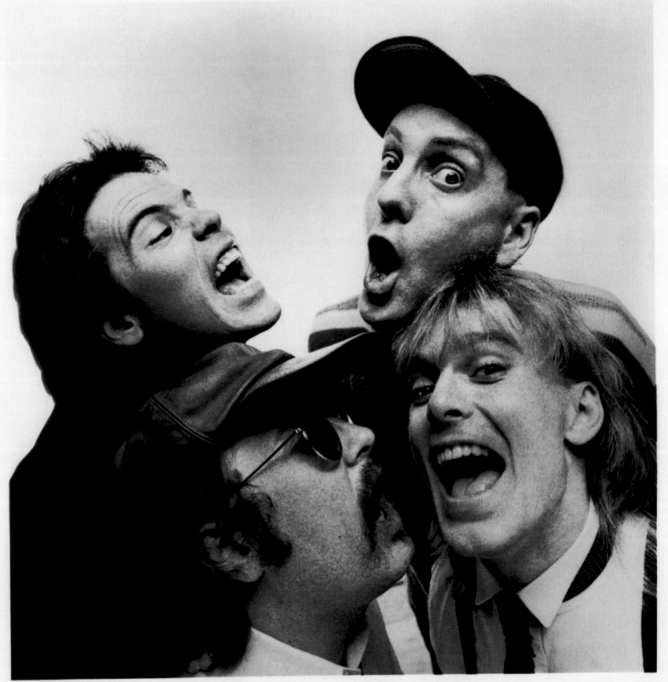

Top Row: Jon Brant Rick Nielsen
Bottom: Bun E. Carlos Robin Zander

CHEAP TRICK Photo Credit David Kennedy

The Tubes finally earned their first ride on the Top 10 singles chart with the enthralling "She's a Beauty."

Billboard 200: *Outside Inside* (#18)
Billboard Hot 100: "She's a Beauty" (#10); "Tip of My Tongue" (#52); "The Monkey Time" (#68)

FOR MORE than a decade, the members of the Tubes believed that the basic interest in the band hinged on their bent theatrical productions. "Everyone in America gets bombarded by media and hype, and there's an effect to all of that," singer Fee Waybill noted. "We simply take it and spit it back out, twisted by our collective imaginations."

Such sentiments spawned cult acts, and the Tubes' stock-in-trade was satire and spectacle. Waybill, the head cynic, would dress up in a studded leather jockstrap to sing "Mondo Bondage," or stick his head through a television tube to deliver "Prime Time." Authorities regularly pressured the group for using obscenities on stage.

But the Tubes were no longer an underground attraction sneaking around on the concert circuit. The commercial success of the single "She's a Beauty" redefined the public's perception of the band.

"We've got a whole new crowd," Waybill enthused. "Now there are college girls who have only heard 'She's a Beauty' on AM radio and come to our show expecting to see another typical Spandex band—we call them 'Marshall Shags' (derived from the prototypical use of Marshall amps and shag haircuts). They come to see us, and what they get is this whole fiasco—and it blows their minds. It's like the old days all over again, when people didn't know what to expect from us."

"The Monkey Time," with Martha Davis of the Motels sharing vocals with Waybill, scored another hit for the Tubes, courtesy of David Foster, who produced *Outside Inside* and the previous album. Although he had steered the band in a pop direction (to the dismay of old Tubes fanatics), Waybill maintained that it wasn't a sellout.

"It's just allowed us to keep going," he insisted. "We found out that by sticking a couple of commercial rock singles between the Tubes cuts on a record, we'd get a little airplay and sell the whole album. It just makes all the difference. The music was secondary for years, because nobody in the audience had heard it on the radio. But it's different now, because we're not afraid to emphasize the songs."

The Tubes' had always produced shows at enormous expense. Before its newfound record sales, the band racked up a debt of "hundreds of thousands of dollars," Waybill recalled. "We didn't know what was going on. We're still paying for a big dinner we had in Europe eight years ago, and for our very first tour—we took 38 people on the road with us, including eight dancers. And when you're not selling records to pay for it, it makes it tough to justify your existence to a record company!" ■

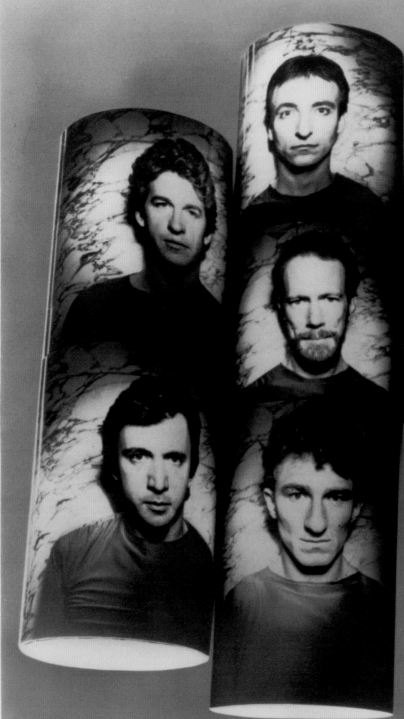

ON RECORD 1983 [RAMONES]

Billboard 200: *Subterranean Jungle* (#83)

A **Ramones** cover of the Chambers Brothers' "Time Has Come Today," though inspired, went largely unnoticed.

SETTING OFF the whole punk explosion in 1976, the Ramones galvanized the Sex Pistols and every other fast-and-loud band that had come down the pike ever since. The key was the band's classic first album, replete with 90-second songs, marvelous albeit mumbled lyrics about glue-sniffing and a distorted, paint-peeling guitar sound. It was perceived by some as the dumbest album ever recorded. It was also funny, superbly executed and a welcome is-nothing-sacred attack at a time when singer-songwriters ruled the airwaves.

The Ramones continued to churn out album after album with wit and style, but their minimalist approach hadn't been parlayed into hit songs. Most radio programmers had decided that the scuzzball New Yorkers, with their black leather jackets and bowl haircuts, were doing something to rock music, not for it. That wasn't a fair assessment. With several of their blatant imitators meeting with commercial success, there was no reason that the Ramones shouldn't capitalize on their godfathers-of-punk status.

That feeling was reinforced with *Subterranean Jungle*, an enjoyable record featuring their nastiest guitar textures. Ritchie Cordell and Glenn Kolotkin, both of whom had worked extensively on many Sixties pop masterpieces, produced the album. The Ramones recorded a rendition of "Time Has Come Today," the Chambers Brothers' tune, and it turned out Kolotkin had engineered the original countercultural hit.

"Back then, he'd developed this 'Sensurround' technique where the music sort of wraps around the room," singer Joey Ramone said. "He'd forgotten how it was done until we cut 'Time,' and it all came back to him. We got it all down on that track. It's a great song, a very intense classic, and nobody's covered it. We thought it was about time."

The song didn't chart, and *Subterranean Jungle* failed to gain the band a larger audience. Why more people weren't getting the message continued to be a mystery. ■

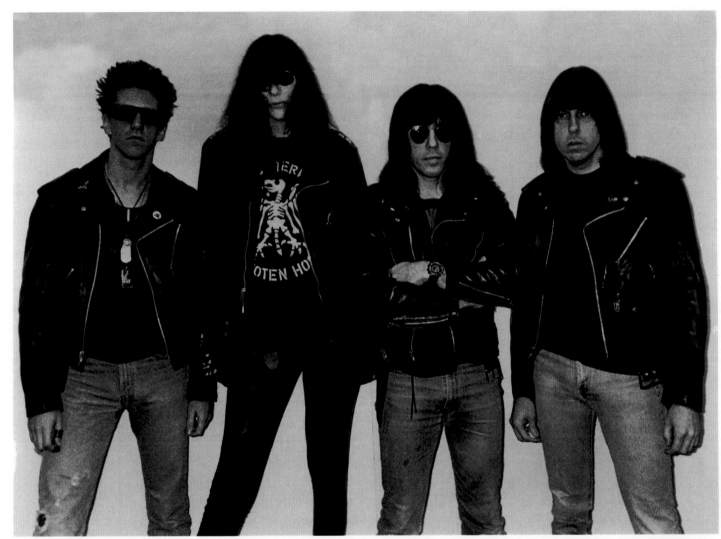

RAMONES

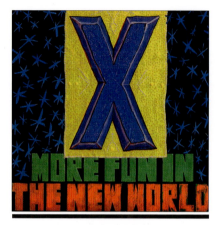

Billboard 200: *More Fun in the New World* (#86)

America's most celebrated independent band, X drew critical plaudits for the album *More Fun in the New World*.

CALLED THE best new rock band in America by *Newsweek* and *The New York Times*, X's career had been marked by outstanding press and equal commercial neglect—only the most adventurous radio stations played the group's songs.

"We have a basic sound, but we shift the emphasis between R&B or country or hard rock or whatever," bassist John Doe admitted. "But radio goes, 'Well, X is punk, so they must be loud, ugly and stick safety pins in their cheeks.' Well, I've never stuck a safety pin in any part of my body. If they played us on the radio, people might say, 'Hmm, maybe this new music is okay.'"

The only middle-American exposure X had gleaned was in the movie *The Decline of Western Civilization*. That documentary of Los Angeles-based punk groups showed X members fawning over their tattoos and playing to kids who were slam-dancing, considered the in-vogue footwork in punk circles—a cross between doing the Bunny Hop and playing middle linebacker in the NFL.

"The idea of punk rock is still a good one, and punk rock was a good term when it set musicians apart from the mainstream," Doe said. "But now the music has gotten diffused into a million splinter groups, and the term has lost its meaning. We'd like to consider ourselves a rock 'n' roll band in the truest sense of the word—we're fun to see, and we mean something more than background music."

More Fun in the New World marked the second X album released on a major label, Elektra Records, as the two previous albums were on the small independent Slash label. "It's given us the chance to play Sioux Falls, South Dakota," drummer D.J. Bonebreak noted sardonically. "And our records are in the stores now. No fans seem to have deserted us since we signed with a major label. Heck, the real hardcore fans deserted us when we signed with Slash."

X had begun to show some willingness to blend into the popular music mainstream. *More Fun in the New World* was produced by Doors keyboardist Ray Manzarek, who also helmed the Elektra debut and the Slash releases, and the band's burnished sound moved toward decided rockabilly influences. The anthemic "The New World" offered a broader view of the condition of the nation—"We're writing some songs Woody Guthrie style, if we may be so immodest," vocalist Exene Cervenka said.

The word "commercial" appeared in a few reviews, decrying the onset of a more marketable sonic salvo. "We have no idea if the records are going to sell—I mean, we thought *Los Angeles* (the band's first album) was commercial," Cervenka said. "I don't know what the American public likes, and I'm not very good at second guessing, so I don't try. We're very commercially successful by my standards. I've been making a living at this for more than three years, and for an artist or musician, that's really swell." ■

 EXENE CERVENKA JOHN DOE D.J. BONEBRAKE BILLY ZOOM

PHOTO CREDIT: KEN MARCUS/1983.

ON RECORD 1983 [JOAN JETT]

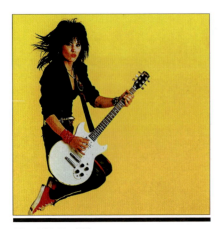

Billboard 200: *Album* (#20)
Billboard Hot 100: "Everyday People" (#37); "Fake Friends" (#35)

Recording *Album* with the Blackhearts, her backing group, **Joan Jett** applied her unfussy production formula.

POPULAR MUSIC had its share of "road animals," hard-rocking acts that thrived on the thrill of incessant touring. Joan Jett and her band, the Blackhearts, counted themselves among them, gearing their recordings for performances.

"I'm 'live' oriented," Jett, the ex-guitarist for the Runaways, explained. "I do enjoy making albums—with the technology now, the things you can do are unlimited. But we choose not to use it, or at least minimize the use of it. We try to stick with the basic things people discovered in the Fifties and Sixties, stuff like echo and reverb. We keep it simple—it only takes two or three takes to get a track, and if it takes more, we just go on to another song."

At 15, Jett had formed the Runaways and guided the all-girl group through four tumultuous years. "It was my dream to play in a rock band, and I was doing it," she said. "We didn't really pay attention to what was going on around us—we were just normal teenage girls who swore a little bit and smoked and drank now and again. But we had a jailbait image and got put down for it. We were fighting uphill, it seemed, so we decided to wrap it up. But the only thing I know is music—I had to get another band."

The feisty Jett bounced on to the Blackhearts. Her troubles weren't over—when no record company wanted to sign them, Jett formed her own label and put out *Bad Reputation*. That renegade album and nonstop touring created a groundswell, but the fan appeal and momentum was still not enough to break into the record industry until they were signed to a label with major distribution. For the next two and a half years, the Blackhearts toured incessantly, which resulted in several smash hits, including "I Love Rock 'N Roll" and "Crimson and Clover."

The years of hard work paid off when *Album* went gold immediately upon its release. While it failed to produce a big single, fans found the stripped-down sound of Jett's teen anthems endearing

"Ricky (Byrd) plays his lead guitar on the basic track, while most groups overdub that type of thing until they get it right. Heck, a lot of times Ricky doesn't know what he's gonna play until he shows up. And in a way, that's more creative—it's so spontaneous. We opt for a track with a few mistakes in it if the feel of it is right."

Jett and the Blackhearts got back out on the road. Playing the new songs mostly as an opening act on the arena-rock circuit, she was thrilled with the response. "When the show starts, everybody's in their seats," she enthused. "It's weird, because I've been to a lot of shows where people don't pay attention to anyone but the headliner. But people don't have that much money anymore, so if they can see us and a headliner in one show, that's not a bad deal at all." ■

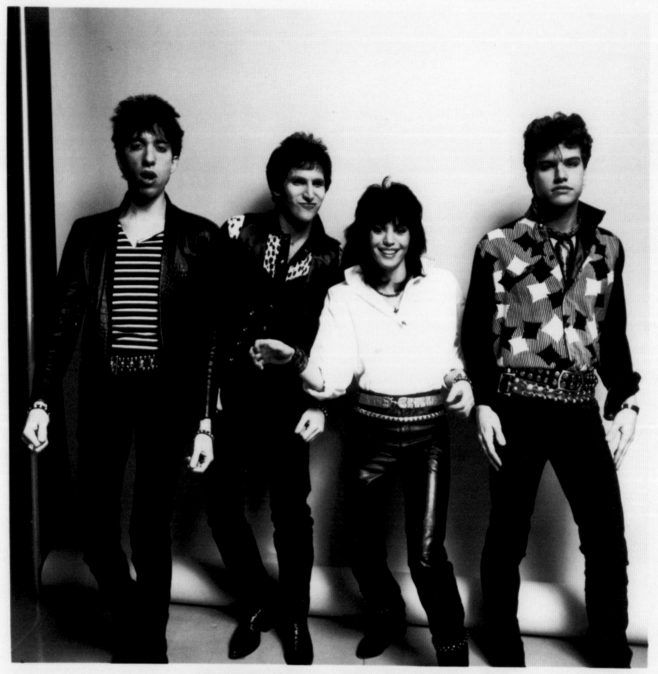

ON RECORD 1983 [LOVERBOY]

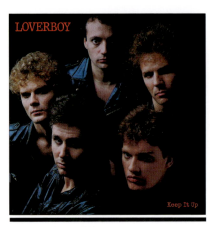

In support of the *Keep It Up* album, Vancouver's **Loverboy** announced a run of tour dates across North America.

Billboard 200: *Keep It Up* (#7)
Billboard Hot 100: "Hot Girls in Love" (#11);
"Queen of the Broken Hearts" (#34)

SINCE FIRST exploding on the scene, Loverboy had worked its way up the touring ladder on multiple band billings with Journey, ZZ Top, Foreigner and others. The roadwork in support of *Keep It Up*, the hard-rocking group's third album, represented its first opportunity as a headlining act.

"We've figured out what we want to do," bassist Scott Smith said. "I mean, we have carte blanche—we could come out with leather codpieces and Conan-style guitars and rely on special effects, but we'd rather say, 'We're five guys, here we are, we hope you're into it.'"

That attitude had infused Loverboy's slew of commercial rock radio staples—"The Kid Is Hot Tonight," "Turn Me Loose," "Working for the Weekend" and "When It's Over" established the Canadian band's hold on the charts. Upon the release of *Keep It Up*, the singles "Hot Girls in Love" and "Queen of the Broken Hearts" quickly went into rotation on radio and the fledgling MTV.

But the rest of the *Keep It Up* material featured subtle differences. "We did our last album in two weeks," Smith recalled. "This time we got rid of the self-imposed limitations on what we were supposed to be doing. We managed to pull off a ballad, which we hadn't done before. And lyrically, we tried to widen our spectrum of subjects. We've done a lot of traveling, and it's always an eye-opener to see Europe and Japan. In Germany, we saw the commitment to the nuclear issue."

Consequently, the political "Strike Zone" spilled out, an elaborate jam that alternated moody synthesizer riffs with Paul Dean's sizzling guitar work. The group's attempt at penning something other than "party music" tracks made things intriguing for the band members.

"There was a debate about direction," Smith admitted. "Some in the band said we should stick with what we do best—we'd be successful with the 'Hot Girls in Love' type of songs, so why change? But others, including myself, didn't look at expanding as if we were doing 'message music'—we're showing more of what we're thinking about."

"Strike Zone" became a fan favorite, and the result, Smith concluded, was better Loverboy performances. "Everything that's gone down has been filtered through the live show. There's room for lots of emotions in a concert. Mood changes are what make a two-hour headlining set interesting, not lasers." ■

LOVERBOY

Photo: Randee St. Nicholas

8308

ON RECORD | 1983 | [PAYOLAS]

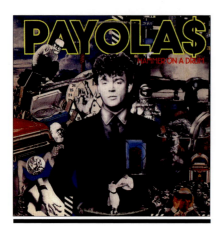

Hammer on a Drum, the third **Payolas** recording, grew the band's rep with bigwigs in the hard-rock community.

EVERY YOUNG band on the popular music scene hoped for a long career, and the Payolas were no different. "It depends on two things," singer Paul Hyde noted. "We have to tour to make ourselves visible. And we have to try and write better and better songs—give people their money's worth."

One such track was "Eyes of a Stranger," which broke the Vancouver-based group on indigenous radio playlists in 1982. It won a Juno Award—Canada's equivalent of a Grammy. "We were very surprised,' drummer Chris Taylor said. "It takes you from being within your cult following to being seen by millions of people sitting at home watching the awards on a Tuesday night. The next thing you know, you're recognized. It makes a big difference. It greases the gears and makes everything run smoother."

But the American market presented greater challenges. "Canada is comprised of about 25 million people," Taylor explained, "which is a small fraction of the US population. You can get across to that many people quicker. In the States, you have a lot of diversified people—it's a big country and it's harder to be heard."

There was enough diversity on *Hammer on a Drum,* the group's third album, to give further credence to Hyde's aspirations. The band once again recorded with producer Mick Ronson. "He did all of the string arrangements for (David) Bowie during the Ziggy Stardust days, plus he's worked with Bob Dylan and Ian Hunter," Hyde said. "We just had him on our list of prospective producers, and it turned out he was available. He fits in well—he's open to any suggestions whatsoever."

Hyde and Bob Rock merged their songwriting abilities, from the light-hearted "Christmas Is Coming" to "Never Said I Loved You," an immediate hit in Canada. "It's a harmless little story about the games that go on in bars every night," Hyde explained. The cut featured a duet between Hyde and singer Carol Pope of Rough Trade, another Canadian act. "We realized the song was perfect for a boy-girl vocal, and Rough Trade was in town at the time. The two groups aren't close musically, but it worked out great."

The group promoted "Where Is This Love," a long, produced piece about child abuse. "We've always tried to make our music fairly intelligent," Hyde mused. "I know that 'Where Is This Love' is not a pleasant subject, but I have a kid myself now, so I relate to it a little more closely. It's an intense song, and it lends itself to a visual treatment—it's nice to do a video that isn't all legs." ∎

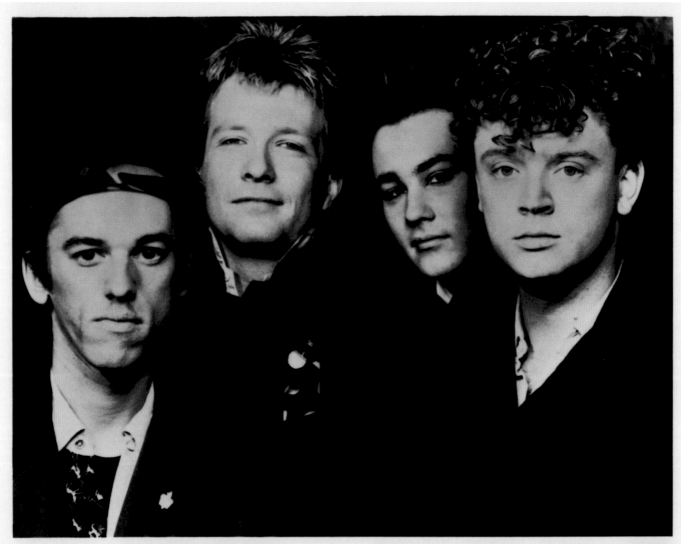
Chris Taylor Bob Rock Christopher Livingston Paul Hyde

PAYOLA$

Lifted by Tom Cochrane's insightful lyrics, the pertinent "Human Race" propelled the Canadian band **Red Rider**.

Billboard 200: *Neruda* (#66)

IN BUILDING up a solid catalogue to make inroads in the North American music scene, Canada's Red Rider had produced "Lunatic Fringe," a No. 1 mainstream-rock track in the US. The catchy warning to homegrown hate groups came courtesy of lead singer Tom Cochrane, who had taken the group's songwriting reins. "Throughout our music, there has always been an undercurrent of social consciousness," he said. "There is too much 'wham-bam-thank-you-ma'am' in rock 'n' roll already. Musicians shouldn't be afraid to take a stand."

For a third album, Red Rider returned to the studio for a year and emerged with *Neruda*, a loosely structured concept album that established Cochrane's reputation for dynamism and drive. *Neruda* became Red Rider's third straight platinum album in Canada, and "Human Race" picked up considerable FM radio airplay in the US. The song's theme recurred through the first side of the album.

"Neruda is a gypsy phrase meaning movement under duress, forceable expulsion," Cochrane explained. "They were always of a lower caste, they never had a home. It is also the adopted name of the Latin American poet, Pablo Neruda, whose work I happened to be reading. A lot of the imagery of the record is very reminiscent of Neruda—using the contrast of the sky and the sea, or nature against an urban backdrop. He always seemed to have one foot in the sky and one foot on the ground." ∎

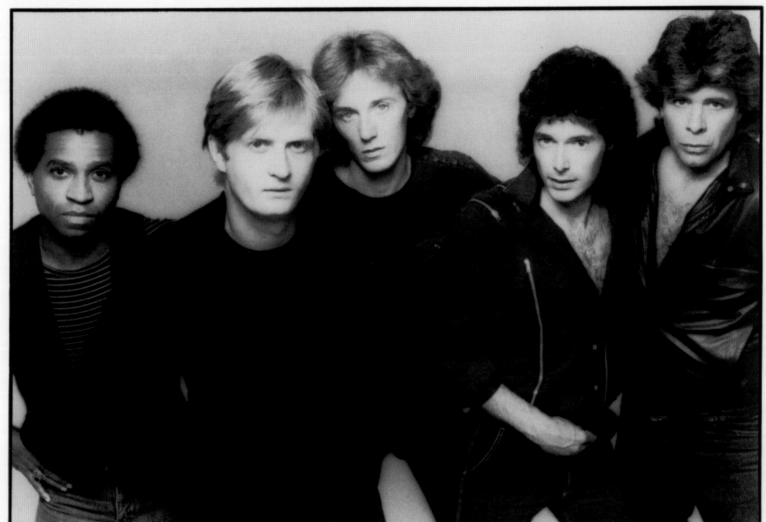

RED RIDER

ON RECORD 1983 [TRIUMPH]

Billboard 200: *Never Surrender* (#26)

The Canadian power trio **Triumph**'s "Rock & Roll Machine" continued to trundle along with *Never Surrender*.

FORMED IN Toronto in 1975, Triumph shined amidst the thriving Canadian hard-rock community. 1981's *Allied Forces* became the threesome's first US gold album, and *Never Surrender*, Triumph's fifth album released in America, achieved gold status in half the time, spawning the guitar-driven rock-radio anthems "All the Way," "A World of Fantasy" and the title track.

"Triumph's sound is kind of English progressive meets American blues rock 'n' roll," drummer Gil Moore said. "And it's even more direct now." Triumph's recording studio, the Metalworks, was a 48-track computerized MCI atelier.

"Time is no longer the keeper—time becomes an ally, an affordable luxury," bassist Mike Levine enthused. "The security comes through in the music—pre-production is better, therefore better written and arranged. The recording is better, as the technical requirements are more well-known. And the mixing is better, as the only pressure that exists is quality. The only concerns are positive, creative ones."

"As a musician, recording is the ultimate test, and the highest art form available," guitarist Rik Emmett added. "But the live show made us and sustains us." Triumph's onstage extravaganzas were already legendary. The "Never Surrender" tour drew the largest audiences of the band's career, including an appearance at the US '83 Festival, where more than a quarter of a million people attended. Moore, the resident effects expert, co-produced the show of hydraulic lighting trusses and lasers and pyrotechnics.

"We've always maintained that smaller is not better," Moore quipped. "Bare-bones production masquerading as some sort of music-stressing artistic choice seems like a cheap, lazy rip-off of the concertgoer. A rock 'n' roll musician who is a concert performer has a responsibility to present the music larger than life. So Triumph is going 'star wars,' and we wouldn't have it any other way." ■

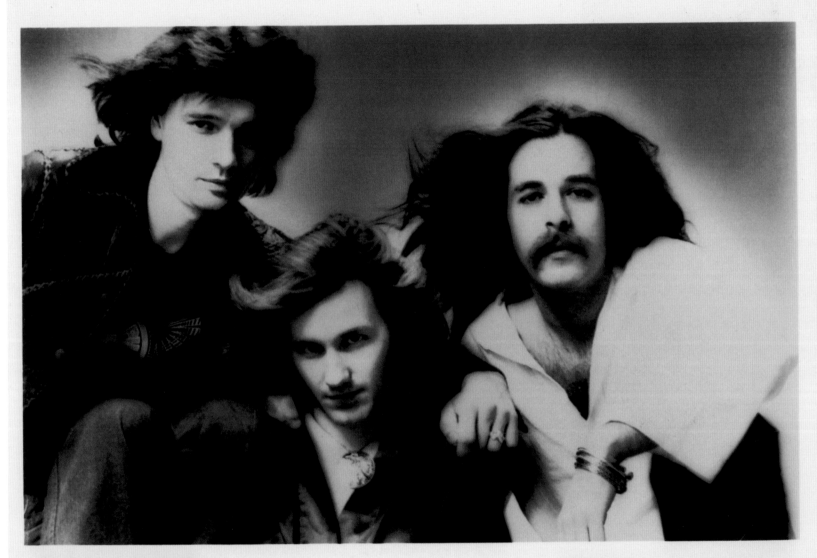

ON RECORD | 1983 | [DAVE EDMUNDS]

Billboard 200: *Information* (#51)
Billboard Hot 100: "Slipping Away" (#39)

Coming after 1970's "I Hear You Knocking," "Slipping Away" became Dave Edmunds' second US Top 40 hit.

THE ENGLISH band Rockpile, led by Dave Edmunds and Nick Lowe, seemed like a sure bet for Eighties stardom when the decade began. The duo's passion for traditional rock 'n' roll made the group a killer attraction on record and in concert. But tensions surfaced, and Rockpile disbanded. Lowe was already established as a producer (Elvis Costello) and as his own entity ("Cruel to Be Kind"), while Edmunds' lone smash came in the early Seventies with a revamped version of Smiley Lewis' "I Hear You Knocking."

But a few years in, Lowe had released a few competent records that didn't match his earlier works, and Edmunds—who had turned 40—sounded more inspired than ever. Part of the charm of *Information*, a collection of rootsy rockers, stemmed from Edmunds' collaboration with Jeff Lynne, the leader of Electric Light Orchestra. Edmunds had never met Lynne, but a simple phone call put the two together. "Jeff was in the middle of a new ELO album," Edmunds said. "But he took three days off, and we cut the tracks."

Edmunds had done some notable production work on his own, particularly "Rock This Town" with Stray Cats. On *Information*, he used Lynne as a producer on two songs, the title track and "Slipping Away." "I'd had this idea of using a producer for over a year," he explained. "The attraction was that I'd never used one in all my years making records, and I thought it might add an interesting twist. As it turned out, he'd never tried producing anyone, so it was a first for both of us."

Lynne pressed Edmunds to work with synthesizers and drum machines, resulting in the seamless sonics of "Slipping Away," Edmunds' first Top 40 single in a dozen years. The hit nestled him onto the airwaves between artists nearly half his age, and the video received ample airplay on the fledgling MTV network. ∎

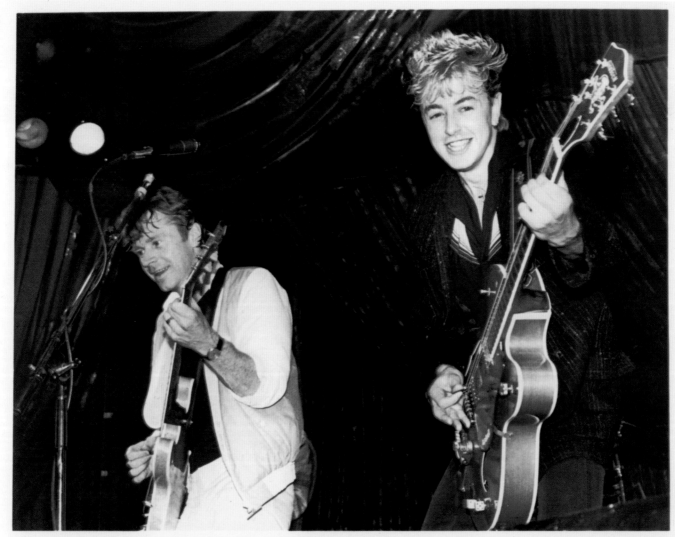

DAVE EDMUNDS (left) and BRIAN SETZER of the STRAY CATS (right) rock New York City's Roseland Ballroom with encore of Eddie Cochran's "C'mon Everybody" (May 18, 1983)

DAVE EDMUNDS

Building on Fleetwood Mac's success, the group's drummer steered a side project, Mick Fleetwood's Zoo.

SINCE THE late Sixties, Mick Fleetwood had provided Fleetwood Mac with a foundation in all its incarnations—not only the band's drummer but its mainstay. But Fleetwood also established an outside career. In 1981, he led a group of musicians, technicians and friends on a six-week excursion to Ghana to play and record *The Visitor* with some African counterparts—an expensive, lengthy and logistically complicated project.

After *Mirage*, a 1982 Fleetwood Mac album, he formed a new group billed as Mick Fleetwood's Zoo. *I'm Not Me*, mostly recorded at his house in Malibu, featured contributions from the core of guitarist/singer Billy Burnette (a solo artist in his own right), bassist/singer George Hawkins (who'd been featured on *The Visitor*) and guitarist/singer Steve Ross.

"I suppose my role is to nurture a situation, to represent something that's musically solid, an entity that people feel safe with," Fleetwood said. "Yes, this is a solo album—I consider it my project, in terms of pulling people together that I enjoy playing with. It's something I know I can do—I have the credentials. And it makes sense to put my name on the cover, because I'm the best known.

"The main thing is that we're all friends—we hang out together, we socialize, and that's the beginning of a bond. No, it's not Fleetwood Mac, and it hasn't got the years and the emotion behind it. But all these people are very close. It's not like phoning up the musicians union and bringing out someone who checks in and checks out."

Other prominent contributors included Fleetwood Mac members Christine McVie and Lindsey Buckingham. Buckingham popped up on the marvelous, canny "I Want You Back," a minor hit. Burnette sang the opening cover version, a delicate appreciation of the Beach Boys' "Angel Come Home."

"I've always liked Dennis Wilson's voice—he sings really emotionally," Fleetwood enthused (Wilson would die in a drowning accident that December). "He sang that song with the Beach Boys—I used to play it with him, hanging out in a garage. One night at home, Billy was there, and amongst a huge mound of disorganized cassettes, I found a cassette of that lovely, sweet song—it was sort of like radar. We started working on it, sped it up a bit and ended up rerecording it." ∎

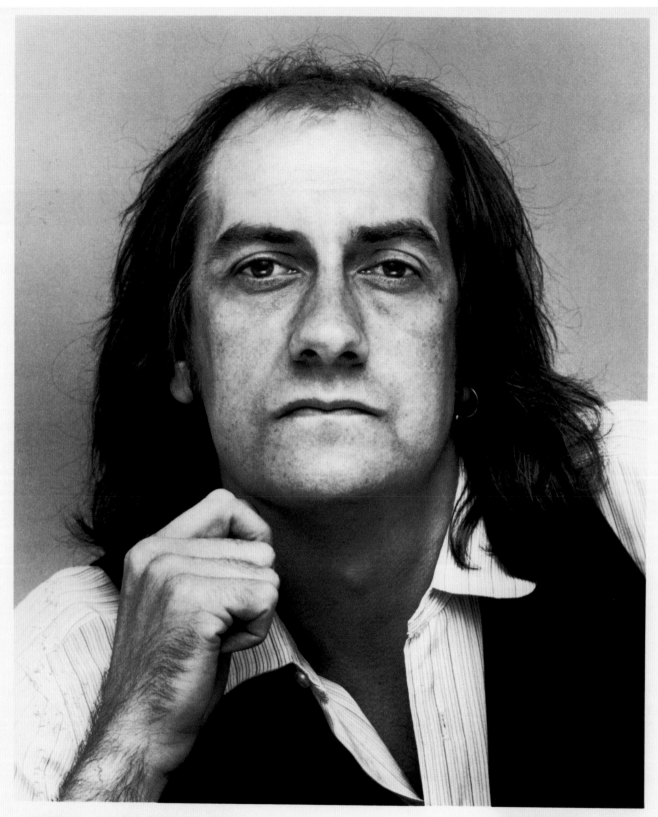

MICK FLEETWOOD

RCA Records and Cassettes

ON RECORD | 1983 | [JIM CAPALDI]

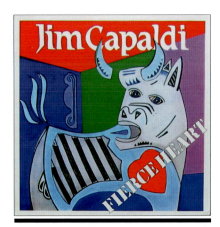

Billboard 200: *Fierce Heart* (#91)
Billboard Hot 100: "That's Love" (#28); "Living on the Edge" (#75)

A co-founder of the storied band Traffic, British musician **Jim Capaldi** tallied a charting single, "That's Love."

ENGLAND IN the late Fifties and early Sixties was a generative time and place for Jim Capaldi and other young Britons who started to hear American R&B and rock 'n' roll over loudspeakers at fairgrounds and on obscure, underground radio stations. The streams of music converged and changed the shape of sounds to come.

"Little Richard was really a big head-opener for me, living in the Midlands and never having heard Black music before," Capaldi recalled. "It's interesting, that moment of experiencing something for the first time—what happens to you is cataclysmic. When I first heard the blues, it was electric for me. Immediately, I was right there—I had no trouble identifying."

Capaldi's entire family was actively involved in music, and he founded his first band at age 14. Soon enough, the young drummer hooked up with guitarist Dave Mason, and their band developed a reputation strong enough to draw Steve Winwood, then 16, in to jam with them. Winwood, the lead vocalist for the Spencer Davis Group, one of the finest British R&B groups, was planning his future moves. He forged ahead with Capaldi, Mason and another Midlands musician, Chris Wood, and Capaldi gave the band its name—Traffic.

Capaldi and Winwood found that they collaborated well, and much of that group's material—hits like "Paper Sun" and "40,000 Headmen"—was written by the pair. By the time Traffic's nine-year career was over, the drummer/singer-songwriter Capaldi already had released two solo works. He then produced a series of singles and albums.

Fierce Heart renewed an old friendship—the album was co-produced by Winwood, who also provided a little guitar, keyboards and vocal work. "That's Love," which reached the Top 30 in the US singles chart, drew inspiration from Capaldi's new second home, Brazil. "Living on the Edge" conveyed Winwood's savvy with synthesizers.

"The basic idea was written while touring in Germany, and the lyric was inspired by the nagual Don Juan," Capaldi said. "But the song later developed with Steve—he contributed the fine chorus riff and all synth arrangements. Lots of people talk about Traffic and say what a special thing we had. We both have a desire and appreciation for a wide range of music." ■

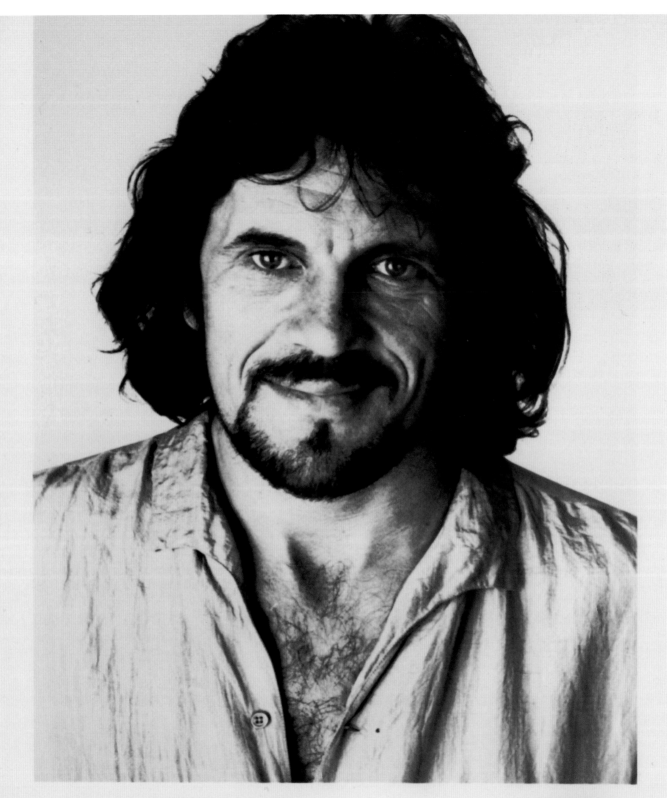

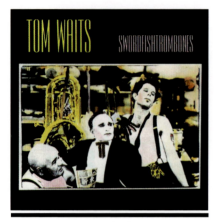

Billboard 200: *Swordfishtrombones* (#167)

Accolades were heaped on **Tom Waits'** *Swordfishtrombones* album for its textural range and inventive methods.

A BOOZY, bluesy stream-of-consciousness poet, Tom Waits started growing his reputation and following in 1973, when people first took notice of his fine storytelling. He took to the stage with a cocked hat, pointy Italian shoes, a skid row suit and a growl. He sang sentimentally, played piano with delicacy, and seemed to speak jive just as well.

Many of Waits' songs seemed naturally suited for the screen, and Francis Ford Coppola asked him to write the soundtrack for *One from the Heart* in 1980. Waits received an Academy Award nomination for his score, and movie work had since been something of a sideline. His endeavor in films spurred him to new creative directions—the self-produced *Swordfishtrombones* album was as much sculpted as recorded.

"I tried to listen to the noise in my head and invent some junkyard orchestral deviation—a mutant apparatus to drive this noise into a 'wreck collection,'" Waits said. "Each song was ladled from a dark reservoir and handled separately, like a scene in a film, and then sewed to the sleeve of the next song."

Thematically, the wayward Waits put together what he termed a "demented journal" from an "odyssey of exotic design." The record featured an array of instruments from calliopes to Balinese metal aunglongs (squeeze drums), plus a glass harmonica and clanging pipes. The songs were treks through chaos, pathos and absurdity, from dark portraits of sailors on leisure time ("Shore Leave") to dry burgs in the Australian outback ("Town with No Cheer").

"Rhythmically, in the choice of instruments and in the choice of room mikes, I tried to recreate that sense of raw, dramatic adventure—to give the album an open-air sound," Waits said. "Instruments such as the tuba, trombone, marimba, banjo and harmonium avoid bringing the music inside or indoors like a piano, bass, drums, sax and guitar can do."

Darting down artistic alleys, *Swordfishtrombones* marked a stylistic departure from all of Waits' preceding work. "A swordfishtrombone is either a musical instrument that smells bad, or a fish that makes a lot of noise," he allowed. "Kind of a mutant little item there." ■

TOM WAITS

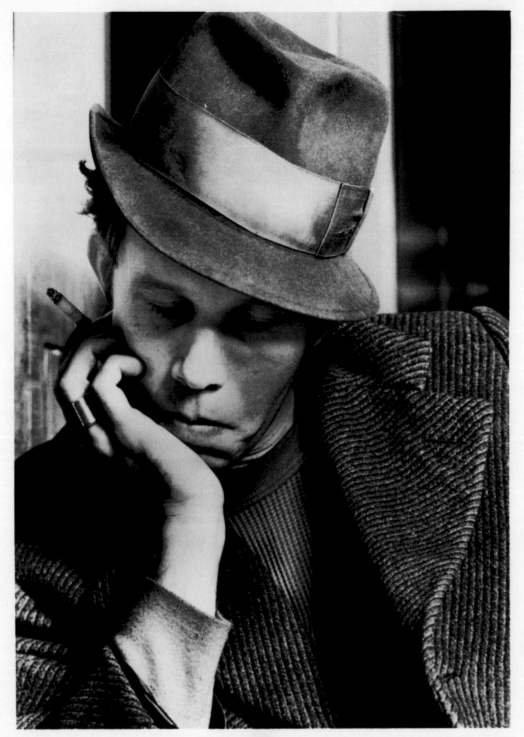

Photo Credit: Colm Henry

Distributed by ATCO Records

Billboard 200: *The Man from Utopia* (#153)

Defending free expression, **Frank Zappa** released an orchestral album and the rock-slanted *The Man from Utopia*.

ROCK'S MOST dedicated iconoclast, Frank Zappa had never gotten along with the corporate minds of the music industry. The former Mothers of Invention leader still had a 7-year-old suit pending with Warner Bros. Records, and he sued CBS Records (his last distributor) after an audit.

"When a company treats me unfairly, I sue them, whereas many artists don't," he explained. "The general practices in the record business are so—I wouldn't say totally criminal, but they're looking in that direction. And because I will fight for my rights, they would rather sign a group with blue hair that knows nothing about nothing and won't give them any trouble, rather than signing me."

The Man from Utopia was released on Zappa's own Barking Pumpkin Records. His basic approach was unchanged—a framework of contexts for his complex guitar solos, intricate time changes (absolutely no 4/4) and the usual "raw, unbridled buffoonery," to quote Zappa himself, of his lyrics. The opening track, the antidrug "Cocaine Decisions," scorned doctors, lawyers and rich executives.

Zappa seemed intent on surviving. "It's difficult for me to get product released, and it's one of the reasons why I'm trying to build up the mail-order business we have," he admitted. "I know there are people who want to hear my records." With the release of another project, *London Symphony Orchestra, Vol. 1*—a recording of his instrumental compositions performed by the LSO—Zappa was having a fling with the classical music world. But he wasn't having the best time.

"I want to do quite a bit of it, but the more I get into the serious music world, the less I like it, because the people are so incredibly pathetic and phony," he mused. "Not the musicians, but the people behind the concerts, the committees who put these things on. These people don't give a fuck about music or art or anything like that. They'll put on an event just so they can have a little party after the show with the white wine, so they can stand around and act like they're hot shit. Their whole life is geared toward that."

But Zappa wasn't entirely giving up. "The fact of the matter is, what I do is just as good if not better than what anybody else is doing," he said. "Musically, there's nothing to upset (symphony patrons). The only thing that might disgruntle them is sitting next to somebody they would never see in a classical audience, guys yelling for 'Whipping Post.' But they just like to be talked to. If conductors would speak to the audience more, it would make a more human event out of those stuffy, fake concerts." ■

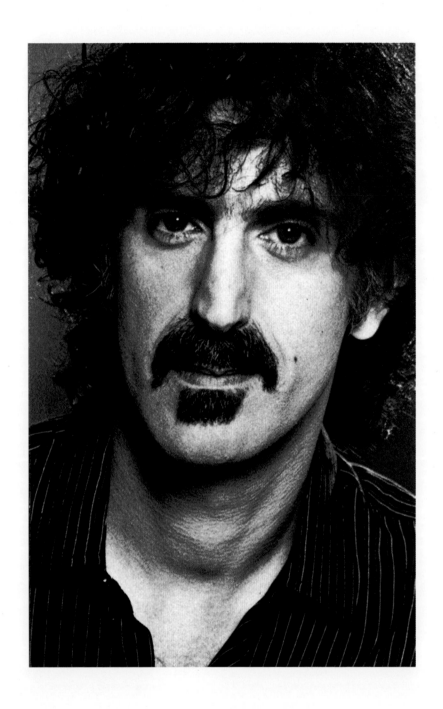

Joe "King" Carrasco found himself at the forefront of the dance-rock movement with his *Party Weekend* album.

PLAYING WILD party music, Joe "King" Carrasco was doing for Tex-Mex what George Thorogood had done for blues in the last few years—driving audiences nuts with his out-of-control performances. "Tex-Mex is that Sam the Sham dance rhythm (the Farfisa organ sound of 'Wooly Bully' in the Sixties), and that's what I want to get to in a song," Carrasco said. "I like it when the audience participates, when there's a frenetic atmosphere out there."

Carrasco and his band, the Crowns, could make people slam-dance and polka simultaneously, creating the "party weekend" frenzy even on a Tuesday night. Lots of rock's excitable boys got revved up in front of an audience, but Carrasco went one step further by wearing capes to preserve his "King" status. The Texan guitarist had no qualms about instigating berserk activity—a common vision at his shows was a headlong leap into the crowd. He thought it might be a case of arrested development.

"I first started playing dances when I was 13," he recalled. "They said, 'Joe, don't move around too much or they'll think you're drunk or something.' But I had seen Jerry Lee Lewis and Little Richard and Chuck Berry, and those guys always moved around. Rock 'n' roll is supposed to be exciting, and that's one way of doing it."

Carrasco and the Crowns were one of rock's most original live acts, and *Party Weekend* represented their best recording yet. Whereas concessions to new music trends had plagued earlier albums, Carrasco credited producer Richard Gottehrer (producer of the Go-Go's and early Blondie, composer of oldies "I Want Candy" and "My Boyfriend's Back") for letting the ethnic hooks shine through.

Carrasco had conquered the chic New York club scene, the Texas honky-tonk circuit and half of the European continent. Ironically, his biggest market was Scandinavia, where a fondness for regionalism in music had made the Texan a star. "They must like the hot temperature rising up off the records," he laughed. "They play one and then put it at the bottom of the bed at night. I tend to take our style for granted, but I'm sure a lot of people who've never heard of me before can't figure me out. Maybe they can with this record."

America was still catching up to Carrasco, since rock radio couldn't see fit to play his music. Compounding his commercial woes, his record label had undergone a corporate shakeup, and *Party Weekend* got lost in the transition. "I'm doing my job—playing and making records," he said. "So when I come to town, get your tennis shoes and Band-Aids on. I usually get go-go dancers in San Diego and Los Angeles, but I want them everywhere. Any potential prospects should come to sound check with qualifications." ■

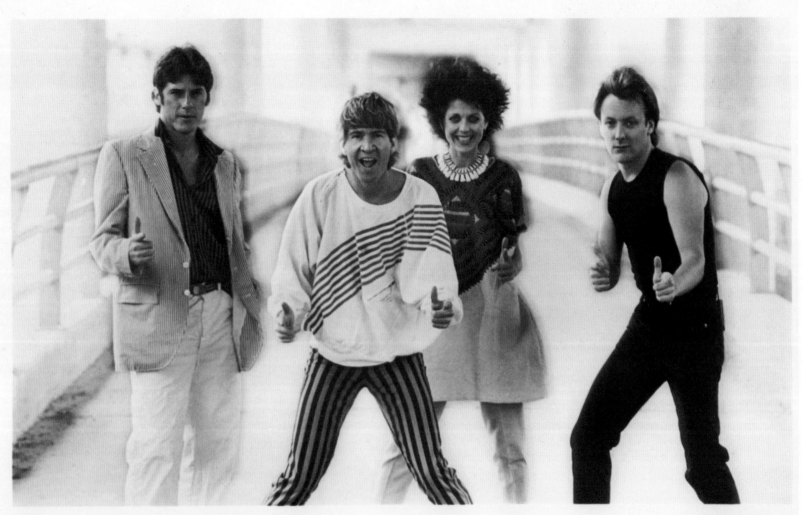

Billboard 200: *Future Shock* (#43)
Billboard Hot 100: "Rockit" (#71)

The electro-funk hit "Rockit" set renowned jazz giant **Herbie Hancock** on an upward trajectory to the club scene.

FROM YOUTHFUL sideman to mature bandleader, Herbie Hancock's long career had touched upon sounds from tough funk to elegant solo piano. The noted keyboardist and composer's peerless V.S.O.P Quintet, featuring Wayne Shorter and Freddie Hubbard, transformed acoustic jazz. His Headhunters band revolutionized Seventies fusion, landing on the pop charts with the single "Chameleon."

And with his daring *Future Shock* album, Hancock altered the street music of Eighties America. His newest collaborators, the New York City-based Material—avant-garde electric bassist Bill Laswell and synthesizer player Michael Beinhorn—were inventive in their use of mechanical noise and flesh-and-blood funk.

The Grammy Award-winning track "Rockit," Hancock's first 12-inch dance single, shot to Top 10 positions on pop, R&B, jazz and dance music charts, propelled by throbbing sequencer patterns, electronic claps and New York turntable wizard Grand Mixer D.ST's scratching technique. Hancock, who had double-majored in music and electrical engineering at Grinnell College, laid down the synthesizer lines with the more than $500,000 worth of computer equipment he owned.

"Underground New York street music was starting to emerge, and I caught the crest of the wave just right," Hancock explained. "My record opened up the general public and filled a slot that wasn't filled by anyone else. Another reason for the success of 'Rockit' is that urban contemporary stations were definitely not playing this kind of record—instrumental music is something considered taboo. But when Frankie Crocker at WBLS jumped on it, everybody else followed suit."

The innovative "Rockit" video was directed and produced by Kevin Godley and Lol Crème, formerly of 10cc. The team utilized nude and headless plastic robots who danced to the jerky rhythms of Hancock's electronic synth-funk in an unlikely and banal suburban home setting. "It's one of the most exciting videos on MTV, whose programmers were being railed for refusing to play videos by Black artists," Hancock pointed out.

Future Shock's other collaborative compositions included "Autodrive" and an interpretation of Curtis Mayfield's title song, both marked by the absence of lengthy solos and the team structure.

"Even though I call *Future Shock* an 'electric record,' there's an improvisatory character that we associate with all the great jazz of the last three or four decades," Hancock said. "Even the way the songs were recorded—pieced together like a series of puzzles—created a kind of improvisation of writing and structure. So even if the album isn't what many people would call a jazz record, I believe the music on it has the *feeling* of jazz." ■

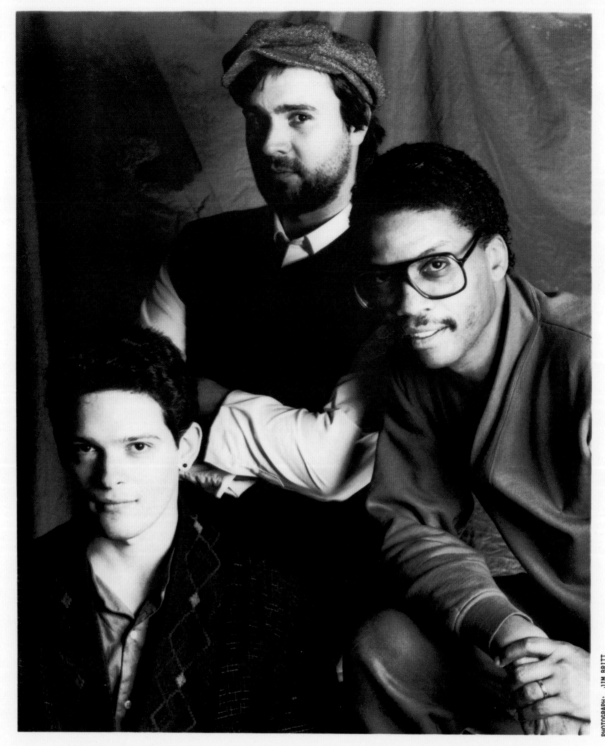

From left Material's Michael Beinhorn and Bill Laswell, Herbie Hancock

Adams Dad Management Company

HERBIE HANCOCK

827 Folsom Street San Francisco, California, 94107
(415) 777-2930

ON RECORD | 1983 | [WYNTON MARSALIS]

In the making of *Think of One*, young trumpeter **Wynton Marsalis** had already set precedents in the jazz world.

Billboard 200: *Think of One* (#102)

BORN IN New Orleans, trumpeter Wynton Marsalis studied classical music at school and jazz at home with his father Ellis, a respected pianist, composer and educator. "When I was 12, I started practicing seriously and studying the instrument," Marsalis recalled. "By 13, I had improved 200 percent.

"I decided to enter the solo competition in school. Every year, the three winners performed youth concerts with the New Orleans Philharmonic. Nobody believed I had a chance—'Who wants to hear a trumpet player play a concerto?' A teacher told me that only string players, pianists and flutists win solo competitions in classical music. Anyway, at 14 I played the Haydn Trumpet Concerto with them, and at 16 the Brandenberg Concerto No. 1 in F Major."

Throughout high school, Marsalis played first trumpet in the New Orleans Civic Orchestra, and he enrolled at Juilliard, intending to pursue a career in classical music. But the summer after his freshman year, he toured as a member of Art Blakey's Jazz Messengers and turned to jazz. He soon went on the road with the Herbie Hancock Quartet, and their performances cemented Marsalis' reputation. He recorded his first album as a leader, and recognition came from many directions.

Marsalis released simultaneous jazz and classical albums in the same week. On *Think of One,* he was joined by members of his quintet—brother Branford Marsalis on soprano and tenor saxophones, pianist Kenny Kirkland, drummer Jeff Watts and bassist Ray Drummond. The other side of Marsalis was represented on *Haydn/Hummel/L. Mozart Trumpet Concertos*, recorded at Abbey Road Studios in London with Raymond Leppard conducting the National Philharmonic Orchestra.

"I studied classical music because so many Black musicians were scared of this big monster on the other side of the mountain," he said. "After you sit up there and play all those scores, you find out that classical musicians are just like all other musicians—most of them are mediocre and a handful are excellent. You learn the composers' tricks, the ideas they use over and over, and the difference between an inspired piece of writing and just some notes that are there to get you from one place to the next.

"It's harder to be a good jazz musician at an early age than a classical one. But because I've played with orchestras, some people think I'm a classical musician who plays jazz. They have it backwards—I'm a jazz musician who can play classical music."

Think of One peaked at No. 1 on the jazz album charts and won a Grammy Award for Best Jazz Instrumental Performance, Soloist. Marsalis was committed to being a standard-bearer as well as an artist. "When you see me on the bandstand, I'm always going to look sharp," he stated. "How can you get respect from an audience when you come on the bandstand looking like a bum? You're in the wrong before you play a note." ∎

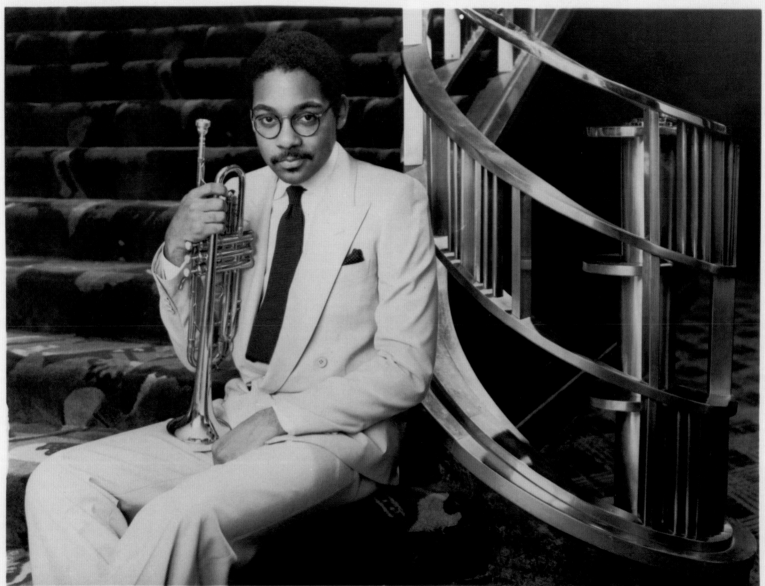

WYNTON MARSALIS

ON RECORD | 1983 | [GEORGE BENSON]

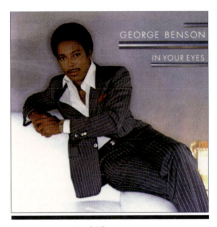

Billboard 200: *In Your Eyes* (#27)
Billboard Hot 100: "Inside Love (So Personal)" (#43);
"Lady Love Me (One More Time)" (#30)

Honoring his religion and home life, George Benson recorded another pop hit, "Lady Love Me (One More Time)."

JAZZ GUITAR great George Benson was well-versed on the twists and turns a musician's career could take. In 1976, "This Masquerade" suddenly transformed him into a singing star. But the newest factor in his craft was one that most of his followers knew little about. Benson was baptized as a Jehovah's Witness in 1979, and the tenets of his religion wouldn't allow him to sing the suggestive songs that were the staple of contemporary radio.

On 1980's *Give Me the Night*, Benson worked with producer Quincy Jones, and the two tangled over what Benson diplomatically termed "bedroom-type stuff." Even though *Give Me the Night* sold more than 2 million copies, Benson and Jones hadn't worked together since. At that point, Benson tried his hand at producing his own album. However, Warner Bros. Records didn't approve of the final product.

"They decided to go with a 'best of' collection rather than my album, because they didn't think mine had enough sex appeal—at least, that's how I construed their reaction," Benson graciously observed. "They just didn't believe in it." Jay Graydon wound up producing two new singles for inclusion on the 1981 greatest hits package, "Turn Your Love Around" and "Never Give Up on a Good Thing."

For the album *In Your Eyes*, Benson turned to ace producer Arif Mardin, who had worked with hundreds of hit artists. "I know my beliefs make things difficult for producers, but I can't change what I believe," the soft-spoken musician continued. "I had worked with Arif before on a film score and on a Chaka Khan album. It was only a matter of time before we worked together. He's a hard-working man, loves what he's doing and has a tremendous respect for R&B music. But I still have my own vision for my music, and there are certain types of songs that I simply won't perform."

Benson's attitudes had affected more than just his recording activities. He also had limited his touring schedule to downplay his exposure to the excesses that were often a part of pop music tours. "I do about six weeks in the US every year," he noted. "That's not much compared to other artists, but I just don't like the effect that all that stuff eventually has on you. I'd rather concentrate on a quality presentation when I do choose to perform."

To that end, Benson utilized a local symphony orchestra whenever possible. He was still enamored with the music business despite the conflicts his religion had brought about. "Oh, I'm just frustrated, but I always have something cooking," he chuckled. "I'm full of surprises." ∎

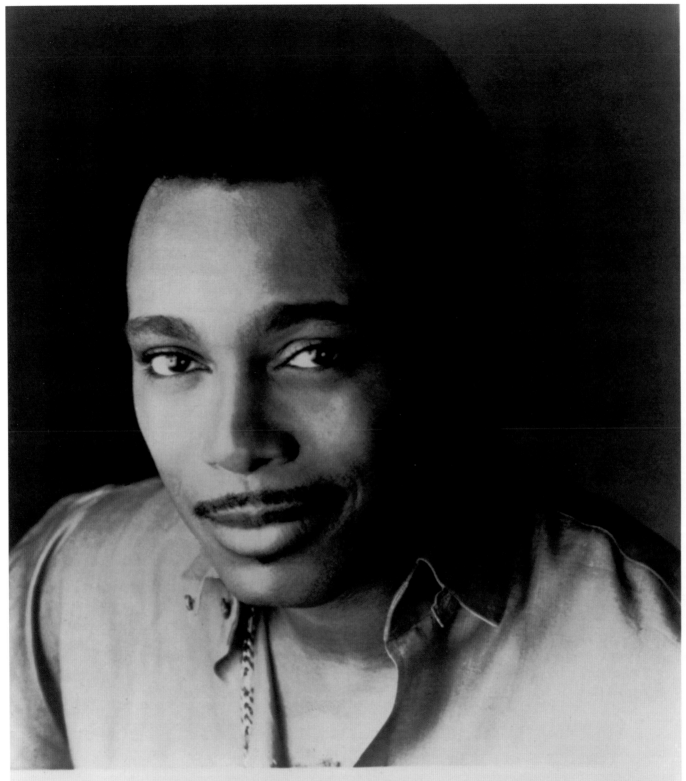

GEORGE BENSON

WARNER BROS.

Billboard 200: *Procession* (#96)

Weather Report remained at the vanguard of innovative bands on the jazz scene, forging the *Procession* album.

WHILE PLAYING in Maynard Ferguson's band, keyboardist Josef Zawinul and saxophonist Wayne Shorter developed a friendship. In the late Sixties, when both were contributing substantially to such Miles Davis albums as *Bitches Brew*, they resolved to work in a conceptually free direction that became Weather Report in 1971.

Since its inception, Weather Report had garnered every honor and award offered, a consistent winner in polls conducted by jazz publications and recognition given by the Grammys and industry trades. Individual members had additional special attention bestowed on them. The list of previous Weather Reporters included bassists Jaco Pastorius, Miroslav Vitous and Alfonso Johnson; drummers Ndugu, Peter Erskine, Alphonse Mouzon and Chester Thompson; and percussionists Airto and Alex Acuna.

Procession perpetuated the band's tradition of not duplicating the work of previous incarnations. Zawinul and Shorter recruited three young musicians—drummer Omar Hakim, bassist Victor Bailey and percussionist Jose Rossy. "Every knowledgeable person in New York jazz circles was talking about Omar, who'd played with David Sanborn, Roy Ayers and George Benson," Shorter said. "We were really looking for a bass player, but Omar ended up selecting who else he wanted to play with."

Hakim designated Bailey, who had recorded with Larry Coryell and Tom Browne, and Rossy, who had extensive studio work in New York to his credit. The new Weather Report went straight on tour, developing the music that was later recorded for *Procession*. "We trusted Hakim to bring the right musicians—we didn't know anybody who could go out on the road with us," Zawinul said. "We signed all three of them before we ever met them. We would have really been in trouble if they couldn't play."

"Where the Moon Goes" was Weather Report's first-ever track to include lyrics throughout, an electronically processed vocal part sung by members of the Manhattan Transfer, the vocal group that had recorded a Grammy-winning version of Weather Report's "Birdland" in 1980. "I looked at the vocal part as just another instrument," Zawinul said.

The album showed Weather Report making a return to the "world music" approach to rhythmic influences and textures it had pioneered in the mid-Seventies. "The band isn't as flamboyant as the one we had before, but they interpret the compositions correctly," Zawinul stated. "It's developed into something else." ■

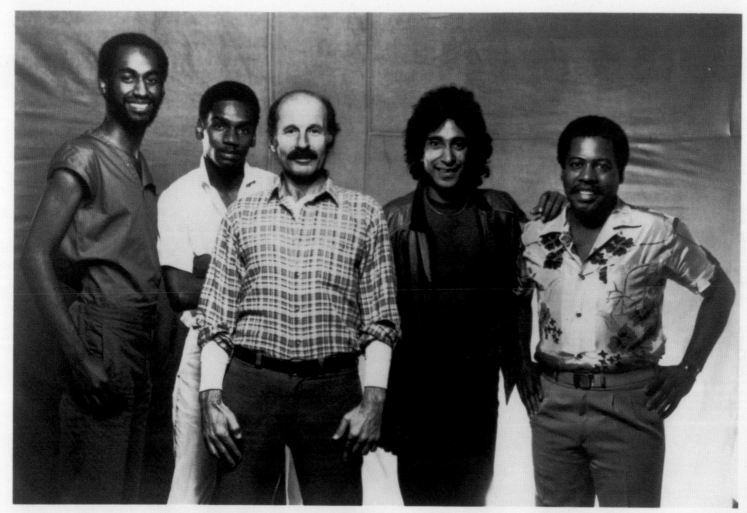

CORVALAN-CONDLIFFE MANAGEMENT **WEATHER REPORT**

Photo: Bruce W. Talamon

With modern harmonies and inspired arrangements, Rare Silk emerged as a Grammy-nominated jazz vocal group.

WHEN THEY first met in Boulder, Colorado, in 1978 to sing background vocals on commercials, Marguerite Juenemann and sisters Gaile and Marylynn Gillaspie had no idea a recording contract would eventually be in the cards. Quickly discovering a mutual affinity for revisiting tunes from the swing era of the late Thirties and early Forties, they called themselves Rare Silk, performed locally and created a regular public access show at the 1978 inception of KGNU, a community radio station for Boulder.

The threesome got their break when they opened a show for an important fan—Benny Goodman. "The King of Swing" fell in love with Rare Silk's precisely harmonized material and asked the act to go on his 1980 world tour, a gig that lasted ten months. The women debuted with the clarinetist at the Boston Globe Jazz Festival, which was live broadcast on PBS, and performed at Carnegie Hall, the Playboy Jazz Festival at the Hollywood Bowl and the Aurex Jazz Festival in Japan.

"It was the most exciting thing that could have happened for us," Gaile Gillaspie recalled. "Not only was it steady work, but we got to travel and play the best concert halls in the world. And Benny is such a virtuoso—he taught us so much, treated us right." But Goodman wanted the trio to sing standards, and Rare Silk was restless.

"We needed a spark," Juenemann admitted. "Here we were coming off a worldwide tour, and we were going to go back to the same old thing. We were determined to break out of swing and get into more mainstream jazz." Joined by male vocalist Todd Buffa, the innovative ensemble began modernizing its approach. The echoes of the past were gone—programs now came from stylistic versions of Keith Jarrett and Chick Corea songs.

"We didn't sound like any other four-part harmony group," Marylynn Gillaspie said. "Manhattan Transfer, the other leading vocal jazz group, had the standard two men, two women lineup, and they stacked their voices in typical intervals. But we didn't come from tradition—Todd had his own way of putting harmonies together. He and Marguerite were trained, and Gaile and I had a street sense—we couldn't even read music. But that was the magic."

Rare Silk's sound was soon heard by a PolyGram A&R exec. The group recorded a debut album with illustrious session players such as Michael and Randy Brecker backing them up. *New Weave* made its way to #2 on the trade publication *Radio & Records*' jazz album chart, where it stayed for many weeks. It contained a notable version of "Red Clay," and Buffa was nominated for the Arrangement – Two or More Voices category at the 1984 Grammy Awards, where *New Weave* also received a nomination for Best Jazz Vocal – Duo or Group category. ■

Management:

OUT WEST MANAGEMENT
2888 BLUFF ST.
SUITE 115
BOULDER, CO 80301

Rare Silk

UNITED ENTERTAINMENT COMPLEX, LTD.
527 Madison Avenue, Suite 1410
New York, NY 10022
(212) 753-7000

POLYGRAM RECORDS, INC.
810 Seventh Avenue, New York, N.Y

ON RECORD | 1983 | [CLARENCE CLEMONS]

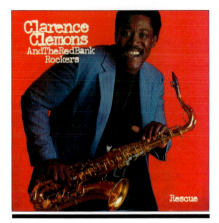

Billboard 200: *Rescue* (#174)

Outside of Bruce Springsteen's E Street Band, Clarence Clemons played with his own group, the Red Bank Rockers.

THE MEMBERS of Bruce Springsteen's talented E Street Band traditionally had remained on call while Springsteen labored over his songs to create an album every three or so years. But after providing memorable solos on 1981's *The River,* saxophonist Clarence Clemons found other projects to fill his time.

Clemons had long been Springsteen's most visible foil, both onstage and on record. On the cover of the classic *Born to Run* album, Springsteen leaned on Clemons' broad shoulders, and "the Boss" devoted a part of every concert to telling the story of how he and Clemons met, when Clemons checked out Springsteen at a club in Asbury Park, New Jersey circa 1971.

"The way he tells it, it was a cold night on the boardwalk, windy, raining like crazy," Clemons related. "And when I opened the door, the wind just blew it right off the hinges and down the street—it was like, 'Here I am! I came to play!' And Bruce couldn't say no. When we jammed, it was like we'd been together forever, like a team."

Clemons was called "the Big Man," and the nickname fit. The ex-football player remained a rock of a man at 42, and his heart was equally immense. When he talked about his most recent accomplishments, he was proud in a humble way that reflected his hard work over the past two decades.

"What started everything coming together was when I got married—it was the greatest thing that ever happened to me," he related. "I met my wife Christina in Stockholm in 1975 when I went there with Bruce. I told her I'd be back. Only one letter transpired between us all those years until I rekindled our relationship in the summer of 1981. I asked her to marry me and she said 'Yes.'"

That bit of happiness was parlayed into a new level of expression, Clemons noted. "I went out and bought a club—Big Man's West in Red Bank, New Jersey. I closed it recently, though—it's a real financial drain, and it takes too much out of you when you can't be there. I'm a rocker—too nice of a guy to run a bar!"

But one thing Clemons got out of the deal was acting as musical leader for the Red Bank Rockers, who released their first album, *Rescue*—"They were the house band, the perfect example of having a dream and sticking with it until it works," Clemons explained. Singer John "J.T." Bowen, a longtime friend of Clemons, was working as a bouncer at the club until the Rockers gave him a vehicle for his authoritative vocals. "It's fate," Clemons insisted. "Johnny and I had a dream 22 years ago of doing this. When I put together the band and needed a vocalist, there he was."

But as Springsteen worked on the album that would become *Born in the U.S.A.*, Clemons wasn't straying far. "There will be a Bruce tour sometime next year. When it happens, I will be with him." ■

CLARENCE CLEMONS

ON RECORD — 1983 — [PATRICK SIMMONS]

Billboard 200: *Arcade* (#52)
Billboard Hot 100: "So Wrong" (#30); "Don't Make Me Do It" (#75)

The only consistent member of the Doobie Brothers throughout their tenure, Patrick Simmons supplied *Arcade*.

OF THE four musicians who started the Doobie Brothers in San Jose in 1970, only Patrick Simmons was still around when they played their last gig 12 years later. Although most of the Doobies' hits were written by Tom Johnston and later Michael McDonald, Simmons gave the band its first gold single, "Black Water," and his compositions—"South City Midnight Lady," "Neal's Fandango" and "Echoes of Love" among them—brought range to every Doobies release.

"I always enjoyed making records with the Doobies," Simmons said. "Any capacity in which I could contribute to that was so exciting. Let's face it—most musicians never get the opportunity to step inside a recording studio, and if they do, it's usually because they paid for it themselves. Working on music or any art form is satisfying whether you get paid for it or not—so when you do get paid to do it, what a compliment to your life."

On his solo debut, *Arcade*, Simmons shared songwriting credit on half the tracks with Chris Thompson, late of Night and a veteran of Manfred Mann's Earth Band. They met when Night toured with the Doobie Brothers. "I used to run to keep in shape on the road, and Chris was a runner, too. We talked about doing some songwriting. It's not like something a publicist dreamed up—that wouldn't be very natural."

The track "So Wrong" emerged as a Top 40 hit and was also a surprise entry on the dance/disco charts. *Arcade* included contributions from many associates, including the Tower of Power horn section. A host of ex-Doobies helped out, too—Johnston sang on "Don't Make Me Do It," written by Huey Lewis & the News.

But Simmons devoted most of his post-Doobies time to working on his farm in the Santa Cruz mountains, riding an assortment of vintage motorcycles and managing plants and animals. With the Doobies, the guitarist/vocalist had endured through several changes of personnel and musical direction, nine studio albums and tour after grueling tour.

"I'll always be a musician first, because that's what I've chosen to do," he observed. "Rock 'n' roll is the bizarre edge in my life. I keep healthy, I work hard and I don't have a lot of other people handling things for me." Making *Arcade*, he said, was "frightening, exciting, humbling and challenging. But going for it—just having the opportunity and doing it for the pure enjoyment—is what it's all about." ∎

PATRICK SIMMONS

PHOTO CREDIT: MICHELE BENSON/1983

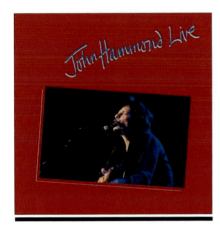

Veteran acoustic blues artist **John Hammond** celebrated his 20 years of performing with *John Hammond Live*.

THE BLUES proved to be more than a passing musical fancy for John Hammond. He was the son of John Hammond Sr., the famed record producer and talent scout who'd played a key role in either or both the discovery and development of the careers of Billie Holiday, Bob Dylan, Bruce Springsteen, Stevie Ray Vaughan and many others. The younger Hammond was raised by his mother after his parents divorced when he was six; while father and son shared a passion for music, his father actually discouraged him from the business.

But in 1958, at the age of 15, Hammond fils heard a recording by Robert Johnson, the legendary blues singer of the Thirties. From that moment on, Hammond had no doubts—he knew that he had a personal bond with the blues. "My fantasy instantly became to be a blues player," he recalled. "I had been a fan of other blues records, but in hearing Robert's music, something emerged in me and built up until it just had to come out."

Since embarking on his career in 1962, Hammond had recorded some 19 albums in every imaginable style of blues, working with big bands or playing solo acoustic guitar. His rigorous touring schedule had taken him to Europe, where audiences had embraced his knowledge of the blues. Hammond was regarded as part of the same venerable tradition as such classic bluesmen as Johnson, John Lee Hooker, Blind Boy Fuller, Blind Lemon Jefferson and others.

Hammond had given thought to the current state of the traditional blues. "It seems like the big recording companies and radio did some heavy damage to American cultural reality," he noted. "They just stopped playing and promoting blues and jazz and folk music—our heritage, for God's sake. And they lost two generations of kids who are older now and don't even know what blues music is.

"But it still exists. It's not dead. You have to search it out in nightclubs, but there are still vital young bands that know what they're doing. There's a profundity to the blues that I think is important. It's much more articulate, expressive and soulful than modern R&B, which seems like 'fashion show' stuff. When you hear the lyrics of that junk on the air, it's shocking. The blues gets right down to the real thing. Blues isn't just Black music, either—it is a real American poetry."

John Hammond Live showcased Hammond at his best, playing and singing his sizzling versions of Delta blues classics. He commanded a substantial Stateside following that appreciated his intense dedication, but he found a lot of irony in his European success. "They're quite sophisticated in their tastes concerning blues and jazz—which are both American genres of music," he said. "It's been a change to play for audiences that are aware of the history of the blues." ■

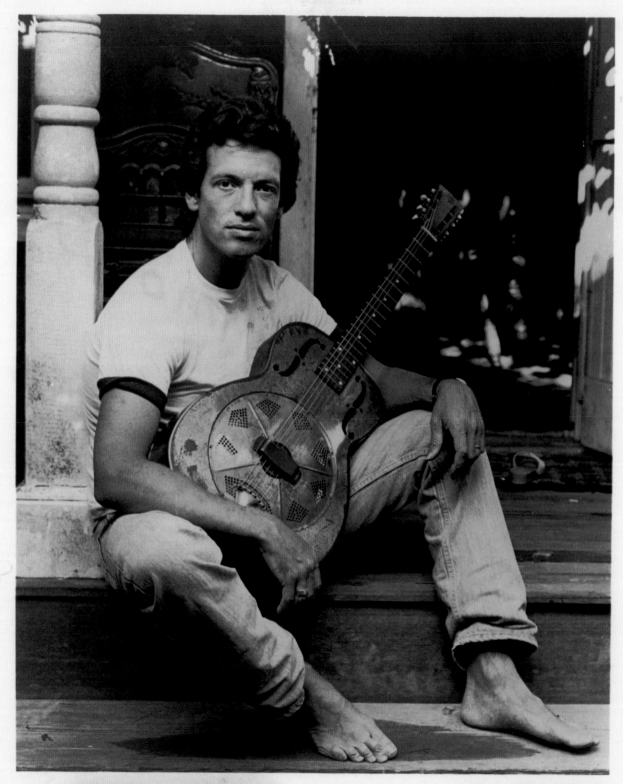

JOHN HAMMOND

the rosebud agency
P. O. Box 1897
San Francisco, CA 94101
415-566-7009

Billboard 200: *The Key* (#32)
Billboard Hot 100: "Drop the Pilot" (#78)

Joan Armatrading's *The Key*–as usual, a Top 10 success in the UK– reached the Top 40 on US album charts.

WHEN SHE first performed in America in 1973, Joan Armatrading's onstage persona suggested that of a child too petrified to speak to her audience. The distinctive musical strengths that had since marked the British singer's material were in evidence—the commanding, husky voice and her individualistic lyrics. But her reluctance to perform didn't bode well for the future.

A decade later, a much more charismatic Armatrading reflected on those early concerts. "Oh, I was shy—frightfully so," she admitted. "It doesn't matter if you're Frank Sinatra or Mick Jagger or me, every performer goes through those stages of being a little bit unsure. But over the years you get built up by people coming to see you and liking what you're doing. You're bound to get confidence—it's just experience. And it's also the audience getting more confident—they get used to you, you get used to them."

Born on the Caribbean island of St. Kitts, Armatrading moved with her family to Birmingham, England, where she began her musical career. Performing at the urging of friends, she was soon compared to everyone from Joni Mitchell to Elton John. American audiences were the last market to discover her charms en masse, even though she had sold 7 million records worldwide.

Her standing in the US changed with *The Key*, an album that mined the same aggressively experimental direction that she began exploring on 1979's *How Cruel*. "My earlier albums were maybe quieter, more polished-sounding records," she noted of her past proclivity for folky reggae rhythms. "But I've done that—now I want to do something else."

Most of the punchy, straightforward tunes on *The Key* were produced by Steve Lillywhite, who had worked with such progressive rockers as U2 and Peter Gabriel. "(I Love It When You) Call Me Names," featuring a wailing guitar solo by Adrian Belew, became a staple of Armatrading's live performances. "That's a difficult song to explain—it took a long time to write it," she said. "It's about two blokes—they're not gay, they're just friends continually calling each other names. It's a real love-hate relationship."

However, in a move suggested by the record label, her single "Drop the Pilot" was produced by Val Garay (responsible for Kim Carnes' Grammy-winning "Bette Davis Eyes") and became her first song to crack the American charts. "I don't write songs just for an album," Armatrading explained. "I just write, period, because that's what I do." ■

JOAN ARMATRADING

Billboard 200: *A Child's Adventure* (#107)

On *A Child's Adventure*, **Marianne Faithfull** honed her métier of raspy vocals immersed in desperation and rage.

MERE MENTION of Marianne Faithfull's name conjured up memories linked with the Rolling Stones at the height of the Sixties British invasion. At 17, Faithfull made her recording debut, cutting "As Tears Go By," written by Mick Jagger and Keith Richards. She had a highly publicized love affair with Jagger—as his girlfriend, she was found wearing only a fur rug by police executing a drug search at Richards' home.

But by the Seventies, Faithfull had become a heroin addict and an alcoholic, and her relationship with Jagger was history. She'd all but abandoned her recording career, contributing lyrics to the Stones' "Sister Morphine" but generally retreating from public life.

Faithfull returned in 1979 with the singular *Broken English* album. Her voice was harsh, nicotine-encrusted and capable of frightening aggression, and the frequently coarse lyrics spoke volumes about her state of mind. Critics wrote that the strident songs were "a cry from the gutter" and "telegrams from hell." Still, the controversial "Why D'Ya Do It" became a worldwide hit. Two years later, she completed *Dangerous Acquaintances*, an album not quite as intense as its predecessor.

A Child's Adventure was co-produced by two of Faithfull's band members, guitarist Barry Reynolds and keyboardist Wally Badarou. Reynolds, her long-lasting collaborator, wrote "Times Square." "A lot of our songs are like blues from another angle," Faithfull said. "'Times Square' has a restless energy to it. It's about our lives, particularly about Barry's—carrying your guitar around, staying in Howard Johnson's, and perhaps having a moment where you think, 'What would it be like if my guitar was a machine gun?'"

Faithfull was still grappling with addiction. "Whatever happened with my voice hasn't gone away," she said. "There have been so many changes in my life and myself. I know there's a way through this." Richards stepped up, insisting that the uncredited Faithfull receive the royalties she deserved for "Sister Morphine." "But I'm glad my path hasn't crossed with the Stones otherwise," she said. "I needed to sever myself from them, and I did it a long time ago. I don't want that back." ∎

Marianne Faithfull

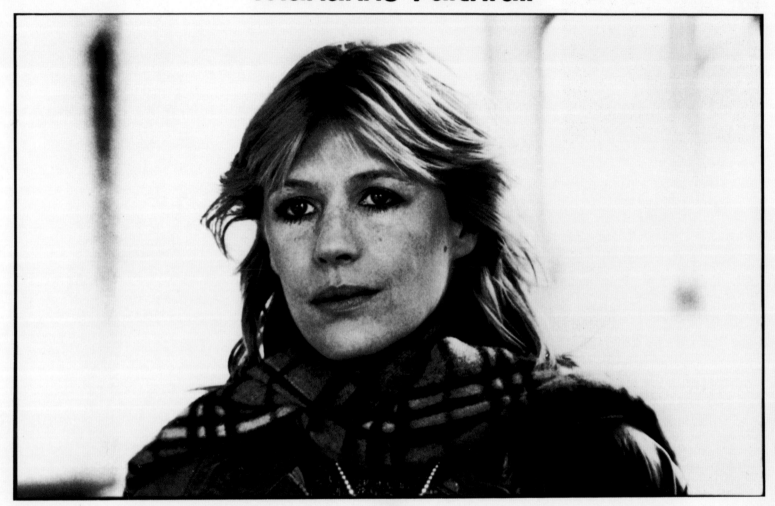

Pic. Don McCullin.

Distributed by ATCO Records

Billboard 200: *Modern Romans* (#84)
Billboard Hot 100: "The Walls Came Down" (#74)

The Call greatly broadened its fan base with "The Walls Came Down," a passionate hit inspired by geopolitics.

GIVEN THE state of new music, it seemed that a group without a battery of synthesizers or crazy hairstyles wouldn't stand a chance, but the Call managed to buck the trends. Hardly formulaic, the material found on the Bay-Area-based outfit's *Modern Romans* was angular and intense, with the credit going to vocalist and guitarist Michael Been. "I don't really think of them as songs," he noted. "It's more like feelings, subconscious things that I'm not even aware of until they've been written."

It took several years for the Call to develop its stylized sound. Been moved to Los Angeles from his Oklahoma and Chicago roots in the mid-Seventies to crack into the music business. He started writing songs upon his arrival, but "the scene wasn't really happening back then," he said. "There was only session work or Top 40 cover bands." Yet Been remained true to his vision.

"Ever since high school, I'd been a big fan of the Band and Robbie Robertson's songwriting," he recalled. "They were my biggest influence, so I definitely wanted to be in a group, to be part of a band." By 1979, he had lined up the right people, and the Call members found themselves relocated in Northern California. "We live 80 miles south of San Francisco," Been noted. "It's sort of a self-imposed isolation to avoid being bombarded by fashion and trends. That sort of musical community never worked for us."

The Call's maverick status didn't interfere with securing a record contract in 1980. And during a demo session, the band gained a noted benefactor. "Someone asked if we were going to use any outside musicians, and we laughingly said Garth Hudson (the keyboardist for the Band)," Been mused. "Someone got him a tape that night and he called us the next morning. He's been with us ever since, and it's been the absolute inspirational peak of my life."

"The Walls Came Down" made the charts and earned major FM radio play, and the Call was genuinely admired by peers and hailed in the rock press. Major fan Peter Gabriel asked the Call to open for his tour of the US and Europe. The firm point of view in Been's lyrics was belied in concert by his explosive stage persona. His careening, reckless performances were offset by the push-pull ensemble sound offered by band members Greg Freeman (bass), Tom Ferrier (guitar) and Scott Musick (drums).

"It's real exciting right now—we're just grateful for the opportunity to play," Been said. "We're finding that our audience crosses all sorts of boundaries, and we're attracting young and old fans. We're not in any category as far as we can tell. It's funny—that seems to have hurt us in the past, but now it seems to be in our favor." ∎

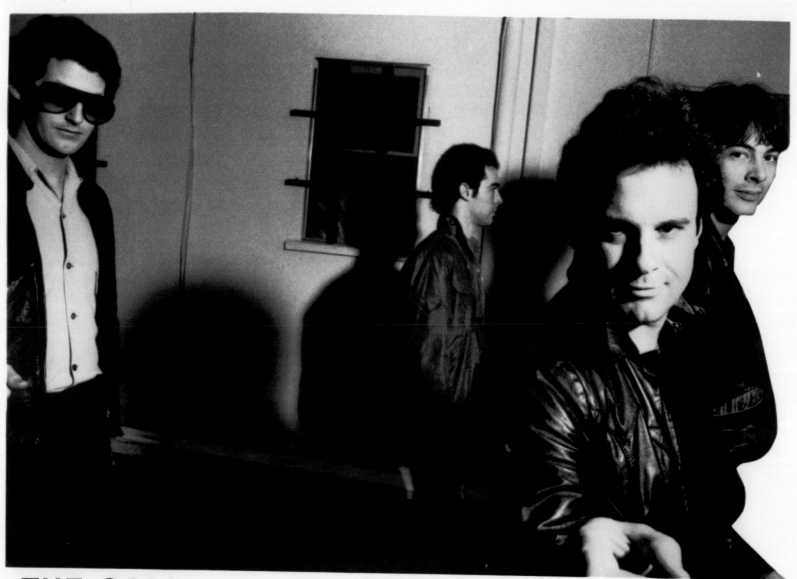

THE CALL

PolyGram Records

ON RECORD | 1983 | [WIRE TRAIN]

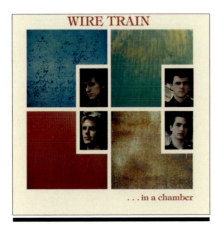

Billboard 200: *In a Chamber* (#150)

A four-piece from the Bay Area, **Wire Train** made a splash with an edgy, propulsive debut album, *In a Chamber*.

WANTING TO be both heard and listened to, singer/lyricist Kevin Hunter encountered Kurt Herr while studying poetry at San Francisco State University. "I asked him two questions—did he play music, and did he want to be in a band?—and his answer to both questions was no," Hunter said. "When we first got together, we had no intention of playing live or even getting a deal."

Hunter forced Herr to quickly get the hang of guitar, solidifying the core of Wire Train. The band signed to the local 415 Records—a punk and new wave label that was also home to Translator, Red Rockers and Romeo Void. Building upon a tiered, haunting guitar-based sound and Hunter's ragged, chameleonic vocals, the band made *In a Chamber* in 17 days "We had cots in the studio and stayed there 24 hours a day," Hunter said.

Wire Train ended up with national distribution when 415 entered into a deal with Columbia Records. The eerie but danceable "Chamber of Hellos" was a college radio hit, and the determined strains of "I'll Do You" made an impact on the alternative charts.

U2's Bono endorsed *In a Chamber* as his favorite album of the year. With Herr, Hunter had achieved a collaboration that divined varied states of experience.

"I don't think we write together in the sense that most people envision," Hunter explained. "When we started, we didn't know how to play, so we relied on me exclusively as a songwriter. But that's not the case anymore. It's more of a late-period Lennon and McCartney relationship. If I wanted to write and not have anything to do with anyone else, I'd get back to writing nonmusical things. Music is a collaborative thing, something that it takes a bunch of people to do.

"A lot of people in groups are starting to get their whole philosophy, their whole iconography down into three words so they can be described to anyone. I can get Wire Train down into one word—I just say 'human.' But people don't know what I mean. They're not ready to take the songs and the sum total of what we are as complexity. Instead, they demand simplicity. And I don't think Wire Train is willing to make up a pigeonhole and jump right into it." ∎

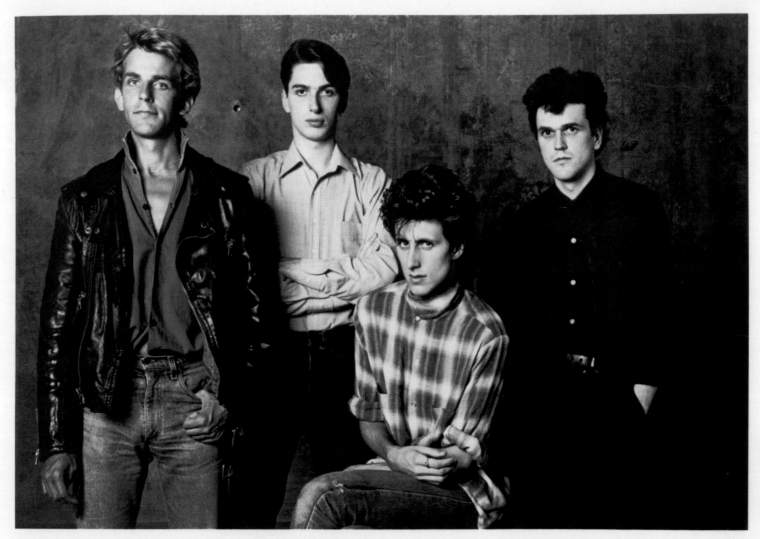

from left: Anders Rundblad, Federico Gil-Sola, Kevin Hunter Curt Herr

PHOTOGRAPH: JIM MARSHALL

WIRE TRAIN

8311

ON RECORD | **1983** | **[THE ROMANTICS]**

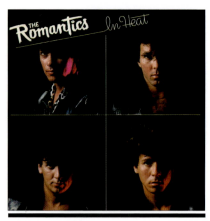

The Romantics hit the jackpot internationally with a radio-perfect nod to parasomnia, "Talking in Your Sleep."

Billboard 200: *In Heat* (#16)
Billboard Hot 100: "Talking in Your Sleep" (#3);
"One in a Million" (#37)

ROARING OUT of Detroit in 1979 with a self-titled debut album and a sizzling national hit with "What I Like About You," the Romantics prospered. "We were disgusted about the music in the Seventies—all those platform shoes, egocentric star mentalities and dinosaur rock," drummer Jimmy Marinos said. But the following two albums failed to generate the same type of response.

In Heat, the outfit's fourth effort, finally recaptured the momentum, as the single "Talking in Your Sleep" became a staple on radio playlists across the country. Marinos gave two reasons for the revitalization of the Romantics—the return of Mike Skill (on bass instead of guitar) and a reunion with producer Pete Solley after a brief alliance with Mike Stone.

"We've never produced ourselves, so what comes out of the speakers, the way a finished record sounds, is the decision of one man," Marinos explained. "We're easy guys to get along with, and if a producer has a strong idea, we'll go along with it. We gave it a shot with Stone, tried something different—he was into giving us a harder-edged sound—and we weren't too happy with it. For *In Heat* we decided, well, at least let's go with the guy that gave us our best-selling album to date."

The return of Skill was another matter. "We grew up together," Marinos said. "We're like brothers, real tight, and after a time we just needed to take a break, because our arguments had turned into fist fights. We didn't see each other for two years. But you start missing somebody that close to you, and we started talking on the phone, hanging out, and finally picking up the instruments and jamming together again. It flipped out our fans when he left, and now they're flipped out that he's back."

In Heat was certified gold, and the Romantics won tens of thousands of new fans, amassing more than 200 dates a year on tour. For Marinos, Skill and guitarists Coz Canler and Wally Palmar, there was a new brand of brotherhood working beneath their trademark black snakeskin suits and pompadour haircuts.

"We went through a period where we were kinda cocky because we had success thrown at us with the first album," Marinos said. "We were tagged new wave, punk, whatever, and it didn't hurt us. We were going against the short-hair-and-skinny-tie look and it actually gave us an identity. We all still live in Detroit, born and raised, but we'll only be there for a week before we get the itch to get back on the road. Once you start traveling, you become used to it—it's fun. Some people can't relate, but we're into it."

However, playing US and international concert tours and making television appearances in support of *In Heat* created division and confrontation with management. Marinos abruptly left the band that had relaunched its career. ∎

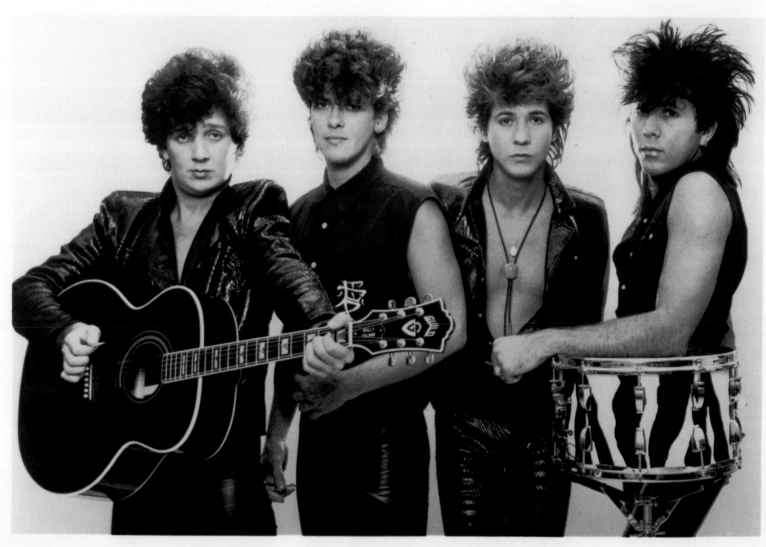

L-R: Wally Palmar; Mike Skill; Coz Canler; Jimmy Marinos

 ROMANTICS

Photo: Bob Alford

Billboard 200: *Everywhere at Once* (#186)
Billboard Hot 100: "A Million Miles Away" (#82)

The Plimsouls' "A Million Miles Away," a power-pop classic, led to a coveted major-label recording contract.

FRONTED BY guitarist Peter Case, who had previously hooked up with Jack Lee and Paul Collins in the Nerves (a single, "Hangin' on the Telephone," was later recorded by Blondie), the Plimsouls' story dated back to 1978. That's when Case decided to form another power-pop band following a chance meeting with other musicians, and the Plimsouls quickly attained a reputation as one of the best "skinny-tie" outfits on the club circuit, voted "Best Unsigned Band in Los Angeles" by *Music Connection*, a West Coast publication.

But when the Knack and other groups managed to score first with a similar musical approach, the Plimsouls found themselves lost in the shuffle. "Things weren't working out for us back then," Case recalled. "We had recorded an independent record (*Zero Hour*) that did well, but our first album for a big record company didn't have a very good sound to it, plus they were struggling themselves at the time. In the end, it just seemed to our advantage to bail out and start from our own resources again."

Case was confident that the band would be back as serious contenders. "It was frustrating in that it was a low point publicly and career-wise, but the band was at a high point musically. We just couldn't get arrested in Los Angeles after a time."

The Plimsouls' recourse was to record another independent record, a self-financed single titled "A Million Miles Away." The song, released on their own Shaky City Records, sold more copies in Southern California than their previous album had across the country. It received national attention when 76 album-rock radio stations across the US picked it up for airplay.

At that point, the Plimsouls were once again in demand. They signed on with Geffen Records, and the album *Everywhere at Once* followed. The soaring "A Million Miles Away" was re-released "so that everyone who didn't hear it the first time will have a chance," Case surmised.

"It's a good situation, because we couldn't carry an independent operation all by ourselves. I don't care what song they decide to play. All I know is that, musically, we've finally managed to make a record that we really like." The band broke up shortly after the album's release. ∎

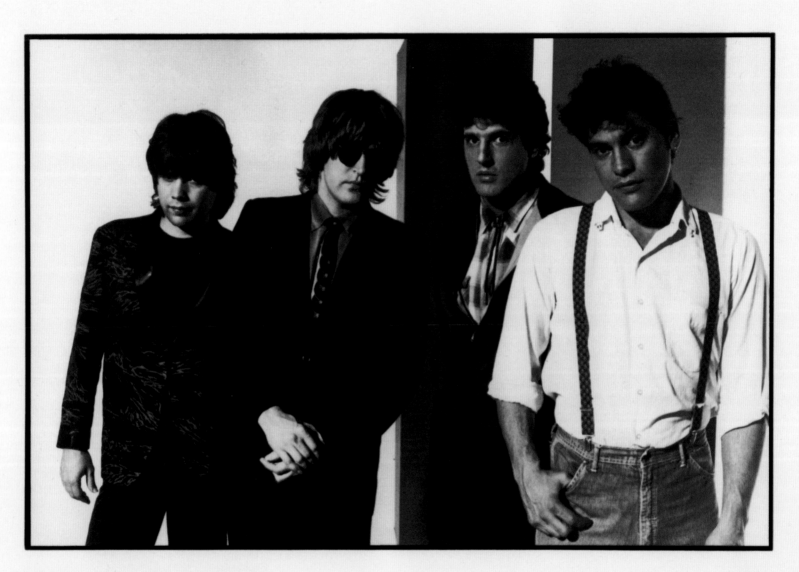

THE PLIMSOULS

ON RECORD　1983　[ZEBRA]

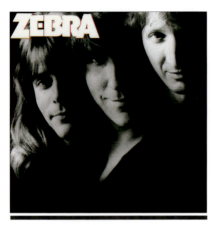

Billboard 200: *Zebra* (#29)
Billboard Hot 100: "Who's Behind the Door" (#61)

Zebra's "Who's Behind the Door" culminated an eight-year drive from local popularity to national recognition.

THERE WAS always a shot at the big time for a local band willing to chance the right combination of skill, connections and luck. Zebra's story began in New Orleans in 1975, and from the outset, the trio developed original material, playing it onstage as time and circumstances would permit, expanding their instrumental and singing prowess.

Bassist Felix Hanemann added a keyboard setup to help generate the large-scale sound they were after. Randy Jackson's guitar collection swelled, while he also began to pitch in on keyboards and percussion. Along with Hanemann, drummer Guy Gelso provided expanding vocal support. "We learned a lot about different instruments and different ways to make our sound bigger," Jackson said.

Zebra's following grew steadily, and after two years of constant effort, every performance was packed. Deciding they needed to explore new territory, the threesome accepted an offer to play on New York's Long Island. It began an unusual pattern of regularly alternating between Louisiana and the Big Apple's club scene, earning Zebra the uncommon distinction of being a bi-regional band.

"We needed to get things happening," Hanemann explained. "Sure enough, we had a tape played on WBAB (a Long Island FM station) that got in rotation and eventually made us the most requested band. And *Good Times* (an East Coast entertainment tabloid) voted us the best unsigned group in the area."

That was enough for Atlantic Records to ink the trio. The debut album *Zebra* spawned a significant hit with "Who's Behind the Door," a track that showcased the group's Led Zeppelin-like hard-rock influences. "Tell Me What You Want" surfaced as another favorite on rock radio. ■

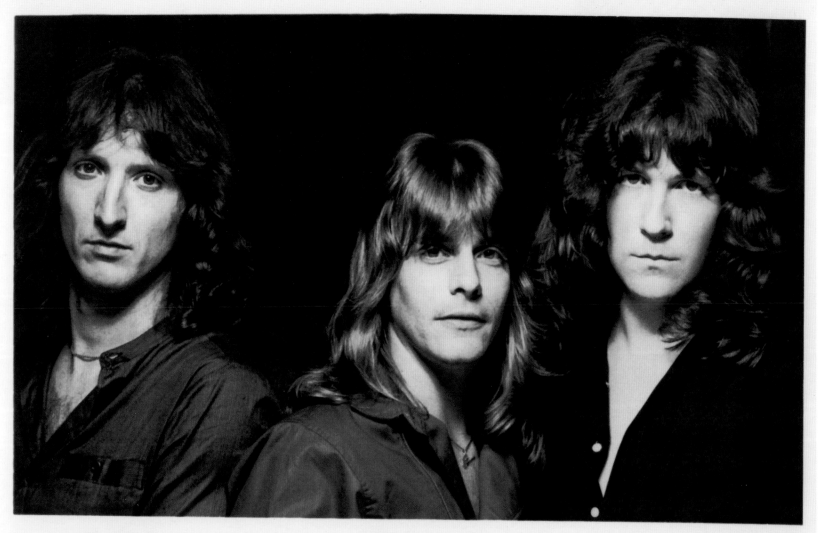

Guy Gelso · Felix Hanemann · Randy Jackson

ZEBRA

Billboard 200: *Fastway* (#31)

Former Motörhead guitarist "Fast" Eddie Clarke formulated **Fastway** and soon secured an American following.

AFTER HIS surprising departure from *Motörhead* after six and a half years, "Fast" Eddie Clarke, the English group's guitarist, quickly picked up the gauntlet, forming Fastway with ex-UFO bassist Pete Way. Drummer Jerry Shirley, an original member of Humble Pie, joined next. Then lead singer Dave King, a 21-year-old newcomer from Dublin, came into the picture.

However, Way never played on the band's first album, *Fastway*—by the time sessions began, he was enticed away by an offer to play with Ozzy Osbourne. "I haven't seen him since," Clarke said. A session musician played the bass parts.

The man recruited to build chemistry in the studio was legendary producer Eddie Kramer. A personality in his own right, he had garnered enviable credentials on albums by the likes of Jimi Hendrix, the Rolling Stones, Led Zeppelin, Kiss and many others. Kramer marked Fastway as his first studio project back in London after nearly 10 years. "His guitar sound is really professional," Clarke enthused. "He had microphones hanging from the ceiling, the walls, the floor—and it sounded great."

A video of "Say What You Will" was popular on MTV and other outlets. A phone call from the same management company that handled Billy Squier convinced Fastway to give touring a go in America, opening dates for Iron Maiden and AC/DC. *Fastway* blasted past the competition to land in the Top 40. All of which proved immensely satisfying for Clarke, who had never managed to crack the US market with *Motörhead*'s ear-bending thrash.

"We've toured hard and linked up with good management and a good record company," Clarke noted. "With *Motörhead*, we used to say we were the nastiest band in the world. Well, this is the fiercest band in the world." ∎

Billboard 200: *Breaking the Chains* (#136)

Through connections with Germany's thriving scene, Dokken learned the nuances of heavy-metal handicraft.

AS THE new-wave movement crested, a heavy-metal scene burgeoned, with a startling number of new groups—Black 'n Blue, Ratt and Great White—beginning to make their way onto vinyl. Another hopeful was Dokken, a Los Angeles-based foursome with an album, *Breaking the Chains*, making a dent on the airwaves.

After recording a demo, gigging around L.A. and performing on a German tour, singer Don Dokken had attracted the attention of Scorpions' producer Dieter Dierks. The German band was entering the studio to record *Blackout* (an effort targeted for the US market which eventually went platinum), and Dokken sang backing vocals on the album. Dierks invited him to record demos. "There was no question that I'd do it," Dokken recalled. "I wasn't afraid to miss what was happening on *Days of Our Lives* or anything."

He recruited impressive guitarist George Lynch and drummer Mick Brown from an L.A. band called Xciter, one of the heavy-metal bands that had adapted—Dokken claimed "sold out"—to new wave when it came on the scene. With a European record deal in hand, they pulled together *Breaking the Chains*.

While Europe had been cordial to his namesake band, Dokken believed that American ears would respond strongest to the metal-with-melody attack. The group members headed back to their homeland and signed with Elektra/Asylum, re-mixing *Breaking the Chains* for American release—recording new instrumental tracks, improving upon vocal harmonies and generally tightening the album's sound.

"The import definitely sounds rougher, rawer—they go for the energy over in Europe," Dokken observed. "Over here, you've gotta compete with Toto and Genesis and these $300,000 ultra-sonically perfect albums, and you need these studio tricks for it to pop out on the radio. So, we copped out!"

Dokken noted the irony of the heavy-metal deluge coinciding with his Stateside return. "Now I've gone the opposite—I'm in all white leathers." Whether Dokken could be heard above the din of the competition remained to be seen. "There's a million bands out there," he allowed. "I don't feel we're a heavy-metal band, though. I'm a singer. There's still only one bottom line—if you write good songs, people are gonna catch on to you."

The four members of Dokken had to resolve creative and personal tensions—admittedly, they didn't get along. "It's like a husband and wife who hate each other but they stay together for the kid," Dokken shrugged. "Our music is the kid." ∎

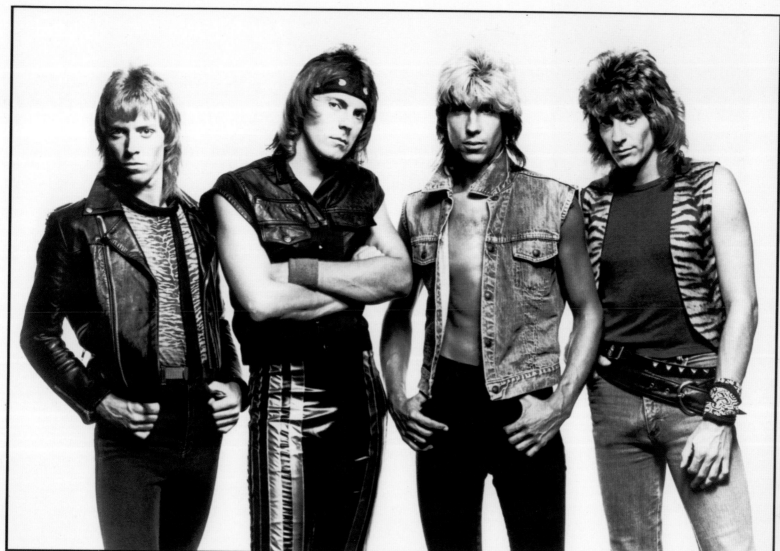

JEFF PILSON DON DOKKEN GEORGE LYNCH MICK BROWN

DOKKEN

Billboard 200: *Jon Butcher Axis* (#91)

Jon Butcher Axis earned attention for a hard-rock approach stressing subtlety and pertinence over flamboyance.

A PROMISING new three-man band from Boston, Jon Butcher Axis was intent on redefining the public's concept of a "power trio." "What we're doing for rock music is a little unorthodox," leader Jon Butcher explained. "We're trying to combine aspects of hard rock and psychedelia and come up with something unique."

The band had been playing the Boston club scene when singer Peter Wolf of the J. Geils Band discovered it and got the act added to a national tour in 1982. The exposure resulted in a recording contract, and the debut album *Jon Butcher Axis* marked the group as one to watch, featuring Butcher's moody playing and interaction with drummer Derek Blevins and bassist Chris Martin. "Life Takes a Life" enjoyed some success on radio and MTV.

"I don't think there's gonna be any more guitar heroes in the old sense of the word," Butcher proclaimed. "We've passed the point where people are impressed if you just play the speediest lick, or leap off a drum platform, or bend the notes screaming. The days of flashing people to death are gone. I think the other way to go is towards atmospheric playing. There's a lot more room to establish a personality there."

Ironically, Butcher never expected to be fronting a rhythm section by himself. "We were a four-piece band with another guitar player in the early days, because I lacked confidence," Butcher admitted. "But when our second guitarist left to join Joe Cocker a few years ago, Derek said I should give it a go. I was against it from the very beginning, but it forced me to expand my sound and my style to be able to play dual lead and rhythm parts."

Butcher suffered through parallels to Jimi Hendrix because he was Black, played guitar and fronted two white guys. "The comparisons are favorable but superficial," he noted. "Hendrix loved the blues, and I'm anywhere but that. I like folk music, and that comes through in my lyrics. Still, I like more ethereal sounds, and I'm not a screamer. We've played a lot of arena shows with Def Leppard, Rush and Scorpions, and heavy-metal bills show off our best side. We take the force of metal and add our own touch to it." ∎

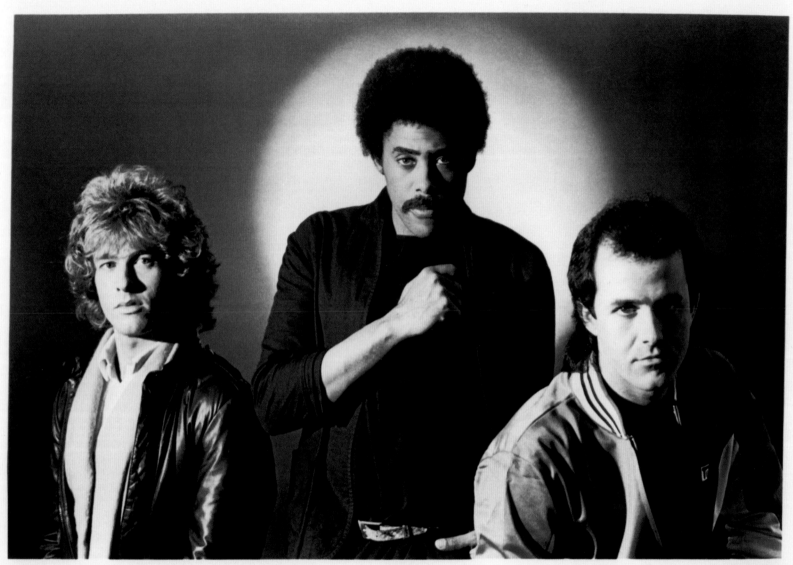

Billboard 200: *Ross* (#32)
Billboard Hot 100: "Pieces of Ice" (#31); "Let's Go Up" (#77)

The album *Ross*, Diana Ross' experiment with the use of synthesizers, met with dampened public enthusiasm.

ACHIEVING STARDOM with the Supremes, then breaking from the group and pursuing a career of her own for more than a decade, Diana Ross had maintained her position as one of world's all-time top-selling female recording artists. The release of *Ross* marked the 14th solo album of her career. "I stopped counting," the popular singer, actress and performer said. "But I remember every song."

Ross ventured out of the diva's earlier soul-based sound for a more pop-rock approach. Five tracks were produced by Gary Katz, a multi-Grammy nominee for his work with Steely Dan and Donald Fagen. Guitarist Joe Walsh played on the Top 40 hit single, "Pieces of Ice," and a video clip became an important part of promotion.

"I'm trying this like everybody else," Ross said. "'Pieces of Ice' is a very abstract song, and the video is almost Fellini-ish in movie terms—it really has no meaning, but it is interesting and fun. It's a great idea, a great vehicle for record sales and for the kids. They're quite expensive, though! Sometimes a video will give you an image and you think that's what the song is about. I like people to go inside themselves and have their own experience when I do a song. Without video, people are able to use their imagination—they can create what they think the story is about and begin to identify personally with it."

Two cuts were produced by fellow Detroiter Ray Parker Jr.—and one by Ross herself. "That's a natural process in the music business," she said. "As you sing beautiful songs, you learn about melody and what you sing best, and you just want to give it a try. I know what I can do and what I can't do.

"I feel a change right now—it's more electronic, it's synthesizers. My whole album was done digitally—that fast, clean sound, a lot of sound effects, mechanical things. People stopped using the word disco, but there is still a lot of dance music, and people like to move and jog and exercise to music. I don't think melody will ever die—it's what people hear inside of their heads, what stays with them."

The singer performed a pair of historic free concerts in New York's Central Park, but *Ross* was her first album in five years that failed to achieve gold status. ∎

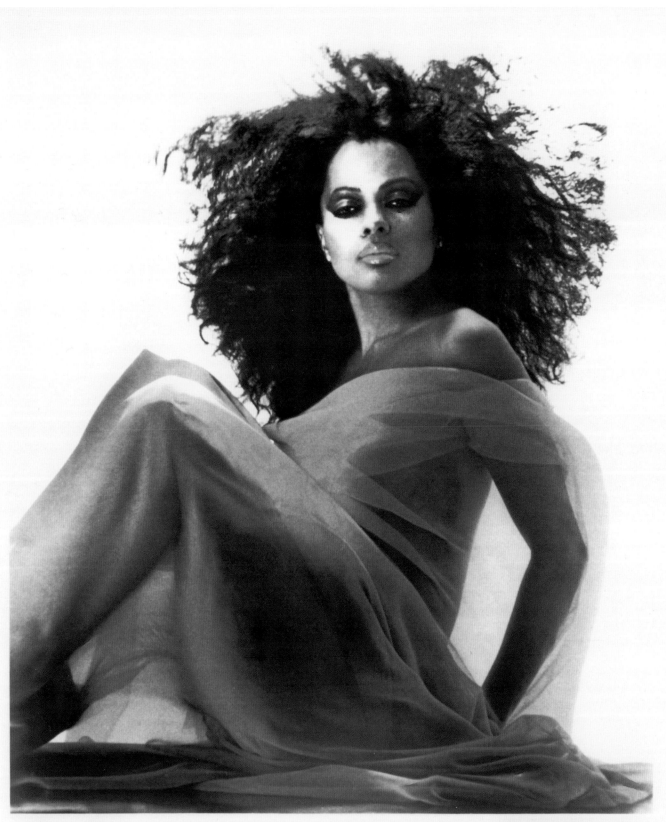

ON RECORD | 1983 | [NATALIE COLE]

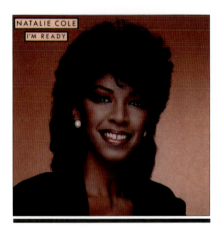

Billboard 200: *I'm Ready* (#182)

With *I'm Ready*, Natalie Cole attempted to silence suspicion that her career might be in some sort of jeopardy.

STRINGING TOGETHER a series of versatile, passionate soul hits that started with "This Will Be" in 1975, singer Natalie Cole—the 33-year-old daughter of the late Nat King Cole—had established herself as a top talent. But during the summer of 1982, the bottom dropped out. Reports began surfacing that Cole was battling drug addiction, and that her mother was seeking conservatorship powers over her estate because she was too ill to care for herself.

"Being one of the few Los Angeles natives still out here, I always thought I grew up knowing how to deal with some of the riff-raff, the Hollywood scene that goes on," the affable songstress explained. "But last summer, my life had gotten to the point where I was not taking care of myself.

"When my troubles first started, they were more mental than physical. I knew I had to do something, and when you're under that type of pressure, there's no one to turn to but your family, right? The petition for conservatorship was voluntary, not mandatory. I was in full control of my faculties. I wasn't crazy or clear off, which is what a conservatorship usually implies. Mom just said, 'What can I do to help?' I didn't want to deal with any business affairs."

Compounding Cole's problems, doctors discovered a polyp on her vocal cords. The surgery resulted in a spate of cancelled appearances. After the operation, the doctors delivered a "strange" diagnosis. "I was told I was screaming too much—which is probably true—and that I was under way too much stress."

Cole decided the time was right to straighten out her situation, and a "house-cleaning" commenced. Cole changed managers, record labels, her musical staff and her circle of friends. "I was very scared before, but I was very confident afterwards," she said. "I went about finding people to surround myself with that were 'cool,' not yelling at each other. I needed a more relaxed atmosphere."

I'm Ready, an album in the making for more than a year, signaled the completion of her return. It featured two sets of producers, famed bassist Stanley Clarke and a pairing of Cole's two previous studio mentors, Chuck Jackson and Marvin Yancey. The single "Too Much Mister" did reasonably well in the UK.

Cole hated the word "comeback." "It sounds a little corny to me," she allowed. "But I guess it's time to face up to the fact that I'm in the middle of one. The last thing will be to move into a new house. My five-year-old son needs to ride his bike someplace where it's not so hilly—right now he's doing it indoors!"

Following the release of *I'm Ready*, Cole entered a rehab facility and stayed for six months. ■

NATALIE COLE

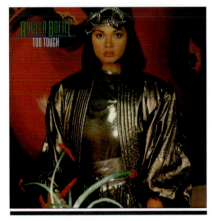

Billboard 200: *Too Tough* (#40)

Making a move toward mainstream R&B and pop music, **Angela Bofill** testified to her versatility on *Too Tough*.

ALTERNATELY TOUGH and tender, Angela Bofill resisted stylistic categorization. "I see each song as a script and try to sing the song as an actress," the vocalist said. "A lot of people have compared me to a number of different artists, but I couldn't really be anyone but myself."

The fount of Bofill's capability was her heritage—she was born to a French-Cuban father and Puerto Rican mother—and her influences. "I was raised in Harlem. If you didn't have the latest 45 by the Supremes or the Temptations or James Brown, you weren't hip. I bought them all and I loved them. But I also listened to a lot of Dionne Warwick and Burt Bacharach. I was just floored by those gorgeous ballads."

During her childhood, Bofill sang as a member of New York's All-City Chorus. After attending Hunter College High School, she went on to study at the Manhattan School of Music, and then studied classical music at Hartford Conservatory. "I was gigging with Richard Marrero's Latin band," she said, "where I met a fine flautist named Dave Valentin."

Valentin and producers Dave Grusin and Larry Rosen guided Bofill through her first two albums, *Angie* and *Angel of the Night*. Accolades and awards followed, but Bofill felt it was time for a new production approach with Narada Michael Walden. "Narada brought it down to a more basic level. What we're working towards is a balance between the lush and the basic."

On *Too Tough*, Bofill expressed being lost in love on the soulful ballad "Tonight I Give In." She conveyed the funkier title song in a kittenish but beguiled manner and scored a sizable hit on the R&B and dance charts. "It's a hipper mix," she said. "I love jazz, and can improvise with the best of them, but I'm really a pop singer with jazz and R&B influences. It's not like the old days when jazz was just bebop—even rock and R&B have been heavily influenced by jazz, and that's very positive for the future of music in America."

Production was divided between Walden on side one and Bofill herself on side two. In undertaking that creative role, Bofill cited the title "Accept Me (I'm Not a Girl Anymore)." "I'm finally able to make my songs sound closer to how I hear them in my head," she said. "That's been my goal for as long as I can remember." ■

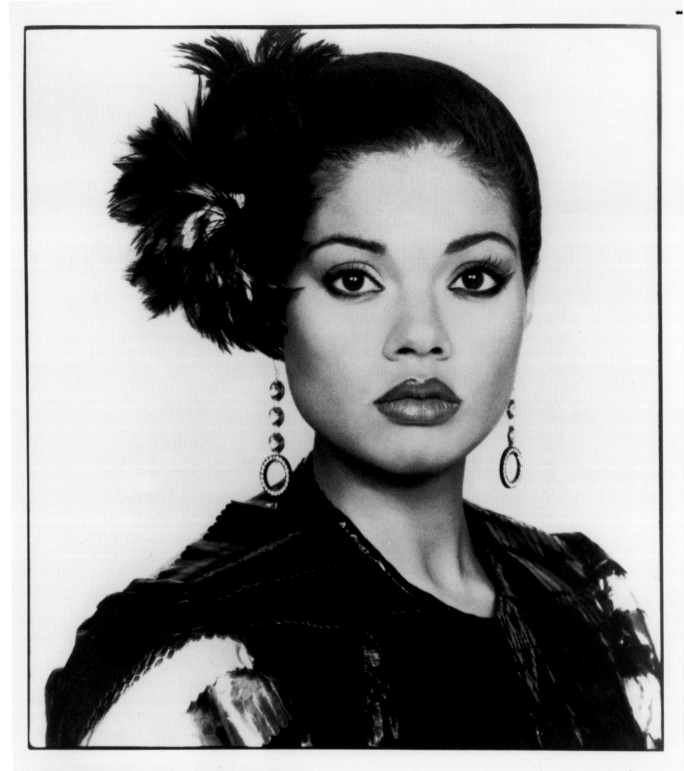

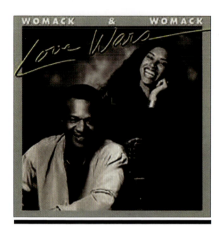

Husband and wife **Womack & Womack** made a debut as a recording partnership with the *Love Wars* album.

THE SINGING and songwriting team of Womack & Womack—Cecil Womack and his wife, Linda—drew from some involved personal experiences. Performing with his brothers as the Valentinos, Cecil toured with the legendary Sam Cooke and enjoyed a pop hit with "Lookin' for a Love." The band scored another crossover smash with "It's All Over Now," which the Rolling Stones subsequently covered in 1964. Cecil began writing for Teddy Pendergrass and many others, sometimes collaborating with then-spouse Mary Wells.

Linda's biggest influence was also Sam Cooke—her father. After his tragic death in 1964, she began a career writing songs—"Woman's Gotta Have It," which went gold for both James Taylor and Bobby Womack, as well as hits for Aretha Franklin and Wilson Pickett. Linda had first met Cecil when he was 13 and she was 8 years old. As teenagers, Cecil told Linda he felt they'd get married someday, but many years passed before they began a personal and professional relationship.

They wed in 1976 and, with *Love Wars,* an album of contemporary soul, recorded together as Womack & Womack. "We're about a couple sticking together and sharing and loving and living," Cecil explained. "A lot of people who grew up in the Sixties—our own age group, which is the largest in the country—can relate to that now. It's time for people to develop a relationship. Everybody's got somebody, even if they're not with them at the moment."

Love Wars produced several international hits—"T.K.O." reached the US R&B singles charts, and "Baby, I'm Scared of You" and the ace title track were hits in the UK. Where there had been a handful of other married couples capturing the trials, travails and tribulations of love, Womack & Womack were authoritative.

"We're looking for a spiritual understanding of feelings," Cecil said. "That's something you can't find in a book or on a poster. We're together, a joint effort. She'll express what a woman feels, and I'll say what a man feels, and we'll kick it back and forth and the song comes out almost like people talking. We write it simple." ■

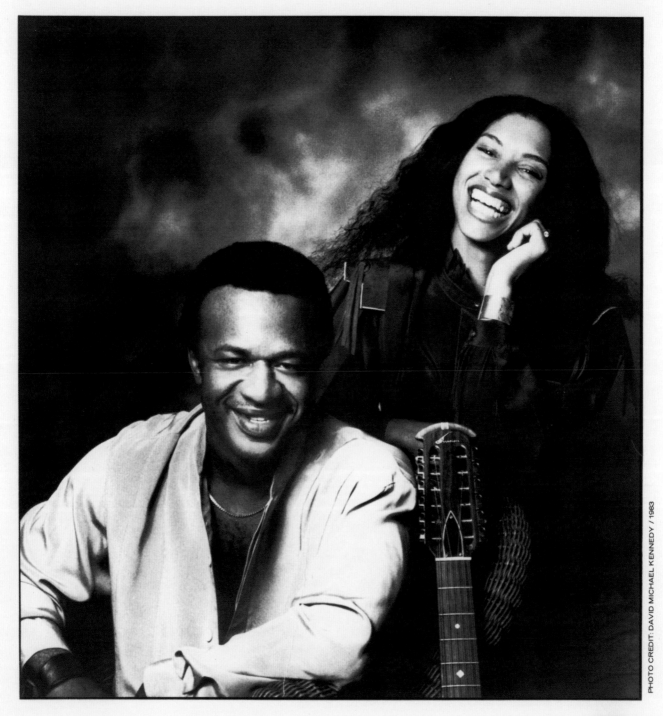

WOMACK & WOMACK

ON RECORD | **1983** | **[CHAMPAIGN]**

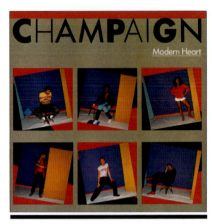

Billboard Hot 100: "Try Again" (#23)

Having burst on the scene with the hit "How 'Bout Us," Champaign returned to the charts with "Try Again."

NAMING THEIR smooth soul group after their Illinois hometown, the six members of Champaign scored a big international hit in 1981 with "How 'Bout Us," the title track from the interracial act's debut album. The song reached #4 on the US R&B chart, #12 on the pop chart and the Top 5 in the UK.

"I like the recent transition in urban music, which is recognition that whites listen to Black music and Blacks listen to white music," guitarist and keyboardist Michael Day said. "Even to call it Black music or white music is almost pointless. And what's great about dance clubs is that there isn't the stigma of 'He's a white artist'—people don't care about those things. I went to the Ritz in New York to see George Clinton and half the audience was white. To me, that's a terrific development."

Modern Heart was produced by George Massenburg, known as the engineer for artists as diverse as Earth, Wind & Fire and Little Feat. Much of the album was recorded at Champaign's own 24-track studio in Illinois. "We're somewhat isolated, not influenced by 50 other studios and all the top players making their records and having to compete with them," Day said. "Most people have this idea that you have to go to one of the coasts to make it. But I don't buy it—we believe we can make the music anywhere."

But Champaign didn't get out its second album out fast enough to keep up commercial momentum. The ballad "Try Again" was another pop and soul crossover hit (#2 R&B in the US), but *Modern Heart* was largely ignored. ∎

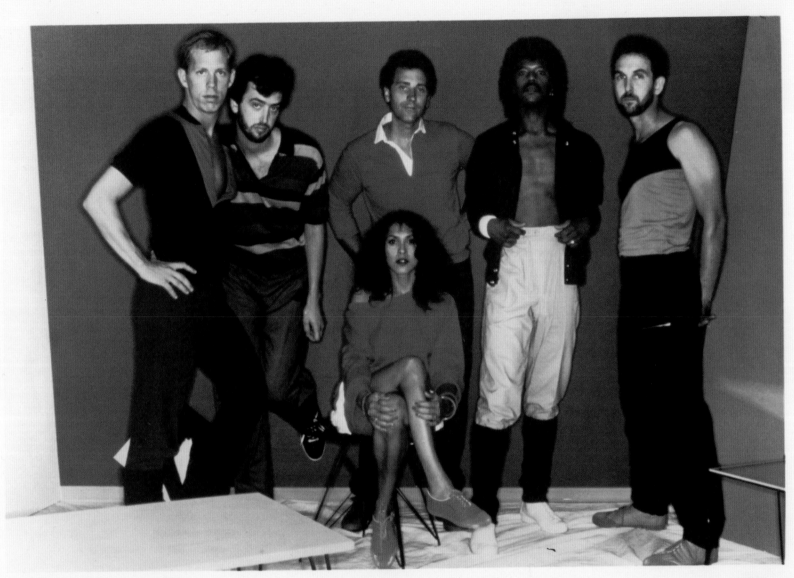

CHAMPAIGN

8302

Billboard 200: *Between the Sheets* (#19)

The Isley Brothers managed to keep the funk in their family for two generations of special musical siblings.

A MAJOR force in Black music, the Isley Brothers' historical success endured with the release of *Between the Sheets*—their 22nd album. "The reason we've lasted so long is that we've always been a self-contained group," bassist Marvin Isley stated.

Originally comprised of Ronald, Rudolph and O'Kelly Isley, the three brothers constructed their first single in 1959, and "Shout!" eventually became a call-and-response rock 'n' roll standard. The biggest hit of their early period, "This Old Heart of Mine," was released on the seminal Motown label in 1966. The Isley Brothers lineup doubled in size in 1969 when younger brothers Ernie and Marvin and brother-in-law Chris Jasper added to the band's music.

"Kelly, Rudolph and Ronald wanted us to go to school and get good jobs as doctors or lawyers," Marvin recalled. "But one day Ronald got the idea for 'It's Your Thing,' and he taught us the parts so he could play it for the band. When the band recorded it that evening, they couldn't get the right feel, so Chris and Ernie and I played it again for them. The engineer taped it, and everyone knew that we had a take. We couldn't believe it—not only was it our first record, but it went on to sell 5 million copies."

Ernie, Chris and Marvin all attended college and learned music theory while still contributing. The younger brothers helped the older brothers make the transition into rock-oriented material. "We got them to cover Carole King, Neil Young and Jim Croce songs, and they came up with James Brown and Wilson Pickett," Marvin recalled.

In 1973, when the band's hired guitarist didn't show up for a gig, Ernie reasoned with his brothers that he should fill in. Onstage that evening, he proceeded to play the guitar behind his head, with his teeth, and in all manners in between. "We'd never seen that side of him, but we knew we had something," Marvin laughed. "The album title *3 + 3* referred to the fact that there were six members now, the three oldest and the three youngest. And there were no other Isleys coming up—it was our band, period."

They began to write, arrange and produce each of their albums and generated a legacy of hits ("Here We Go Again," "Fight the Power"). In addition to celebrating a 25th anniversary in 1983, the Isley Brothers had another musical trick in them. *Between the Sheets* returned them to the top of the R&B album charts, and the title track and "Choosey Lover" became Top 10 R&B hits.

"Us younger guys are writing more, and we're always listening to the newest sounds, like the rap and scratching records," Marvin enthused. "We talk a lot among ourselves about how we really haven't reached our peak yet. There's a lot of things we haven't expressed, but we're real close to it." The following year, cutting loose from the older-generation Isleys, Marvin, Ernie and Chris Jasper formed Isley-Jasper-Isley. ∎

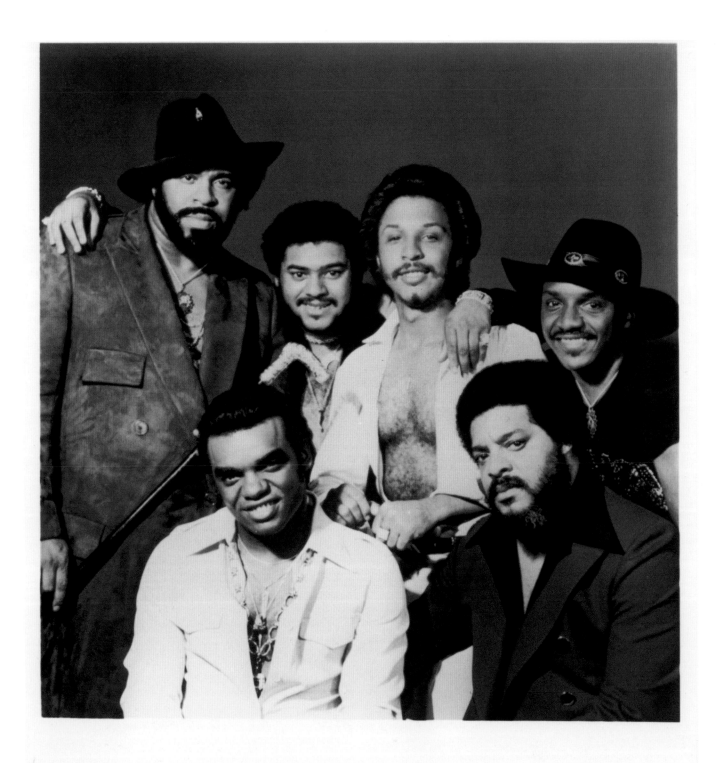

Billboard 200: *New Looks* (#193)
Billboard Hot 100: "Whatever Happened to Old-Fashioned Love" (#93)

Known for his wonderful pop and gospel hits, singer **B.J. Thomas** hit his country music peak with *New Looks*.

BLESSED WITH an ability to mold a tune into his identifiable style, B.J. Thomas launched his career in 1966 with his soulful treatment of the Hank Williams classic "I'm So Lonesome I Could Cry," his first million-selling national hit. At the time, he was a member of the Triumphs, a Houston band that had just gone into the studio.

"My dad told me not to come home unless I recorded something country," Thomas said. "He was my first motivation to be a singer, but the Grand Ole Opry was the first inspiration for my music. It had such an influence in my early life, dating back to me seeing Hank Williams in person when I was in the third grade."

Thomas became an across-the-boards star with the million-selling titles "Hooked on a Feeling," the Oscar-winning "Raindrops Keep Fallin' on My Head" and "(Hey, Won't You Play) Another Somebody Done Somebody Wrong Song." The latter not only went to No. 1 on the pop charts, it also established a country career for Thomas.

By 1976, Thomas had experienced a spiritual rejuvenation, and he became the first contemporary Christian artist to achieve platinum status with *Home Where I Belong*. "I've tried to express some of my newfound peace of mind through my music," he said. "I think my involvement has helped change the face of gospel and Christian music—it makes it possible for other entertainers to express their own beliefs without being put into any one category."

In the late Seventies, Thomas returned to mainstream pop, and he became the Opry's 60th member in 1981. *New Looks* was the result of Thomas' work with Nashville producer Pete Drake, and he reached No. 1 on the country music charts with "Whatever Happened to Old-Fashioned Love" and "New Looks from an Old Lover."

"We haven't strayed from the style of song that I've become known for doing, or the sound that I've had success with," Thomas assured. "The hits I cut years ago that were successful pop records fit right into today's country market because of the lyrics—people can relate to them." ∎

B.J. Thomas

photo credit: NORMAN SEEFF

Columbia

Cleveland International

8302

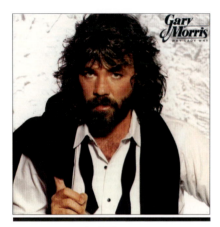

Billboard 200: *Why Lady Why* (#174)

A country version of the beloved song "The Wind Beneath My Wings" showcased Gary Morris' soaring tenor.

COLORADO WAS a full-time address for Texas-born Gary Morris from 1976 to 1979, when he fronted a country-rock band called Breakaway, "as good a band as you'll ever hear," the Fort Worth native recalled. "The band was conceived to support my singing. In time, though, it became a 'personality' band with everyone involved using a nickname and so on. We were vying to get signed as a pre-Alabama, pre-Charlie Daniels Band type of group, but it wasn't in the cards at that time."

Morris eventually made the decision to go solo, making the trek to Nashville, where any serious country artist had to commit most of his time. "Nashville's got its share of warm people, but it's run by song publishers," he reasoned. "So success lies with some very sharp people, which makes it a political city, too."

Morris managed to whittle down his dues-paying period to two months. "Even that seemed like an eternity," he laughed. "I'm a fairly aggressive guy, and I just hit the streets, trying to get an appointment with anybody. I finally managed to wrangle some time with Norro Wilson, who headed up the Warner Bros. country music department. Warners was the first major label I saw, and everything happened pretty fast after that."

A month later, however, the machinations of the music industry threatened to defuse Morris' breakthrough. "Norro left the company," Morris explained, "and I was left as a new guy on the label who no one else knew anything about." Morris managed to score a couple of minor country hits through his own efforts, and subsequently "Headed for a Heartache" established him as a Nashville brand name.

Morris then turned toward ballad material on the *Why Lady Why* album and enjoyed his biggest success with "The Wind Beneath My Wings" (named Song of the Year by the Country Music Association), "The Love She Found in Me," "Velvet Chains" and the title track. All four singles peaked in the Top 10 of the country charts.

"Things are changing for the better," Morris admitted. "But I've had five hit records in the past two years, and it's still hard to go out on the road and make enough to pay the band, the agents, the managers, transportation costs and so on. The days of developing an act on the road are gone—it just costs too much."

Instead, Morris hoped his recordings would sustain momentum. "I think it was Frank Zappa who said that different forms of music are simply different ways for people to dress—if it's country you wear boots, or if it's punk you wear safety pins.

I want my audience to evolve into a cross-section of folks—from hippies who 'made it' to your nine-to-five crowd to mainstream America. Not just country, or bluegrass, or jazz," he laughed, "but middle-of-the-road country-bluegrass-jazz!" ■

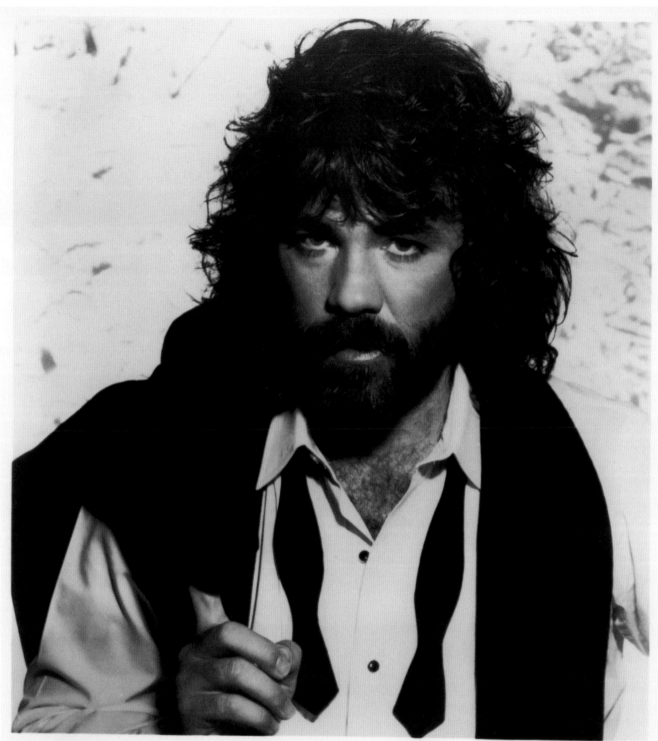
Gary Morris

WARNER BROS.

Billboard Hot 100: "Minimum Love" (#41)

Performers and producers had no problem spotting Mac McAnally's facility for turning emotions into songs.

INSPIRED BY his teen years by the novels of William Faulkner, Flannery O'Connor and Ernest Hemingway, Mac McAnally admitted to a literary approach to even his simplest lyrics. "I've always thought of life as being like a river," he said. "You could either stand on the side and watch how everybody was spinning every which way, or you could jump in and spin."

The culture and pace in rural Belmont, Mississippi—population 900 when he was growing up there—didn't offer what McAnally needed to lead a happy life. "I'm considered a pretty nice guy outside of Belmont—I'm just the worst thing that ever happened there," he conceded. "I'm the reason they lost all their school spirit. I'm the reason for the drug issue in the schools. I had all the labels—Communist, dealer, homosexual, you know…"

McAnally fought about the merits of structured learning with his father, a superintendent. In the middle of his junior year of high school, they agreed it best he abandon formal education. As a dropout, he spent days at home alone while his parents worked, playing the guitar and writing songs for his own pleasure.

"The only reason those songs were written was because it clarified something for me," he explained. "Coming from a small town sealed it for me. It's like a little world that nobody ever gets outside of—you know everybody. If you hurt someone, you not only see it hurt them, but the next person, too. And I think you end up being more sensitive because of it."

In 1976, when McAnally was 19, he drove to Muscle Shoals, Alabama, about 50 miles from home. He impressed producers Terry Woodford and Clayton Ivey so much that they recorded his self-titled debut album, illuminating human nature in parables of small-town life. It contained the hit "It's a Crazy World," which peaked at #2 on the adult-contemporary charts in 1978, and he toured with Randy Newman. The two solo albums that followed produced no charting singles.

But in 1981, Jimmy Buffett recorded McAnally's tune "It's My Job" on his *Coconut Telegraph* album, and McAnally wrote Alabama's No. 1 hit "Old Flame." His *Nothing but the Truth* included the Top 10 adult-contemporary hit single "Minimum Love," which peaked just shy of the Top 40 on the pop chart. The album dealt primarily with compromise—the balance between aspirations and reality.

"The old songs had those clean-cut conclusions. These new songs have only clean-cut questions," he suggested. "If you're in the river, all you can maintain is direction—occasionally notice what you are trying to attain, and maybe make a couple of strokes toward it. That's where you come to understand compromise." ■

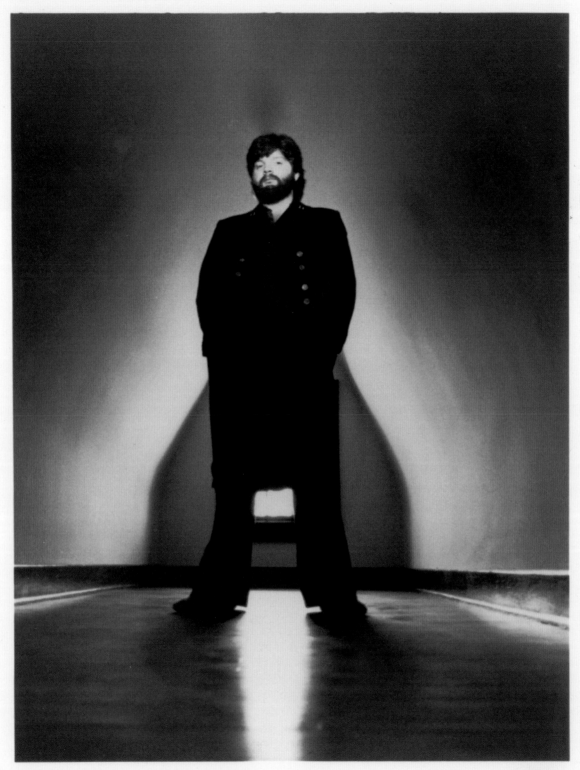

MAC Mc ANALLY

ON RECORD 1983 [THE STATLER BROTHERS]

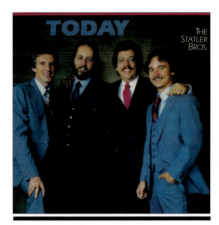

Billboard 200: *Today* (#193)

The Statler Brothers' original members maintained their reputation as unflagging workers for almost 20 years.

COUNTLESS TIMES, the Statler Brothers—brothers Don and Harold Reid, Phil Balsley and Lew DeWitt—clarified the origin of the name. It was taken from a box of tissues in a hotel room—"The name could just have easily been the Kleenex Brothers," Harold Reid explained.

Formed in 1955, the quartet was discovered and mentored by Johnny Cash, touring with him as opening act and backup singers for over eight years. The Statlers then became one of the most awarded country music vocal groups in history. The band's style was closely linked to their gospel roots on countless hit songs, including "Flowers on the Wall," "Bed of Roses," "I'll Go to My Grave Loving You," "Do You Know You Are My Sunshine" and "Class of '57."

"It's as much by accident as by plan, but the sound probably comes from our harmonies," Harold Reid said. "We've got it all over single artists, because the arrangements are built-in, and we can do solos, duets, trios and four-part singing, all in one song."

The Statler Brothers continued to live in Staunton, Virginia, where they first sang together at Lyndhurst Methodist Church. Dubbed "America's Poets" by Kurt Vonnegut, they had bought their old grade-school building and converted it into an office.

"Even though we are, so to speak, country music stars, our songs talk about the same fears, beliefs and lives as the people who pay $10 to see us," Balsley said. "They see a stability that they don't see other places, be it their jobs, neighbors or the economy. We're from humble beginnings, we've been here a long time, and we sing about things that have happened to us years ago, or last year, but all things that everyone's been through."

DeWitt, the "eccentric" Statler, sang tenor and was the guitarist of the group. Fame, he said, "is a two-edged blade. It lets us be the people we always wanted to be, but it's also created certain expectations that are sometimes not so easy to live up to. Because we have to, it makes us better people than we might have been."

Due to his failing health, DeWitt was replaced by Jimmy Fortune on *Today*, the group's 24th studio album. Fortune immediately proved his worth—the group reached No. 1 on the country charts with "Elizabeth," the first song he wrote, soon after joining the group. The homage to actress Elizabeth Taylor featured him on lead vocals. ∎

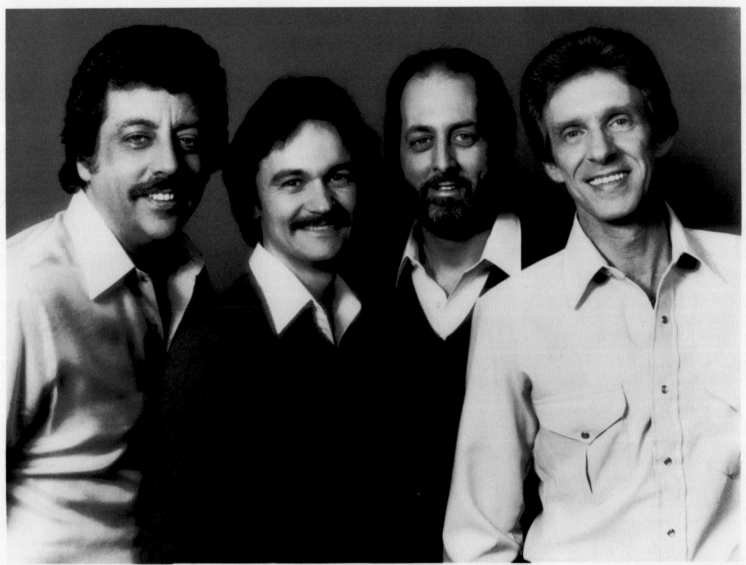

HAROLD • JIMMY • DON • PHIL **THE STATLER BROTHERS** PolyGram Records

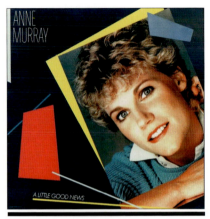

Billboard 200: *A Little Good News* (#72)
Billboard Hot 100: "A Little Good News" (#74)

Anne Murray scored two No. 1 country hits, "A Little Good News" as well as "Just Another Woman in Love."

CONCERT SELLOUTS from Monte Carlo to Minneapolis. Twenty American chart hits, consistently crossing over from pop to country. Countless music awards—six gold and two platinum albums in the US, 19 Canadian Juno Awards. No wonder Elton John had said, "There are only two things I know about Canada—hockey and Anne Murray."

The Canadian songstress was born and raised in Springhill, Nova Scotia, a coal-mining town not unlike one found in rural America. "Singing was a natural part of life for anyone from the town, and music was always big there, although I wasn't so aware of it then." Murray recalled. "I heard some of the best singers I know in that little town."

Canada's songbird had her first hit single in 1970 with "Snowbird," and soon Murray became a semi-regular on *The Glen Campbell Goodtime Hour*, commuting to Los Angeles from Nova Scotia. But the weekly flights didn't last long, as she preferred to stay close to home.

Recording in Toronto didn't seem so strange considering the string of hit singles she recorded there—"Danny's Song," "A Love Song," "You Won't See Me," "You Needed Me," "I Just Fall in Love Again," "Shadows in the Moonlight," "Broken Hearted Me" and "Daydream Believer." "The musicians in Toronto are as good as those you'd find anywhere," Murray said. "There just aren't as many."

A Little Good News was another high point in her continuing fame. Producer Jim Ed Norman, who had worked successfully with Murray in the past, seasoned her songs with synthesized sounds, and the collaboration proved fruitful once again—the album reached No. 1 on the country charts and earned Murray her fourth Grammy Award.

The Canadian songstress maintained that her husband and children warranted most of her attention; she planned tours around them, chiefly performing on four-day weekends. "I'm just a small-town girl," Murray vowed, "and I always will be." ■

ANNE MURRAY

Photo: Bill King, New York / 1983

ON RECORD 1983 [DEBORAH ALLEN]

Billboard 200: *Cheat the Night* (#67)
Billboard Hot 100: "Baby I Lied" (#26)

Country artist **Deborah Allen** recorded the crossover hit "Baby I Lied," which developed into her signature song.

HER CAREER read like a study on the power of positive thinking. In 1972, Deborah Allen arrived in Nashville as a 19-year-old innocent from her hometown of Memphis. She rented a room at a boarding house on 16th Avenue, the hub of the city's music industry. Unknown to her at the time, the property was a stop for transients and drunkards. "I never looked at it as anything terrible because I had such a nice childhood," she said. "But I wouldn't let my parents come see where I was living because I knew they'd make me come home."

Her first break resulted after a chance meeting with Roy Orbison in a local restaurant. "I saw this man sitting there with jet black hair and sunglasses and thought to myself, 'I'll bet he's in the music business,'" she recalled. "I went up to him and said, 'Excuse me, are y'all in the insurance business?' He said, 'No, I'm in the music business.' I said, 'That's what I thought—listen, I'm a singer and I'm trying to get started.' It was just like you see in the movies."

Orbison admired Allen's moxie and hired her to sing background on a couple of his tracks, and Shel Silverstein encouraged her to write songs. While working at the Opryland USA theme park, Allen was chosen as a soloist and dancer to accompany Tennessee Ernie Ford on a 1974 tour of Russia. After returning, she landed a regular spot on Jim Stafford's summer-replacement TV series from Los Angeles and performed as an opening act at his concerts.

Eventually, she returned to Nashville. In 1979, her voice was over-dubbed on five unfinished duet tracks by the late Jim Reeves, which were released by RCA, Reeves' longtime label. She signed with Capitol for one well-received album, titled *Trouble in Paradise*, and married one of her cowriters, Rafe VanHoy.

And then Allen achieved her greatest success, releasing a mini-album, *Cheat the Night*, and "Baby I Lied," a single which reached the country, pop and adult-contemporary charts. "You can't knock somebody for doing something they feel in their heart," Allen surmised. "I always think big—if you shoot for the stars, you just might land on the moon." ∎

DEBORAH ALLEN

30 Music Square West
Nashville, TN. 37203
Telephone (615) 244-9880

ON RECORD | 1983 | [MANNHEIM STEAMROLLER]

Chip Davis wrote the music and conceived the marketing plans for Mannheim Steamroller's flashy productions.

IT STARTED when Chip Davis, with his partner Bill Fries, ran an advertising agency headquartered in Omaha, Nebraska. Davis had a talent for putting music, writing and art together, and the partners collaborated on the character of C.W. McCall for an ad campaign to sell bread. When Americans suddenly were chattering away on their CB (Citizens Band) radios at the height of the oil shortage in 1975, they recorded "Convoy," attributed to McCall—and the tale of using CBs to outwit the cops turned into the trucker national anthem and became a No. 1 pop and country hit.

The success allowed Davis to focus on his own original music. He had recorded a thematic album in his spare time, what he termed "18th Century rock," applying classical principles to rock rhythms. Under the Mannheim Steamroller banner—"I was told I had to sell a group, not an album"—he released the Fresh Aire project on his own audiophile label, American Gramaphone, since no major record company would handle the distribution.

The first four Fresh Aire albums were devoted to the feelings of the four seasons, and Davis perceived enough interest to bring the music to the stage. Gathering an ensemble of classically trained musicians and a team of technicians to orchestrate various effects, he took Mannheim Steamroller on the road, combining film, animation, theatrics, a computerized visual display—and live music.

"I borrowed a little money to get going," Davis recalled. "But most everything has been generated from ticket sales. My wife's a photographer, so we could do a lot of the multimedia elements cheaply when we started. We also borrowed equipment—I was scoring commercials for advertising agencies, projects that utilized five-screen presentations. Our first show was only 20 minutes long, but we built it up to 40, then over an hour. I dream stuff up as I go along, then find the technology to do it with."

Davis termed *Fresh Aire V* "the beginning of the second volume, devoted to intellectual topics." After laying down basic tracks in Omaha, he used the London Symphony Orchestra and the Cambridge Singers Choir, recording in an ancient cathedral that had a nine-second echo. The album, subtitled "To the Moon," was based on *The Dream*, an obscure treatise written in 1609 by the German astronomer and mathematician Johannes Kepler.

"He was a contemporary of Galileo's, and he wanted to become an authority on the moon after seeing it through a telescope," Davis explained. "So he wrote a description of a journey to the moon. He hit so much stuff dead on that it smokes your mind—the only thing he was off on was his belief that there were creatures on the moon. What I've done is scored the book, in a sense." Music from the recording was widely used during the TV broadcast of the 1984 Olympics. ■

Thanks to co-production by guitarist Nile Rodgers of Chic and impeccable, inventive videos, **David Bowie** reached his commercial peak with *Let's Dance*.

Billboard 200: *Let's Dance* (#4)
Billboard Hot 100: "Let's Dance" (No. 1); "China Girl" (#10); "Modern Love" (#14)

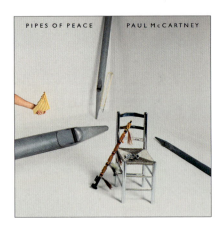

Paul McCartney's *Pipes of Peace* engendered two global singles, the title track and "Say Say Say" with Michael Jackson, who co-wrote the hit duet.

Billboard 200: *Pipes of Peace* (#15)
Billboard Hot 100: "Say Say Say" (No. 1); "Pipes of Peace" (#23)

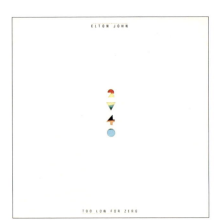

Reunited with his songwriting partner Bernie Taupin after seven years, **Elton John** returned to the limelight with his 17th studio album, *Too Low for Zero*.

Billboard 200: *Too Low for Zero* (#25)
Billboard Hot 100: "I Guess That's Why They Call It the Blues" (#4); "I'm Still Standing" (#12); "Kiss the Bride" (#25)

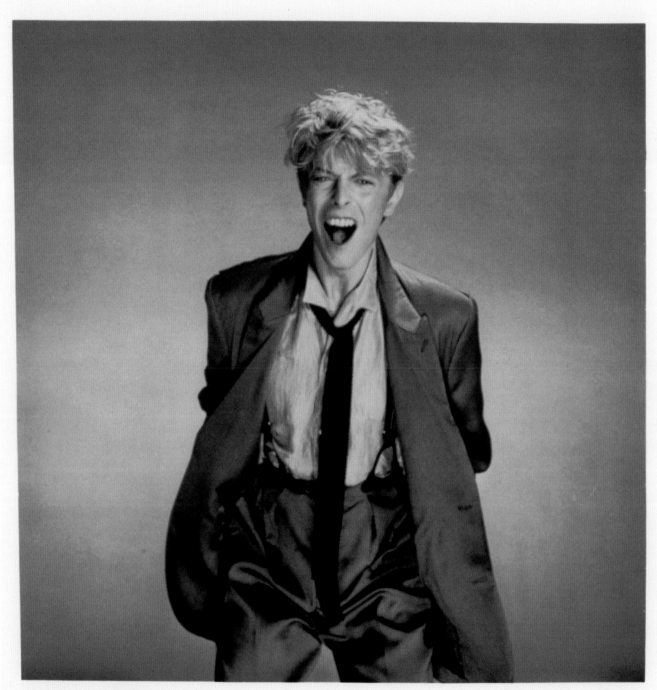

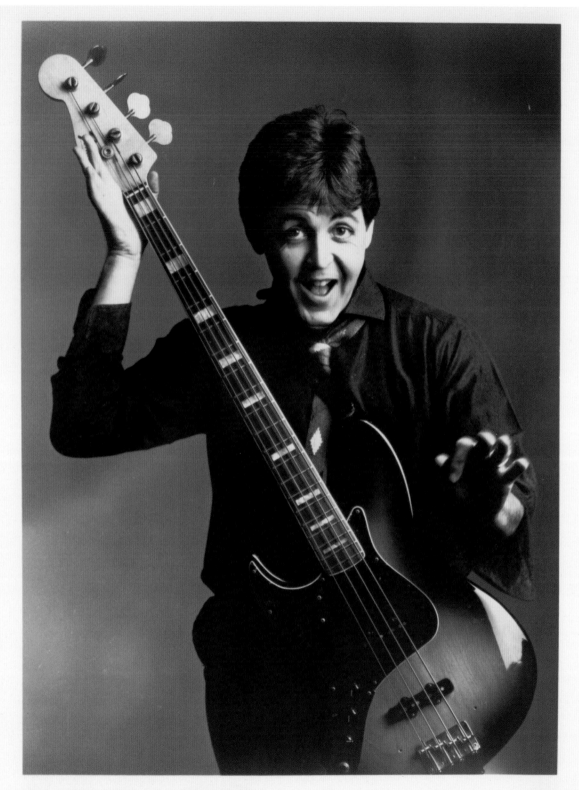

PAUL McCARTNEY

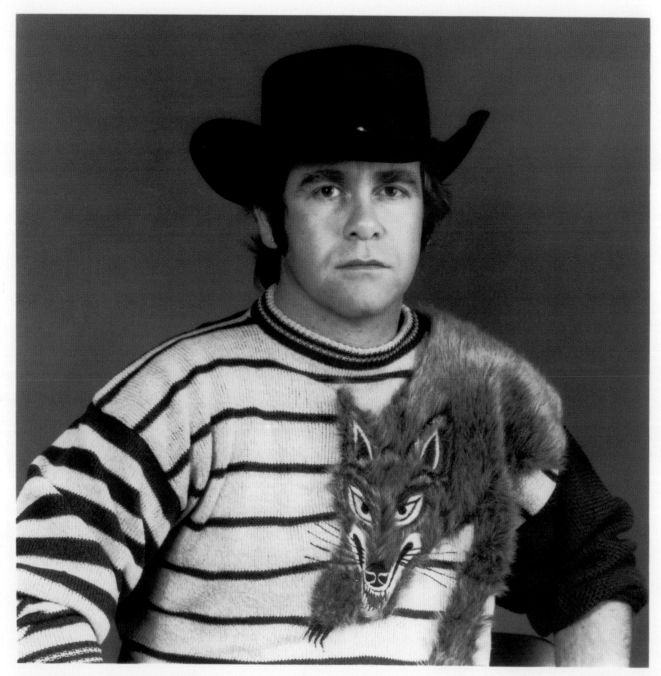

ELTON JOHN

ON RECORD | **1992** | **[MADONNA | PAT BENATAR | HEART]**

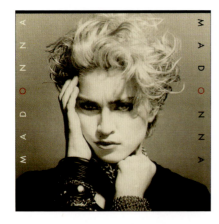

Madonna rose to stardom with her debut album, three dance-pop hits—"Holiday," "Lucky Star" and "Borderline"—and a crucifix-centric fashion style.

Billboard 200: *Madonna* (#8)
Billboard Hot 100: "Holiday" (#16); "Lucky Star" (#4); "Borderline" (#10)

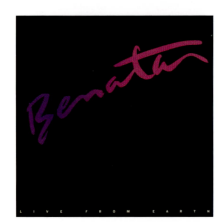

Pat Benatar's *Live from Earth* contained a studio recording, "Love Is a Battlefield," one of the distinctive rock singer's biggest international smashes.

Billboard 200: *Live from Earth* (#13)
Billboard Hot 100: "Love Is a Battlefield" (#5)

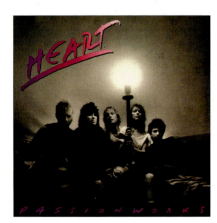

With "How Can I Refuse," **Heart**, led by sisters Ann and Nancy Wilson, made it to No. 1 on the charts ranking airplay on album-oriented rock stations.

Billboard 200: *Passionworks* (#39)
Billboard Hot 100: "How Can I Refuse" (#44); "Allies" (#83)

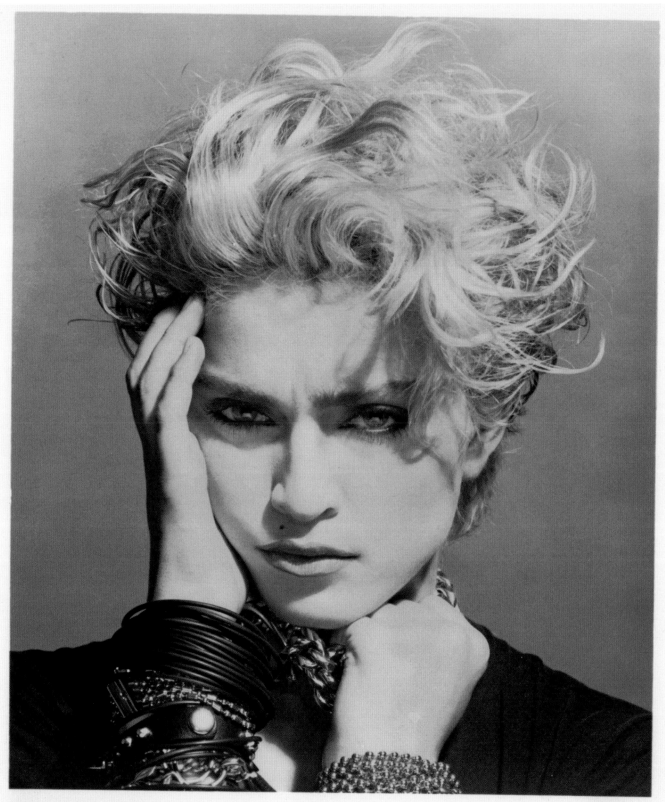

MADONNA

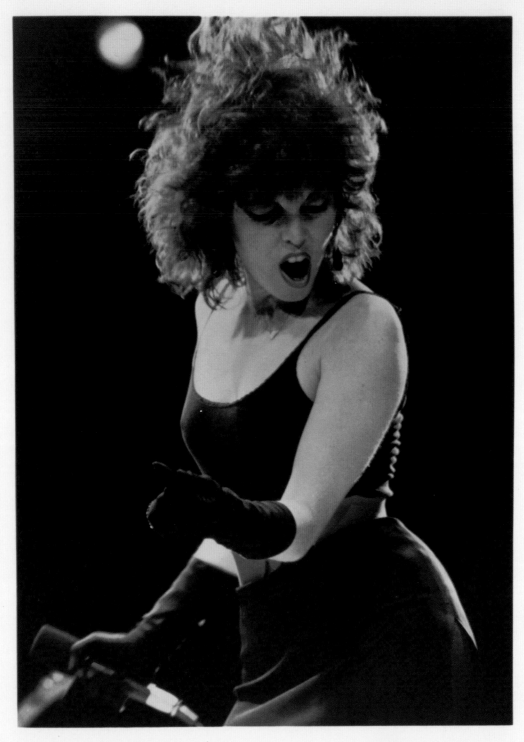

PAT BENATAR

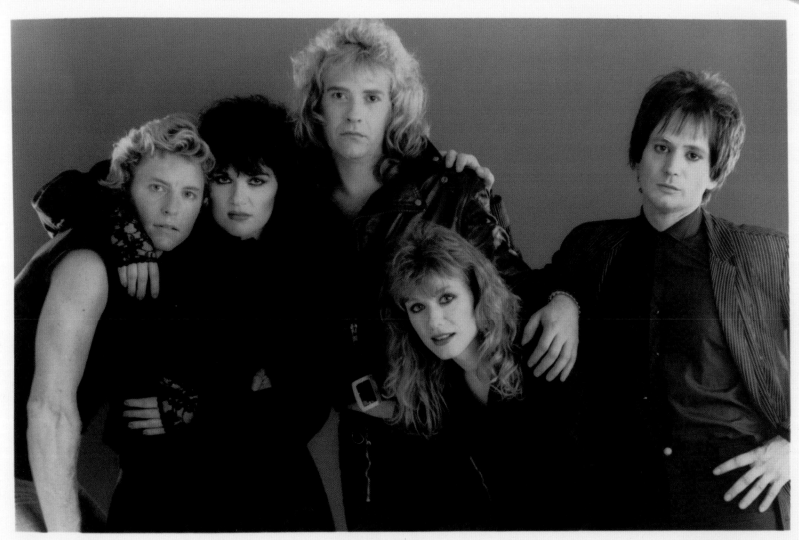

MARK ANDES　　ANN WILSON　　HOWARD LEESE　　NANCY WILSON　　DENNY CARMASSI

heart

ON RECORD | 1983 | [DURAN DURAN | SPANDAU BALLET | TEARS FOR FEARS]

Seven and the Ragged Tiger spawned the global bestsellers "Union of the Snake" and "The Reflex," **Duran Duran**'s first single to hit No. 1 in the US.

Billboard 200: *Seven and the Ragged Tiger* (#8)
Billboard Hot 100: "Union of the Snake" (#3); "New Moon on Monday" (#10); "The Reflex" (No. 1)

The London quintet **Spandau Ballet** enjoyed vast American success with the polished pop-soul sound of "True," the single from an album of the same name.

Billboard 200: *True* (#19)
Billboard Hot 100: "Communication" (#59); "True" (#4); "Gold" (#29)

Tears for Fears offered edgy "primal theory" lyrics on its debut album, *The Hurting*, and "Change" accorded the British band a charting single in the US.

Billboard 200: *The Hurting* (#73)
Billboard Hot 100: "Change" (#73)

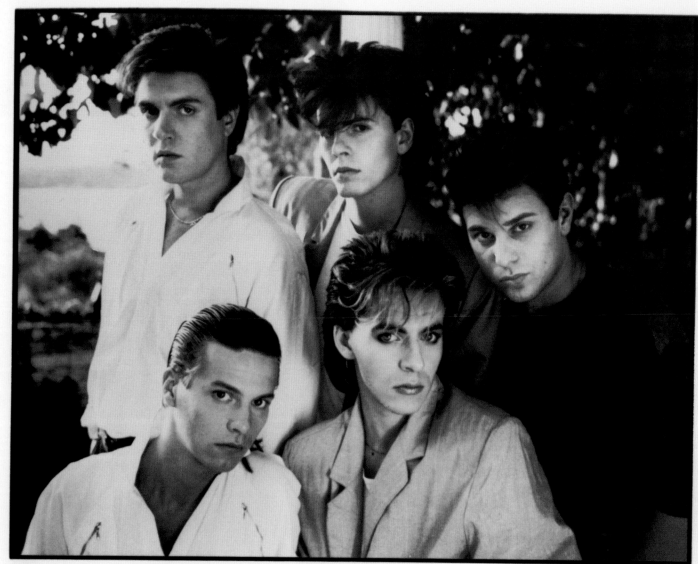

duran duran

Photo: Brian Aris / 1983

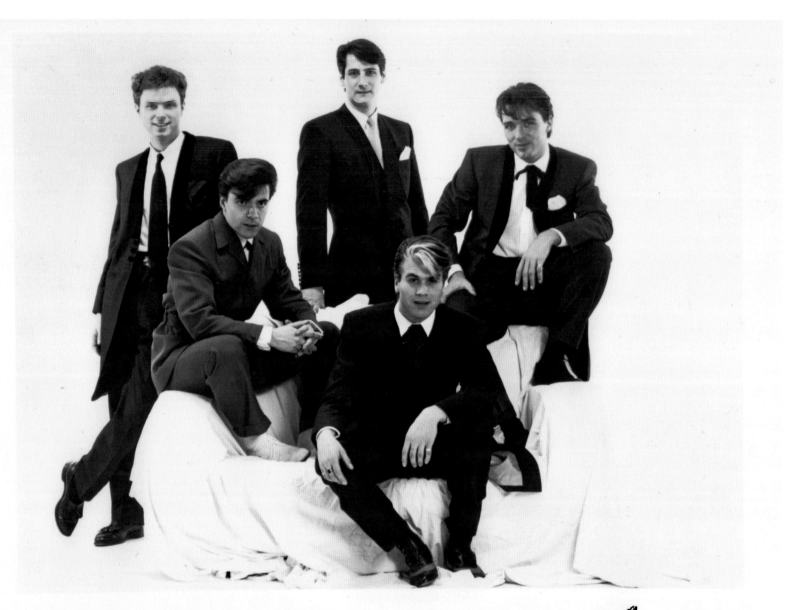

SPANDAU BALLET

Tears For Fears **PolyGram Records**

ON RECORD | 1992 | [THE HUMAN LEAGUE | THOMPSON TWINS | WHAM! U.K.]

The Human League issued a six-song EP as a stopgap between albums and scored a pair of synth-pop hits, "(Keep Feeling) Fascination" and "Mirror Man."

Billboard 200: *Fascination!* (#22)
Billboard Hot 100: "Mirror Man" (#30); "(Keep Feeling) Fascination" (#8)

Thompson Twins broke through on the US charts with dance-club hits that caught the essence of British techno-pop, "Lies" and "Love on Your Side."

Billboard 200: *Side Kicks* (#34)
Billboard Hot 100: "Lies" (#30); "Love on Your Side" (#45)

As **Wham! U.K.**, George Michael and Andrew Ridgeley first appeared with *Fantastic*, presenting themselves as sullen leather-jacketed North London lads.

Billboard 200: *Fantastic* (#83)
Billboard Hot 100: "Bad Boys" (#60)

IAN BURDEN
JOANNE CATHRELL

SUSAN SULLEY
ADRIAN WRIGHT

PHIL OAKEY
JO CALLIS

HUMAN LEAGUE

 WHAM! U.K.

ON RECORD | 1992 | [CULTURE CLUB | STRAY CATS | NEIL YOUNG]

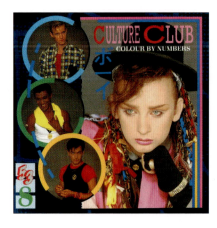

Fronted by the beguiling Boy George, **Culture Club** hit No. 1 in 17 countries with "Karma Chameleon," taken from the group's *Colour by Numbers* album.

Billboard 200: *Colour by Numbers* (#2)
Billboard Hot 100: "Karma Chameleon" (No. 1);
"Miss Me Blind" (#5); "It's A Miracle" (#13)

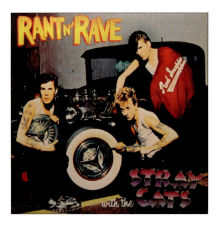

From *Rant N' Rave with the Stray Cats*, rockabilly revivalists **Stray Cats** racked up the hit singles "(She's) Sexy + 17" and "I Won't Stand in Your Way."

Billboard 200: *Rant n' Rave with the Stray Cats* (#14)
Billboard Hot 100: "(She's) Sexy + 17" (#5);
"I Won't Stand in Your Way" (#35); "Look at That Cadillac" (#68)

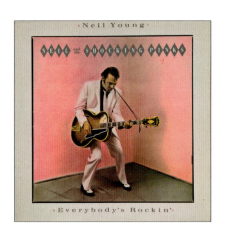

Everybody's Rockin', **Neil Young**'s rockabilly collection, had a total running time of 25 minutes, and his label sued him for making "uncharacteristic" music.

Billboard 200: *Everybody's Rockin'* (#46)

CULTURE CLUB

Pic. Mark Lebon.

NEIL YOUNG

GEFFEN RECORDS

ON RECORD 1992 [THE FIXX | A FLOCK OF SEAGULLS | ECHO & THE BUNNYMEN]

The Fixx entered the upper tier of British new-wave bands with the sprightly pulse of "One Thing Leads to Another" and the shimmer of "Saved by Zero."

Billboard 200: *Reach the Beach* (#8)
Billboard Hot 100: "Saved by Zero" (#20);
"One Thing Leads to Another" (#4); "The Sign of Fire" (#32)

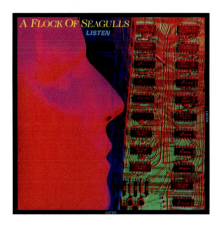

A Flock of Seagulls' sophomore effort, *Listen*, delivered the British synth-pop quartet another alluring radio hit, "Wishing (If I Had a Photograph of You)."

Billboard 200: *Listen* (#16)
Billboard Hot 100: "Wishing (If I Had a Photograph of You)" (#26)

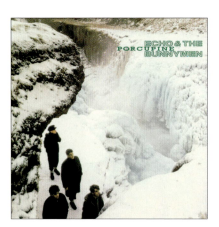

Porcupine, **Echo & the Bunnymen**'s third album, began with the stunning surge of "The Cutter," propelled by the vivid playing of Indian violinist Shankar.

Billboard 200: *Porcupine* (#137)

The Fixx

Exclusively On
MCA RECORDS

 A Flock of Seagulls

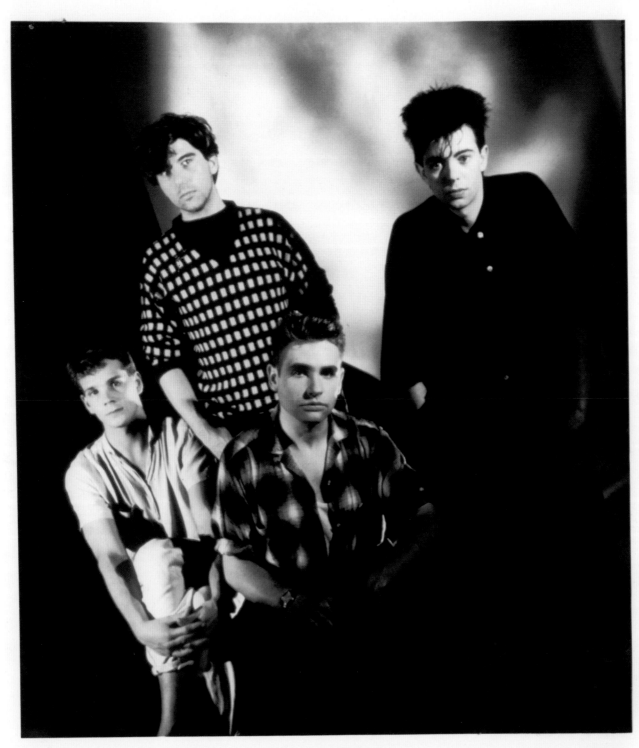

ECHO & THE BUNNYMEN

ON RECORD | 1992 | [TALKING HEADS | KING SUNNY ADÉ | RE-FLEX]

Cutting ties with producer Brian Eno, **Talking Heads** saw a commercial breakthrough with the funk-flavored "Burning Down the House," their first Top 10 hit.

Billboard 200: *Speaking in Tongues* (#15)
Billboard Hot 100: "Burning Down the House" (#8); "This Must Be the Place (Naïve Melody)" (#62)

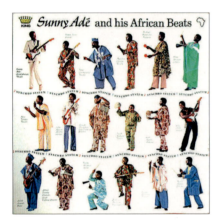

The clear star of juju, the popular music of Nigeria, **King Sunny Adé** entered the US album chart and garnered a Grammy nomination with *Synchro System*.

Billboard 200: *Synchro System* (#91)

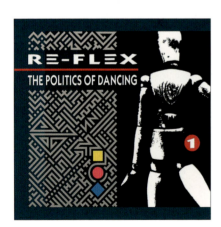

Distinguished by a walloping club-ready groove, **Re-Flex**'s "The Politics of Dancing" achieved monumental worldwide success for the English new-wave band.

Billboard 200: *The Politics of Dancing* (#53)
Billboard Hot 100: "The Politics of Dancing" (#24); "Hurt" (#82)

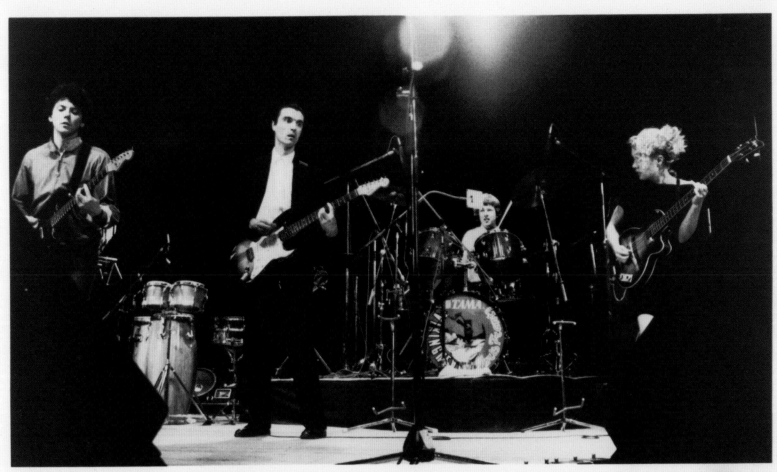

TALKING HEADS

ON RECORD 1992 [BONNIE TYLER | LAURA BRANIGAN | OLIVIA NEWTON-JOHN]

Welsh singer **Bonnie Tyler**'s emotive rasp and Jim Steinman's histrionic production made the power ballad "Total Eclipse of the Heart" a best-selling hit.

Billboard 200: *Faster than the Speed of Night* (#4)
Billboard Hot 100: "Total Eclipse of the Heart" (No. 1);
"Take Me Back" (#46)

"Solitaire," a Top 10 pop hit, and "How Am I Supposed to Live Without You," which rose to No. 1 on adult-contemporary charts, glorified **Laura Branigan**.

Billboard 200: *Branigan 2* (#29)
Billboard Hot 100: "Solitaire" (#7);
"How Am I Supposed to Live Without You" (#12)

Grease stars **Olivia Newton-John** and John Travolta reunited for *Two of a Kind*, a film that bombed, but a soundtrack pushing her "Twist of Fate" blew up.

Billboard 200: *Two of a Kind* (#26)
Billboard Hot 100: "Twist of Fate" (#5);
"Livin' in Desperate Times" (#31)

BONNIE TYLER

LAURA BRANIGAN

Punch the Clock generated a scintillating pop single, "Everyday I Write the Book," **Elvis Costello & the Attractions**' first hit to crack the Top 40 in the US.

Billboard 200: *Punch the Clock* (#24)
Billboard Hot 100: "Everyday I Write the Book" (#36)

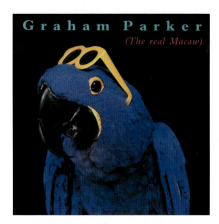

Flinty singer-songwriter **Graham Parker** started taking some of the bark out of his biting worldview, revealing an upbeat romanticism on *The Real Macaw*.

Billboard 200: *The Real Macaw* (#59)
Billboard Hot 100: "Life Gets Better" (#94)

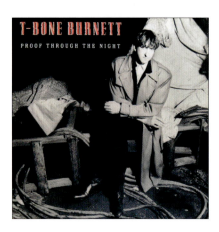

Coming to attention as Bob Dylan's guitarist during the Seventies, **T-Bone Burnett** got secondary airplay for "When the Night Falls," with guest Ry Cooder.

Billboard 200: *Proof Through the Night* (#188)

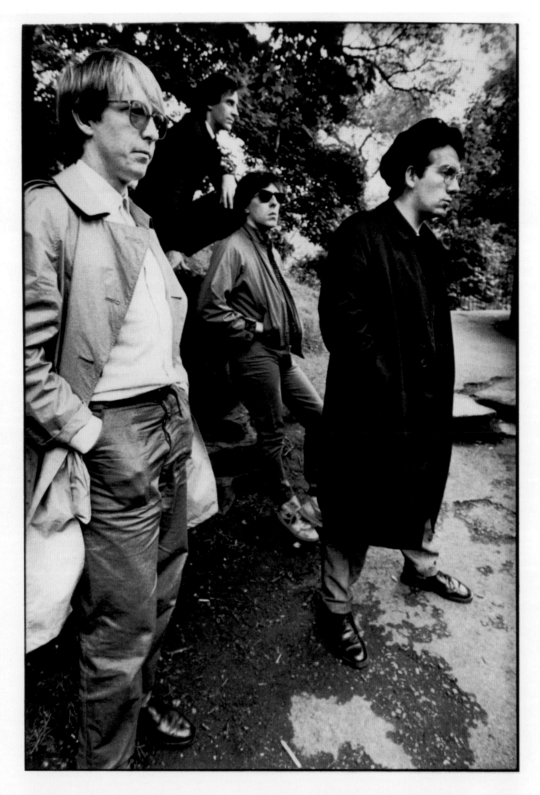

ELVIS COSTELLO and the ATTRACTIONS

Photo By Jo Dee

Management:
Ernest Chapman
London
01-221-7422

Graham Parker

ARISTA

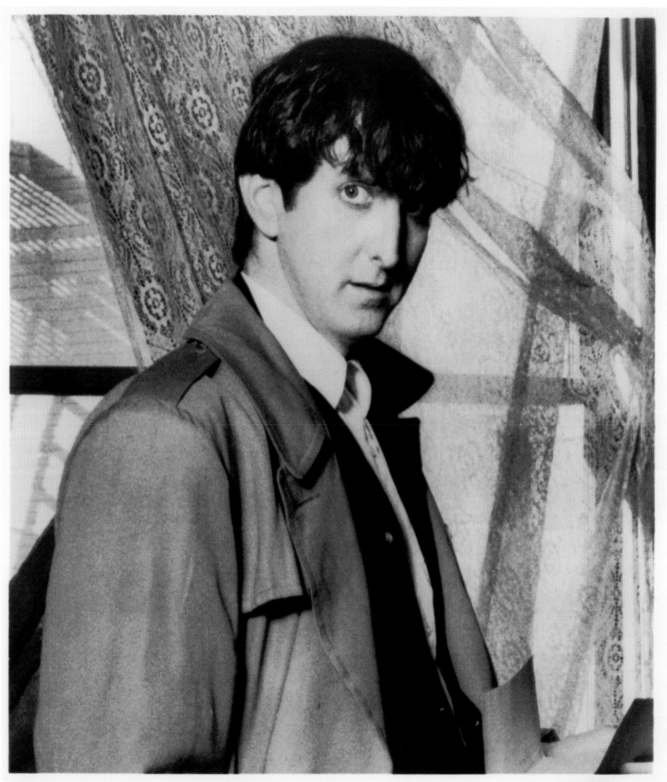

T–BONE BURNETT

WARNER BROS.

ON RECORD | 1992 | [JACKSON BROWNE | COREY HART | RICK SPRINGFIELD]

Singer-songwriter **Jackson Browne**'s *Lawyers in Love*, his seventh album, explored themes both personal ("Tender Is the Night") and political (the title track).

Billboard 200: *Lawyers in Love* (#8)
Billboard Hot 100: "Lawyers in Love" (#13); "Tender Is the Night" (#25); "For a Rocker" (#45)

A Canadian singer and songwriter, **Corey Hart** debuted to worldwide accolades with the massive hit "Sunglasses at Night" and the ballad "It Ain't Enough."

Billboard 200: *First Offense* (#31)
Billboard Hot 100: "Sunglasses at Night" (#7); "It Ain't Enough" (#17)

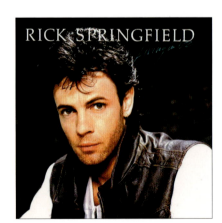

The intimate *Living in Oz*, a self-produced album by Australian-born musician and actor **Rick Springfield**, bore another Top 10 US hit, "Affair of the Heart."

Billboard 200: *Living in Oz* (#12)
Billboard Hot 100: "Affair of the Heart" (#9); "Human Touch" (#18); "Souls" (#23)

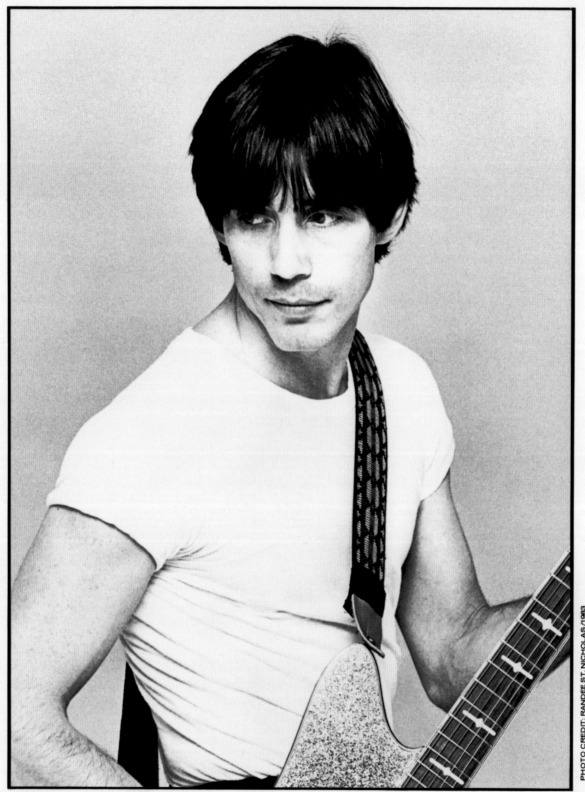

JACKSON BROWNE

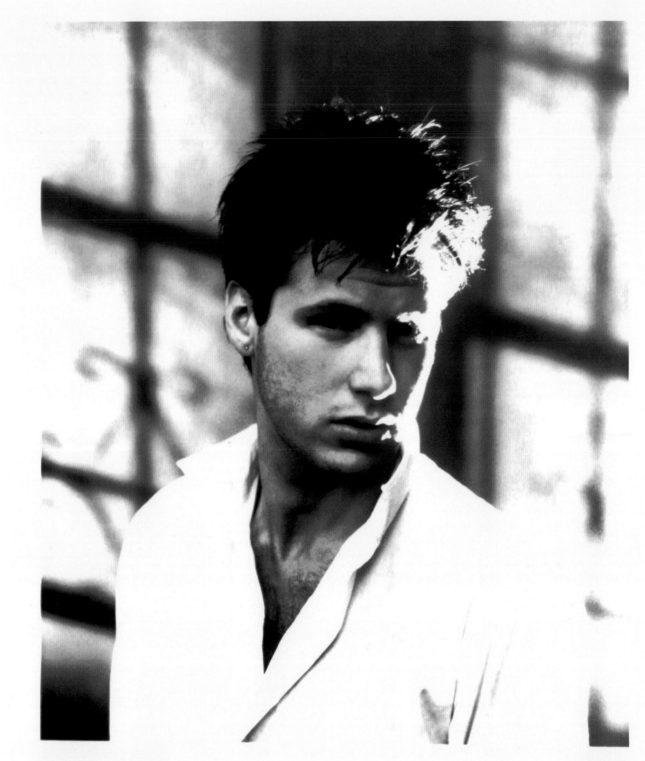

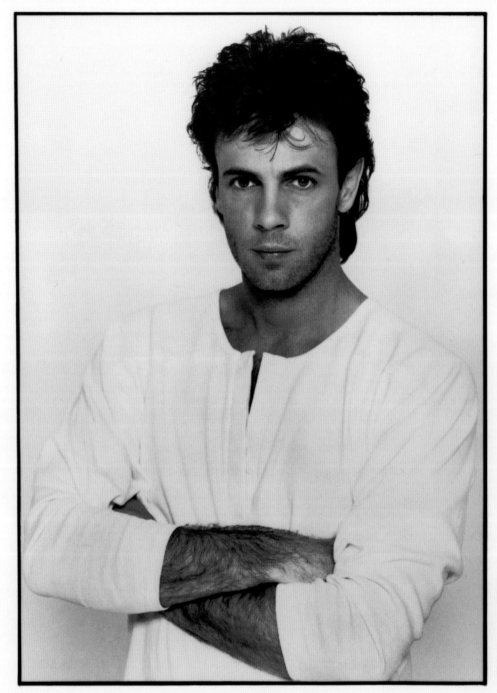

RICK SPRINGFIELD

Public Relations:
ROGERS AND COWAN
9665 Wilshire Blvd.
Beverly Hills CA 90212
(213) 275-4581

122 East 42nd Street
New York NY 10168
(212) 490-8200

Photograph by LEON LECASH

ON RECORD | **1992** | **[ADAM ANT | JoBOXERS | ROMAN HOLLIDAY]**

Abetted by Phil Collins, who produced and played drums, the title track from *Strip*, **Adam Ant**'s second solo album, benefited from a lighter pop approach.

Billboard 200: *Strip* (#65)
Billboard Hot 100: "Strip" (#42)

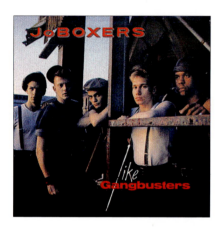

Featured on **JoBoxers**' debut album *Like Gangbusters*, the soulful "Just Got Lucky" broke into the US Top 40 and boosted the London-based pop quintet.

Billboard 200: *Like Gangbusters* (#70)
Billboard Hot 100: "Just Got Lucky" (#36)

The seven members of the young British act **Roman Holliday** broke through with an energetic mix of rockabilly and the pre-R&B sound of swing-jazz artists.

Billboard 200: *Cookin' on the Roof* (#116)
Billboard Hot 100: "Stand By" (#54); "Don't Try to Stop It" (#68)

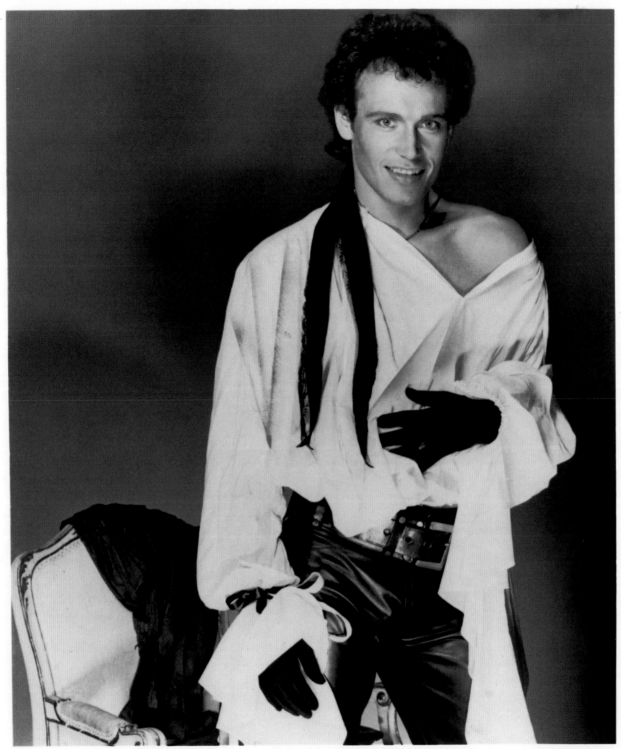

ADAM ANT

Photo: Allan Ballard

JoBOXERS

RCA Records and Tapes

Hailing from Melbourne, Australia, **Real Life** rose to fame with "Send Me an Angel," a synth-pop classic culled from the band's debut album *Heartland*.

Billboard 200: *Heartland* (#58)
Billboard Hot 100: "Send Me an Angel" (#29); "Catch Me I'm Falling" (#40)

Electro-pop duo **Naked Eyes** scored with "Always Something There to Remind Me," an indelible cover version of the Burt Bacharach/Hal David standard.

Billboard 200: *Naked Eyes* (#32)
Billboard Hot 100: "Always Something There to Remind Me" (#8); "Promises, Promises" (#11); "When the Lights Go Out" (#37)

Kajagoogoo reached the Top 10 in several countries with a singable debut single, "Too Shy," the British new-wave act's only hit of significance in the US.

Billboard 200: *White Feathers* (#38)
Billboard Hot 100: "Too Shy" (#5); "Hang on Now" (#78)

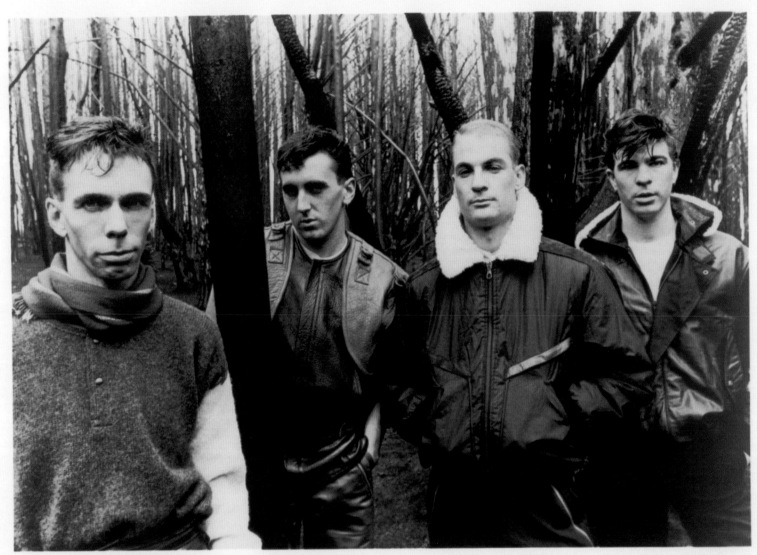

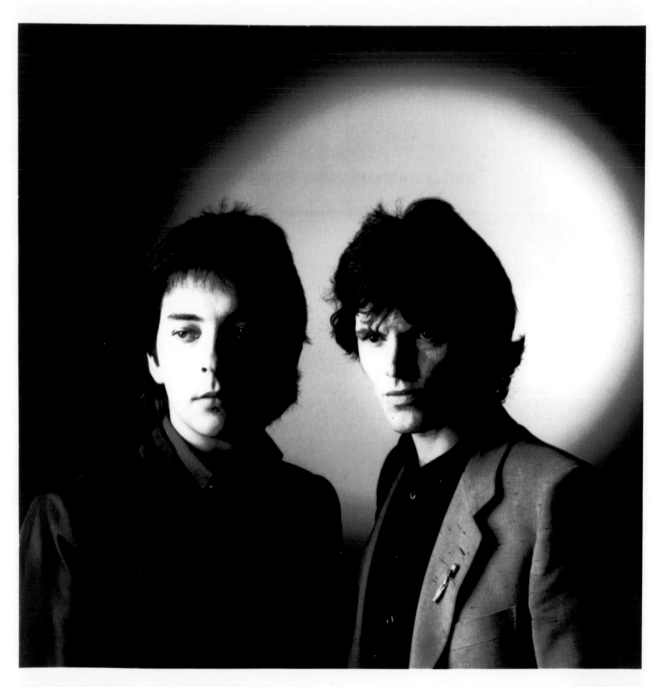

COPYRIGHT EMI RECORDS (UK) - PHOTOGRAPHER: BRIAN ARIS

NAKED EYES

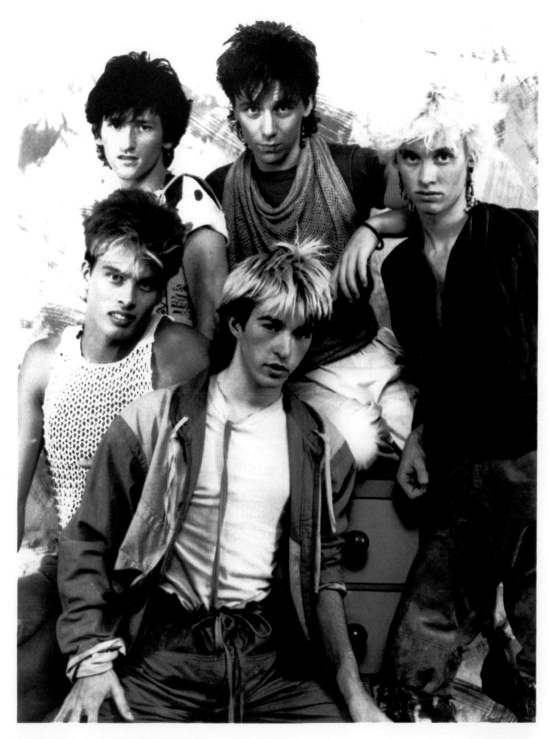

COPYRIGHT EMI RECORDS (UK) - PHOTOGRAPHER: SHEILA ROCK

ON RECORD 1992 [THE KINKS | ROD STEWART | ERIC CLAPTON]

The Kinks' second wave of fame crested with "Come Dancing," the British Invasion band's highest charting US hit since 1965's "Tired of Waiting for You."

Billboard 200: *State of Confusion* (#12)
Billboard Hot 100: "Come Dancing" (#6);
"Don't Forget to Dance" (#29)

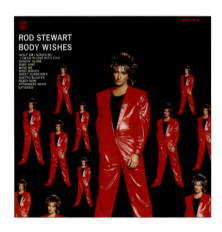

Rock star **Rod Stewart**'s *Body Wishes* album felt obligatory and bromidic, vindicated only by the track "Baby Jane," a consequential single internationally.

Billboard 200: *Body Wishes* (#30)
Billboard Hot 100: "Baby Jane" (#14);
"What Am I Gonna Do (I'm So in Love with You)" (#35)

Having survived lengthy mental and physical struggles with alcoholism, **Eric Clapton** somehow remained strong, recording the album *Money and Cigarettes*.

Billboard 200: *Money and Cigarettes* (#16)
Billboard Hot 100: "I've Got a Rock 'n' Roll Heart" (#18)

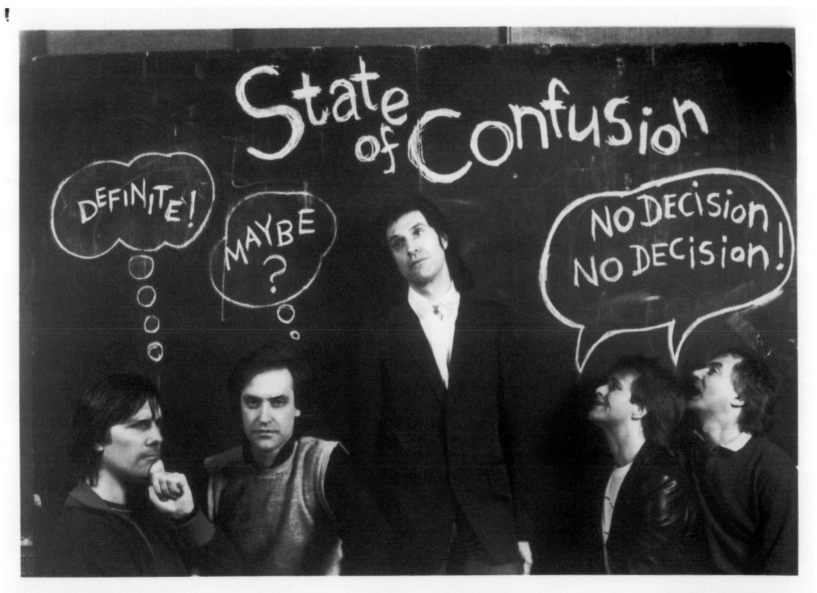

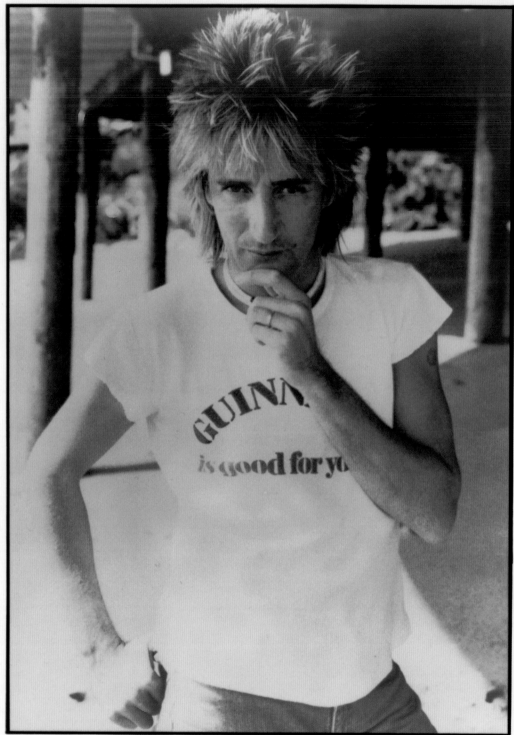

ROD STEWART

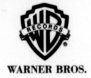

WARNER BROS.

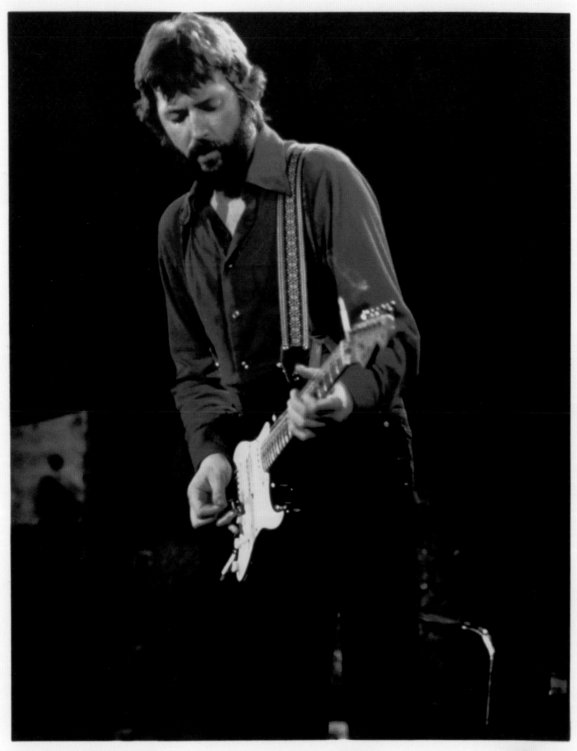

MANAGEMENT: Roger Forrester
77 Harley House
Regents Park
London NW1 5HF
England

WARNER BROS.

ON RECORD 1992 [CHRISTOPHER CROSS | JIMMY BUFFETT | GUY CLARK]

Another Page, **Christopher Cross**' second album of soft rock, gained ground when "Think of Laura" was featured on the soap opera *General Hospital*.

Billboard 200: *Another Page* (#11)
Billboard Hot 100: "All Right" (#12);
"No Time for Talk" (#33); "Think of Laura" (#9)

Jimmy Buffett reached the adult-contemporary charts with "One Particular Harbor," an immediate fan favorite that he played at nearly all his concerts.

Billboard 200: *One Particular Harbour* (#59)

An affecting laudation of life's simple pleasures, "Homegrown Tomatoes" graced *Better Days*, master Texas singer-songwriter **Guy Clark**'s fifth album.

260

CHRISTOPHER CROSS

Photo credit: MATTHEW ROLSTON

WARNER BROS.

Jimmy Buffett

FRONT LINE MANAGEMENT
9044 Melrose Avenue
3rd Floor
Los Angeles, Ca. 90069
(213) 859-1900

MCA RECORDS

GUY CLARK

ON RECORD | 1992 | [AC/DC | BLACKFOOT | KROKUS]

Seeking to reclaim the directness and rawness that defined earlier albums, **AC/DC** ceased its association with producer Mutt Lange for *Flick of the Switch*.

Billboard 200: *Flick of the Switch* (#15)
Billboard Hot 100: "Guns for Hire" (#84)

The lineup for heavy Southern-rock group **Blackfoot**'s *Siogo* album included British keyboardist Ken Hensley, a founder of the pioneering Uriah Heep.

Billboard 200: *Siogo* (#82)

Swiss hard rockers **Krokus** made headway in America with the frenetic *Headhunter* album, which boasted a skillful power ballad, "Screaming in the Night."

Billboard 200: *Headhunter* (#25)

264

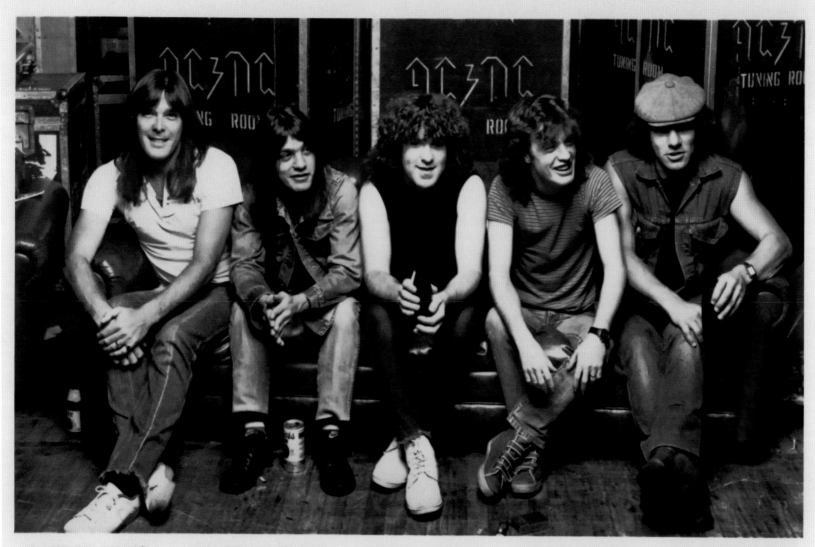

CLIFF WILLIAMS MALCOLM YOUNG SIMON WRIGHT ANGUS YOUNG BRIAN JOHNSON

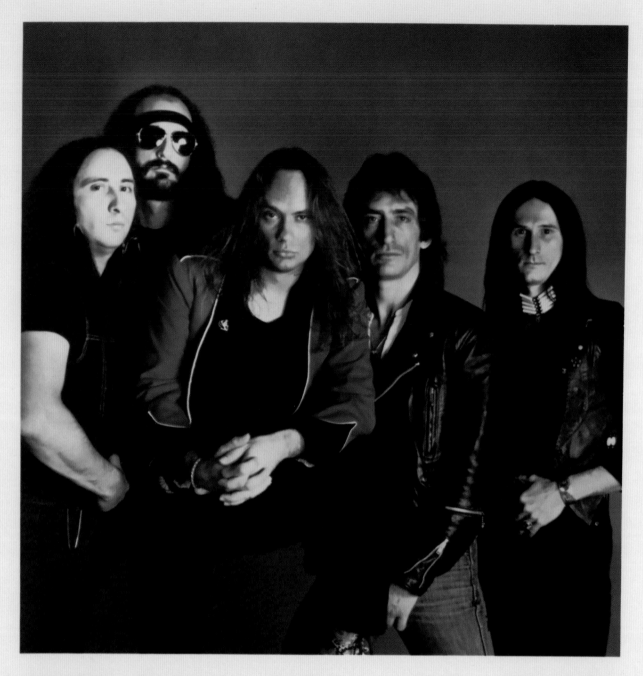

Jakson Spires Charlie Hargrett Rick Medlocke Ken Hensley Greg T Walker

BLACKFOOT

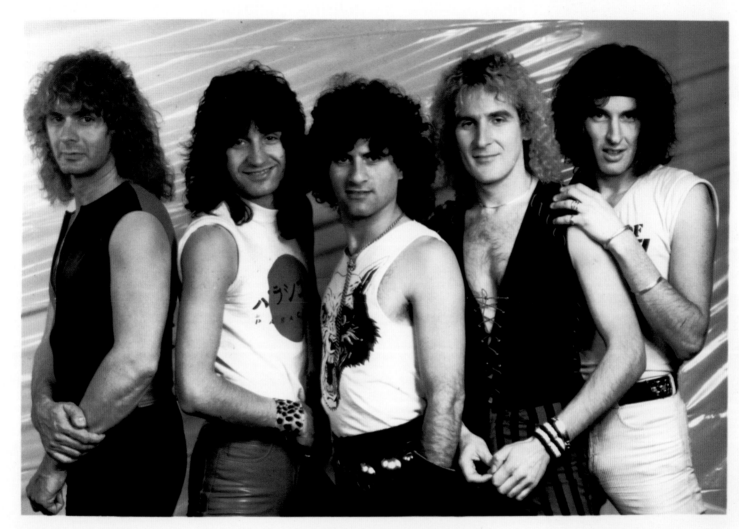

ATI
888 Seventh Avenue
New York, New York 10019

Management:
Butch Stone
(501) 481-5131

Photo Credit: Steve Joester

Havana Moon, a winsome solo project fueled by Chuck Berry's title song, revisited **Carlos Santana**'s musical path from Fifties rock 'n' roll to Tex-Mex.

Billboard 200: *Havana Moon* (#31)

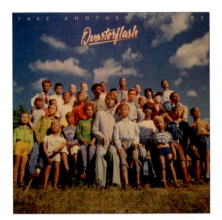

Keen to build on its smash 1981 debut offering, **Quarterflash** delivered a second album and another Top 20 hit single, the satisfying "Take Me to Heart."

Billboard 200: *Take Another Picture* (#34)
Billboard Hot 100: "Take Me to Heart" (#14); "Take Another Picture" (#58)

The English band **Marillion** debuted its neo-progressive rock stylings on the album *Script for a Jester's Tear*, stewarded by theatrical lead vocalist Fish.

Billboard 200: *Script for a Jester's Tear* (#175)

CARLOS SANTANA

Bill Graham Management
PREMIER TALENT AGENCY
New York (212) 758-4900

8304

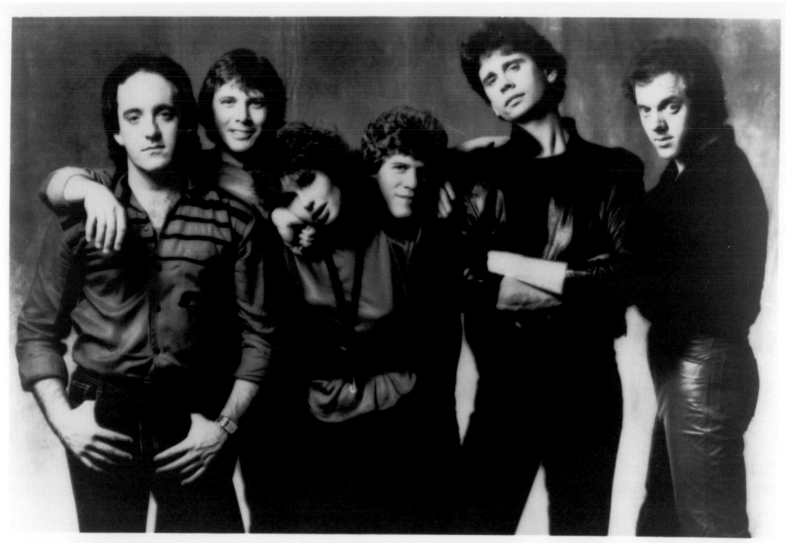

Rick Di Giallonardo, Rich Gooch, Rindy Ross, Brian David Willis, Marv Ross, Jack Charles

QUARTERFLASH

GEFFEN RECORDS

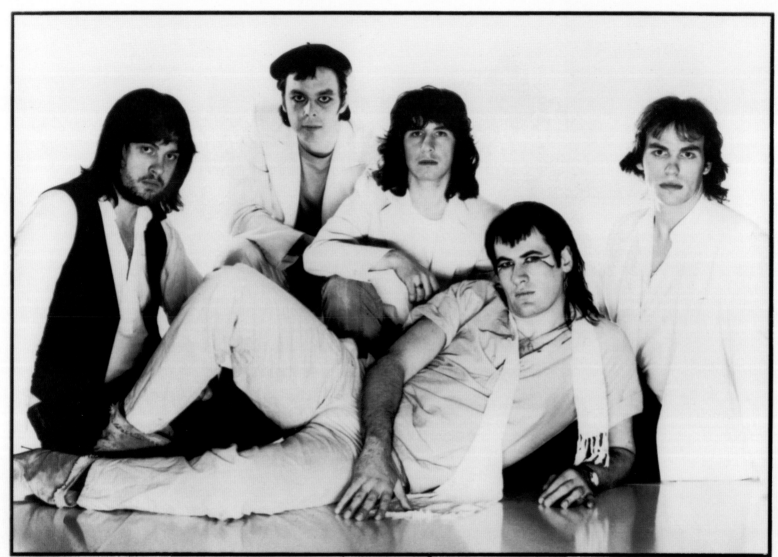

Photo: Gered Mankowitz / 1983

ON RECORD 1992 [THE MOTELS | BANANARAMA | NINA HAGEN]

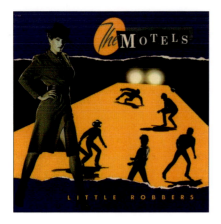

The Motels, led by sultry Martha Davis, provided two estimable tracks, the No. 1 album-rock hit "Suddenly Last Summer" and "Remember the Nights."

Billboard 200: *Little Robbers* (#22)
Billboard Hot 100: "Suddenly Last Summer" (#9);
"Remember the Nights" (#36)

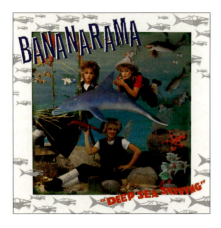

Deep Sea Skiving, **Bananarama**'s debut album, housed four British hit singles, with "Shy Boy" becoming the girl trio's first song to dent the US pop charts.

Billboard 200: *Deep Sea Skiving* (#63)
Billboard Hot 100: "Shy Boy" (#83)

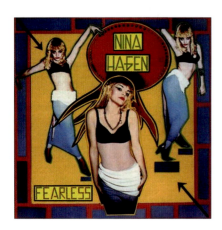

German singer **Nina Hagen** moved on from her new-wave theatrics for a dance-pop sound, generating two US club hits, "Zarah" and "New York New York."

Billboard 200: *Fearless* (#151)

272

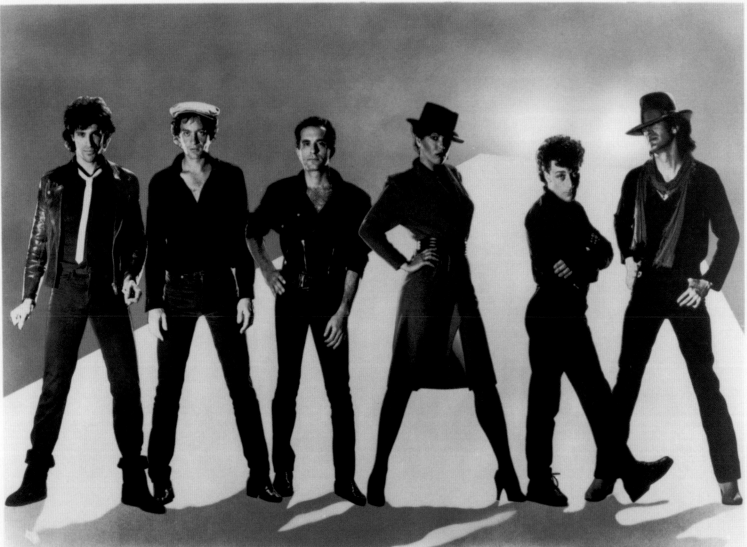

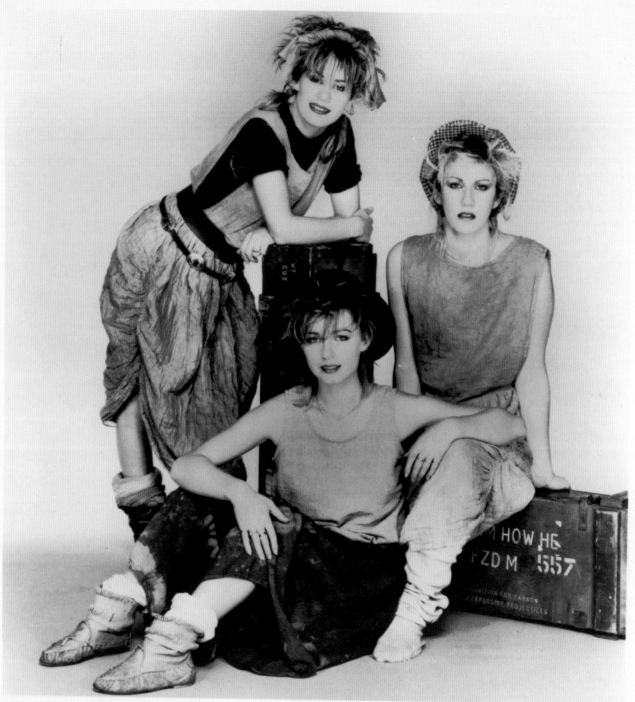

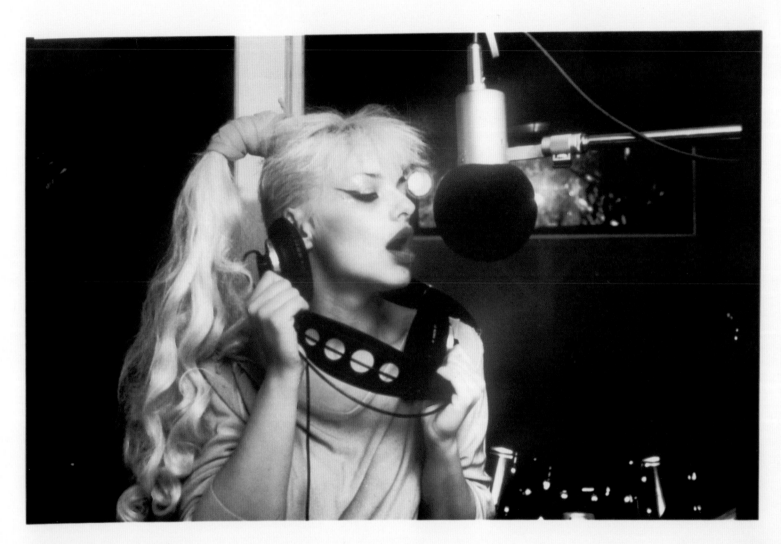

NINA HAGEN

ON RECORD 1992 [ROLLING STONES | THE MOODY BLUES | ASIA]

The album *Undercover* exposed a rift between **Rolling Stones** singer Mick Jagger and guitarist Keith Richards concerning the band's direction.

Billboard 200: *Undercover* (#4)
Billboard Hot 100: "Undercover of the Night" (#9);
"She Was Hot" (#44)

The Moody Blues' *The Present* bore two moderate hits, the elegant "Blue World," written by Justin Hayward, and John Lodge's "Sitting at the Wheel."

Billboard 200: *The Present* (#26)
Billboard Hot 100: "Blue World" (#62); "Sitting at the Wheel" (#27)

Hot on the heels of a multiplatinum debut, the English progressive-rock supergroup **Asia** delivered *Alpha* and the No. 1 album-rock track "Don't Cry."

Billboard 200: *Alpha* (#6)
Billboard Hot 100: "Don't Cry" (#10);
"The Smile Has Left Your Eyes" (#34)

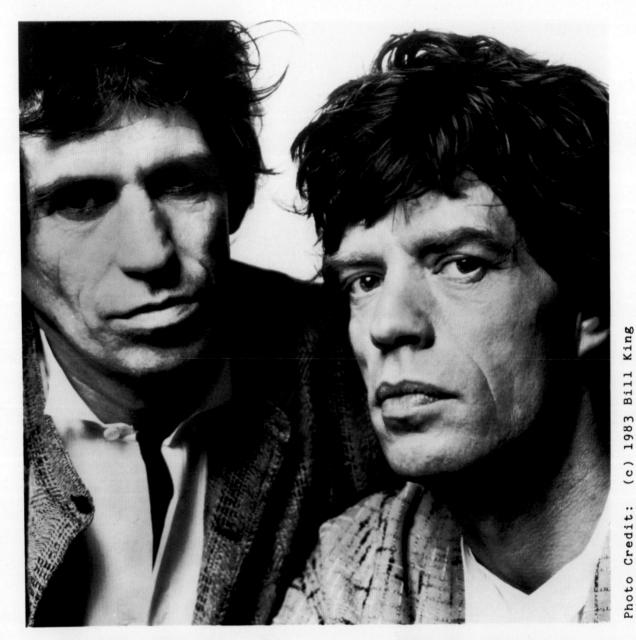

Keith Richards **Mick Jagger**

Photo Credit: (c) 1983 Bill King

Rolling Stones Records

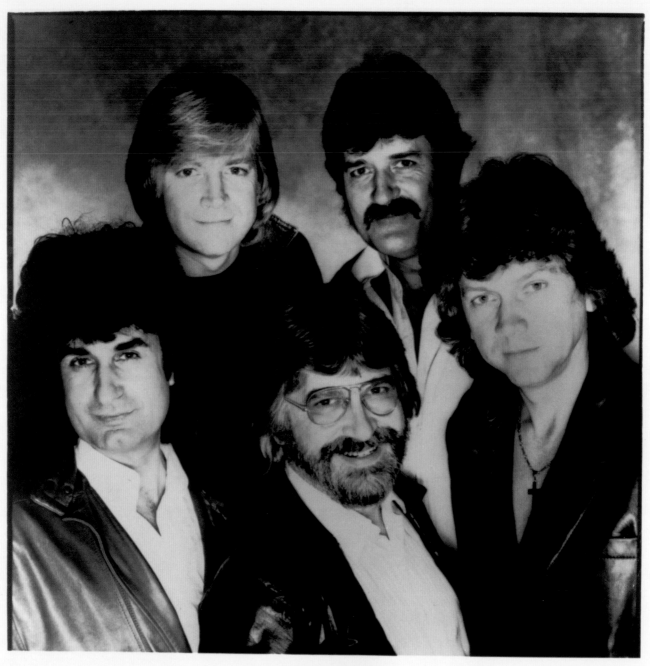

THE MOODY BLUES **PolyGram Records**

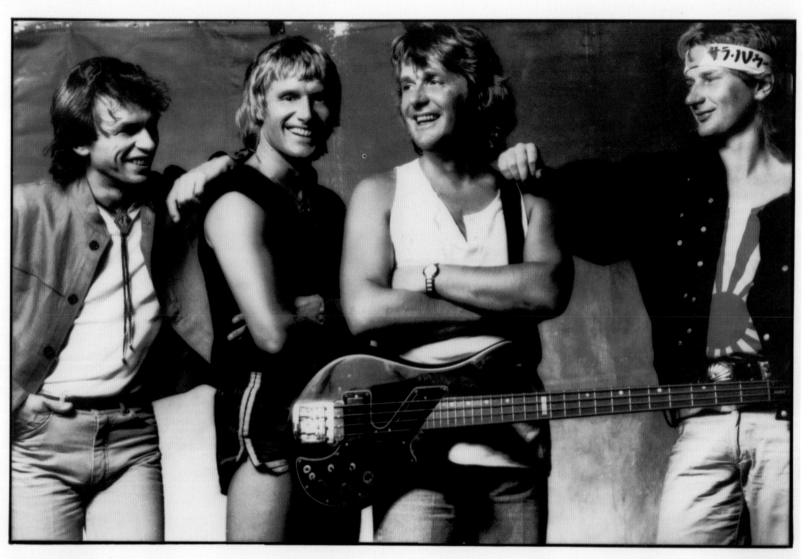

ASIA

Known for "Magnet and Steel," a Top 10 single from 1978, **Walter Egan** showed his resilience by scoring a minor hit with the sublime "Fool Moon Fire."

Billboard Hot 100: "Fool Moon Fire" (#46)

English singer-songwriter **Martin Briley**, a touring and studio musician for a number of artists, nabbed the spotlight with an MTV hit, "The Salt in My Tears."

Billboard 200: *One Night with a Stranger* (#55)
Billboard Hot 100: "The Salt in My Tears" (#36)

"All of the Good Ones Are Taken" became a lesser solo hit in the US for **Ian Hunter**, the former frontman of the British hard-rock band Mott the Hoople.

Billboard 200: *All of the Good Ones Are Taken* (#125)

Photo: *MOSHE BRAHKA*

Walter Egan

Direction: Greg Lewerke
(213) 653-4024

MARTIN BRILEY

PolyGram Records

IAN HUNTER

ON RECORD | **1992** | **[BEE GEES | IRENE CARA | MICHAEL SEMBELLO]**

The film *Staying Alive*, the sequel to *Saturday Night Fever*, was supported by more **Bee Gees** music and the soundtrack's lead single, "The Woman in You."

Billboard 200: *Staying Alive* (#6)
Billboard Hot 100: "The Woman in You" (#24);
"Someone Belonging to Someone" (#49)

Winning an Oscar for "Flashdance...What a Feeling," the No. 1 hit she co-wrote and sang for the film *Flashdance*, **Irene Cara**'s career reached a peak.

Billboard 200: *What a Feelin'* (#77)
Billboard Hot 100: "Flashdance...What a Feeling" (No. 1);
"Why Me?" (#13); "The Dream (Hold On to Your Dream)" (#37);
"Breakdance" (#8); "You Were Made for Me" (#78)

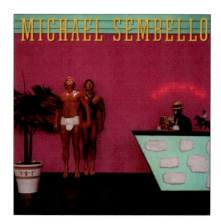

In-demand session musician **Michael Sembello** co-wrote and perfomed "Maniac," which was picked for the soundtrack to *Flashdance* and hit No. 1.

Billboard 200: *Bossa Nova Hotel* (#80)
Billboard Hot 100: "Maniac" (No. 1); "Automatic Man" (#34)

THE BEE GEES **PolyGram** Records

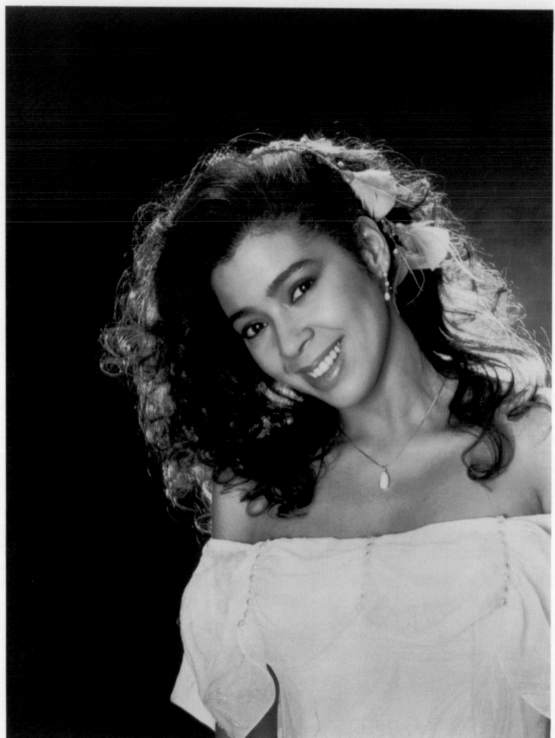

IRENE CARA

GEFFEN RECORDS

NETWORK RECORDS

HARRY LANGDON PHOTOGRAPHY © 1983

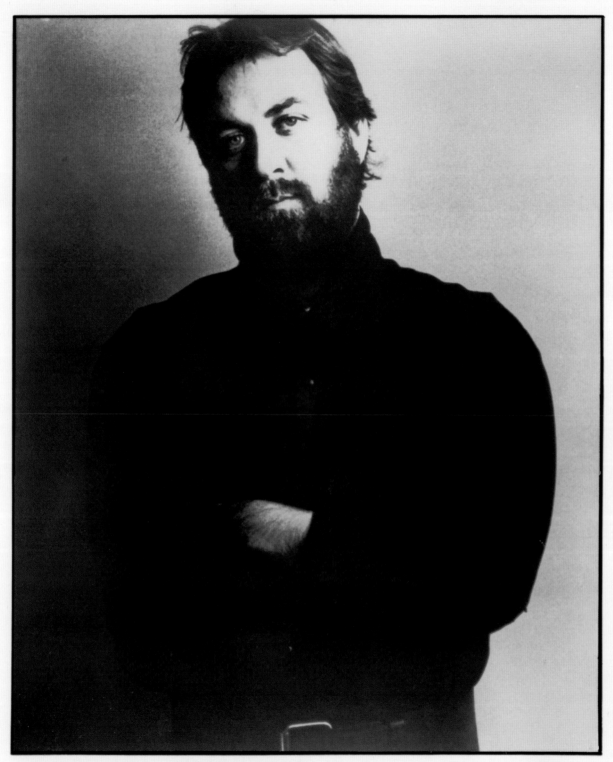

MICHAEL SEMBELLO

WARNER BROS.

[SPARKS | RICK JAMES | AL JARREAU]

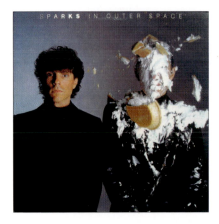

After a dozen albums, cult pop-rock band **Sparks** finally earned a hit in its American homeland with "Cool Places," featuring Jane Wiedlin of the Go-Go's.

Billboard 200: *In Outer Space* (#88)
Billboard Hot 100: "Cool Places" (#49)

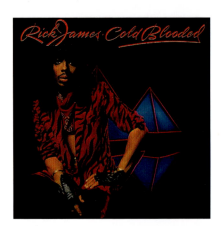

The title track from *Cold Blooded* became **Rick James**' third R&B No. 1 hit, and the album also marked a joint effort with Smokey Robinson, "Ebony Eyes."

Billboard 200: *Cold Blooded* (#16)
Billboard Hot 100: "Cold Blooded" (#40); "Ebony Eyes" (#43)

Singer **Al Jarreau**'s third successive No. 1 album on the jazz charts, *Jarreau* spawned three hit singles and picked up four Grammy Award nominations.

Billboard 200: *Jarreau* (#13)
Billboard Hot 100: "Mornin'" (#21); "Boogie Down" (#77); "Trouble in Paradise" (#63)

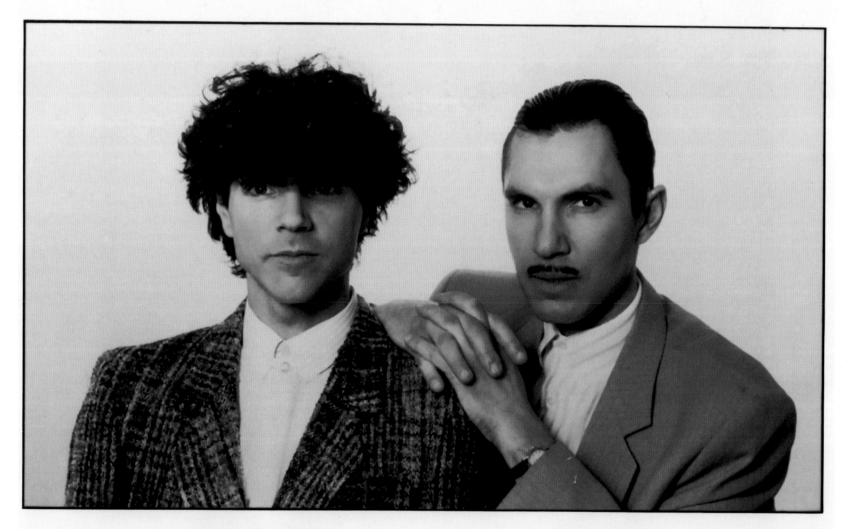

Russell Mael Ron Mael

SPARKS

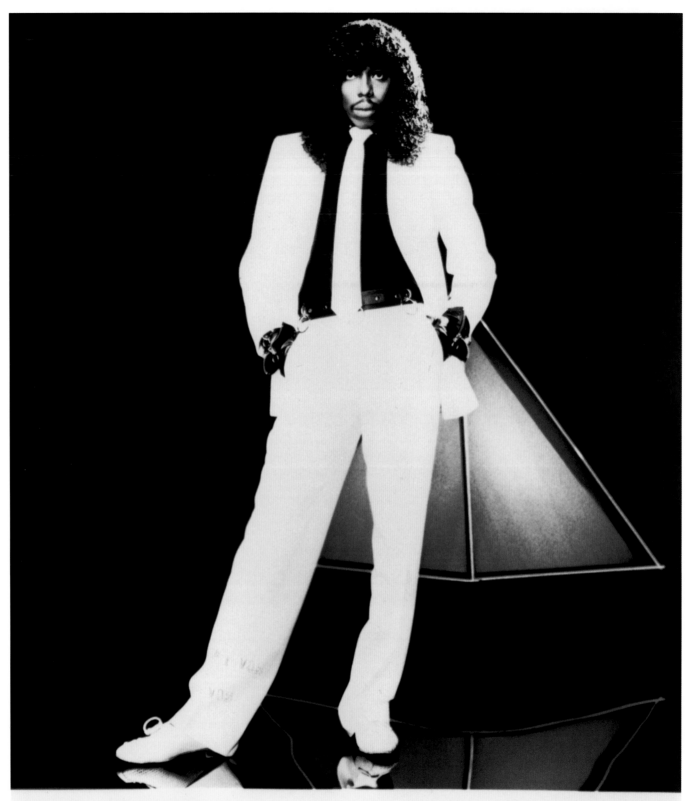

RICK JAMES

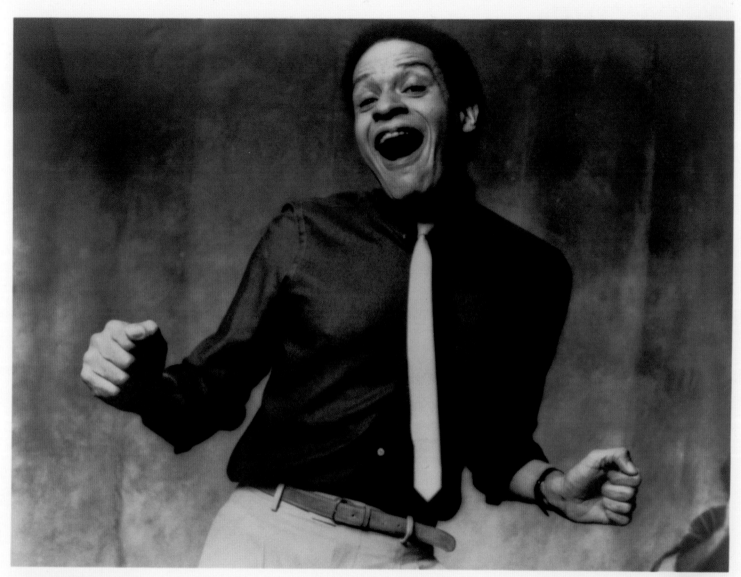

JARREAU

WARNER BROS.

Ish "Angel" Ledesma, frontman of Foxy in the late Seventies, organized **OXO** and constructed a snappy pop single, "Whirly Girl," the band's solitary hit.

Billboard 200: *OXO* (#117)
Billboard Hot 100: "Whirly Girl" (#28)

With "Belly of the Whale," L.A.'s **Burning Sensations** melded African rhythms with Tim McGovern's rousing guitar licks, blasting into clubs and onto MTV.

Formerly a hard-driving punk outfit, New Orleans' **Red Rockers** reconstructed their sound, and the new-wave cultivation produced a radio hit, "China."

Billboard 200: *Good as Gold* (#71)
Billboard Hot 100: "China" (#53)

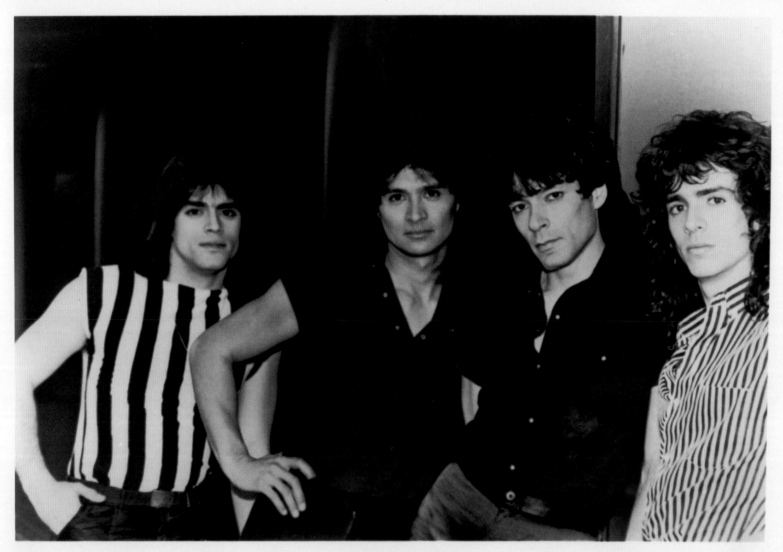

OXOXOXO XOXOXO XOX

FRANK GARCIA FREDDY ALWAG ISH ANGEL ORLANDO

GEFFEN RECORDS

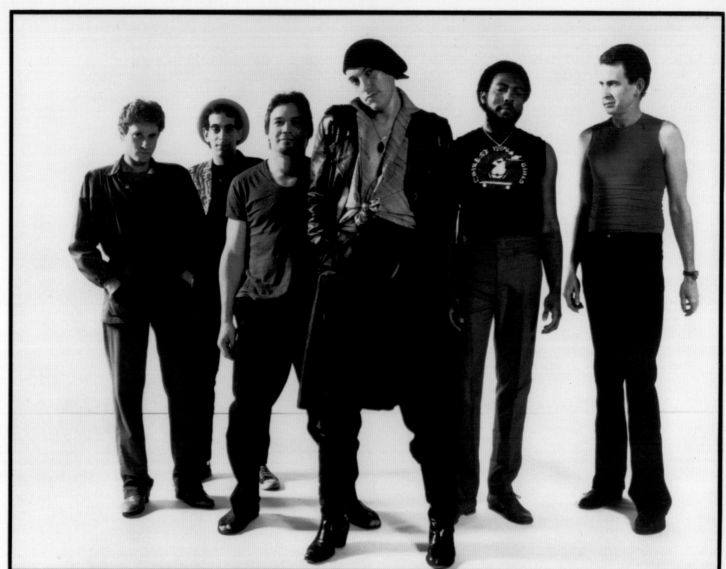

BURNING SENSATIONS

Photo: Ron Slenzak / 1983

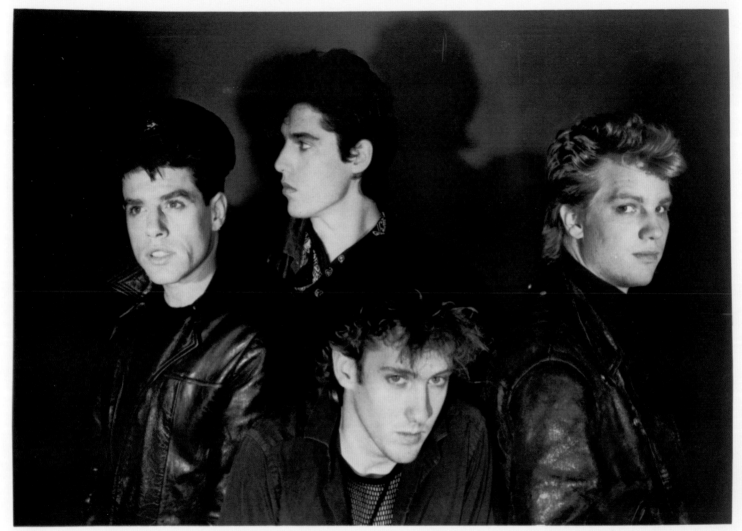

From left: Jim Reilly, Darren Hill, Shawn Paddock, and (front) John Griffith

on 415/Columbia. **Red Rockers**

ON RECORD | 1992 | [THE SYSTEM | ĒBN-ŌZN | MINISTRY]

The System, a New York duo, created the synth-driven "You Are in My System" and caught a break when British rocker Robert Palmer covered the R&B hit.

Billboard 200: *Sweat* (#94)
Billboard Hot 100: "You Are in My System" (#64)

NY-based **Ēbn-Ōzn** reached the culminating point of its career with the synth-pop single "AEIOU Sometimes Y," a staple on MTV and modern-rock radio.

The driving force behind **Ministry**, Al Jourgensen produced the group's debut album *With Sympathy* in a dance style associated with new-wave artists.

Billboard 200: *With Sympathy* (#96)

ĒBN-ŌZN

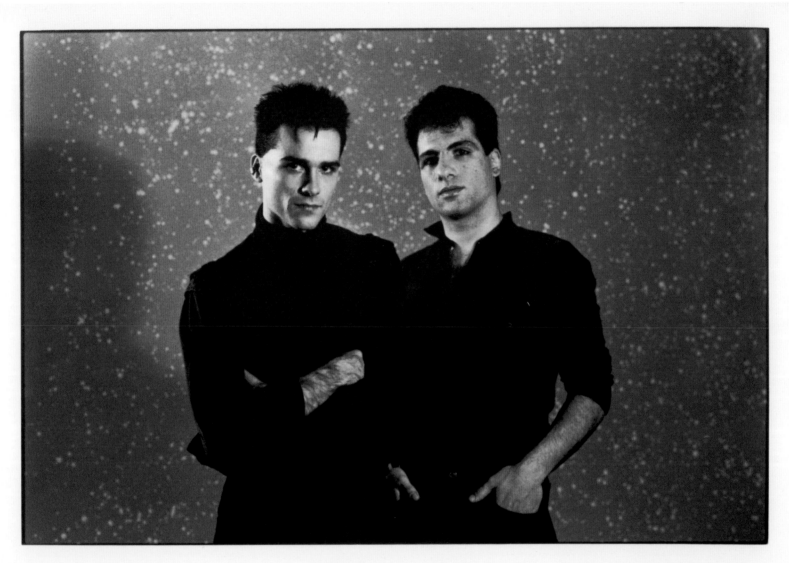

Steve Berkowitz &
Elliot Roberts
LOOKOUT MANAGEMENT
(617) 424-1060

Al Jourgensen & Stevo

ARISTA

ON RECORD | 1992 | [NONA HENDRYX | CHERYL LYNN | SHALAMAR]

The spirit behind the seminal pop-soul trio Labelle, **Nona Hendryx** put together her second solo release with support from the jazz-funk group Material.

Billboard 200: *Nona* (#83)
Billboard Hot 100: "Keep It Confidential" (#91)

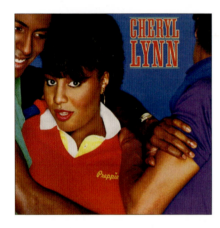

Jimmy Jam & Terry Lewis fashioned **Cheryl Lynn**'s "Encore," her second No. 1 R&B single and the first chart-topper for the Minneapolis production duo.

Billboard 200: *Preppie* (#161)
Billboard Hot 100: "Encore" (#69)

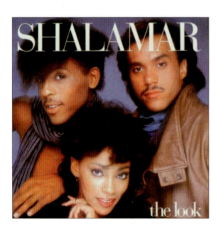

The last **Shalamar** album to feature Jody Watley and Jeffrey Daniel, *The Look* veered from R&B to new wave on a Grammy-nominated hit, "Dead Giveaway."

Billboard Hot 100: "Dead Giveaway" (#22)

NONA HENDRYX Management: VICKI WICKHAM
 212-977-3170

RCA Records and Tapes

CHERYL LYNN

JEFFREY DANIEL JODY WATLEY HOWARD HEWETT

SHALAMAR

PHOTO CREDIT: BOBBY HOLLAND/1983

SOLAR
SOUND OF LOS ANGELES RECORDS

Distributed by Elektra/Asylum Records.

ON RECORD | **1992** | **[EARTH, WIND & FIRE | KOOL & THE GANG | THE S.O.S. BAND]**

Steered by founder and leader Maurice White, *Powerlight*, **Earth, Wind & Fire**'s 12th studio album, yielded the Grammy-nominated "Fall in Love with Me."

Billboard 200: *Powerlight* (#12)
Billboard Hot 100: "Fall in Love with Me" (#17); "Side by Side" (#76)

Returning to producing themselves, funk group **Kool & the Gang** continued to top the charts with the smooth R&B of "Joanna," a smash hit love song.

Billboard 200: *In the Heart* (#29)
Billboard Hot 100: "Joanna" (#2); "Tonight" (#13)

The S.O.S. Band's *On the Rise* was marked by two knockout singles, the sensuous ballad "Tell Me If You Still Care" and the bold "Just Be Good to Me."

Billboard 200: *On the Rise* (#47)
Billboard Hot 100: "Just Be Good to Me" (#55); "Tell Me If You Still Care" (#65)

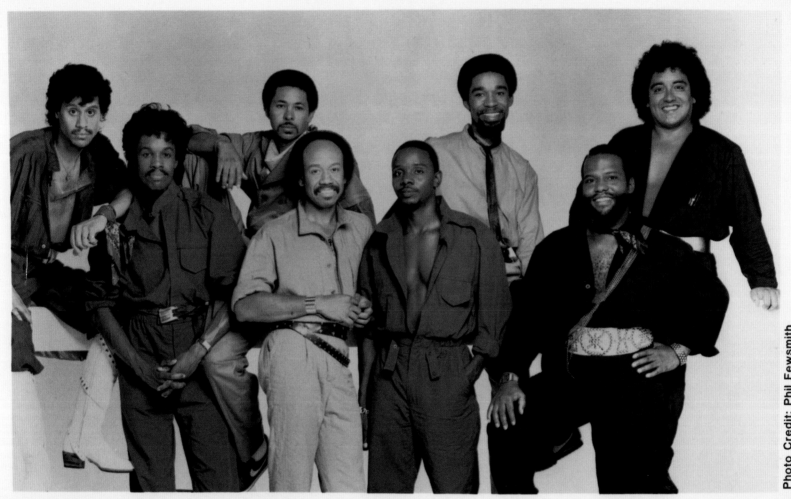

EARTH WIND & FIRE

Photo Credit: Phil Fewsmith

8311

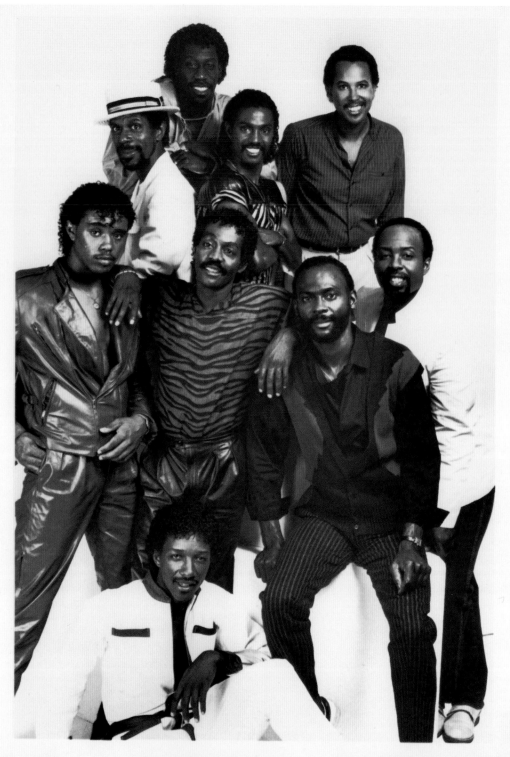

Management & Direction
Quintet Assoc. Ltd.
And TWM Management
641 Lexington Ave.
New York N.Y 10022
Bookings:
 Norby Walters Assoc.

PolyGram Records

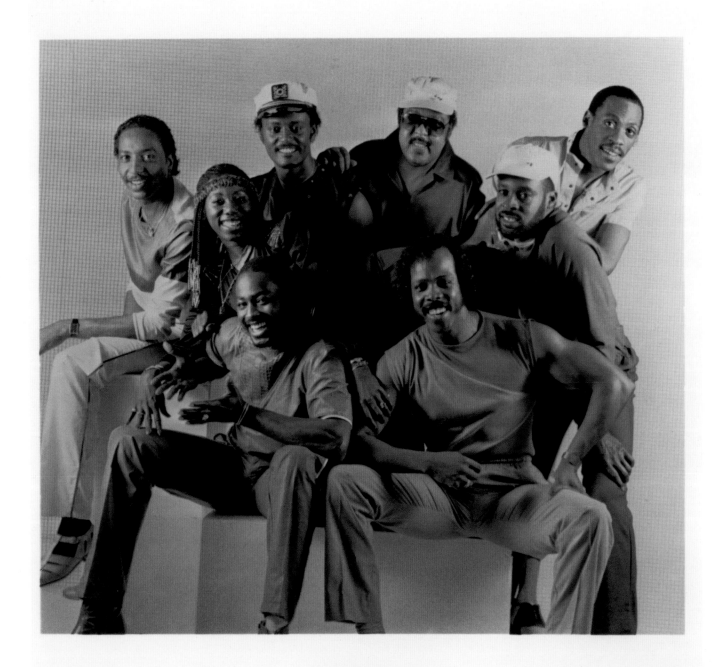

REPRESENTATION:

firstClass, inc.

1422 W Peachtree, N.W
Suite 303
Atlanta, Georgia 30309
404/892-1434

EPIC PORTRAIT ASSOCIATED
8307

ON RECORD | 1992 | [THE MANHATTANS | MIDNIGHT STAR | RAY PARKER JR.]

The Manhattans, marking 19 years together in show business, broke into the Top 5 on the R&B charts thanks to the silky, sonorous harmonies of "Crazy."

Billboard 200: *Forever by Your Side* (#104)
Billboard Hot 100: "Crazy" (#72)

No Parking on the Dance Floor proved to be **Midnight Star**'s breakthrough album, set off by the kinetic single "Freak-A-Zoid," a mix of funk and techno.

Billboard 200: *No Parking on the Dance Floor* (#27)
Billboard Hot 100: "Freak-A-Zoid" (#66); "Wet My Whistle" (#61); "No Parking (On the Dance Floor)" (#81)

Woman Out of Control, R&B artist **Ray Parker Jr.**'s second solo album, contained "In the Heat of the Night," an underestimated piece of electronic funk.

Billboard 200: *Woman Out of Control* (#45)
Billboard Hot 100: "I Still Can't Get Over Loving You" (#12)

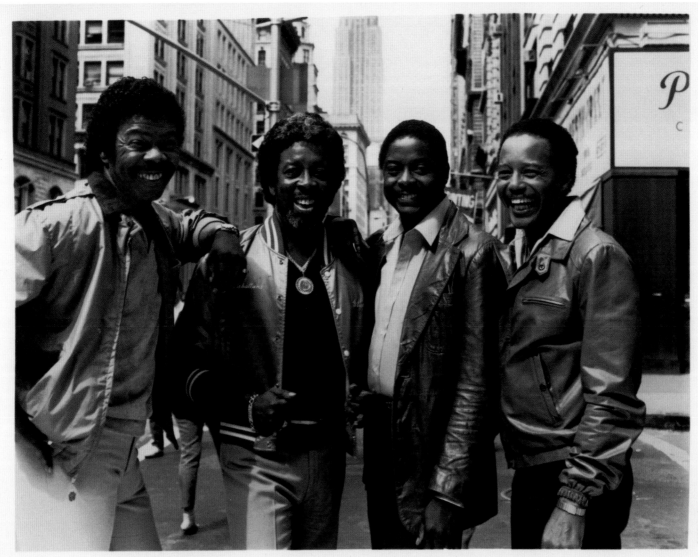

From left Sonny Bivins, Blue Lovett, Gerald Alston, and Kenny Kelley

Management: Gerald Delet
TWM Management Services Ltd.
641 Lexington Avenue
New York, N.Y 10022
(212) 421-6249

THE MANHATTANS

8306

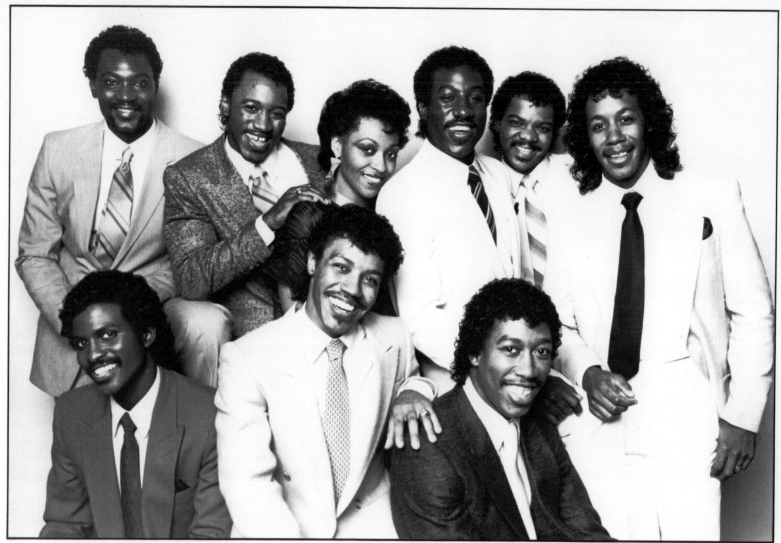

| KENNETH GANT | BO WATSON | BELINDA LIPSCOMB | BOBBY LOVELACE | WILLIAM SIMMONS | VINCENT CALLOWAY |
| JEFFREY COOPER | | REGINALD CALLOWAY | | MELVIN GENTRY | |

MIDNIGHT STAR

Distributed by Elektra/Asylum Records.

PHOTO CREDIT: JIM SHEA/1983

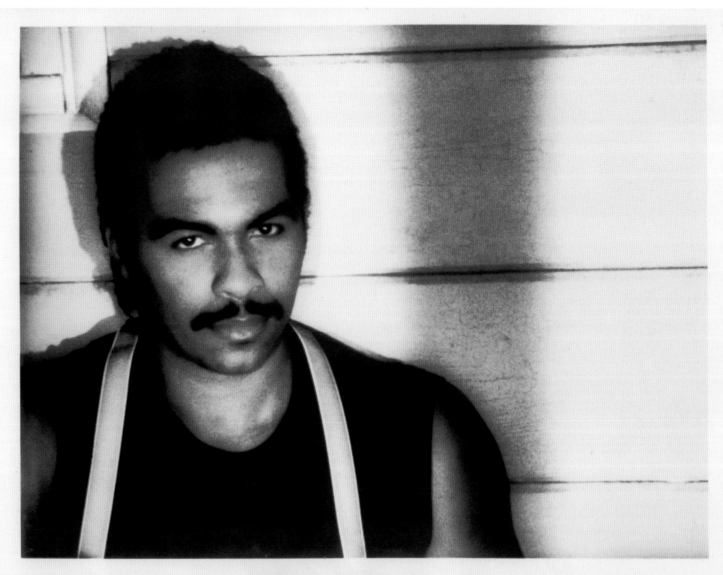

ON RECORD 1992 [THE DEELE | GAP BAND | DAZZ BAND]

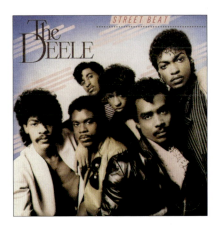

The Deele, a young group from Cincinnati featuring Antonio "L.A." Reid and Kenny Edmonds, scored its first R&B smash with the up-tempo "Body Talk."

Billboard 200: *Street Beat* (#78)
Billboard Hot 100: "Body Talk" (#77)

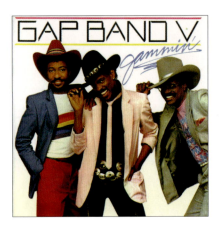

The funky **Gap Band** formula was duplicated on the R&B hit "Party Train" and the ballad "Someday," graced by a guest vocal by friend Stevie Wonder.

Billboard 200: *Gap Band V - Jammin'* (#28)

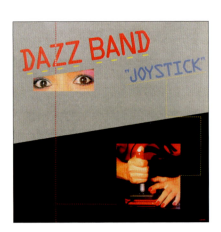

Cleveland's **Dazz Band** evolved its sound to go after the rising techno-funk market, snagging another R&B hit with the title track from the *Joystick* album.

Billboard 200: *Joystick* (#73)
Billboard Hot 100: "Joystick" (#61)

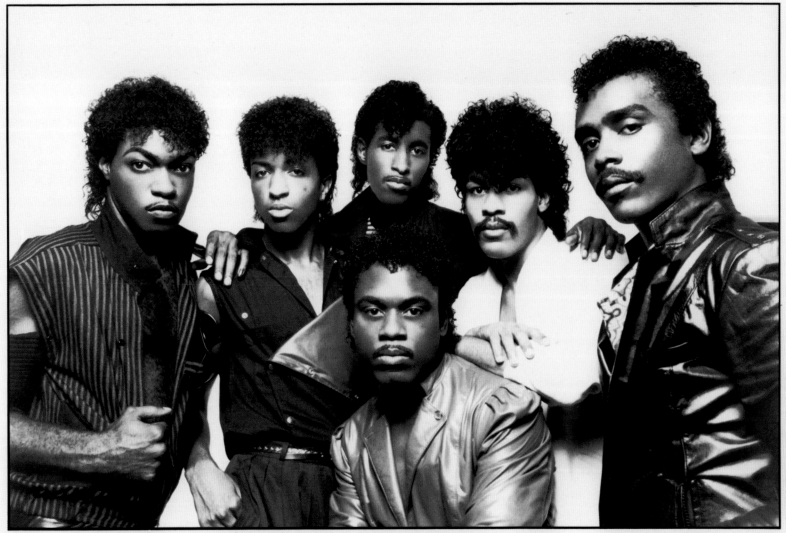

KAYO KEVIN ROBERSON "STICK STANLEY BURKE KENNY EDMONDS DEE" DARNELL BRISTOL CARLOS GREENE
"L.A." ANTONIO REID

THE DEELE

THE DAZZ BAND

ON RECORD | 1992 | [JOHN DENVER | WILLIE NELSON & MERLE HAGGARD | DON WILLIAMS]

Emmylou Harris joined **John Denver** as a harmony vocalist on "Wild Montana Skies," one of the singular Western anthems featured on his *It's About Time*.

Billboard 200: *It's About Time* (#61)

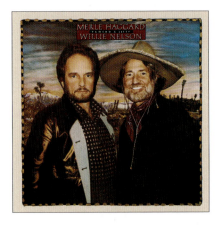

Pancho & Lefty, a duet album by country music icons **Willie Nelson & Merle Haggard**, centered on the title track, a nascent classic from Townes Van Zandt.

Billboard 200: *Pancho & Lefty* (#37)

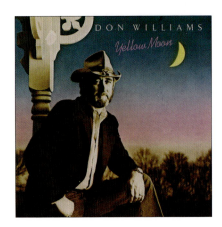

The hits continued for **Don Williams**, the influential "Gentle Giant" of country music, as his singles "Love Is on a Roll" and "Stay Young" reached No. 1.

316

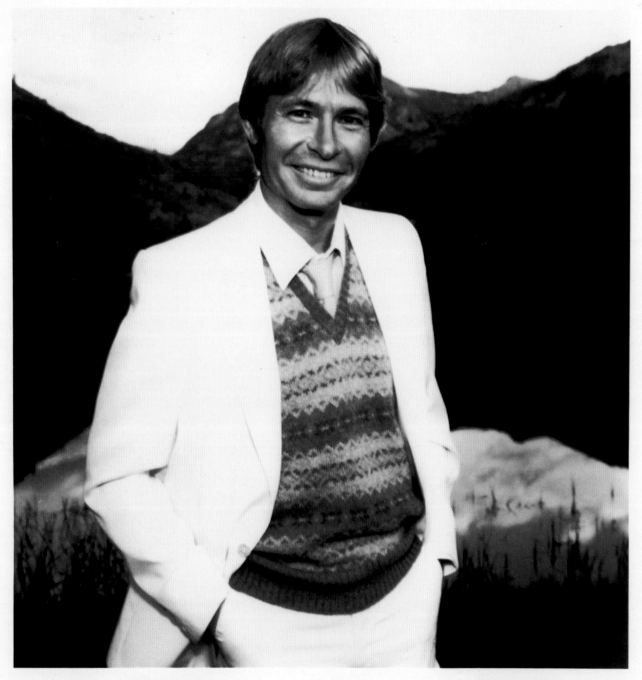

JOHN DENVER

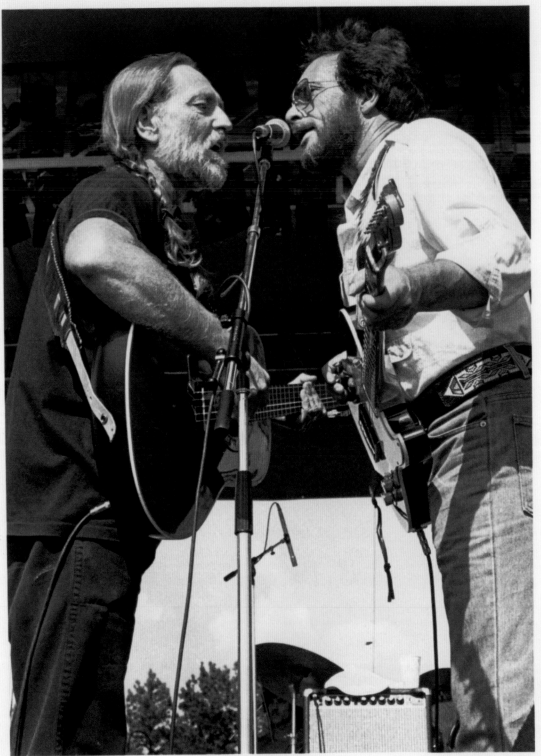

ON RECORD | 1992 | [GEORGE STRAIT | ALABAMA | THE OAK RIDGE BOYS]

Reviving the honky-tonk and Western swing genres, **George Strait**'s first country chart-topper, *Right or Wrong*, also generated three best-selling singles.

Billboard 200: *Right or Wrong* (#163)

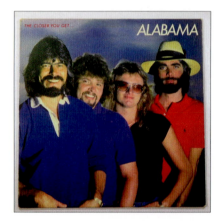

A trio of singles from **Alabama**'s Grammy Award-winning *The Closer You Get...* album reached the pinnacle position on *Billboard*'s country music charts.

Billboard 200: *The Closer You Get...* (#10)
Billboard Hot 100: "The Closer You Get" (#38);
"Lady Down on Love" (#76)

The Oak Ridge Boys landed their fourth crossover hit when "American Made" climbed the pop charts while also becoming their seventh country No. 1.

Billboard 200: *American Made* (#51)
Billboard Hot 100: "American Made" (#72)

GEORGE STRAIT

MCA RECORDS
8/83

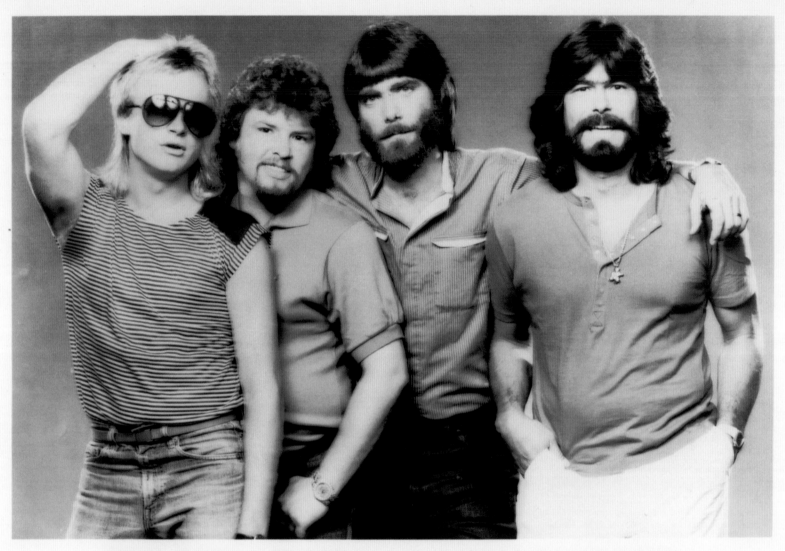

NASHVILLE, TN 8/18....In 1983 ALABAMA has already played to 1.3 million fans performing songs from their current LP, THE CLOSER YOU GET Approaching double platinum in sales, THE CLOSER YOU GET has been in the #1 position on Billboard's Country LP Chart for 13 weeks. The third-charted single from the LP "Lady Down on Love," a ballad written by Randy Owen, will be performed by the group this year on the nationally televised CMA program. Alabama is nominated in 4 categories by the CMA including Entertainer of the Year, Album of the Year (THE CLOSER YOU GET), Instrumental Group of the Year and Vocal Group of the Year.

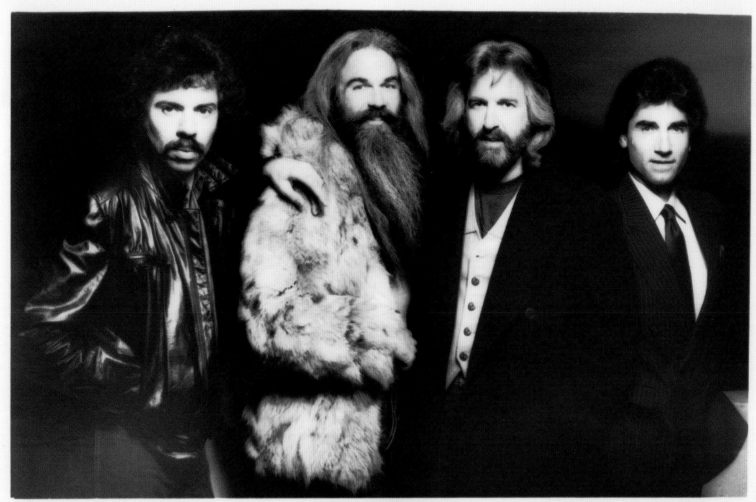

Joe, Bill, Duane, Richard

ON RECORD | 1992 | [BARBARA MANDRELL | CRYSTAL GAYLE | SHELLY WEST]

Barbara Mandrell, the People's Choice Award winner for Favorite All-Around Female Entertainer, added a country No. 1 with "One of a Kind Pair of Fools."

Billboard 200: *Spun Gold* (#140)

Two singles from **Crystal Gayle**'s *Cage the Songbird*, "Turning Away" and the pop crossover "The Sound of Goodbye," hit No. 1 on the country charts.

Billboard 200: *Cage the Songbird* (#171)
Billboard Hot 100: "The Sound of Goodbye" (#84)

The daughter of country music star Dottie West, **Shelly West** peaked with the smash "José Cuervo," bringing a sales boost to the titular tequila company.

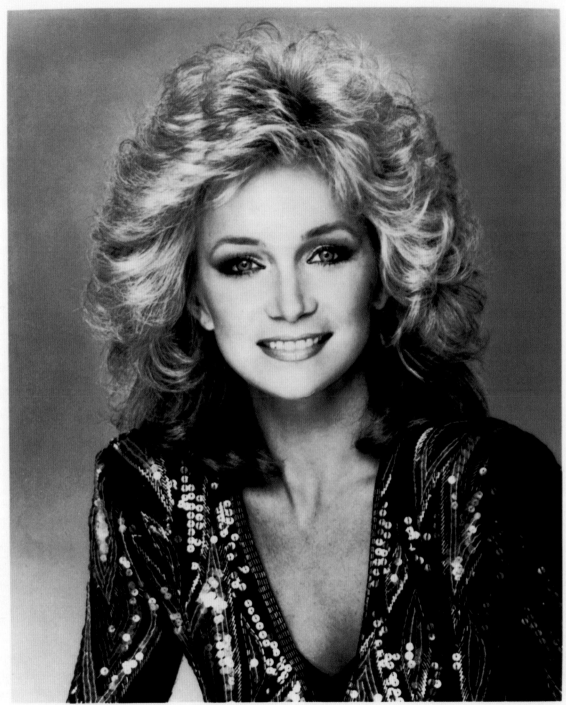

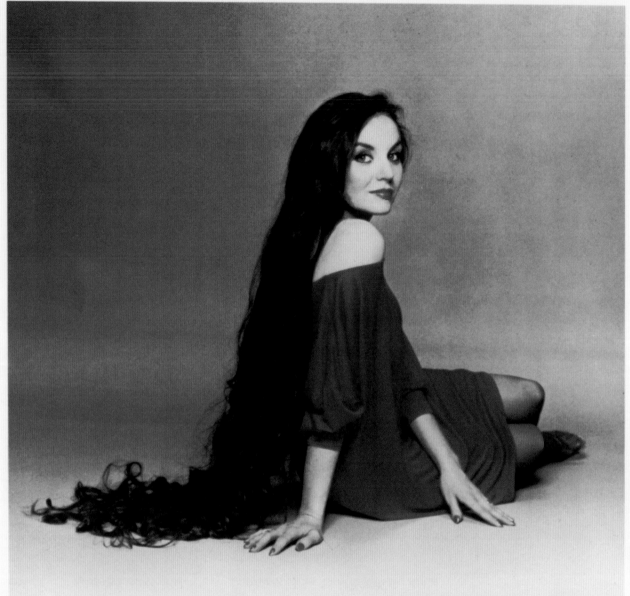

CRYSTAL GAYLE

HARRY LANGDON PHOTOGRAPHY

WARNER BROS.

SHELLY WEST

February 1983

ON RECORD 1992 [RICKY SKAGGS | JOHN CONLEE | LEE GREENWOOD]

Ricky Skaggs paved his road to country music's top accolades with a No. 1 album, *Don't Cheat in Our Hometown*, and its three chart-topping singles.

From singer **John Conlee**'s *In My Eyes* came three No. 1 country hits—the title track, "I'm Only in It for the Love" and "As Long as I'm Rockin' with You."

Lee Greenwood racked up two singles, "I.O.U." and "Somebody's Gonna Love You," that made inroads into country, pop and adult-contemporary charts.

Billboard 200: *Somebody's Gonna Love You* (#73)
Billboard Hot 100: "I.O.U." (#53); "Somebody's Gonna Love You" (#96)

RICKY SKAGGS

WAITIN' FOR THE SUN TO SHINE

Certified Gold 1983

HIGHWAYS AND HEARTACHES

MCA RECORDS

3/83

ON RECORD | 1992 | [JEFFREY OSBORNE | LUTHER VANDROSS | DIONNE WARWICK]

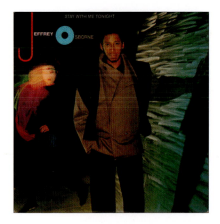

Velvet-smooth singer **Jeffrey Osborne**'s second project after exiting the band L.T.D., the gold album *Stay with Me Tonight* spawned four Top 20 R&B singles.

Billboard 200: *Stay with Me Tonight* (#25)
Billboard Hot 100: "Don't You Get So Mad" (#25);
"Stay with Me Tonight" (#30); "We're Going All the Way" (#48)

Busy Body, **Luther Vandross**' third album, gave birth to a tetrad of R&B hit singles, including a masterly medley that stood as his salute to Aretha Franklin.

Billboard 200: *Busy Body* (#32)
Billboard Hot 100: "How Many Times Can We Say Goodbye" (#27);
"Superstar/Until You Come Back to Me (That's What I'm Gonna Do)" (#87)

"How Many Times Can We Say Goodbye," **Dionne Warwick**'s resplendent duet with Luther Vandross, grew into a pop, R&B and adult-contemporary smash.

Billboard 200: *How Many Times Can We Say Goodbye* (#57)
Billboard Hot 100: "How Many Times Can We Say Goodbye" (#27)

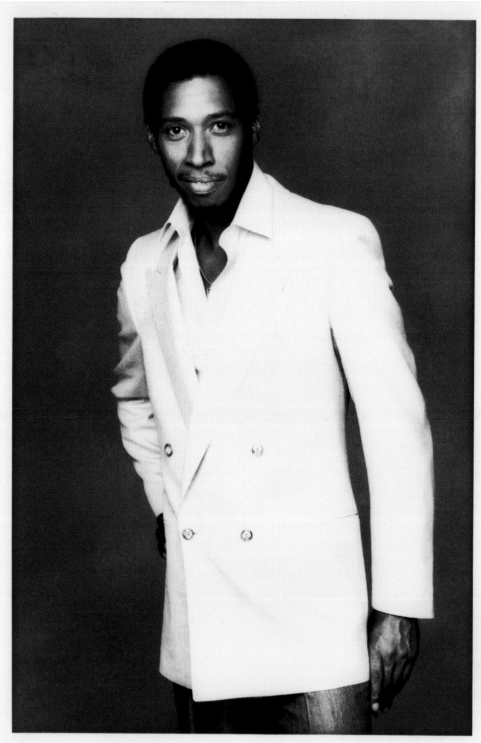

Management:
Jack Nelson & Associates
Los Angeles, California
Booking: Regency Artists

JEFFREY OSBORNE

Photo Credit: Bobby Holland

Printed in U.S.A.

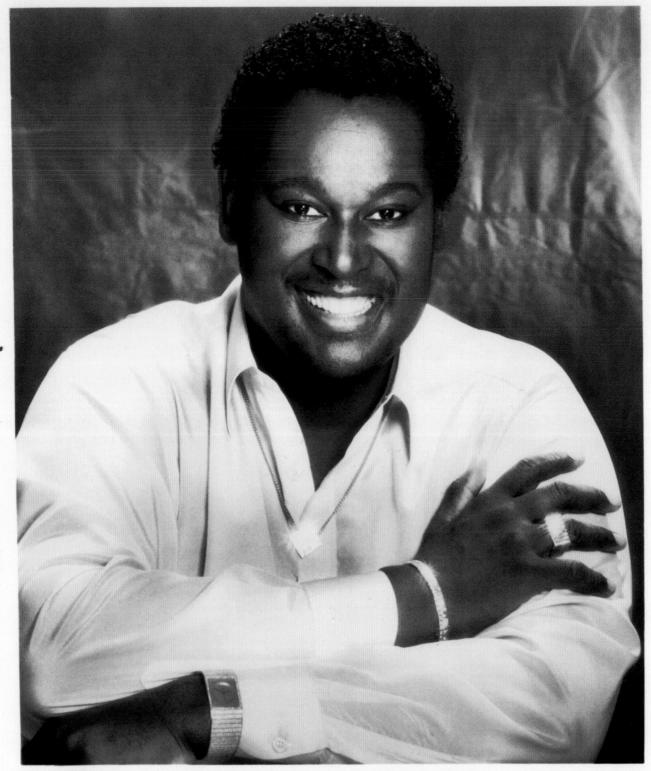

 LUTHER VANDROSS

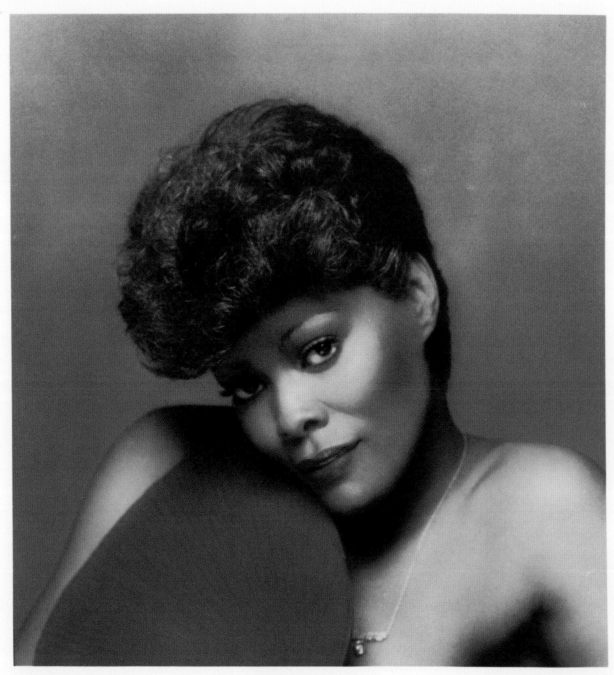

Personal Management:
G.M.I.
Joseph Grant
6464 Sunset Blvd.
Suite 1030
Hollywood, CA 90028
(213) 466-3335

Dionne Warwick

ON RECORD | 1992 | [MTUME | JAMES BLOOD ULMER | PIECES OF A DREAM]

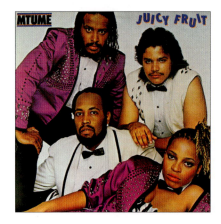

Known for his work with Miles Davis, percussionist James Mtume wrote, arranged and produced "Juicy Fruit," a No. 1 R&B hit by his own band, **Mtume**.

Billboard 200: *Juicy Fruit* (#26)
Billboard Hot 100: "Juicy Fruit" (#45)

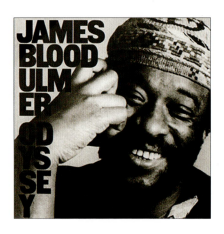

Free-jazz guitarist **James Blood Ulmer** forsook funk and rock conventions to forge *Odyssey* with drummer Warren Benbow and violinist Charles Burnham.

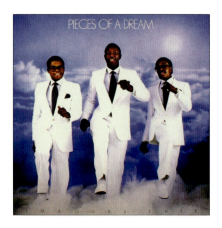

Produced by saxophonist Grover Washington, Jr., the rhythmic "Fo-Fi-Fo" prompted chart success for **Pieces of a Dream**, Philadelphia's young jazz combo.

Billboard 200: *Imagine This* (#90)

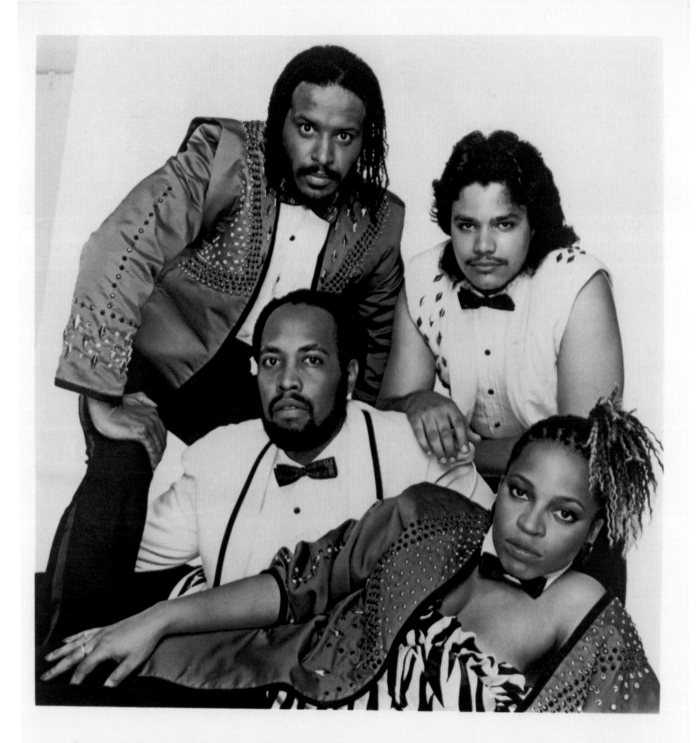

James Mtume (top left hand corner) with from left to right:
Ed "Tree" Moore, Philip Fields and Tawatha

MTUME

JAMES BLOOD ULMER

CEDRIC NAPOLEON CURTIS D. HARMON JAMES LLOYD

CURTIS D. HARMON CEDRIC NAPOLEON JAMES LLOYD

PHOTO CREDIT: IRWIN WASHINGTON / 1983.

PIECES OF A DREAM

ELEKTRA

The Manhattan Transfer issued *Bodies and Souls*, dropping its jazz vocal roots for an urban-contemporary bent and scoring a sleek R&B hit, "Spice of Life."

Billboard 200: *Bodies and Souls* (#57)
Billboard Hot 100: "Spice of Life" (#40)

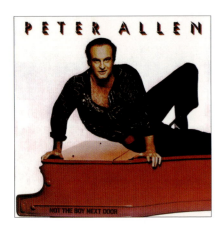

Flamboyant Aussie composer, singer, dancer and actor **Peter Allen** charted three adult-contemporary singles from his *Not the Boy Next Door* album.

Billboard 200: *Not the Boy Next Door* (#170)

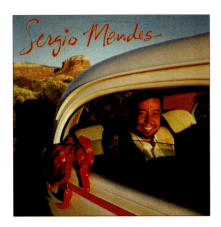

Famous for the bossa nova sounds of his band Brazil '66, **Sergio Mendes** explored pop/R&B territory and enjoyed a huge hit, "Never Gonna Let You Go."

Billboard 200: *Sergio Mendes* (#27)
Billboard Hot 100: "Never Gonna Let You Go" (#4);
"Rainbow's End" (#52)

The Manhattan Transfer
(L-R) Tim Hauser, Janis Siegel, Alan Paul, Cheryl Bentyne

THE MANHATTAN TRANSFER

PETER ALLEN

Direction:
DEE ANTHONY ORGANIZATION

ARISTA

ON RECORD 1992 [MECO | EDDIE MURPHY | RODNEY DANGERFIELD]

Acknowledged for his 1977 disco version of the theme to *Star Wars*, **Meco** took on "Ewok Celebration," associated with his *Return of the Jedi* installment.

Billboard Hot 100: "Ewok Celebration" (#60)

Eddie Murphy's *Eddie Murphy: Comedian*, recorded during the stand-up tour for his *Delirious* TV special, won the Grammy for Best Comedy Album.

Billboard 200: *Comedian* (#35)

Comedian **Rodney Dangerfield** got a little respect at 61 via a Grammy nomination for "Rappin' Rodney," a novelty song and music video popular on MTV.

Billboard Hot 100: "Rappin' Rodney" (#83)

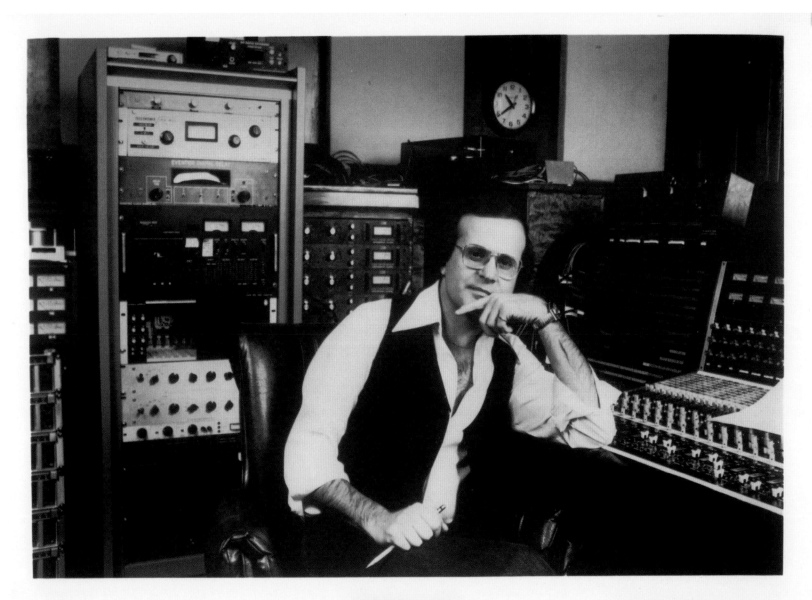

MECO ARISTA

Entertainment Management Associates, Ltd.
Richard Tienken and Robert Wachs
232 East 63rd Street
New York, New York 10021
(212) 308-6070

EDDIE MURPHY

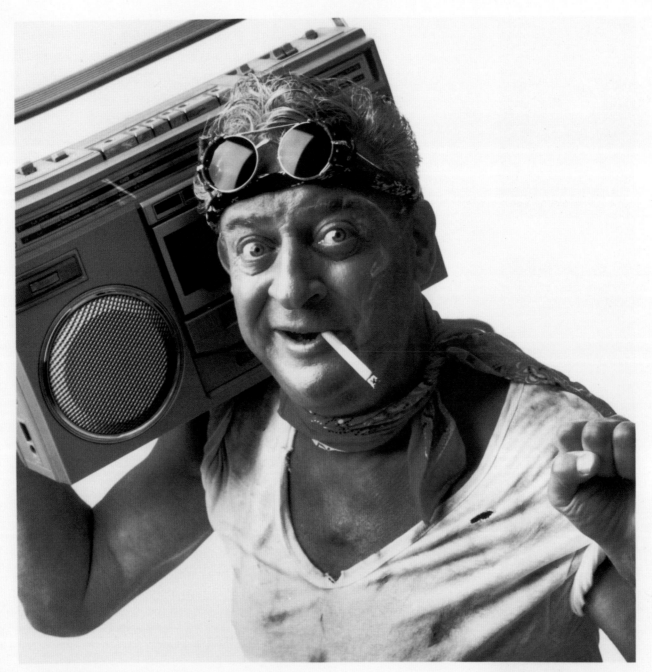

RODNEY DANGERFIELD

On tour to promote *Avalon*, **Roxy Music** recorded *The High Road*, an EP with covers of John Lennon's "Jealous Guy" and Neil Young's "Like a Hurricane."

Billboard 200: *The High Road* (#67)

On *Apollo: Atmospheres & Soundtracks*, English ambient-music savant **Brian Eno** collaborated with brother Roger and Canadian producer Daniel Lanois.

Aberrant funk band **Was (Not Was)** drafted vocalists ranging from Ozzy Osbourne to Mitch Ryder to crooner Mel Tormé for *Born to Laugh at Tornadoes*.

Billboard 200: *Born to Laugh at Tornadoes* (#134)

Plagued by contention behind the scenes, **Pink Floyd**'s *The Final Cut* was virtually a Roger Waters solo work, fusing personal history to an anti-war concept.

Billboard 200: *The Final Cut* (#6)

"Rock 'n' Roll Is King" emerged as a sizable single for **Electric Light Orchestra**, but *Secret Messages* marked the end of core members recording together.

Billboard 200: *Secret Messages* (#36)
Billboard Hot 100: "Rock 'n' Roll Is King" (#19); "Four Little Diamonds" (#86)

A pseudonym used by musician Tony Carey for his progressive sci-fi themed music, **Planet P** clicked at rock radio stations with the pulsating "Why Me?"

Billboard 200: *Planet P* (#42)
Billboard Hot 100: "Why Me?" (#64)

ON RECORD | 1992 | [JOE JACKSON | DONNIE IRIS | MARTY BALIN]

Joe Jackson's soundtrack to the movie *Mike's Murder* generated a charting single, "Memphis," and a Grammy-nominated instrumental, "Breakdown."

Billboard 200: *Mike's Murder* (#64)
Billboard Hot 100: "Memphis" (#85)

Fortune 410, **Donnie Iris**' fourth album, contained a hit built around a promotional partnership with the electronics company Atari, "Do You Compute?"

Billboard 200: *Fortune 410* (#127)
Billboard Hot 100: "Do You Compute?" (#64)

A founding member of Jefferson Airplane, the pioneering San Francisco rock band, vocalist **Marty Balin** released *Lucky*, his sophomore solo recording

Billboard 200: *Lucky* (#156)
Billboard Hot 100 "What Love Is" (#63)

[BOB DYLAN | PAUL SIMON | VAN MORRISON] 1992 ON RECORD

Bob Dylan employed Dire Straits frontman Mark Knopfler as producer of *Infidels*, seen as a return to personal themes following three religious records.

Billboard 200: *Infidels* (#20)
Billboard Hot 100: "Sweetheart Like You" (#55)

Succeeding Simon & Garfunkel's reunion concert in Central Park and world tour, **Paul Simon**'s *Hearts and Bones* had no input from his erstwhile partner.

Billboard 200: *Hearts and Bones* (#35)
Billboard Hot 100: "Allergies" (#44)

Van Morrison's *Inarticulate Speech of the Heart*, informed by several imaginative instrumental tracks, fostered matters of spirituality, faith and healing.

Billboard 200: *Inarticulate Speech of the Heart* (#116)

ON RECORD | 1992 | [YAZ | WANG CHUNG | HEAVEN 17]

Yaz, a synth-pop duo comprised of former Depeche Mode member Vince Clarke and vocalist Alison Moyet, broke up before the release of *You and Me Both*.

Billboard 200: *You and Me Both* (#69)

Changing its name from Huang Chung, the English new-wave group **Wang Chung** re-recorded 1982's "Dance Hall Days" and found success in the US.

Billboard 200: *Points on the Curve* (#30)
Billboard Hot 100: "Don't Be My Enemy" (#86); "Don't Let Go" (#38); "Dance Hall Days" (#16)

"Temptation," "Come Live with Me" and "Crushed by the Wheels of Industry" were smashes in the UK for **Heaven 17**, an innovative synth-pop outfit.

Billboard 200: *The Luxury Gap* (#72)

352

[METALLICA | MINOR THREAT | THIN LIZZY]　1992　ON RECORD

California band **Metallica** recorded its debut album, the fast and heavy *Kill 'Em All*, which set the foundation for the nascent underground metal scene.

Billboard 200: *Kill 'Em All* (#120)

With *Out of Step*, **Minor Threat**, a staunchly independent Washington, D.C. band, set an anti-commercial standard for the hardcore punk movement.

The album *Thunder and Lightning* turned out to be **Thin Lizzy**'s last studio release, with leader Phil Lynott recruiting John Sykes to handle guitar parts.

Billboard 200: *Thunder and Lightning* (#159)

353

ON RECORD 1992 [LOS LOBOS | 38 SPECIAL | MARSHALL CRENSHAW]

Los Lobos' *...And a Time to Dance* gained fans outside of East L.A. as "Anselma" won the first Grammy Award for Best Mexican-American Performance.

Imbued with sparkling hooks and melodies, **38 Special**'s "If I'd Been the One" and "Back Where You Belong" extended the rock band's string of hits.

Billboard 200: *Tour de Force* (#22)
Billboard Hot 100: "If I'd Been the One" (#19);
"Back Where You Belong" (#20)

"Whenever You're on My Mind," a perfect pop statement from **Marshall Crenshaw**'s second album, *Field Day*, emerged as one of his best-known songs.

Billboard 200: *Field Day* (#52)

"Buffalo Soldier," which became a Bob Marley & the Wailers classic, appeared on *Confrontation,* a collection released after the reggae pioneer's death.

Billboard 200: *Confrontation* (#55)

Maintaining her status as "the queen of soul," Aretha Franklin scored a No. 1 R&B hit with "Get It Right," crafted in collaboration with Luther Vandross.

Billboard 200: *Get It Right* (#36)
Billboard Hot 100: "Get It Right" (#61)

James Ingram teamed with Michael McDonald for "Yah Mo B There" and won the Grammy for Best R&B Performance by a Duo or Group with Vocal.

Billboard 200: *It's Your Night* (#46)
Billboard Hot 100: "How Do You Keep the Music Playing" (#45); "Yah Mo B There" (#19); "There's No Easy Way" (#58)

ON RECORD 1992 [THE ROBERT CRAY BAND | B.B. KING | NEW EDITION]

The Robert Cray Band's *Bad Influence*, containing the songs "Phone Booth" and the title track, ingrained the guitarist into contemporary blues culture.

Billboard 200: *Bad Influence* (#143)

The legendary **B.B. King** tracked the entirety of *Blues 'N' Jazz* on his 57th birthday, and the recording wound up winning the Grammy for Best Blues Album.

Billboard 200: *Blues 'N' Jazz* (#172)

Ranging in age from 13 to 15, the members of **New Edition** experienced fame with the title track to *Candy Girl*, which went to No. 1 on the R&B charts.

Billboard 200: *Candy Girl* (#90)
Billboard Hot 100: "Candy Girl" (#46); "Is This the End" (#85)

Let's Go heralded the return of the **Nitty Gritty Dirt Band** name and Jimmy Ibbotson to the group, yielding the Top 10 country hit, "Dance Little Jean."

Singer **Charly McClain** found harmony with duet partner Mickey Gilley, returning to No. 1 on the country music charts with her single "Paradise Tonight."

The Ballad of the Fallen by bassist **Charlie Haden** and his Liberation Music Orchestra was voted Album of the Year in *DownBeat* magazine's jazz critics' poll.

{ IN MEMORY OF HERB KAUVAR }

ACKNOWLEDGMENTS

Many people were essential to the creation of this book. My first thanks go to my amazing publishing team—Jon Rizzi for bringing his special brand of editorial wit and intelligence, and Kate Glassner Brainerd for her design artistry and unflagging pursuit of excellence. Special appreciation goes to the Michael & Patricia Matthews Fund, as well as John Cerullo, Annette Hobbs Magier, and Kevin Votel and his colleagues at Publishers Group West.

Mike Dickson, Chip Garofalo, Jennifer Soulé, Mark Zaremba, Peter Marcus, Matt Rue, Jay Elowsky, Dave Zobl, Mark Lewis and Alexander Hau contributed expertise and resources. I am especially indebted to my dear friend Michael Jensen, as well as Sue Satriano, Janice Azrak, Bryn Bridenthal, Byron Hontas, Kathy Acquaviva, Shelly Selover, Sue Sawyer, Glen Brunman, Rick Ambrose, Bob Merlis, Bill Bentley, Heidi Ellen Robinson, Les Schwartz, Rick Gershon, Jim Merlis, Judi Kerr and Susan Blond—all of whom supported my efforts.

I specifically treasure the beneficence of Dave Rothstein, Greg Phifer, John Tope, Kevin Knee, Dick Merkle, Jeff Cook, Michael Brannen, Zak Phillips, Rich Garcia, Jason Minkler, Burt Baumgartner, Mitch Kampf, Don Zucker, Carl Walters, Charlie Reardon, Robin Wren, Jimmy Smith, Sharona White, John Ryland, Geina Horton, Michael Linehan, Mike Prince and Jeffrey Naumann, who all graciously furnished information and assistance.

I gratefully acknowledge the editing and reviewing skills of Dick Kreck, Tom Walker, Diane Carman, Mike Rudeen, Ed Smith, Jay Whearley, Mark Sims, Jeff Bradley and Peggy McKay.

I also salute David Gans, Leland Rucker, Steve Knopper, David Menconi, Jon Iverson, Gil Asakawa, Mark Bliesener, Butch Hause, Ricardo Baca, John Moore, Justin Mitchell, Michael Mehle and Harvey Kubernik, whose writings formed a vital index for the music-obsessed.

Finally, I would like to acknowledge with gratitude my beloved wife, Bridget, for her constant devotion and kindness. I cherish her—the love of my life.

EDITOR | **JON RIZZI**
ART DIRECTOR | **KATE GLASSNER BRAINERD**

Copyright ©2024 Colorado Music Experience
ALL RIGHTS RESERVED. No portion of this book may be reproduced, stored in retreival system, or transmitted in any form, by any means, mechanical, electronic, photocopying, recording or otherwise, without the written permission of the publisher.

ISBN 979-8-9885329-3-4 PRINTED IN CHINA | Asia Pacific Offset

HOLA PISTOLA
LIVE!

Laetrile Records

Next in the *ON RECORD* book series

Vol.11 1989

ON RECORD 1989

IMAGES, INTERVIEWS & INSIGHTS FROM THE YEAR IN MUSIC > G. BROWN